# Seeing Human Rights

**Information Policy Series**

Edited by Sandra Braman

The Information Policy Series publishes research on and analysis of significant problems in the field of information policy, including decisions and practices that enable or constrain information, communication, and culture irrespective of the legal siloes in which they have traditionally been located as well as state–law–society interactions. Defining information policy as all laws, regulations, and decision-making principles that affect any form of information creation, process-ing, flows, and use, the series includes attention to the formal decisions, decision-making processes, and entities of government; the formal and informal decisions, decision-making processes, and entities of private and public sector agents capable of constitutive effects on the nature of society; and the cultural habits and predis-positions of governmentality that support and sustain government and governance. The parametric functions of information policy at the boundaries of social, infor-mational, and technological systems are of global importance because they provide the context for all communications, interactions, and social processes.

A complete list of the books in the Information Policy Series appears at the back of this book.

# Seeing Human Rights

## Video Activism as a Proxy Profession

Sandra Ristovska

The MIT Press
Cambridge, Massachusetts
London, England

The open access edition of this book was made possible by generous funding from Arcadia—a charitable fund of Lisbet Rausing and Peter Baldwin.

The MIT Press would like to thank the anonymous peer reviewers who provided comments on drafts of this book. The generous work of academic experts is essential for establishing the authority and quality of our publications. We acknowledge with gratitude the contributions of these otherwise uncredited readers.

This book was set in Stone Serif and Stone Sans by Westchester Publishing Services. Printed and bound in the United States of America.

Library of Congress Cataloging-in-Publication Data

Names: Ristovska, Sandra, author.
Title: Seeing human rights : video activism as a proxy profession / Sandra Ristovska.
Description: Cambridge, Massachusetts : The MIT Press, 2021. | Series: Information
   policy | Based on the author's dissertation (doctoral)--University of Pennsylvania,
   2016. | Includes bibliographical references and index.
Identifiers: LCCN 2020033981 | ISBN 9780262542531 (paperback)
Subjects: LCSH: Human rights advocacy. | Video recordings--Political aspects. |
   Video recordings--Social aspects.
Classification: LCC JC571 .R575 2021 | DDC 323--dc23
LC record available at https://lccn.loc.gov/2020033981

10  9  8  7  6  5  4  3  2  1

# Contents

# Series Editor's Introduction

Sandra Braman

Fifty percent of human cognitive capacity is devoted to processing visual information. Thus it should be no surprise that, as Sandra Ristovska tells us in *Seeing Human Rights*, images were critical to the development of the concept of crimes against humanity. Today, videos are authoritative sources of information for the human rights community as it engages in advocacy and provides evidence in cases involving compliance with international human rights treaties and national laws.

Reportage has been important to verification of compliance with international treaties at least since it was incorporated into arms control agreements beginning in the mid-1980s. In order to be effective for such purposes, video production, analysis, and distribution must meet certain criteria. Ristovska proposes the concept of a "proxy profession" to help us understand the ways that video advocates balance the temptation to be tactically creative against the credibility and utility strategically needed for institutional legitimacy. The professional practices, standards, and community networks that have been developed for the use of video by human rights collectives make it possible for them to serve as brokers between eyewitness content producers and journalists. They address each stage of the process, from the collection and analysis of myriad sources of information, through the presentation and distribution of findings, to the archiving so necessary for memory. Provenance itself is little discussed in this book, but its presence hovers over all. With the development of curricula and training mechanisms, these practices are being passed on and the number of people trained to use them has been growing, not only within the field of human rights advocacy, but in other professional communities—including, quite significantly, journalism—as well.

The uses of video images for advocacy and activism purposes are myriad. In addition to providing information, they serve an epistemological function described by Eyal Weizman of Forensic Architecture, a group that uses video in open-source investigations, as verifying "violence at the threshold of visibility." Videos contribute to the development of ideals about democracy, humanitarianism, and human rights. They provide vision, and voice, engaging affect, fostering identity, mobilizing passions, and creating a sense of community. The metadata typically captured along with such videos facilitates analysis across witnesses. Viewing them creates witnessing publics of political efficacy.

Videos also serve as vehicles for social policy. Taking off from calls for a New World Information and Communication Order (NWIO) during the 1970s and early 1980s, an effort by the nonaligned countries operating as the Group of 77 in the United Nations to provide the foundation for a more equitable global distribution of resources by establishing more equitable networks of information flows ensuring that all communities have voice, there are calls for a "New World Image Order" by media activists. Even shy of such an ambition, videos set agendas for policy makers. They provide medium and content for policy debate, and have forensic functions as both tools and records. They are used as evidence in court, support legal processes, provide legal education, and influence how people understand the nature of their rights. Techniques developed by human rights collectives working with video advocacy take important steps forward in translating the affordances of today's electronic technologies into approaches to information collection and processing that ensure the evidentiary value of what is produced; the work is explicitly multi-perspectival, combining enormous amounts of fragmentary information to see relationships across time and space, and takes advantage of information unintentionally gathered as well as that gathered intentionally.

The analysis provided in *Seeing Human Rights* is part of the larger story regarding the intertwining of facts and politics today as we struggle with, on the one hand, the decline in resources of and trust in historically authoritative fact-producing institutions such as professional journalism organizations and universities and, on the other hand, the affective turn in politics that has replaced information with emotion as the basis of so much policy making. Those using video advocacy in the domain of human rights are engaging simultaneously with these developments in a highly sophisticated

manner, aware of both the affective importance of the work they produce and the need to meet the more rational requirements of verification for legal purposes.

The story Ristovska tells here provides insight into the even broader developments regarding transformations in the nature of power and in law-state-society relations we are experiencing. As trust in and the relative influence of historically authoritative fact-producing institutions decline, new types of institutions and practices will take their place. Video activism is by definition participatory, and is thus an inherently democratic tool. We are several decades into appreciation of what citizen science has to offer. "Data activism" has become a "thing," but is not always practiced in a way that is self-aware of the importance of ensuring that what is undertaken will have evidentiary and other types of policy-making value. With its documentation of how human rights video advocacy operates as a proxy profession, *Seeing Human Rights* provides guidance for those seeking political and legal effectiveness using other types of tools as well.

# Acknowledgments

Writing the acknowledgments may appear like a ritualistic practice in book publishing, but to me they are more difficult to write than the book itself. My gratitude is deeply felt and, perhaps in the spirit of the book, exceeds the capacity of words to communicate it. Knowing that these few pages cannot do justice to the people who have inspired my thinking and supported me and this project in myriad ways, I offer here my best effort to thank them.

This book would not exist without the people who took time to reflect on their experiences with video and human rights. I owe my deepest gratitude to (in alphabetical order) staff members at Amnesty International, Berkeley's Human Rights Center, the European Journalism Centre, eyeWitness to Atrocity Project at the International Bar Association, First Draft, Forensic Architecture, Human Rights Watch, the International Criminal Court, the International Criminal Tribunal for the former Yugoslavia, Syrian Archive, the Visual Investigations Unit at the *New York Times*, and WITNESS.

*Seeing Human Rights* would have not been possible without earlier superb guidance, immense inspiration, and tremendous support from Barbie Zelizer. Her exceptional work as a scholar and her generosity as a mentor have provided ongoing sources of inspiration for my academic journeys. Dean John L. Jackson, Jr., Marwan Kraidy, and Monroe Price gave important advice and feedback for the early development of this project.

Sandra Braman saw the potential in this research in its early stages. I could not have asked for a better editor to guide me in this process. Her editorial and scholarly brilliance may be matched only by her generosity as a mentor. A set of anonymous reviewers treated the manuscript with care, offering valuable feedback and suggestions. The outstanding professionalism of Gita Manaktala and her team helped me navigate with ease the logistical process of book publishing.

Cathy Hannabach and her staff at Ideas on Fire provided important suggestions during the developmental editing phase. Leah Ferentinos kindly offered her copyediting expertise when I desperately needed another pair of eyes. She also assisted me with locating stock images for the book cover, which is designed by the talented Macedonian artist Ivanco Talevski.

Colleagues at the College of Media, Communication, and Information made me feel at home at the University of Colorado Boulder, easing the institutional transition in numerous ways. Their support was much needed for finishing this book as well. I am especially thankful to Dean Lori Bergen, Michela Ardizzoni, Shu-Ling Berggreen, Andrew Calabrese, Angie Chuang, Nabil Echchaibi, Stewart Hoover, Christine Larson, Janice Peck, Nathan Schneider, Pete Simonson, J. Richard Stevens, and Erin Willis. A dedicated staff at the college also supported me and my research: Stephanie Cook, Elina Day, Stacey Gilbert, Lisa Guinther, Helen Gurnee, Errol Hughes, Malinda Miller, and Deborah Schaftlein.

I was privileged to work with stellar graduate students in my seminar on visual epistemologies, who engaged with earlier drafts of this work. Luz Ruiz assisted me with the references and the archive of the International Criminal Tribunal for the former Yugoslavia. Anat Leshnick read the final draft and helped me with the references. Thoughtful and passionate undergraduate students in my seminars on visual culture and human rights keep reminding me why work in this area matters. For its completion, the book benefited from the de Castro Research Award from the College of Media, Communication, and Information.

I was fortunate to receive valuable feedback during different stages of this research as part of the George Gerbner Postdoctoral Fellowship at the Annenberg School for Communication at the University of Pennsylvania and as part of my fellowships with the Center for Media, Data, and Society at the Central European University, the Institute for the Study of Human Rights at Columbia University, and the Information Society Project at Yale Law School. Invited talks and lectures at Columbia University, Central European University, the European Institute for Communication and Culture Colloquium in Slovenia, Temple University, University of Amsterdam, University of Padova, University of Southern California, University of Westminster, and Yale University were invaluable opportunities to engage with exceptional audiences, who helped me work through the arguments in this book.

My heartfelt gratitude also goes to Paul Frosh, Peter Lunt, Stefania Milan, Amit Pinchevski, Catherine Preston, Sharon Sliwinski, Christina Spiesel, Claire Wardle, and Rebecca Wexler, who suggested readings, facilitated key contacts, and asked thoughtful questions about my research at various stages. Sun-ha Hong commented on some draft chapters. Omar Al-Ghazzi, Deepti Chittamuru, Elisabetta Ferrari, Sun-ha Hong, Debora Lui, Alexandra Sastre, Dror Walter, and Natacha Yazbeck are the kind of friends one is lucky to have in academia.

Personal biographies are often implicated in one's research interests. This is certainly the case with this book. My upbringing in the former Yugoslavia and what later became the independent country of Macedonia made me acutely aware early on in my life about the power of images of conflict, the importance and limits of human rights frameworks, the role of activism in society, and the significance of having voice. As I was growing up, people called my generation the "children of the transition," a transition that still seems endless. Each of us in our own way had to come to terms with many contradictions while never losing sight of the possibility for a better future and the value of love and compassion. It is no surprise that my dear friends in Skopje and Belgrade have been instrumental in shaping my thinking. In Skopje, Aleksandar Andonovski, Aleksandar Janushevski, Borjan Sandrevski, Darko Stevkovski, and Biljana Temelkovska and, in Belgrade, Milja Cvorović, Ivan Cvorović, Stevan Marinković, and Boris Marković always welcome me with warmth and kindness. To me, our *kafana* gatherings are the Balkan public sphere at its finest.

Last, life would not be the same without my brother, Stefan Ristovski, with whom adventure never ends, and my mother, Snežana Ristovska, whose kindness and selflessness are my GPS in life. To them, I dedicate this work.

# 1  Seeing Human Rights: Institutions, Agents, and Practices

"How do we know which videos are the right ones?" A fellow passenger on a connecting flight from Skopje to New York City asked me this question some years ago. Although she spoke about the challenges of navigating the avalanche of videos about police brutality during antigovernment protests in Macedonia in May 2015, her query addressed broader issues about today's media landscape, which is teeming with videos whose meanings are often unclear. Those videos are the topic of this book because they provide an important glimpse into possible human rights claims.

Videos capturing traumatic incidents—though not always properly credited, labeled, contextualized, or dated—are frequently produced, circulated across media platforms, and used for many purposes by journalists, activists, citizens, nongovernmental organizations (NGOs), governments, militaries, law enforcement agents, and even terrorist groups and other perpetrators of violence. Some of these videos end up being used in court. As a result, videos are often at the crossroads where the information work of various actors converges, offering a position from which to see events from the complicated scenes of their unfolding.

The power dynamics that shape the images of the public domain, however, have long been characterized by a lack of clarity. John Tagg insists that photography's "status as technology varies with the power relations that invest it. Its nature as a practice depends on the institutions and agents which define it and set it to work. . . . It is this field we must study, not photography as such."[1] This book takes up Tagg's call in the context of human rights video. It examines the institutional environments in which video takes shape as well as the agents and practices that render it meaningful as a tool for human rights. I contend that questions about reliability

and legitimacy, such as the one asked by my fellow passenger, involve not just the site of the video itself but also the institutions with their agents and practices that set video to work as an evidentiary, policy, and advocacy material in a human rights context.

The following questions motivate this book: What are the circumstances that facilitate the emerging institutional and legal turn to human rights video? How and why are the journalistic, legal, and political institutions that help legitimize human rights claims incorporating video? How and to what end is this turn to video affecting the relationships among human rights activists and institutional authorities? How and under what circumstances does visual information shape institutional and legal decision making? Whose expertise matters in rendering human rights video meaningful and why? This book tackles these questions to understand how institutional and legal environments at the international level are changing through their adoption of video and what this shift suggests about the status of visual evidence and global human rights activism today.

In the chapters that follow, I show that the growing centrality of human rights video in different institutional and legal domains has created the need to professionalize video practices long claimed by activists as their own craft in the broader pursuit of justice. Following Tina Askanius's practice-based framework,[2] the term *human rights video activism* denotes a various set of practices that document and voice critique against global instantiations of civil, political, economic, cultural, environmental, and social injustice. Of central concern here is how, when, and why human rights collectives operate across journalistic, legal, and political settings, seeking to professionalize video activism so they can better leverage video's evidentiary, policy, and advocacy potential in serving human rights goals.

*Human rights collectives* is an umbrella term that refers to the diverse range of human rights groups and networks constituting today's global human rights movement: well-established organizations such as Amnesty International (Amnesty) and Human Rights Watch (HRW); mid- to small-size NGOs such as WITNESS, Videre est Credere, B'Tselem, and Syrian Archive; local activist groups and media collectives such as Coletivo Papo Reto in Brazil and Mosireen in Egypt; networks such as Video4Change; university-based centers, such as Forensic Architecture at Goldsmith University of London and the Human Rights Center (HRC) at the University of California,

Berkeley; and emerging partnerships between human rights organizations and universities around the world, as in the case of Amnesty's Digital Verification Corps program. Some of these collectives have long operated in the human rights research, campaigning, and advocacy fields. Others have emerged in response to growing needs around human rights video production, verification, preservation, and investigation that have resulted from the rise of smartphones and social media. Table 1.1 provides a brief overview of the different human rights collectives discussed in this book.

These human rights collectives seek to professionalize video activism through video production, verification standards, and training. These efforts, however, do not qualify as a traditional profession. They instead lead to what I call a *proxy profession* that strategically places video in institutional and legal service. This proxy profession is legitimized within the existing structures of NGOs, enabling human rights collectives to claim visual expertise and facilitating their role as a broker between publics and various institutions serving public needs. Positioned as such, the proxy profession ends up retaining some of the flexibility of video activism as a critical voice against injustice by giving up on the more radical potential and imaginative scope of video activism as a cultural practice that sustains important human rights dialogue even in the face of institutional and legal stalemate.

## Institutional Context for Human Rights Video Activism

Visual imagery is at the heart of humanitarian and human rights activism. Political turbulence around the world over the past two decades has been venerated for its use of video—including in the Saffron Revolution in Myanmar (Burma), the Green Movement in Iran, the Arab uprisings throughout the Middle East, and the Black Lives Matter movement in the United States—reinforcing long-held (though not always articulated) beliefs in the power of video as a human rights tool. Commenting on the unfolding of the Arab Spring in Egypt, Jehane Noujaim, director of *The Square* (2013), a documentary film on the topic, echoed a lasting hope that video has an ability to facilitate social change by bearing witness to injustice and violence: "[Ahmed Hassan] used that camera as a weapon to fight back and expose human rights abuses and oppression that he saw. Many times, when he was on the front line, Ahmed was the only one there with a camera.

**Table 1.1**

Human Rights Collectives: A Brief Overview

| Name and Website (in alphabetical order) | Central Location and Founding Year | Primary Work |
| --- | --- | --- |
| Amnesty International (www.amnesty.org) | London, 1961 | a human rights organization engaged primarily in human rights research and campaigning around the world |
| B'Tselem (www.btselem.org) | Jerusalem, 1989 | a human rights organization that uses video to document Israeli violations of Palestinian human rights and to end Israel's occupation |
| Digital Verification Corps program, Amnesty International (www.citizenevidence .org/2019/12/06/the -digital-verification -corps-amnesty -internationals -volunteers-for-the-age -of-social-media/) | No central location, 2016 | a program between Amnesty International and seven universities (University of California, Berkeley, University of Cambridge, University of Essex, University of Hong Kong, Universidad Iberoamericana, University of Pretoria, and University of Toronto) that trains students to verify visual evidence of potential human rights violations from around the world and uses the students' work to support the reporting by Amnesty's research teams |
| Forensic Architecture (www.forensic -architecture.org) | Goldsmith University of London, 2010 | a research agency that conducts spatial and media investigations of global human rights abuses, with and on behalf of communities affected by political violence, human rights organizations, international prosecutors, environmental justice groups, and news media |
| Human Rights Center (www.humanrights .berkeley.edu) | University of California, Berkeley, 1994 | a research center that investigates war crimes and other violations of international humanitarian law and human rights and trains students and advocates to research, investigate, and document human rights violations using new tools and technologies |

**Table 1.1** (continued)

| Name and Website (in alphabetical order) | Central Location and Founding Year | Primary Work |
| --- | --- | --- |
| Human Rights Watch (www.hrw.org) | New York City, 1978 | a human rights organization engaged primarily in human rights research and advocacy around the world |
| Syrian Archive (www.syrianarchive.org) | Berlin, 2014 | a nonprofit organization seeking to support human rights investigators, advocates, and journalists in their efforts to document human rights violations in Syria through open-source tools and methodologies for collecting, preserving, verifying, and investigating visual documentation in conflict areas |
| TRIAL International (www.trialinternational.org) | Geneva, 2002 | an NGO fighting impunity for international crimes and supporting human rights victims |
| Video4Change (www.video4change.org) | Founded in Indonesia, 2012 | a consortium of organizations convened by WITNESS and EngageMedia that seeks to better leverage information and communication technologies for human rights, social justice, and environmental change through training, development of tools and resources, and the hosting of activist gatherings |
| Videre est Credere (www.videreonline.org) | London, 2008 | a human rights organization that works directly with remote communities, equipping them with the technology and training to record visual evidence of human rights abuses |
| WITNESS (www.witness.org) | New York City, 1992 | a human rights organization engaged primarily in advocacy, training, and development of tools and resources on how to use video to expose injustice |

The other protesters would form a circle around him and make sure he was protected. They would say to him, 'Record, Ahmed! Record!' because it was so important for them that there was a witness, that what was happening was documented."[3] Suffice it to say, this deeply felt imperative to record injustice is part of a longer visual tradition that precedes the video camera.

Although the proliferation of human rights videos stems from a rich history of visual activism, today activist videos feature prominently across institutional and legal environments that have traditionally disregarded such content as a form of legitimate evidence. The unreliability of visual materials, their emotional resonance, and the partisan underpinning of activist footage have been invoked as grounds for evidentiary dismissal. This classification of video, however, is starting to change. Consider, for example, how the Islamic State's videos have taken on the status of objective evidence instantly with little discussion of their authorship, nature, or the circumstances of their production and consumption.[4] This extreme case perhaps best captures the unfolding turn to video as taken-for-granted material even in institutional contexts. This book scrutinizes this turn to video across different institutions related to human rights.

Conceived by Western iterations of modernity as the pillar of social and political life, institutions such as journalism, the law, and political advocacy have not always been the most hospitable environments for visual human rights work. They have instead privileged words over images as presumed vehicles of reason, systematic thinking, and behavior as modernity gave rise to an institutional authority built around words. Although visuality, imagination, and emotion relate in various ways to words, they have typically been pushed to the background of institutional thinking.[5] It is not surprising, then, that only in the past two decades have histories of human rights highlighted the visual encounters, emotional responses, and cultural underpinnings that are equally constitutive of and central to human rights discourse and practice.[6]

Though widely used, visual imagery has typically figured as an appendage to words, an illustration on the side, or an afterthought in the institutional calculus supporting human rights in various ways. The so-figured institutions have promoted linear thinking, deductive reasoning, and deliberation and nurtured professional expertise that draws from a set of tools, guiding principles, and standards anchored in the epistemological ethos of Western modernity. This ethos, however, has been unable to recuperate the

seeming tension between different modes of knowing: reason and emotion, judgment and imagination, word and image.[7] As a result, to this day and in different domains, there exists a tension between institutional practices that rely heavily on images and institutional doctrines that have yet to accommodate systematic procedures for handling visual materials. Courts, for example, typically think of images as illustrative evidence that needs the words of witnesses to render it legally meaningful. Yet images are increasingly performing functions of substantive evidence despite the lack of clear standards that guide visual-information creation, processing, flow, access, and use across law and policy domains.[8] The rise of human rights video cuts to the heart of this enduring institutional and legal tension.

Journalism, today considered a vital social institution for publicizing human rights claims, turns to images overwhelmingly in times of crises but often fails to develop standards for their systematic treatment.[9] As Barbie Zelizer argues, when "the verbal record underpinning journalists' authority as arbiters of the real world takes precedence over its visual counterpart . . . accommodating a tool that works in other ways challenges longstanding notions of what journalism is for."[10] This has led to an environment where, despite the trust that investigative journalists place in video recordings,[11] journalism is yet to grapple with how to handle such evidence methodically and ethically. Inconsistent labeling and sourcing, ignorance about rights and permissions, and a lack of dedicated staff to work with social media imagery are just some of the recent challenges around journalistic standards for video.[12]

Similarly, as a key institution that safeguards human rights as legally enforceable entitlements, the law presumes words are the primary vehicles for transporting its logic. According to Neal Feigenson and Christina Spiesel, the "law, like most other disciplines or practices that aspire to rationality, has tended to identify that rationality (and hence its virtue) with texts rather than pictures . . . to the point that it is often thought that thinking in words is the only kind of thinking there is."[13] As a result, clear legal standards guide every aspect of text and documents—even at the level of font choice and point size—but there is a lack of unified guidance to inform how video evidence is assessed under the law in criminal matters across jurisdictions.[14]

Political advocacy, widely regarded as fundamental in pushing forward human rights agendas, also has a conflicting relationship with visuals. For Sabine Lang, "advocacy conjures images of experts who assess specific spheres of influence and target specific goals and institutions."[15] Political

advocacy is central to both decision-making platforms and civil society as a sphere of public debate. As such, it belongs to a line of thinking rooted in a rational ideal or "a long tradition of political thought that makes plain speech—'communication'—the center of democratic life."[16] As the institutional projects of Western modernity put aside the rigorous engagement with visuals as a way of knowing on an equal footing with words, political advocates frequently prioritized carefully crafted messages and documents when seeking to secure influence in institutional and legal decision-making settings. When used, images have been assumed to serve merely as a tool for raising public awareness.

The institutional logic and professional practices associated with journalism, the law, and political advocacy have therefore sidelined images in different ways and for different purposes. Premised on the epistemological ethos of Western modernity, these institutions have neglected the need to standardize tools that work differently than words do, downgrading the value of images as a unique mode of knowledge. Video is just the latest technology that amplifies the problems resulting from the lack of standards that account for the particularities of distinct forms of visual evidence.

As an institutional domain, however, political advocacy is also closely related to social activism—broadly conceived as a public assembly of critical voices mobilized against injustice. Although activism is thought to pursue broader social change agendas than political advocacy does, without necessarily confining itself to existing institutional frameworks,[17] at times the two blend together. When that occurs, their interlinking relies heavily on the purchase of the visual. Many examples can be found. Humanitarian activism in the 1870s in response to Ottoman atrocities in the Balkans and to famine in southern India rested on visual media.[18] The campaign to end colonial brutalities in Congo at the turn of the twentieth century first used the phrase "crimes against humanity" in 1890 and presented photographs as indispensable evidentiary materials in British Parliament in 1903.[19] The campaign to raise awareness about and provide relief to the survivors of the Armenian genocide was organized around screenings of a film called *Ravished Armenia* (Oscar Apfel, 1919), which were accompanied by a conversation with a survivor.[20] This practice obviously continues today.

Human rights collectives are a product of the global human rights activism movement; by some accounts, they have even been considered the driving force that sustains the movement.[21] They are thus emblematic of the

blending of political advocacy and activism. Amnesty, HRW, and WITNESS illustrate this blending well. Both Amnesty and HRW were set up by lawyers in 1961 (in London) and 1978 (in New York City), respectively. They are thus considered human rights "group[s] based in a profession."[22] As they expanded, they became open to a wide range of staff profiles.

Amnesty considers itself "the world's largest grassroots human rights organization," "a global movement of over 7 million people" who constitute its membership.[23] Its team consists of human rights campaigners, advocates, researchers, activists, and communication professionals whose mission is to "investigate and expose abuses, educate, and mobilize the public."[24] Amnesty won the Nobel Peace Prize in 1977, an important milestone for the global recognition of the human rights movement. Public campaigning continues to be central to Amnesty even as the organization has expanded the range of work it does.

HRW began as Helsinki Watch to investigate human rights abuses in countries that were signatories of the Helsinki Accords of 1975 to shore up détente between the Soviet Union and the West. Contrary to Amnesty's focus on public campaigns, HRW has traditionally been involved in research and direct advocacy with governments, diplomats, and United Nations (UN) officials, to name a few. It has also diversified its work, which has recently included efforts for public engagement. HRW considers itself "an independent, international organization that works as part of a vibrant movement,"[25] whose 450 staffers from seventy nationalities identify as country experts, researchers, lawyers, advocates, and journalists.

WITNESS also has roots in the law. It was set up by the musician and human rights activist Peter Gabriel as part of the New York–based Lawyers' Committee for Human Rights in 1992. It became an independent organization in 2001, seeking to "train and support activists and citizens around the world" on how to harness the power of video for human rights. Although its work has evolved over time, WITNESS is different from both HRW and Amnesty in that it does not conduct regular human rights investigations. WITNESS instead "believe[s] [that], with the right tools, networks, and guidance, anyone, anywhere, can use video and technology to defend human rights. Anyone can be a witness."[26] The staffers—human rights activists and advocates—seek to build and strengthen this witnessing capacity.

Amnesty, HRW, and WITNESS draw differently on the dynamics between political advocacy and activism as they grow and seek to shape the global

human rights movement. Together with other human rights collectives, they have embraced video as an important human rights tool, which is gaining in institutional and legal relevance at this time of cultural, social, and political challenges.

Increasing global anxieties fuel deep concerns about the future of international norms and human rights frameworks. Governments that question the legitimacy of international institutions safeguarding human rights continue to commit arbitrary and cruel actions. Elections are marred even in Western democracies, where xenophobia is on the rise, and freedom of expression and press freedom are challenged. Information disorders proliferate around the world. States actively manipulate and distort facts, while attacks against any institutional authorities who produce and support facts are booming. Human rights are increasingly invoked as a rhetoric to denounce the validity of human rights claims.[27] Global conflicts in which civilians become targeted proliferate, resulting in massive displacement of populations. According to the UN Refugee Agency, the number of people fleeing war, persecution, conflict, and natural disasters exceeded 70 million in 2018.[28] These unfolding concerns, coupled with specific issues related to refugees and displaced persons, have important consequences for global human rights practice. Imaginative thinking may be crucial to reposition human rights issues in light of the present challenges and to address the growing need for new tactics and strategies for human rights investigation, reporting, and advocacy.[29]

Traditional institutional sources and their professional expertise may no longer be readily available when human rights investigations are conducted, and such sources may be completely absent when efforts are made to document displaced populations, who pose numerous logistical problems arising from the context and from the cross-jurisdictional nature of the decision-making involved.[30] When Syria and Myanmar, for example, closed their borders to journalists and international investigative bodies, online videos and commercial satellite images became the main mode of accessing the crises in these countries. This turn to images is a significant change from institutionalized practices consisting of on-the-ground investigation and collection of eyewitness testimonies by professional authorities. To document abuses related to the refugees fleeing Syria and Myanmar, different human rights actors have instead developed and adopted new open-source investigation methodologies that tap into the evidentiary

potential of online video.[31] In other words, human rights practice today necessitates new ways of thinking about what constitutes evidence, how to go about evidence-gathering processes, and how to present the resulting evidence and the arguments it supports convincingly in ways that can affect change.

Human rights collectives are proactive in this area, utilizing videos shot by civilians, activists, and other actors as key data of difficult events. Yet widely accepted evidentiary standards for visual media either vary by legal jurisdictions or are simply nonexistent. Syrian Archive, therefore, has worked with the International Criminal Court (ICC); the UN Office of the High Commissioner for Human Rights; the International, Impartial, and Independent Mechanism on international crimes committed in Syria; the Institute for War, Holocaust, and Genocide Studies; HRW; WITNESS; and other institutions and organizations to standardize verification and archival methods for visual evidence that may one day be used in court.[32] Video, then, is increasingly used as a practical solution to emerging problems, but its adoption demands evidentiary and workflow considerations in areas of long-standing institutional and legal neglect. New institutional dynamics are therefore emerging to tackle the role and scope of human rights video today.

Grassroots activists, a range of eyewitnesses who document unfolding incidents of violence, human rights collectives, journalists, governmental agencies, international courts, international investigative bodies, and corporate social media platforms are becoming part of a linked ecology surrounding visual human rights content that exists alongside other forms of contemporary media activism and social movement media.[33] In other words, there are multivalent networks of interaction between different institutions, media platforms, activists, and human rights collectives. What develops from this interaction is an institutional blending that can best be described under the sociological rubric of new institutionalism,[34] wherein institutions converge and transform as a result of facing similar environmental circumstances—in this case the increasing role of video as a unique form of evidence and material for policy making.

The lens of new institutionalism is relevant because it conceives of institutions as evolving configurations (rather than as stable phenomena) that are directly shaped by other institutions and environments. Institutions are thus part of a linked ecology—networked environments whose organizational arrangements imply standardized social patterns with qualities that

are taken for granted.[35] Rooted in cultural and historical circumstances, institutions attain over time a state of legitimacy, with institutionalization as a key part of this process.[36]

To understand new institutionalism in today's human rights context, it is important to describe the processes of institutional blending driven by video and to scrutinize their effects on the agents and practices that set video to work as a human rights tool. This is critical because the increasing evidentiary, policy, and advocacy importance of human rights video is altering the workflows and practices of human rights collectives as well as of the journalists, legal professionals, and political advocates working in spaces that overlap with human rights activism. Consider the following examples.

In a pioneering effort, the *New York Times* established the Visual Investigations Unit in 2017, which has reported on (among other events) police violence during protests in Hong Kong, airstrikes on a detention center in Libya, and bombing in Yemen, all based on video footage circulated online and corroborated with other materials. Malachy Browne, a senior story producer, believes that open-source analysis, the unit's bread and butter, is becoming a new genre of journalism for which there is an overall lack of skilled personnel.[37] Christoph Koettl, a former image analyst at Amnesty, now works for this team, signaling both a radical departure from traditional hiring practices in journalism and a new linkage between journalism and the human rights community. This linkage is further amplified by the collaborations between this news unit and several human rights collectives, such as Amnesty and Forensic Architecture.

The ICC's first verdict, handed down in *Prosecutor v. Thomas Lubanga Dyilo* (ICC-01/04–0106) in 2012, relied on video footage to corroborate aspects of witness testimony about soldiers' age, helping secure Thomas Lubanga's fourteen-year sentence for his role in recruiting and using child soldiers in Congo. A former WITNESS member provided the prosecution with some of this footage, which was used early in the legal process to urge the court to investigate Lubanga's crimes.[38] This example illuminates the important interplay between different human rights collectives and the law around visual evidence. Members of these human rights collectives also sit on the ICC's Technology Advisory Board, which consults with the court on new technologies and emerging forms of evidence, including video.

The various reports by the UN Independent International Commission of Inquiry on Syria include satellite imagery and video obtained through social

media as key evidentiary tools to establish the Syrian government's usage of barrel bombs and chemical weapons against civilians.[39] Video footage collected, verified, and preserved by various human rights collectives has been important in this context, indicating institutional blending with political advocacy areas around visual standards and investigations. It is not surprising, then, that human rights collectives now believe that "video is becoming more and more the medium in . . . which issues are raised and discussed."[40]

The foregoing examples are illustrative of how undergoing transformations across journalism, the law, and political advocacy in spaces overlapping with human rights activism have together created the new institutional circumstances that put video at the heart of global human rights policy making. In the process, human rights collectives are emerging as visual experts, providing analysis, research, training, guidance, and tools for activists and different institutional and legal authorities. These human rights collectives claim visual expertise by incorporating, building on, and even modifying the long tradition of video activism as they seek to shape the institutional and legal dynamics through which human rights claims receive fuller recognition and restitution. In other words, human rights collectives aspire to professionalize human rights video activism in ways that relate to the institutional and professional logics of journalism, the law, and political advocacy that are now accommodating (differently) the power of video long claimed by activists as their own.

## Human Rights Video Activism as a Proxy Profession

Professionalization, a set of practices and standards through which a collective defines the scope and nature of its work, is key to survival in institutional environments. As video attains institutional and legal legitimacy, it becomes a form of knowledge that professions must address in an organized fashion. The growing need for systematic use, verification measures, evidentiary standards, and interpretative schema for human rights video moves across journalism, the law, and political advocacy, whose authority has long had a conflicting relationship with visual imagery. Human rights collectives have seen this visual turn as a prosperous moment, adapting and shaping the values and practices central to video activism in ways that propose solutions to current institutional and legal challenges with video as a distinct form of knowledge.

To survive in institutional environments, however, human rights collectives cannot sustain video activism in its familiar form as an occupational craft. Institutions privilege professionalism as a way of ordering knowledge so they can shape social life, political life, and action systematically. As Eliot Freidson writes, "Knowledge cannot be connected to power without becoming embodied in concrete human beings who in turn must be sustained by organized institutions."[41] Western modernity gave rise to professions as entities that safeguard such knowledge. Journalism, the law, and political advocacy are institutions that enshrine various types of specialized knowledge, whose agents agree, however differently, on basic ideals and principles about how they create and apply that knowledge—a key aspect of professions.

Human rights collectives practice a form of video activism that competes for authority over knowledge and expertise via the professional powers connected to these institutions. Building on a tradition of video activism as an occupational craft that has operated outside of these institutional currents, human rights collectives claim an organizational home for video activism, shaping it so that it might better work within the institutional paradigms and professional logics of journalism, the law, and political advocacy. In this manifestation, human rights video activism is no longer characterized by the familiar streams of occupational artistry. It is shaped instead by professional dynamics.

Michel de Certeau's notions of strategies and tactics provide a useful analytical lens to think about the professionalization of human rights video activism.[42] He defines *strategies* as the calculus of power relations delineated by place, whose authority is established to generate a specific kind of knowledge. Strategies denote systematic thinking and behavior according to official procedures, which thus facilitate the rise of formal knowledge. Institutions usually employ strategies. Video activism, in contrast, has typically been a craft that speaks the language of tactics in that it is free from institutional and professional confines. For de Certeau, *tactics* are time bound, relative to a given situation, and look to seize opportunities as a challenge to existing power relations and structures. To craft videos for social change, activists have relied on tactics where creativity, intuition, imagination, and emotion are mobilized to draw attention to the perceived failures in the workings of institutions that are supposed to preserve democratic and human rights values. These tactics draw from practical knowledge and experience rather than formalized thinking and consistent methods.

In a pragmatic move, human rights collectives diversify the tactics of video activism, but they also create strategies to standardize visual practices so that video can better serve evidentiary, policy, and advocacy functions. In other words, they seek to professionalize human rights video activism so they can position themselves as viable agents of the knowledge provided by video. The aspirations to professionalism occur in line with Meg McLagan's analysis that "contemporary activism is marked not simply by a continual evolution of political strategies, but more important[ly], by the production of multiple modalities and forms of politics, each adapted to a particular context and audience."[43] The professionalization of video activism is trying to mimic the modalities of journalism, the law, and political advocacy as human rights collectives develop ways to play in these spaces. It is therefore an outward-looking effort that does not display the traditional traits of a profession: autonomy, specialized education, licensing procedures, competence tests, certification, and codes of conduct.[44] It instead involves an ideological orientation about what to do and what to avoid based on the targeted institutional or legal audiences for human rights video content. As a result, human rights collectives create a proxy profession that mediates between activist voices and institutional spaces.

Consider the following example: An eyewitness video, about thirty seconds long, is shot in Providencia favela in Rio de Janeiro in September 2015. It shows three police officers planting evidence on the body of a boy whom the viewer is told they have just killed. The scene is shot from what appears to be the window of an apartment on a higher floor because the camera is pointed down toward the officers, who are not aware they are being filmed. The video seems to be shot on a cell phone, and two female voices provide narrative cues for what transpires.

**Female Voice A:** He's planting it.

[One of the police officers puts the gun in the dead boy's hand and fires it.]

**Female Voice A:** No. They're firing. He's still talking to the kid.

[The police officer fires the gun again from the hand of the dead boy. Two of the officers move, clearing the view of the dead boy's head.]

**Female Voice B:** You're kidding!

[The police officer hands the gun to one of the other officers.]

**Female Voice A:** There, he's handing over the gun.

This video was shot by a bystander who was forced to go into hiding for fear of retaliation. It was preserved by members of the Papo Reto activist collective in Brazil, which works on exposing police misconduct in Rio's favelas. Papo Reto collaborates with and is trained by WITNESS on best practices in video activism and standards for legal evidence. The same eyewitness video was also part of a report and subsequent HRW advocacy campaign on police violence in Brazil in 2016 (figure 1.1).

Because such videos are powerful, public moments of testimony, they inevitably provoke intense struggles over the right to their meaning. Through the proxy profession, human rights collectives are better positioned than activists and citizens on the ground to legitimize such videos' capacity to produce institutionally meaningful human rights claims. The proxy profession thus shapes video activism strategically as an institutionally embedded mechanism for change. By representing activist voices and citizen concerns across institutions, the proxy profession makes vital contributions to protecting human rights in the world. Yet there is a difference between the possibility to give voice and to claim voice, a difference that shapes how, if at all, a particular voice is listened to across institutions. This book shows that the proxy profession's orientation toward institutional and legal legitimacy

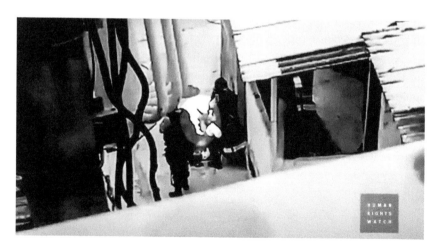

**Figure 1.1**
Screenshot, eyewitness video from *Unlawful Police Killings Undermine Law Enforcement in Brazil*, HRW, July 7, 2016, https://www.hrw.org/video-photos/video/2016/07/07/unlawful-police-killings-undermine-law-enforcement-brazil.

makes it less able to provide structural solutions to long-standing political questions about whose voices matter, whose voices are heard, and why. These questions remain significant because activists and bystanders on the ground continue to risk their lives to document abuse and to express their fundamental human right to communicate even in circumstances of life and death.

Another example illustrates the proxy profession's broker role in an information policy context. In a groundbreaking case, the ICC issued an arrest warrant in August 2017 for Mahmoud Mustafa Busayf al-Werfalli, an alleged commander in Libya accused of having committed or ordered thirty-three murders in Benghazi. The warrant was largely based on social media videos. It listed seven incidents of extrajudicial murders documented on video footage uploaded to Facebook, which was used as direct evidence linking al-Werfalli to the crimes. Facebook, however, quickly took down the graphic video for violation of its terms-of-service agreement. Removals like this have become a rather common practice among social media companies. In the push for social media content regulation with respect to terrorist propaganda, potentially important evidentiary materials for human rights work are also disappearing,[45] but the public has little insight into the corporate decision making and the black-box algorithms involved.

With their videos being taken down, activists around the world are increasingly seeing the consequences of the bargain they made more than a decade ago when deciding to rely heavily on corporate platforms.[46] Meanwhile, human rights collectives are positioning themselves at the forefront of efforts for visual-information policy in this context. For example, Dia Kayyali, a WITNESS staffer who leads the tech and advocacy program that consults with social media companies, testified in front of the European Union (EU) Parliament on social media content removal in March 2019. Syrian Archive has been documenting the removal of content, urging YouTube to restore the videos that the group has identified as verified materials documenting human rights violations in Syria. Berkeley's HRC has been drafting possible solutions for social media archiving, and Amnesty now has a specialized staff position for advocating with tech companies in Silicon Valley. Through the emerging legitimacy of the proxy profession, these human rights collectives are able to act as representatives of public voices in front of corporate social media companies and relevant institutions of internet governance. However, due to the non-disclosure agreements they have to

sign with tech companies, the public and the human rights activists on the ground have little insight into these discussions.

As the foregoing examples demonstrate, the proxy profession can offer a pragmatic solution to broaden the reach of human rights voices across institutions. By virtue of its orientation toward institutional and legal leverage, however, the proxy profession might also end up representing, mediating, filtering, or even silencing those voices. The chapters that follow thus highlight how the new shaping of human rights video activism as a proxy profession has bearing on the role and scope of human rights voices, on the institutional status of video evidence, and on the power of human rights as a global moral grammar for justice.

## Methodology and Outline of Chapters

This book spans more than seven years of qualitative research consisting of interviews, site visits, and textual analysis of videos, organizational documents, training guides, and court trial transcripts. I conducted a total of sixty in-person, phone, and online interviews (e.g., email, Jitsu, Skype, and WhatsApp) with human rights staffers, journalists, and legal professionals working within or alongside human rights spaces. The interviews consisted of broad and open-ended questions about the role and scope of video in human rights work, and each interview ranged between sixty and ninety minutes. More specifically, the book relies on forty interviews with human rights researchers, campaigners, advocates, and communications experts from Amnesty, HRW, and WITNESS, conducted mostly in-person in London, Brussels, Washington, DC, and New York City. To better understand the broader human rights landscape, I conducted ten supplementary phone and online interviews with key research, advocacy, and training personnel from other human rights collectives—Syrian Archive, Forensic Architecture, and Berkeley's HRC—as well as with journalists working in this human rights space (see table 1.2 for the relevant organizations in which these journalists are embedded). I also analyzed more than 400 online human rights videos produced by these human rights collectives for the purposes of research, advocacy, campaigning, and training alongside annual organizational reports, organizational publications, and training guides.

The book is supplemented with ten in-person, phone, and written interviews with legal professionals (e.g., attorneys, case managers, archivists,

**Table 1.2**

Innovative Journalism Overlapping with Human Rights Spaces: A Brief Overview

| Organization Name and Website (in alphabetical order) | Central Location and Founding Year | Primary Work |
| --- | --- | --- |
| Bellingcat (www.bellingcat.com) | Amsterdam, 2014 | an international investigative collective of researchers and citizen journalists using open-source tools and methods |
| European Journalism Centre (www.ejc.net) | Maastricht, Netherlands, 1992 | a nonprofit institute for innovations in journalism, working on grants, events, training, and media development projects |
| First Draft (www.firstdraftnews.org) | London, New York City, and Sydney, 2015 | a nonprofit that works on techniques, tools, and training to tackle today's information disorders |
| Storyful (www.storyful.com) | Dublin, 2010 | the first global social news agency involved in the verification of user-generated content; it was purchased by News Corps in 2013 |
| Visual Investigations Unit at the *New York Times* (www.nytimes.com/video /investigations) | New York City, 2017 | a unit at the *New York Times* that conducts open-source investigations and presents them to the public in a video format |

audiovisual technicians, and technology advisers) working for the ICC and the International Criminal Tribunal for the former Yugoslavia (ICTY). Some of these interviews were completed during two visits at the ICTY in The Hague in January and April 2015. As part of these visits, I also toured one of the courtrooms with the audiovisual supervisor, observed trial sessions with former general Ratko Mladić, and attended a status conference regarding former Bosnian Serb political leader Radovan Karadžić. Last, I analyzed the transcripts of international criminal court trials involving video evidence at the ICTY and the ICC alongside the video evidence used in each case. This legal research formed the basis for chapter 4.

The book proceeds as follows. Chapter 2 situates the salience of video as a human rights tool within the rich global history of visual activism as an occupational craft that relies on diverse tactics to advocate for social change. This chapter also identifies the affordances of video as a unique form of knowledge that professions must address. It argues that the institutionalization of video across journalism, the law, and political advocacy has supported aspirations to professionalize video activism through strategies and tactics that are facilitating the capacity of human rights video to serve distinct policy functions.

Chapter 3 examines the unfolding relationship between journalists, human rights collectives, activists, and citizens in global-crisis reporting in connection with video. It argues that human rights collectives are adopting activist tactics and journalist strategies for video by turning journalism's challenges into opportunities for human rights work. In the process, they broker arrangements between citizens, activists, and journalists in international emergency coverage.

Chapter 4 uses the ICTY as a main case study, shedding light on how the visual turn in the law has created new possibilities for human rights work. It demonstrates how human rights collectives are borrowing different activist tactics and legal strategies to organize their video work in ways that play to the authority now given to the evidentiary potential of video in court, as in the case of the ICC. The chapter argues that video is becoming a crucial tool for meaning making in human rights courts and that the work of human rights collectives is important to its evidentiary shaping.

Chapter 5 addresses how Amnesty, HRW, and WITNESS use video to summon publics and political stakeholders as key audiences by adopting advocacy and marketing strategies for video production and distribution. It argues that the rise of video brings forward the complicated notion that *feeling is believing,* which cuts right to the heart of long-standing assumptions about the parameters under which deliberative democracy works. The strategic shaping of video for political advocacy, however, risks instrumentalizing emotions and paralyzing possibilities for thinking anew on how to better engage broader constituencies for public good.

Chapter 6 argues that key to video's centrality as a tool for human rights is its ability to facilitate voice acoustically and visually in unbounded fashion. It documents how, when, and why the proxy profession employs voice tactically and strategically to fight for human rights. In doing so, it

contends that video's ultimate potential for social change remains a deeply political question implicated in how human rights activism negotiates with institutional logics, professional dynamics, market streams, and geopolitical arrangements to make human rights voices matter.

Together, these chapters highlight the powerful, complicated, and at times problematic dynamics that arise with the new manifestation of human rights video activism as a proxy profession. Even in a digital landscape characterized by the often venerated democratized processes of image production and cultures of circulation, where creative forms of digital activism and social movement media flourish, the broader media–law–society relations continue to provide an important context for examining the power and limitation of human rights video.

## 2 The Salience of Video as a Human Rights Tool

Throughout the twentieth century—from the initial occasional use of film in the 1910s to the steady growth of video in the 1980s—audiovisual evidence has typically been produced by professional authorities, such as law enforcement agents and attorneys, for the purposes of a specific courtroom trial.[1] The use of amateur video recording in the trials of police officers charged with beating Rodney King is perhaps the most well-known case in the United States that precipitated a shift in the role and scope of visual evidence not only in the law but also across journalism, political advocacy, and human rights practice.

From the balcony of his apartment, George Holliday shot a video of Los Angeles Police Department officers beating Rodney King, an African American man, in 1991. The video was widely circulated on mainstream media channels; it led to street riots and brought the policemen to trial (in a district court in 1992 and then in a federal court in 1993 after the initial acquittals of the officers charged and the subsequent riots). The Rodney King incident is central to the founding of WITNESS, whose "About" webpage from 2001 summarized the power of video as a human rights tool: "The lasting impression of the Rodney King beating and the riots that ensued showed the emotional power of the visual: the videotaped images gave the incident impact and immediacy that words could not." It is precisely this understanding that video communicates and holds emotions differently from written or verbal records that has undergirded its deployment in various activist projects over the decades. The history of video—far preceding George Holliday's famous recording—is closely linked to democratizing impulses as well as to humanitarian, human rights, and social change discourses.

Video became a prominent activist tool during the social movements of the 1960s around the world.[2] Its early oppositional use in guerrilla television,[3] public-access media movements,[4] video art,[5] and alternative cinema set the tone for its entanglement with transformative language that continues today.[6] The current evocation of the phrase "video revolution" in connection with the proliferation of online video thus mirrors the video revolutions brought about by VCRs in the 1980s and by camcorders in the 1990s.[7] In this sense, Michael Newman argues, "video revolution is a phrase that has endured through decades of media history."[8] His study of video sheds light on how the conflation of the technology, medium, format, and eventually moving images of any kind under the single term *video* has incorporated many interrelating and distinct video revolutions that have filled various political, artistic, and consumerist needs over the years.

This chapter addresses one iteration of digital video—human rights video activism—for its cultural significance and technological specificity. By discussing the assumptions that drive the import of visual imagery in political engagement, I situate human rights video activism within the rich and diverse cultural history of images for social change, where it has existed as an occupational craft relying on tactics to challenge injustice. I then identify the affordances of video as a unique form of knowledge that account for its rising usage across institutions, where it is becoming shaped by the dynamics of professionalism. Human rights collectives are borrowing differently from the visual-activism tradition and tapping into video's ability to generate knowledge on its own. By adopting and developing different tactics and strategies, they are professionalizing video activism, helping shape video's legitimacy as a human rights tool across institutional and legal decision-making contexts, and thus facilitating its ability to serve various policy functions.

## Cultural History of Video Activism

Visual imagery has long constituted a crucial element of endeavors to achieve social change with all of their democratizing, humanitarian, and human rights underpinnings. There are countless examples: political posters, drawings, and etchings about the abolition of slavery in England;[9] photographs of the US Civil War;[10] newsreels of the suffragettes;[11] antifascist posters in Mexico;[12] and socially conscious filmmaking in Russia,[13] to name

just a few. Video activism stems from this long-standing and wide-ranging cultural history.

## The Enduring Political Potency of Images

Today it is taken for granted that images matter politically,[14] but this recognition took a while to crystalize. Because "the study of political communication has often been framed by a narrative in which the image supplants the word,"[15] the development of visual culture as an interdisciplinary area of study has been central in giving images their due consideration. Revisionist research on political history in Europe, for example, addressed the long omission of the visual from studies in political history, documenting how the tradition of posters in England and France is just one acute reminder of how visuals inspired energetic political debates throughout the eighteenth and nineteenth centuries.[16] At times of low literacy rates, the democratizing potential of the visual was rooted in its broad appeal, most notably to those excluded from participation in mainstream politics. It is not surprising, then, that political authorities feared the power of the visual. The posters were so popular as a subject of public discussions on the streets that the French government censored any caricatures of political figures throughout various periods in the nineteenth century and during World War I.[17]

Images were also a central part of parliamentary debates in England on a range of topics, among them the abolition of slavery.[18] The British abolitionist movement is often considered to be the first grassroots human rights campaign, and Sharon Sliwinski shows how this early effort was "a thoroughly visual affair." William Wilberforce's second bill on the abolition of the slave trade in front of Parliament in 1792 was structured around the story of a fifteen-year-old girl beaten to death by a slave ship captain. The incident was captured in a hand-colored etching that was later circulated in London's cafés and pubs. "Wilberforce had learned from his initial political failure," states Sliwinski. "The first time around, he had relied upon a closely reasoned presentation of facts to persuade the Members of Parliament. The second time, he played directly to sentiment."[19] This is an early example of a long-running pattern: images are deployed for their presumed political force, which draws largely from the emotions inspired by the visual encounters.

This pattern is also evident in the use of photographs in congressional debates about the US Civil War. For Vicky Goldberg, the first "living-room

war" was not Vietnam; it was the US Civil War, during which the public witnessed mass proliferation of visual imagery.[20] Photographs of prisoners in the Southern camps, known as the "living-skeletons images," and multiple engravings of these photographs of atrocious treatment, were circulated in newspapers and discussed in Congress. Reports by a congressional committee featured photographs and written accounts to present findings about the conditions in these prisons. Goldberg illuminates how the images were strategically framed as evidence to show that prisoners were dying under terrible circumstances and that the South was intentionally killing them. These photographs also created the context for the Lieber Code of 1863, the first comprehensive attempt to codify norms of war conduct, which later became the basis for international human rights law.[21] The use of these photographs inevitably exceeded the purpose of mere evidentiary display, if such a thing ever existed. After all, the interplay between evidence and emotions is what turns images into particularly valuable tools for witnessing difficult events.

The centrality of images to the cultural manifestation of witnessing as a mode of ethical and political involvement rests on their capacity to generate emotional responses that can seemingly appeal to a larger sense of morality. In the Western tradition, the entanglement of morality with the act of seeing goes back to the Enlightenment philosophy of John Locke, David Hume, Jean-Jacques Rousseau, Adam Smith, and Immanuel Kant in the eighteenth century. For example, instead of defining seeing as a passive experience—a common understanding at the time—Kant argued that the significance of the French Revolution lay in its ability to generate passionate responses in its observers.[22] This engagement could drive people's capacity to conceive universal ideals, such as democracy and human rights.[23] Western philosophy, then, elevated the spectator's role, but not without consequences.

Karen Halttunen sheds light on how the conceptualization of ethics vis-à-vis spectatorship, along with the culture of sentimentality prominent at the time, made visual imagery instrumental for the development of Anglo-American humanitarianism between the seventeenth and nineteenth centuries.[24] In the process, she shows how the humanitarian campaigners' regular use of pictorial depictions of flogging at the time—of African slaves as well as of soldiers, convicts, and mental patients—was an effort to provide a structuring relationship between the seemingly ethical citizen and the victim of violence who was marked as the Other, worthy of sympathy only from a distance.[25]

Images were also important for the emergence of the global human rights discourse as we know it today. The Universal Declaration of Human Rights was drafted in 1948 in the wake of the mass circulation of photographs depicting the horrors of the concentration camps during the Holocaust. A year later, the UN Educational, Scientific, and Cultural Organization (UNESCO) organized a traveling human rights exhibition to represent visually the significance of the declaration. Through the various ways photographs bore witness to human trauma, seeing was again at this time conceived as a moral act of the first order.[26] In this sense, Sliwinski contends, "universal human rights were conceived by spectators who with the aid of the photographic apparatus were compelled to judge that crimes against humanity were occurring to others."[27]

The examples discussed so far speak about the long-standing political importance of images as a mode of information relay that is complementary to, but different from, words. They also demonstrate how different agents and practices have been vital in kindling the political energy of images as more than just representational devices. Treating images for their fuller epistemological value illuminates how visual politics has been centrally implicated in the complex development of ideals about democracy, humanitarianism, and human rights. It is not surprising, then, that various image-making collectives have also used the power of the visual for activist undertakings.

The interlinking of visual imagery with human rights concerns is evident in the work of Taller de Gráfica Popular (TGP, People's Graphic Workshop), a print-art collective in Mexico led by Pablo O'Higgins, Leopoldo Méndez, and Luis Arenal. Developed in the aftermath of the Mexican Revolution of 1910, TGP used flyers and posters to empower the silenced voices of the Mexican workers and peasants and to engage local communities in conversations about global politics. The materials often announced workers' strikes and antifascist conferences. As early as 1938, TGP produced multiple posters and held public lecture series at the Palacio de Bellas Artes in Mexico City that supported the Anti-Nazi League.

In 1943, TGP produced a series called *Libro negro del terror Nazi en Europa* (The black book of Nazi terror in Europe), which included the first known image of the Holocaust outside of Europe.[28] It was Méndez's renowned linocut *Deportación a la muerte* (Deportation to death) that depicts the horrific moment of deportation to the concentration camps (in the foreground two Nazi soldiers are depicted as they are about to close a train wagon crowded

with people). Michael Ricker further notes that some of the posters warned against Francisco Franco's infiltrators in Mexico.[29] TGP's firm commitment to social justice was evident in its Declaration of Principles (1945): "TGP puts forth constant efforts to make its work beneficial to the progressive and democratic interests of the Mexican people, particularly in their struggles against the fascist reactions."[30]

Due to its ability to bridge sound and image, documentary film has also been burdened with hopes for inducing social change. In the 1920s, Dziga Vertov experimented with film form and content in Soviet Russia, believing that film had a potential to construct a new visual and social reality. With his group Kino-Eye, Vertov shot numerous documentaries in Russia about people's struggles in the civil war, their social problems, and everyday life.[31] Although the documentaries were used to support Soviet propaganda, the thinking underlying this mode of filmmaking illustrates an early effort to mobilize media for social change and to summon socially and politically aware publics through film.

Similarly, for the documentary group led by John Grierson in the United Kingdom in the 1930s—first at the Empire Marketing Board and then at the Government Post Office—documentary film was a vehicle for promoting social policy. For example, *Housing Problems* (Arthur Elton and Edgar Anstey, 1935) is a well-known film from this period about poor housing conditions in Britain. The Gas Light and Coke Company commissioned Grierson's film unit to produce this documentary and to advocate for the use of gas heat and light in modern housing.[32]

The work of TGP, Vertov's *Kino Pravda* newsreel series, and Grierson's documentary group are among many examples illuminating how collective commitments to visual practice as an orientation toward social change took shape around the world. Though different in their technological preference and cultural embeddedness, they all articulated the visual as a meeting point for activism, public dialogue, and policy change. The groups discussed appropriate social topics for visual engagement, the best way to tell a story visually, how to produce it, how to move audiences to take action, and how to circulate the content. They also lectured and published on how the visual arts could serve an instrumental social function. Vertov's Kino-Eye manifesto claimed that camera-mediated vision was capable of illuminating social realities invisible to the naked eye, and social responsibility was considered of the utmost importance for the relevance of documentary

film (for Grierson) and print art (for TGP) to society.[33] These efforts helped shape visual activism as an occupational craft and crystallized the social role of visual activists.

These collectives' views found deep resonance in what later became a media activism movement calling for "a new world image order."[34] The various ways that different groups around the world have taken up this call is a testament to how media activism broadly, and video activism specifically, can operate as an occupational craft that challenges those power configurations that threaten the dignity of individual and social life. Human rights—defined in their full scope as civil, political, economic, cultural, and social rights—have been at the heart of the media activism movement even if they have not always been labeled as such. Furthermore, the media activist craft has relied on a repertoire of tactics to expose injustice and to seek change. Creative, dispersed, fragmented, or organized, such tactics indicate schemas of action that activists develop to demand social change and human rights.[35] Visual practices are just one instantiation of this action.

### Diverse Media Activism Streams

UNESCO's debate on the New World Information and Communication Order in the late 1970s and early 1980s and its culmination in the controversial MacBride Report, *Many Voices One World*, is often considered the origin story of media activism.[36] The report was a first policy attempt to articulate the imbalances in the communication flows between the Global North and Global South (and within the Global South) and to argue for international media democracy reforms. As a result of its broad concerns with the redistribution of communication power, the MacBride Report became the starting point for debates about the role of what was variously labeled as radical, alternative, grassroots, tactical, and citizen media.[37]

Guided by the premise that community empowerment through direct participation in the media system is fundamental to media democracy and a healthy body politic,[38] media activism took various shapes and forms: video activism, media for social change, public-access television, independent press freedom, and cyber activism, among others. Since then, there has been an expansion in the entanglement between global activist movements and visual media in their multiple manifestations.

Video specifically has been framed within liberating and democratizing impulses since the late 1950s. The rise of video in the United States

was assumed to disrupt mainstream visuality or "to subvert the system that brought the Vietnam War home every night."[39] Just as the French New Wave was a reaction to Hollywood filmmaking, the video movement in the United States was in part a response to the dominance of commercial television.[40] Newman argues that until the late 1990s, "in popular imagination, video was figured as the revolutionary solution to . . . the sense of television's economic and ideological power over its audiences and the society it was understood to be shaping."[41] In this sense, video—documentary, installation, and performance—was initially conceived as a prominent tool for social change, blurring the distinctions between journalism, art, and activism.[42]

Thomas Harding and Alan Fountain link the growth of video activism around the world with (1) the social movements of the 1960s and 1970s, including the feminist movement, Black activism, LGBTQ rights, labor movements, antiwar protests, antinuclear organizing, and student movements; (2) the failure of mainstream media to provide appropriate coverage of oppositional movements; (3) aspirations to democratize participation in the media space; and (4) an increased availability and affordability of video cameras.[43] John Downing sees video activism developing simultaneously in so-called First and Third World countries, whether "empowering low-income inner-city communities" in the United States or "combating communalism in India."[44] The Self Employed Women's Association in India, for example, has been working with video since the early 1980s to educate and empower poor (and often illiterate) women on socioeconomic issues pertinent to their lives.

On the non-Western front, Cees Hamelink's call for development initiatives to "move from strategies of giving voice to the voiceless to strategies by which people can speak for themselves" was answered in part by Indigenous communities around the world, who actively engaged in video production.[45] The Indigenous media movements in the Americas, Canada, Australia, and New Zealand thus underscore important cultural and political agency.[46] For example, video making has been a political project in Brazil that helps mobilize publics to react to various corporate and state interests that violate Indigenous rights and ways of living.[47]

In the United States, the video activism movement also took the identity of guerilla television producers and community video advocates.[48] *Radical Software* and *Guerrilla Television* were the two magazines that served as manifestos for alternative television, calling to open the medium for alternative

voices and visions that radically disrupt the style of corporate television. Community video advocates were interested in community organizing as a means for social change. Their primary goal was to show the videos in and to the communities directly affected by the depicted issues.

The Alternative Media Center in New York City, founded by George Stoney and Red Burns and setting the grounds for the Interactive Telecommunications Program at the Tisch School at New York University, is an important collective for this history. It promoted the use of affordable and easily accessible video technologies to produce and distribute socially conscious documentaries. In addition to training activists in video making for social change, the group also played a significant role in forming public-access cable television—a noncommercial system where the general public, media collectives, and activist groups could create content to be shown on cable television channels. Other collectives also established community television networks, such as the noteworthy Paper Tiger Television and Deep Dish Satellite Network, which were central to the public-access media movement in the United States.[49]

Although public-access television had democratic potential, it suffered from limited financial resources to produce and distribute content at scale. It is not surprising, then, that in the late 1990s video activists fully embraced the web's ability to serve as a platform for seemingly free storage and circulation of content. The antiglobalization protests in Seattle during the World Trade Organization Ministerial Conference in 1999 set a new benchmark for the global video activism movement. The merger of cyberactivist culture and video activism foreshadowed many contemporary video practices. Activists used the networked environment to create video archives, develop peer-to-peer file-sharing sites and interactive interfaces, and support video collaborations around the world.[50]

The Independent Media Center, known as Indymedia, grew out of the protests in Seattle and became a vital media platform for the global justice movement.[51] Since then, it has operated in more than 150 locations, including Canada, Mexico, the Czech Republic, Belgium, and South Africa. It evolved into a global network of activists and journalists reporting on stories ignored by corporate media. It was among the first innovative digital-media spaces where people could upload and download videos, read reports, click links to other materials, and have access to the website at any time. Other digital-media collectives working under the ethos of open

publishing and Creative Commons licensing at the time included the New Global Vision Project, Vision Machine, Undercurrents, and OneWorld TV.

As Dorothy Kidd documents, the participatory ethos embraced by the global justice movement, the student and New Left movements of the 1960s, as well as the Zapatistas in the 1990s can be traced forward to more recent social movements such as Occupy, whose vision of direct democracy has been enacted through democratic communications.[52] The standards that Indymedia and other activist groups set in participatory culture about the use of affordable and accessible technologies, open access, and easy display, sharing, and commenting on video content seem common today, but they were groundbreaking at the time.

Corporate social media platforms are arguably imbued with this underlying activist logic of the past. Yet even as activists from around the world have migrated to platforms such as Facebook and YouTube, these platforms are becoming less hospitable to activist content. Zeynep Tufekci argues that terms-of-service agreements and black-box algorithms reflect a mix of commercial, legal, and ideological choices made by each particular corporate platform that can silence activist voices. [53] The examples are numerous. In September 2020, Facebook suspended the accounts of more than 200 Indigenous activists protesting the construction of the Coastal GasLink pipeline in Canada that would cut through the Wet'suwet'en Nation's territory.[54] In May 2020, Syrian Archive discovered that more than 350,000 videos had disappeared from YouTube, including videos of aerial attacks, protests, and destruction of civilian homes in Syria. The rate of content takedowns at YouTube has increased by 20 percent from the previous year.[55] The frequency of these actions impacts human rights activism and the preservation of what could be potentially valuable video evidence in human rights investigation and litigation. This development is important because the International Criminal Court and internationally mandated investigations do not have the legal power to compel evidence from private companies outside their jurisdiction.[56] This is why, as discussed in chapter 1, human rights collectives like Amnesty, Berkeley's HRC, HRW, Syrian Archive, and WITNESS have started advocating for policy changes and best practices that preserve online content that is of potential use as evidence. Meanwhile, human rights activists on the ground are learning how to navigate the challenges of the corporate online environment.

## Video Activism as a Set of Values

This cultural history—though by no means exhaustive or representative of video activism's full geographical diversity—helps situate video activism within the long-standing political use of images and as part of the diverse media activism streams manifesting globally. In other words, this brief overview sheds light on the enduring belief that there is something powerful about the infusion of the visual with ethics and politics, which activists can tap into as part of their fights for social change and human rights. In this context, video activism has embraced four key values that characterize it as an occupational craft. This interrelated set of values also underpins the visual practices of various human rights collectives today.

First, video activism has been perceived to serve an important public function, intervening in public dialogue on pressing cultural, social, economic, environmental, and political issues. Second, video activism has assumed open and collective participation in media making. Whether fostering identities, creating a sense of community, or aiding engaged citizenry, video has developed a strength that rests in the collectives that produce and use it. Third, video has been thought of as an activist platform for alternative vision and voice. And fourth, video activism has strived for democratic engagement where emotions matter.

The public function of video activism is illustrated well with the vested belief that video can intervene in discussions of utmost societal importance. The availability of public funding for video projects historically helped bring forth this notion in the United States. For Martha Gever, video, "conceived and nurtured in the public sphere, . . . would not [have] survive[d] without public patronage, public TV, or other public institutions."[57] The National Endowment for the Arts, the National Endowment for the Humanities, state arts and humanities councils, nonprofit media centers, and university programs were the first supporters of video projects. As video became ubiquitous, the funding streams diversified. Yet even as video now serves numerous interests and needs, its long-presumed public function remains significant for human rights activism.

Human rights collectives have embraced video's presumed public function. For example, Amnesty's Digital Verification Corps program and Citizen Evidence Lab, discussed further in chapter 3, are public initiatives dedicated to video-verification training, skills, and resources. In the words of the

program's manager Sam Dubberley, "We see [the program and lab] as a public good. We want [them] to be a public good that can benefit human rights and journalism going forward."[58] Amnesty has seven university partners for video-verification student training, echoing the assumed role of public universities in nurturing video's capacity to contribute to societal good.

Over the past several years, HRW has undergone a significant shift in organizational thinking, trying to reach broader publics, not just journalists, policy makers, and other institutional stakeholders—discussed further in chapter 5. The newly established HRW Public Engagement and Campaigning Unit is a direct result of this change, and video is front and center in these efforts. "How do you do something without a video? There's no report that gets released now that doesn't have a video attached to it. I don't think we've ever done a campaign without a video or at least a motion graphics," said Liba Beyer, campaign director at HRW.[59] The underlying logic is that video can serve public interests in promoting human rights values better than other communication tools can.

Video activism is also a collective endeavor. Participating in video production has often been understood as a process through which diverse populations negotiate and assert their cultural identity in the public sphere.[60] According to Clemencia Rodríguez, video making can facilitate "processes of identity deconstruction, personal and group empowerment, demystification of mainstream media, reversal of power roles, and increasing collective strength."[61] Video can thus structure democratic power not just as voting and protests but also as experiential learning and involvement. In this spirit, David Whiteman proposes a coalition model for evaluating the political impact of the documentary genre and, by extension, of video activism.[62] His model takes into account the entire video-making process and moves beyond the focus on individual behavior to look instead at the horizontal structures and networks affected by the issue at hand. Video's strength is in the collective, which gets transformed as part of the broader processes of production and distribution.

When asked why WITNESS defines video as a democratic tool, a former staffer responded, "Because it is a tool that is participatory,"[63] thus echoing the long history of video activism. Similarly, Oren Yakobovich, a cofounder of Videre est Credere, contends that "the most effective way to create a social change is to work within the community."[64] His group has been working with and supporting activists around the world in predominantly

rural areas on how to use video for human rights. Contrary to other human rights collectives, most of Videre's work is undercover, or not disclosed publicly, for security reasons, with activists using custom-made hidden cameras to document rights violations. Even in this clandestine context, the community involved is seen as the key ingredient to video's political impact.

Forensic Architecture is also relevant to this discussion. It has been a pioneer in open-source investigations since its founding in 2010 as a research agency at Goldsmiths University of London. Its investigative work involves videos, satellite imagery, three-dimensional scans, nanotechnology, and other material objects to detect *violence at the threshold of visibility*.[65] Much of that work is centered on gathering and verifying videos and other open-source data to deconstruct scenes of violence. Although many of these videos are shot by individual people on their cell phones, the collective remains vital even as its role is changing. Eyal Weizman, the organization's founder, argues that "verification relates to truth not as a noun or as an essence, but as a practice, one that is contingent, collective, and poly-perspectival."[66] Typically, verification has been associated with scientific and political authorities.[67] Forensic Architecture tactically opens it up as a practice that accommodates "seemingly incompatible institutions and forms of knowledge" in the collective pursuit of human rights truths.[68] Forensic Architecture's human rights investigations incorporate activist tactics and institutional strategies that bridge the domains of art and science to conduct media and spatial analysis, to develop three-dimensional architectural models, and to collect eyewitness testimonies. Even as video practices evolve, collective participation remains at the center of what constitutes video's perceived power as a human rights tool.

Directly related to video investigation as a collective human rights practice is the emergence of open-source verification as a form of both citizen science and data activism. This development is evident in Amnesty's Decoders Project. Scott Edwards of Amnesty's Crisis Response Team distinguishes between crowdsourcing—wherein the public volunteers information over a digital platform—and social computing—wherein Amnesty sends out a request for a specific verification task to hundreds of volunteers.[69] Input is used when it is confirmed statistically or through consensus within the network or both. Decode Darfur is one such project carried out in 2016, with 28,600 volunteers helping Amnesty map villages in Darfur attacked by the Sudanese government and its allied militias. In his analysis of three

Decoders projects, Jonathan Gray shows how Amnesty is fostering a space "for the collective articulation of experience and emotion, not just the instrumental production of evidence."[70] Echoing the values of video activism, such projects demonstrate how the strength remains in the collective that works with video and other data to uncover human rights violations.

From an activist perspective, related to video's public function and collective potency is its ability to generate and nourish alternative spheres of public discourse. Video has long been situated against the mainstream in terms of both aesthetics and content. In terms of aesthetics, early experiments with video discarded the look of cinema, refused the perceived authoritative narration in television, embraced hand-held video making, and strived for raw immediacy. In addition, video has always been a relatively cheaper technology, easier to handle, and more readily available to diverse groups. In terms of content, it has been thought of as an activist platform, facilitating the articulation of voices excluded from public dialogue. Video activism has historically been a way to claim voice in order to raise awareness and generate discussions about wide-ranging issues ignored by the mainstream—disarmament, environmental crises, homelessness, AIDS, LGBTQ, Black and Indigenous rights, to list just a few. Video has thus been seen as an activist tool that can extend the spaces and discourses that promote democratic and human rights values.

Madeline Bair, formerly Media Lab manager at WITNESS, attests to what is now a widely accepted notion that video "is becoming democratized because of greater access to cameras, because of greater access to [the] internet, and because of the ability for anyone with video to upload it on YouTube or Facebook if they have access to the internet."[71] The greater availability of raw footage online has facilitated the rise of open-source human rights investigations. Robert Trafford, a researcher at Forensic Architecture, sees open-source video as an equally seminal or defining moment for human rights practice today as the rise of witness testimonies in the post–World War II moment. "We [at Forensic Architecture] think about open-source evidence . . . [as] a response to the mediatization of conflict."[72] The more videos there are of the same incident, the more ground-level perspectives there are to help establish relations between those present at the scene. In other words, the multiplicity of video voices aids the deconstruction of histories of violence. Forensic Architecture has also actively sought to extend the spaces for human rights practice, presenting its work in the media,

courts, truth commissions, art galleries, and museums. In the process, this collective reintegrates the science and aesthetics of human rights facts—established through open-source analysis—into important contexts from which they routinely get separated.[73] The subjective and situated perspectives provided by multiple videos of a particular scene of violence are analyzed and corroborated using artistic and scientific techniques in an open and transparent manner that documents the process of producing human rights facts.

Video's function as a platform for alternative voice and vision reverberates in the work of other human rights collectives as well. Syrian Archive is a Berlin-based collective of activists and archivists who work on open-source human rights investigations in Syria. The work centers around the collection, verification, documentation, and analysis of online imagery from the Syrian conflict uploaded on social media platforms. Key here are Syrian Archive's efforts to preserve the otherwise ephemeral quality of these human rights videos by storing the footage in ways that could aid future judicial processes for justice and accountability in the region.[74] Video archiving indeed has a long presence in the activist community as a practice that preserves voices excluded from institutional archives and histories, as in the notable cases from the feminist, LGBTQ, and AIDS movements.[75]

In addition to its public, collective, and alternative functions discussed thus far, activist video has promoted democratic models in line with Chantal Mouffe's notion of passionate engagement. In her view, "the prime task of democratic politics is not to eliminate passions from the sphere of the public, in order to render a rational consensus possible, but to mobilize those passions towards democratic designs."[76] Privileging visuality, voice, and emotional engagement as grounds for social critique, video activism has positioned itself in sharp contrast to normative models of deliberative democracy. Its users have instead envisioned democracy and rights as a set of ongoing critical practices that people endorse in their daily lives.

Various human rights collectives have increasingly embraced video's entanglement with the emotions. Emma Daly, communications director at HRW, walked me through the video *You Have the Right to Remain Silent—California Bill Strengthens Miranda for Kids* from 2016 as a successful example of video advocacy. HRW's team organized a screening of this video for politicians to get the necessary votes to pass a California Senate bill requiring consultation with a lawyer before anyone younger than eighteen can waive

their Miranda rights and be questioned. The key component of the five-minute video is footage of a police interrogation of a thirteen-year-old boy.

In one memorable moment, a police officer tells the boy, "Right now you're just a big, f****** liar. A big, cold-blooded killer." In a different segment, the same officer tells the boy, "Your mom was just telling me about your three sisters. You know, she's telling me about your dad, how he's schizophrenic, and she was telling me about your problems." Although the boy's face is pixelated for privacy protection, the viewer can see him leaning toward the table, covering his head and crying out loud (figure 2.1).

In another scene, the boy tells his mother as she walks into the interrogation room, "I'm gonna be straight up with you; I wasn't there." In a crying voice, he continues, "They told me that if I don't say that I did it that they were going to tell the judge that I'm a cold-blooded killer, and I'm gonna get more time." The footage is contextualized with testimony from the mother as well as expert testimonies from an HRW senior advocate, a law professor, and a former probation chief, all of whom explain how police can use psychologically coercive techniques with children to detrimental consequences. In this case, the boy confessed to a murder he did not commit and spent three years in prison until a court reversed the decision. The tactical interplay between the emotions and policy-relevant information is

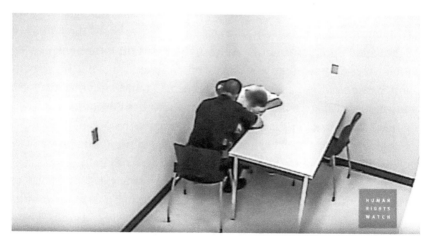

**Figure 2.1**
Screenshot, *You Have the Right to Remain Silent—California Bill Strengthens Miranda for Kids*, HRW, August 17, 2016, https://www.hrw.org/news/2016/08/18/us-california-bill -protect-youth-miranda-rights#.

what turns this video into such a compelling case for human rights advocacy. The video footage of the police interrogation exceeds the functions of an evidentiary display. It brings emotions to institutional decision making in order to get a law sponsored by HRW passed.

This cultural history of video activism illuminates how human rights activist undertakings in their aspirational and idealized forms have multidimensional goals and are a direct response to the perceived failures of cultural, social, journalistic, economic, political, and legal mechanisms to bring justice to the world. In this context, video activism operates as a corrective to the system that shapes social life. Human rights concerns—even if not always called by this name—linger throughout this history.

As information is the backbone of human rights activism, communication tactics have been among the strongest and oldest activist weapons: "the art of the weak."[77] The persistence of specifically visual modes of communication speaks to the long-assumed centrality of the visual in providing the grounds on which public critique emerges. For Luc Boltanski and Eve Chiapello, "the formulation of critique presupposes a bad experience prompting protest, whether it is personally endured by critics or . . . roused by the fate of others. This is what we call the source of indignation. Without this prior emotional—almost sentimental—reaction, no critique can take off."[78] They identify two levels in the expression of any critique: the domain of the emotions, which can never be silenced, and the domain of theories, arguments, and reflections, which voice and translate indignation into critical frameworks that signpost pathways for social change. When operating as a critical force, activism seeks to connect the personal and emotional experience with human rights values broadly conceived to sustain struggles for public good. Video has endured as an important activist tool precisely because it has been understood as a unique public and collective platform for alternative voice and vision that can communicate indignation as part of a larger critical framework.

This brief overview underscores how efforts to use visuals for human rights and social change have always been shaped by technological developments, patterns of cultural belonging, political commitments, aesthetic visions, and practical necessities. Whether we conceptualize visual activism as a project with political intentions, an ongoing intervention in public dialogue, or a call for direct action,[79] this brief cultural history highlights how visual communication in its various permutations has been given the

burden of forming or restoring democratic principles, mobilizing publics, providing evidence, generating moral response through emotional engagement, affecting social change, and advocating for human dignity. This persistent interlinking of the visual with ethics and politics since the seventeenth century demonstrates the often understated relevance of visual imagery to traditional notions of good communication and civic engagement. It also shows how the different iterations of video are a cultural extension of wide-ranging and long-standing visual practices. Because activists were among the first to use video in this context, they helped form cultural expectations that video is a technology and a medium of social upheaval and transformation that generates knowledge on its own terms.

## Video as a Unique Form of Knowledge

The second half of the nineteenth century saw a profound change in the materiality of communication. According to Friedrich Kittler, the various instantiations of writing as the dominant medium of communication were supplemented by technologically driven systems of writing: the phonograph and the cinematograph brought novel ways of experiencing sound and sight. These new forms of media transformed thinking about information storage and transmission because both the phonograph and the cinematograph were far more unselective description devices than writing.[80] Following Kittler, Amit Pinchevski contends that these new devices could capture "the intentional together with the unintentional, the data and the noise, indiscriminately as they come."[81] In other words, for Kittler and Pinchevski, modern technological media and psychoanalysis have comparable logics through their capacity to inscribe deliberate and unintended traces of the past: the psychic has been informed by the technical. The phonograph, for example, could capture speech as well as the silences and pauses that inform psychoanalytic theories.

Pinchevski extends this reasoning to video, arguing that the technological apparatus of this electronic medium—its simultaneous inscription of sound and moving images—rendered trauma and testimony meaningful within scholarship and practice in psychoanalysis and the humanities in the latter half of the twentieth century. According to him, "It is only with an audiovisual medium capable of capturing and reproducing evidence of

the fleeting unconscious that a discourse concerned with the unarticulated traumatic past becomes intelligible."[82] By means of Kittler's definition of recording, processing, and transmission as the three elementary functions of media, Pinchevski contends that trauma theory is centrally connected to how video performs these media tasks. The difficulties of bearing witness experienced by Holocaust survivors were captured on videotapes that clinicians, historians, and literary scholars could repeatedly watch and analyze.

In other words, the affordances of video as a technology—its ability to record, process, and transmit cognitive, affective, and sensory information that may not be available to store otherwise—make it a unique mode of knowledge. Video can record what exceeds human perception in the moment and transfer it across time and place. Here Walter Benjamin provides an important historical context. For him, the transformation of art through technological reproducibility facilitated different experiences. Photography and film, for example, transformed human perception. These new cultural forms had unique affordances ripe for political engagement.[83] The ubiquity and affordability of video today take Benjamin's arguments even further.

Through its electronic infrastructure, video has been able to provide a distinct knowledge of particular value for developing theories about trauma and testimony. This knowledge has also been of central importance to human rights practice, where it is assumed that video's communicative power rests on its ability to hold emotions differently from words. When asked whether there is anything unique about video, a senior program manager at WITNESS iterated a common response. For Priscila Neri, video is "able to literally bring the voice of that person who is directly affected [by a human rights violation] face to face, in a way, with the judge or with the judges [or the policy makers]. [This] is something that photography can't do, for example, and is something that other mediums can't do as effectively because we're hearing the person's voice, we're seeing the person's face. I have a colleague who always says, 'Video puts human in human rights,' if it's done ethically."[84]

Video's role at the Fortunoff Video Archive for Holocaust Testimonies at Yale—which Pinchevski examines—reverberates in Neri's statement. Implicit in her reflection is the idea that expression, tone, gesture, emotions, and silence, which inevitably accompany any testimonial act, matter as much as the content of the speech.[85] Video can also help create witnessing publics for

human rights testimonies even in policy-making settings. It is appreciated as a record that inscribes indiscriminate traces of a human rights testimony that demands to be heard and seen in its full complexity—which is key to video's perceived transformative power as a human rights tool.

The digital infrastructure of the current iteration of video brings about additional possibilities for information storage and transmission. As a digital medium, video today can be considered alongside bulk data-collection technologies because it records indiscriminately not only light and sound but also metadata: data about the digital file itself, such as date, time, and GPS coordinates of the place of recording.[86] Video as data can be and is increasingly used in surveillance programs, but it can also be of immense value to human rights practice. When available, the metadata are helpful for open-source investigations because they help establish the authenticity of the video. Human rights collectives have been working on smartphone apps that strengthen the reliability of human rights videos by boosting the capture of metadata such as velocity information and surrounding Wi-Fi networks, among other data, as in the case of WITNESS's Proof Mode and the International Bar Association's eyeWitness to Atrocities apps discussed in chapter 4. Video is therefore a technology that affords the concurrent processing of audio, moving images, and metadata, which makes it a unique mode of knowledge production that is gaining in relevance across institutions and among human rights collectives.

Trafford told me, "My working life at Forensic Architecture has been a process of finding out that there is always more in a video than you think there is. . . . There is always a phenomenal wealth of information within a video, and that goes not only to what is within the frame but [to] how the frame moves."[87] Video affords simultaneous recording, storage, and transmission of visual data, sound, placement, movement, perspective, and metadata, which is crucial for its unfolding role and scope in human rights investigations. This is why there is an understanding that video captures information that may be overlooked at first viewing but is essential to deconstructing scenes of violence.

Forensic Architecture, for example, analyzed footage from multiple closed-circuit television (CCTV) cameras and police audio recordings to deconstruct the killing of Pavlos Fyssas in Greece in 2013 by the neo-Nazi political party Golden Dawn, which had representation in the government and silent

police support. Since the 1980s, Golden Dawn has been committing various acts of violence against migrants, ethnic minorities, and political opponents, but these acts have rarely been investigated by the government. In the case of Fyssas, his family commissioned Forensic Architecture to reconstruct the murder based on materials available to the Greek court. As part of the investigation, Forensic Architecture synchronized footage from multiple CCTV cameras in the vicinity of the crime scene and plotted the movement of people and vehicles between frames in a three-dimensional model (figure 2.2).

Forensic Architecture was in this way able to establish that members of Greece's elite special police forces were present at the scene of the murder and failed to intervene. The investigation itself was recorded on video and presented at several public exhibits and the Athens Court of Appeal. The example illustrates how human rights video is becoming legitimized as a unique mode of knowledge across institutional and legal contexts, which in turn drives video's capacity to serve diverse policy functions.

**Figure 2.2**
CCTV footage analysis, *The Murder of Pavlos Fyssas*, Forensic Architecture, September 21, 2018, https://forensic-architecture.org/investigation/the-murder-of-pavlos-fyssas.

## The Policy Functions of Human Rights Video

Human rights collectives describe video as a powerful tool for communication and investigation. They claim that video provides a deeper insight into the realities on the ground, that it gives the feeling of context, and that it conveys meaning in ways words alone would be unable to do. By embracing the values of video activism, human rights collectives have put video to different uses in policy making. Human rights videos thus serve numerous policy functions: setting an agenda; providing medium and content for policy debate; serving as legal evidence; facilitating legal argument; serving as a forensic tool and record; supporting the legal process; providing a means of legal education; and establishing communications that influence how people understand the nature of rights.

Online video footage from Syria has played an important agenda-setting role across the news media, triggering UN investigations, congressional hearings in the United States, and parliamentary discussions in the European Union. Human rights collectives and their investigative work have figured prominently in this development. For example, for a report titled *Eyes on Aleppo*, Syrian Archive analyzed 1,748 videos from social media documenting potential human rights violations in Aleppo between July and December 2016.[88] The visual data set supports findings by Bellingcat, Amnesty, and the Independent International Commission of Inquiry on Syria. HRW reports on coordinated chemical attacks in Aleppo also cited online videos preserved and verified by Syrian Archive.[89]

Human rights video can provide a medium and content for policy debates. As mentioned earlier, HRW used footage from coercive police interrogation for its advocacy video *You Have the Right to Remain Silent*, screening it to state senators to ensure that a bill would pass to guarantee that no one younger than eighteen could waive their Miranda rights without the presence of a lawyer in California. In another effort, HRW organized a campaign with twenty other organizations in the fall of 2018 around a short video urging the Greek government to transfer asylum seekers from the Aegean Islands to a more appropriate winter location on the mainland. HRW did successful microtargeting on social media over the course of a week during the convening of EU heads of states.[90]

Video is important for policy making because it can serve as legal evidence and facilitate legal arguments. Both of these functions were important

in a case in front of the ICC in 2016, *Prosecutor v. Ahmed Al Faqi Al Mahdi* (ICC-01/12–01/15), involving crimes against cultural heritage. The investigators incorporated satellite images from Google Earth, YouTube videos, and other open-source information, turning *Al Mahdi* into the first international criminal case to rely heavily on such materials.[91] Situ Research, a design studio in New York City, helped create an interactive digital platform "to facilitate the organization, analysis and presentation of evidence documenting the destruction of cultural heritage in Timbuktu, Mali."[92] The platform comprised videos that were used for their evidentiary role. In line with the standard set for the use of video evidence at the ICTY, because there was no indication of fraud, the prosecution did not take any extra steps to verify the footage other than ascertaining the date, time, and location.[93] Such use shows the elevated role of video in legal contexts. The interactive digital platform also assisted legal argumentation in the courtroom. Lindsay Freeman of the ICC's Technology Advisory Board explains that "because they [the judges] were dealing with so many different locations, the interactive platform presentation assisted [them] in seeing what occurred at each and every one of the relevant locations."[94] The platform, then, was not shown for evidentiary purposes per se, but it was deemed relevant for constructing legal arguments.

Video can also support the legal process, when, for example, witnesses testify via video link in court, a practice in use at the ICTY. In addition, digital video can serve as a forensic tool and record when an analysis is performed on the video itself (e.g., geolocation, call sequences, visual augmentation). Forensic Architecture's analysis of the CCTV footage used in court in Greece is just one example of how video can perform the function of forensic evidence.

Human rights collectives have also turned to video to provide a means of legal education and communications that influence how people understand the nature of rights. Amnesty, HRW, and WITNESS, for example, have been investing in various "know your rights" videos. These short videos range from a broad overview of what human rights are to more specific topics such as immigration rights. WITNESS has produced training videos on how to document encounters with police and Immigration and Customs Enforcement agents in the United States. It has also partnered with the American Civil Liberties Union on "know your rights" training, with WITNESS leading the video component, which includes risk assessment and

digital security for community members and video-evidence protocols for
lawyers.[95]

The institutionalization of video as a distinct mode of knowledge across
journalistic, legal, and political advocacy domains drives human rights
video's ability to perform multiple policy functions. To survive in these
environments, however, human rights video needs to be connected to pro-
fessional power and authority. Human rights collectives are thus seeking
to professionalize human rights video activism by developing tactics and
strategies to play into institutional and legal settings while embracing the
values long associated with video activism.

## The Professionalization of Human Rights Video Activism

The secularization of knowledge promoted by Western permutations of
modernity gave rise to a type of formal specialized knowledge character-
ized by rationalization and distinct from everyday tacit knowledge. As one
instantiation of this kind of modernity, professionalization provides agents
of formal knowledge with a livelihood and access to social power.[96] Silvio
Waisbord defines "professionalization as a process by which occupations
claim jurisdiction over a field of practice."[97] The path toward professional-
ism, states Philip Elliott, is a process "through which the knowledge avail-
able to society is developed and used in the performance of specialized
tasks."[98] Professionalization therefore facilitates both the emergence of an
occupational practice that receives monetary compensation and the forma-
tion of a set of specialized knowledge and skills through which the occupa-
tion attains social recognition and status.

The title *profession* is a changing historical concept whose origin Eliot
Freidson locates in the industrial nations influenced by Anglo-American
institutions.[99] Modern professionalism developed as a direct consequence of
Western industrialization and urban growth.[100] In the nineteenth century,
professionalism was a way for the newly formed middle-class occupations
to claim recognition on the level of the previously regarded gentlemanly
status and to secure a place in the economy.[101]

Although professionalization indicates autonomy in the development
and application of formal knowledge, the rise of professions has depended in
part on the market economy.[102] Professionalization is a logic that needs insti-
tutions to provide economic support for and to enable the occupational

control of work.[103] It is a cultural phenomenon rooted in capitalist economic philosophy.[104] The emergence of professional authority through the development of standards, procedures, certification, and ethical codes of behavior upholds the occupational practices that underlie that authority and its claim to knowledge in an institutional context.

Social movements of the 1960s posed serious challenges to institutions and their professions in the context of capitalism. The critique of this system condemned institutional hierarchies, called for professional autonomy, and denounced the division of labor as alienating and constraining.[105] Rather than undermining the system, however, these movements gave new flavor to capitalism and the institutions sustaining it. Boltanski and Chiapello show how the critique was partially answered and incorporated in a new spirit of capitalism that now emphasizes flexibility, mobility, engagement, and innovation. They claim that in this process "the 'peculiarity of human beings' has changed: reason in the 1960s versus feelings, emotion and creativity in the 1990s."[106]

These new institutional circumstances have urged professions to adapt to the new spirit of capitalism. A university degree or a professional license, for example, is a minimum but not sufficient criterion for employment. Communication skills, creativity, empathy, and the ability to work on multiple projects simultaneously are frequently listed under desired qualifications. On one hand, this development suggests how professions employ strategies and tactics to survive in institutional contexts on a fundamental level. Michel de Certeau argues that scientific rationality is constructed on a strategic model par excellence.[107] Computer scientists, for example, learn to apply these strategies in their work, but when they seek out employment, they turn to tactics that enable them to claim and apply the new sets of qualities desired for the job. On the other hand, this development shows how rationalization is no longer the sole structuring mechanism of formal knowledge. The so-called irrational qualities that Western modernity discarded, such as emotion, intuition, and imagination, are now gaining social currency and generating the possibilities to professionalize and institutionalize differently various forms of knowledge than were previously available, among them video.

Visual forms of knowledge production, with their appeal to emotion, imagination, and memory, have long been central to humanitarian and human rights activism, as discussed in this chapter. Human rights collectives

situate themselves as part of this global human rights activist tradition. Through their NGO status, they are well positioned to claim the knowledge provided by video as their own, establishing and promoting visual proficiency and skills that are pertinent today. The employment opportunities provided through the organizational structures of these collectives sustain human rights video activism economically and provide a place from which to assert responsibility for video as a unique form of knowledge. The professionalization of human rights video activism is therefore a way of claiming control over the use of video as a human rights tool across policy-relevant contexts.

Professionalism is a dynamic process that can be facilitated by institutional changes that demand functional specialization.[108] As institutions evolve and interact, they need professionals to address emerging sets of specified problems. Advocating for social change and achieving human rights have always been a part of video activism. However, the development of ideals and practices delineating how human rights video can count as formal knowledge is facilitated by a new institutional moment: journalistic, judicial, and political advocacy domains have turned to video on their own out of necessity and are seeking to expand their professional projects to accommodate it. Human rights collectives describe the perceived need for their skills and services by explicitly referencing this development:

> If you think about a protest situation—which is how we began working on this issue in Brazil—at the creation point [of the video], you could have the mainstream media . . . you could have citizen witnesses, media activists, accidental witnesses, a whole host of different profiles, which bring with them specific challenges and strengths. Then, at the second stage—What do you do with that footage? How do you store it? Who do you send it to?—there [is] another host of profiles. You have media channels that could broadcast the footage. You have lawyers and judges who could interpret the footage. You have archivists who could store it. So we mapped all of that, and we have specific partners who represent all of these stakeholders, and what we are trying to offer is the specific support that the specific partner needs.[109]

This observation suggests that the professionalization of human rights video activism is seen as a critical intervention in the broad human rights landscape, ensuring that the status, importance, and benefits of the knowledge provided by video are being used for public good.

For Magali Larson, professionalism "must gain support from strategic social and political groups."[110] The points of convergence among journalistic,

judicial, and political advocacy contexts in connection to human rights video—addressed in the subsequent chapters—have created the complicated and multivalent institutional locus supporting the professionalization of human rights video activism. In other words, the new institutionalism resulting from the unfolding prominence of human rights video provides strategic basis for the professionalization efforts. By developing tactics and strategies that give rise to methodologies and standards for video production, investigation, and verification, human rights collectives lead the efforts to professionalize the practices central to video activism. They thus place themselves as visual specialists at times when these skills are needed across the institutional calculus that renders human rights claims legitimate. Amnesty, HRW, WITNESS, and other human rights collectives not only produce and analyze videos but also train others, contributing to an increasing specialization and diversification of practices in video making for human rights and social change.

Freidson describes professions as phenomenological in character.[111] Any claim to professionalism includes normative ideals and evaluative judgments, yet professions cannot be explained normatively. He maintains that they are best understood by looking at how particular occupations aspire to professionalism: what activities they undertake and to what consequences. In the subsequent chapters, I describe the strategies and tactics through which human rights collectives delineate their visual work as sufficiently specialized and distinct from long-standing modes of video making. I argue that the aspiration to professionalism is a way of coexisting better within and alongside the institutional and legal environments that have now recognized the value of video. These efforts result in a proxy profession that legitimizes the capacity of human rights video to serve diverse policy functions while brokering activist and public voices in journalism, the law, and political advocacy.

# 3   Human Rights Video in Journalism

The proliferation of visual technologies and platforms has propelled video to the forefront of the current information environment, bringing about a profound visual turn in journalism. The increasing reliance on online videos has been notable in crisis coverage, especially international news, where the boundaries and integrity of journalism are constantly brought into question as journalists, citizens, human rights collectives, and activists partake in the production and circulation of news. Video is thus often centrally implicated when the paths of different actors cross in the information landscape. Journalists rely on videos shot by civilians to produce the first round of reporting during emergencies or when they are unable to cover an event from the scene of its unfolding. Activists may risk their lives to capture videos so they can place their stories on the international news agenda. Human rights collectives produce videos of interest to news outlets; they conduct open-source investigations and participate in developing verification measures for online videos. This unfolding relationship among journalists, human rights collectives, activists, and citizens in global-crisis reporting is at the core of this chapter.

I situate the current visual turn in journalism as reflective of ongoing economic, technological, cultural, and social transformations that question existing financial models, established journalistic tools and platforms, modes of information relay, and normative assumptions about appropriate models for journalistic work. At the same time, human rights collectives have seen journalism's struggles as an opportunity to tap more prominently into journalism culture. Video has been centrally implicated in this development, and the different attitudes toward visuals among these communities have further facilitated the ensuing relationship. In charting the

growing prevalence of video at the crossroads of news work and activism, this chapter shows how and why the proxy profession unfolds in this context, enabling human rights collectives to permeate journalism. I argue that video now provides authoritative cues for the evolving information work of human rights collectives that embrace the values of video activism and develop tactics and strategies to pursue that activism in journalistic spaces.[1] In the process, they shape video standards and verification measures, positioning themselves as visual experts who broker arrangements between activists and journalists in international emergency coverage.

## Journalism's Challenges, Human Rights Opportunities

A series of economic, technological, cultural, social, and political forces challenges journalism. Decreasing financial resources, rapid technological advancements, lack of public trust, scandals, deviations from ethical standards and professional norms, political attacks, and a growing need to combat mis/disinformation campaigns characterize the field. Meanwhile, human rights collectives have become a more visible part of this changing news landscape. They are using the present transformations and challenges in journalism as a fortuitous moment, becoming both sources for the news media and active agents of news. They are thus partly offsetting some of the deficiencies raised by the current set of circumstances in journalism.

The interplay between contemporary journalism and human rights activism is prominent in the visual field. As video migrates to the forefront of journalism, it makes apparent some of the tensions that the Western project of modernity has tried to keep in the background: the malleability of journalism's authority, the fragility of notions about objective reporting as journalism's gold standard, and the lurking presence of opinion, emotion, and imagination in the news. In this process, video brings to focus some of activism's strengths: the questioning of authority, the purchase of visuality, the role of emotional appeals, and the power of personal storytelling and collective work. As visual practices cut across journalism's core challenges, the new shaping of video activism as a proxy profession is becoming a legitimizing mechanism that delegates to human rights collectives the right to speak in the name of public interests alongside bona fide journalists.

Amnesty, HRW, WITNESS, and other human rights collectives are part of this changing landscape. They all are shaping (in different ways) tactics and

strategies for video activism in ways that better place their work as news segments. They are also responding to the growing need for visual news by conducting investigations, developing verification tools, and promoting standards for open-source data. In the process, they claim epistemological and interpretative control over various images of global injustice. This development centers largely on wavering reputational status and trust, uneven financial resources, technological processes, differing responses to visuals, and shifting expectations about models of information relay.

## Wavering Reputation and Trust

Whereas legacy news media have seen a decline in reputation due to rapidly diminishing financial resources and corporate takeovers,[2] their coverage of the wars in Afghanistan and Iraq,[3] various journalism scandals,[4] and an inability to reconcile professional identity in light of technological progress,[5] civil society groups have experienced growth in their reputation over the years.[6] Human rights collectives, for example, are keen to mention that they are perceived as more trustworthy than legacy news media. The communications director at HRW told me, "We have loyal followers who are going to trust us more that they trust some of the media outlets that they might have gone to in the past."[7]

The Edelman Trust Barometer has documented the rising influence of NGOs globally since 2001, finding the civil society sector to be more trusted than governments and news media, with the latter being the least-trusted institution in 2019.[8] In the United States, the Pew Research Center finds public trust in government near historic lows and no news source to be trusted by more than 50 percent of US adults.[9] Global political efforts to delegitimize the media and civil society have intensified, with government crackdowns on NGOs becoming a routinized practice.[10] The news media remain particularly vulnerable, especially in light of their record low levels of public trust around the world. Civil society, in contrast, has largely been able to maintain a level of trustworthiness thus far, despite being the target of political delegitimization efforts globally.

Registered as NGOs, human rights collectives are a particular subset of the civil society sector. The general perception among the most prominent groups is that it took years of hard work to build public trust. Carroll Bogert, a former executive director, described to me how HRW acquired its reputation over time, remembering the difficulties to secure news media coverage

in the United States in the aftermath of the terrorist attacks of September 11, 2001:

> *New York Times* still won't use the term *torture*. . . . They've been called on that by the Ombudsman, and there has been an interesting exchange over the years in which they've been challenged. But they won't relent. I think that also damaged people's reputations. It was a very lonely time, I remember . . . [when] we put out a statement about September 11, saying that it was a terrible loss of life and [that] it's a crime against humanity. That's the term for it in human rights terms, not terrorist acts. . . . [We also said that] the US should take care in its response to also abide in proportionality by laws of war, which was an incredibly mild thing to have said comparing with what the US did. I remember being called at home by an American diplomat who [was] absolutely enraged . . . [and] told me, "What are you, deaf? How could you say something like that in times like this?" We were very isolated. And we were saying from the beginning [that] Guantánamo [was] a disaster. That was so unpopular. It was really hard. Those were really tough days, and we kind of lost the media. There wasn't very much of that kind of a perspective [in the news]. That maybe contributes a little bit to [journalism's] credibility problem.[11]

Explicit in this reflection is a comparison with legacy news media: journalists and human rights collectives are storytellers of current affairs, but news media's comfortable relations with powerful elites can sometimes fail them in their effort to maintain trustworthiness. Human rights collectives, in contrast, see themselves as a critical and independent force. They thus tactically situate their work against the failures of mainstream journalism.

Human rights collectives single out transparency—about funding sources, political standing, and methodology—as a key variable for building public trust. In terms of funding sources, Emma Daly, the communications director at HRW, told me: "News outlets are perceived to be in the pocket of this magnate or that magnate, you know, pushing their business interests. It's understandable why people feel like 'I'm not getting an accurate picture.' . . . The point is we all have our interests; it's just about being able to recognize where [the] news sources are coming from or what their agenda is. . . . It becomes ever more important to be really clear about where that's coming from, who's funding it, and what their agenda is."[12] Mainstream journalism has long tried to conceal some of its corporate and political biases under the veil of professionalism. Human rights collectives, however, insist that investigative work can benefit from the open disclosure of biases. Daly continued: "We're pretty transparent about what we do. We are

criticizing governments to try to make them change. We're clear about the agenda that we have. I remember a journalist saying to me a few years ago, 'I don't know why you would want to be thought of as being like a journalist because the work that you do is of much higher caliber than most journalism.'"[13] Underpinning this comment are growing concerns about the state of mainstream news media among journalists, some of whom take jobs in humanitarian and human rights organizations, as did the staffers quoted earlier.

As a vehicle for building public trust, transparency is also perceived to be based on methodological principles. Human rights reports have long included a detailed accounting of the methodology used to arrive at the findings and conclusions. This transparency is now embraced in the context of open-source investigations that rely heavily on video and other visual data. Eyal Weizman, the founder of Forensic Architecture, explains the commitment of the human rights community to showcase the evidence and the production of evidence.

> Open verification needs to continuously expose every step by which the work is carried out, its circumstances, the people involved, the materials used, how and where each piece of evidentiary material was found, its modes of authentication, the ways by which different pieces of evidence were brought together, and a case was assembled. Doing this allows for the public domain to function in an analogous process to a scientific peer-review: that is, for the underlying data to be examined by others, and the processes to be replicated and tested. This is the reason that most of the content of our video investigation is a "how-to."[14]

Open verification, as Weizman defines it, has also emerged as a response to viral deception.

The rise of online misinformation (information shared without the knowledge that it is false) and disinformation (intentionally false information shared to cause harm) has been popularized under the rubric of fake news. Yet from the perspective of global audiences, this buzzword connotes a deep dissatisfaction with mainstream news media and politics rather than a broader understanding about the power and scope of deceptive information.[15] To address the current information disorders, the human rights community has emphasized its commitment to transparency, openness, and collective investigative methodologies, all of which are embraced as a shield against political attacks seeking to distort or conceal human rights information.

The journalistic community has also seen results when it embraces these principles to combat viral deception. For example, Comprova, a collaborative project between twenty-four different Brazilian media companies and the nonprofit group First Draft, was able to minimize the effects of mis/disinformation during the Brazil elections of 2018 through collective work and open verification.[16] The Visual Investigations Unit at the *New York Times* has also followed suit. Headed by a former staffer of Storyful, this unit has been able to innovate in the journalistic landscape and has conducted various investigations in partnership with human rights collectives. Such collaborative projects, although growing in frequency, are not yet common practice in mainstream news media. After all, the financial models followed by most news media are biased toward exclusive content.

This parallel between journalism and human rights work is not drawn to suggest a clear binary—messiness is part of both communities of practice. Rather, it highlights how journalism's institutional constraints and news work models slow innovation that can directly address some of the causes of declining public trust, which the human rights community now seems better positioned to do.

### Uneven Financial Resources

Uneven financial resources characterize both Western journalism as a whole and prominent Western human rights collectives such as Amnesty and HRW. The story of the economic transformation of traditional journalism in Western societies is familiar by now: shrinking financial resources have caused a loss of jobs and cuts in live coverage, story length, original content, and international news. For example, cutbacks in US newsrooms put the industry at a number lower than 37,000 full-time journalists in 2015, a record low since 1978.[17] The *State of the News Media* report in 2019 identified troubling takeaways as well. US newspaper circulation has reached its lowest level since 1940. Digital ad revenue has grown significantly, but a majority goes to Google and Facebook—which account for 60 percent of all digital advertising in the United States. Though the total combined revenue of cable news increased from previous years, employment and wages have not.[18] CBS CEO Les Moonves's famous statement regarding the problems in the US presidential election of 2016, "It may not be good for America, but it's damn good for CBS,"[19] is just a recent reminder of corporate bottom lines in cable news.

Obviously, in the context of international news the role of the foreign correspondent is challenged by a lack of funding and competitive sources of information.[20] Freelancers, stringers, fixers, minders, and translators, working in precarious labor conditions, replace or substantially support the work of full-time journalists in global news coverage.[21] Because there are fewer resources for global news content and more opportunities for different actors to engage in information work, the professional boundaries of journalism are changing. The melding of journalism's contours has become salient in the visual field, where financial challenges coincide with a growing demand for images, mandating journalists "to produce more images with less funding."[22]

As a result of the economic conditions in journalism, many journalists have migrated to the nonprofit sector, including human rights organizations, where they can use the same investigative skills. It is not surprising, then, that leading human rights collectives, whose resources are on the rise, have found it easier to produce news with former journalists on their staffs. Although there are fewer foreign correspondents working at major news organizations, the number of researchers at human rights organizations has grown—HRW, for example, has a larger corps of foreign correspondents than the *New York Times* and the *Washington Post* combined.[23] HRW had 450 full-time staff members and total net assets of $213 million in 2017. Amnesty's global expenditure for the same year was €288 million, with a total of 518 staffers working for its international secretariat as of 2010. Although a much smaller human rights collective, WITNESS has been growing as well, with thirty-one core employees and an annual budget ranging between $3 and $5 million.

Unlike in journalism, financial growth in the human rights field has enabled these collectives to operate, investigate, and develop specialized programming in numerous countries around the world. Well-resourced human rights collectives have been able to turn journalism's challenges into an opportunity to place human rights investigations as the focal point of on-the-ground media reporting on global crises. According to Pierre Bairin, a former multimedia director at HRW, the media "have less money to send foreign correspondents all over the world to cover things, so it's a big bonus for us that we are able to give them materials they can use."[24] Human rights collectives indeed enjoy wider publicity in the mainstream news media today than they did earlier.[25] The *New York Times* referred to a story by HRW

roughly every other day in 2010, and Amnesty ranks next to HRW in over-all citations of its work.[26] Bogert told me, "We used to joke [that] you can always tell a newspaper is going to [go] bankrupt because they start quoting us every day."[27] Her observation is supported by research: less-resourceful news outlets are more likely to cite human rights and humanitarian organizations in their reporting.[28]

To take advantage of the gap in international news coverage, human rights collectives have diversified their media strategies.[29] Matthew Powers finds that media savviness is more important than resources as a variable driving the prevalence of these groups in the news.[30] Video, according to human rights staffers, has been among the key forces shaping this development: "As the news media declined, and they have fewer resources, they do look to other reliable sources of information. And if human rights pictures provide them with reliable stuff, they can cite us instead of going [to other countries] themselves."[31] In this sense, HRW and Amnesty's turn to video has been accompanied by a conscious decision to increase their prominence in the news. Daly told me, "It doesn't matter what kind of medium you are. You're a digital outlet, and you need video. If you are a broadcaster, you need it. If you are print, you also need it because you have to fill your news website with stories that in your rapidly diminished newsroom [you] couldn't possible cover. So we're trying to give them as many different types of content as we can that are going to be useful."[32] Human rights collectives have therefore turned the decline in international news into a fruitful opportunity, diversifying how they package their stories in desirable media formats to increase the likelihood of speaking in mainstream news media on issues central to their work. Media coverage is obviously not their end goal, but journalism constitutes an important platform for advocacy and recognition.

Human rights collectives use the news media as a vehicle through which to reach policy makers and citizens. As Daly put it, "We often depend on journalists to get our work out to policy makers."[33] Daniel Eyre, a former researcher at Amnesty, stated, "At times, the media can be a very useful tool for getting stories that we're trying to tell out in the public."[34] When mainstream news media broadcast human rights work, they also validate it as credible information in the eyes of political stakeholders, increasing the visibility of the human rights collective.

In response to HRW's receipt of the Peabody Award in 2012 for multimedia reporting, a former executive told me: "I think it really validated what we do . . . that we are meeting the highest standards of journalism; . . . it makes journalists more comfortable [to] use our stuff, and . . . it makes the public more comfortable; . . . it makes people feel more comfortable with our information as legitimate. . . . [The award is] prestigious in the field of journalism and definitely in terms of getting funding. I can say to funders, like, 'We won [the] Peabody Award.'"[35] News visibility is seen as a legitimizing mechanism that helps with branding and fund-raising efforts. Paul Woolwich, a former audiovisual head at Amnesty, reiterated this connection when explaining to me how news media coverage helps his organization simultaneously accomplish three of its goals: "Not only do we achieve the 'this is a human rights abuse we're trying to expose' . . . [but coverage] also gets us mentioned and raises our profile in a very crowded marketplace, and people might think it is the worthy cause to donate to."[36] News media coverage, then, is important for the acclamation of human rights work, a process centrally implicated in branding and fund-raising strategies that favor publicity.[37] WITNESS, too, tracks and lists press coverage among its accomplishments in its final reports and digital newsletters to members.

To boost their news coverage, HRW and Amnesty, both of which transitioned from print to digital (just like journalism), have been increasingly using video as the primary means by which to feature their work in the news. According to Bogert, formerly of HRW, "The mainstream media often lack the resources to go and do the kind of investigations that we do. CNN's Christiane Amanpour runs a big segment on the Central African Republic—all of the video came from us, all of it. CNN did a story about Buenaventura in Colombia the other day; all of the video came from us—not a part of it, all of it. Now what does that mean? It doesn't mean necessarily that they aren't interested in the story because they ran the story. They don't have the capacity to do all the reporting."[38] Video is thus perceived to be granting human rights collectives greater access to mainstream news media. "Often, you'll find that video gets more traffic than the press release."[39] Philippa Ellerton, a former image archivist at Amnesty, expressed similar sentiments: "Quite a lot of what you see—where you've got Amnesty mentioned on TV news or website news like *Vice*—quite a lot of what you see actually is footage that we've gathered, that we then passed on to the broadcasters so that

they would cover the story. By covering it, we want people to get involved with the issue, not just get involved with Amnesty."[40]

Video thus serves a dual purpose: by helping fill some of the gaps in international news, it can bring the human rights story and the human rights voice to the mainstream news media. In doing so, it validates human rights work, assisting with branding and fund-raising and complicating the markers long assumed to delineate who belongs in journalism and who does not. The active participation of citizens and activists in the current media environment is also casting doubt on professional boundaries within journalism. Madeline Bair, formerly Media Lab manager at WITNESS, told me, "I wanted to report on international human rights issues. Because of the declining funding for journalism, those issues have been covered less and less by the mainstream media, and yet they have been taken up by activists and by video activists, by community media collectives and citizen journalists."[41] As more actors have, in principle, opportunities to partici-pate in news work, human rights collectives have further diversified their tactics to remain relevant in this space.

WITNESS, for example, has gradually moved away from video produc-tion to advocacy around best practices in video usage. It has developed a video curriculum, training activists how to capture videos that may best fit journalistic requirements. By embracing video as a central vehicle for news visibility, human rights collectives master visual modes of informa-tion gathering and news relay. This is especially important when the domi-nant understanding is that "video is not just an illustration on the side; it's not an optional thing or additional material; it's really the material itself."[42]

### Differing Responses to Visual Technology

The differing responses by journalists and human rights workers toward changing technology, in particular visual technology, help foster the unfolding role of human rights collectives in doing journalistic work. The advent of mobile phones with built-in cameras and easy internet or Blue-tooth connectivity as well as the proliferation of social media platforms constitute new means for gathering information and distributing content. According to Philip Rottwilm, "social journalism and the ever-increasing amounts of audience information held by news organizations are redefin-ing the very category of news-worthiness, as well as how journalists write, display, present and follow up their stories."[43] In this landscape, mobile

devices have become a routinized way to document presence and to endorse claims to authority in journalism.[44]

These technological developments are centrally implicated in the visual turn in journalism, especially as news migrates online, where social media algorithms tend to favor video content. In 2015, Malachy Browne, the now head of Visual Investigations Unit at the *New York Times*, told me: "If you get a news article linked to a video, then that gives you much greater chance of your story being seen." It should be no surprise that "when you ask industry strategists where news is going, they talk about three things: mobile, video, and scale."[45] The growing centrality of video in journalism, however, questions established practices, tools, and modes of information relay: in other words, it challenges the presumed parameters under which the profession of journalism operates.

The enduring precedence of words over images "has buttressed a default understanding of news as primarily rational information relay that uses words as its main vehicle and implicitly frames images as contaminating, blurring, or at the very best offsetting journalism's reliance on straight reason."[46] Journalists have long been reluctant to embrace various visual technologies, and the current rise of video is no exception. The unfolding media moment positions international news in the midst of a crowd-sourced video revolution, making visuality "one of the most dominant news values of our time."[47] Images are no longer just a supplement to the written or verbal record; they are becoming an essential tool for gathering evidence and a mode of information relay on their own. Gavin Sheridan, formerly at Storyful, told me, "Images were sometimes seen as a kind of fluff around the story, but now, increasingly, you might see that an image or a video becomes the defining moment of a story, and often that video is an eyewitness video."[48]

Videos captured by bystanders, accidental witnesses, and activists (and even by terrorist groups and perpetrators of violence)—what I refer to as *eyewitness videos*, in line with Claire Wardle and Mette Mortensen[49]— lend journalism a sense of immediacy and proximity, often performing the eyewitness function in news work. In many cases, these videos have become a standardized feature in the news, signaling presence during the instantaneous coverage of breaking news or events otherwise inaccessible to journalists' on-site witnessing. In preferring the phrase *eyewitness video* to other choices (e.g., *citizen video, user-generated content, crowdsourced video,*

*open-source video*, or *amateur images*), I follow a line of scholarship that theorizes the co-implication of technology and the professional, political, and institutional ambiguity associated with these materials.[50] The attribute *eyewitness* also captures the centrality of nonjournalist involvement in journalism's claim to authority in current affairs.[51]

Since the terrorist attacks in the United States in 2001, the London bombings in 2005, and the Iranian Green Movement in 2009, three commonly used reference points for the rise of the so-called citizen journalism, eyewitness videos have often assisted the first round of information gathering by journalists or have offered evidence that has bolstered, challenged, or disrupted the official framing of events. For Sameer Padania, formerly at WITNESS, in 2010 "if you saw a piece of grainy citizen-shot video on the news, it was an anomaly. They [news outlets] would apologize, . . . they would flag it [as an issue]. . . . [N]ow, it's just totally normal. You see citizen video all the time. It's completely central to the news-gathering process. [By now] it has become its own business."[52]

This routine reliance on visuals in journalism is especially pronounced in crisis coverage, where eyewitness images become the key data of difficult news events. During emergencies—war, protest, accident, or natural disaster—the eyewitness footage can offer the first round of reporting before journalists arrive on the scene, if at all. Barbie Zelizer has therefore claimed that citizen journalism, like other developments in journalism, "has allowed the news media to claim they 'have been there' as witnesses of events that they have not witnessed."[53] The implications of this new visual turn in journalism are twofold: eyewitness videos are the new agenda setters, and they are becoming the standard means through which the eyewitness function of journalism is performed during emergencies.

The turn to visuals in times of crises, however, is a long-standing news pattern, and so is the reluctant response to their primacy.[54] The legacy of antagonism between images and words shadowed the arrival of the wire photo in 1935, leaving journalists unable to consolidate "a profession under pressure" as the need for visuals in the coverage of World War II rose above the industry's ability to standardize image usage.[55] Therefore, uneven practices around captioning, accrediting, and presenting images marked the visual relay of World War II atrocities.[56]

A look back in time is important because it suggests how the current lack of standards and systematic approaches to eyewitness videos is not as new

as it initially appears to be. The missed opportunity to think through the complexities of visual tools at the beginning of the twentieth century and the failure to reconcile the tension between images and words in a productive manner since then have meant that technological advancements in the visual field continue to outstrip journalists' ability to grasp and adopt visual innovations systematically. This is especially evident at times when new technologies promise to bear witness to events inaccessible through established journalistic tools and practices. In that sense, just as World War II normalized the use of photography, the Syrian conflict crystallized the routine reliance on eyewitness video.

Human rights collectives insist that Syrian citizens felt a duty to take on the role of journalists because no one else was there to bear witness: "The Syrian government prohibited and prevented international presence in the country, so the people there had to take on the role of journalists."[57] And the deeply ingrained role of bearing witness to unfolding events eased journalists' discomfort about using the available eyewitness content. Claire Wardle, Sam Dubberley, and Peter Brown find that the ongoing Syrian crisis turned the use of eyewitness visuals into a standard feature of news out of necessity: "While the innate power of some of the UGC [user-generated content] from Syria might have pervaded the news no matter what, the limitations placed on journalists to enter the country or move around freely in this case forced even the most reluctant of journalists and editors to use UGC—because it was impossible to tell the story otherwise."[58]

Despite the turn to eyewitness video, though, no standards developed for its use. Eyewitness images are regularly configured in news without proper description, credit, or fact checking.[59] In 2015, the Eyewitness Media Hub observed, "It's a Wild West out there."[60] News managers are mostly unfamiliar with the complexities of using and verifying eyewitness videos. Moreover, national newsrooms still rely on footage from news agencies, which can also fail to handle eyewitness video consistently. As a result, newsrooms have sometimes been unaware of these issues when using this kind of video.[61] Sheridan summarized the challenges: "Television news and newspapers have yet to grapple with the implications of (a) how to monitor this stuff every day because there's a lot of it, (b) how to prioritize it editorially, and (c) how to then distribute it or tell a story around the content itself."[62]

Although there have been significant improvements in journalistic handling of eyewitness videos over the past few years, issues around labeling

and crediting continue to pose challenges: navigating the growing reposi-
tory of online videos through standardized editorial procedures, meeting
the increasing demand for technical skills to assess videos, and balancing
professional journalism standards with the emerging aesthetics and ethics
of the unfolding shape of eyewitness reporting.

These current responses to visual technologies are a repeated performance
in journalism.[63] Although manifested differently, discourses of resistance in
the journalistic community previously characterized the rise of newsreels,[64]
the prominence of photography,[65] the ascent of TV,[66] and the advent of so-
called citizen journalism.[67] Seen as inferior to words, each visual tool was
perceived as a threat to the esteemed, fact-based, and impartial journalis-
tic mode of storytelling. Thus, the four central moments related to images
in news were turned into challenges for journalists, rearranging boundary
markers and questioning previous notions about professional membership.
Each moment eventually expanded the professional definition of journal-
ism to accommodate the newly created roles in newsmaking.

In today's context of eyewitness video, open-source investigation is slowly
emerging as a new genre of journalism, although there are few journalists
trained to do this work. Entrepreneurial news agencies such as Storyful—in
its initial iteration (i.e., before its purchase by News Corps)—teams such as
Bellingcat, nonprofits such as Eyewitness Media Hub and First Draft, and
human rights collectives have been not only at the forefront of this field
but also central to its development. They were, after all, the first to experi-
ment with new verification techniques and investigative processes. More
recently, following in the steps of the *New York Times*, ProPublica is also
setting up a visual-investigation unit. In the United Kingdom, the BBC and
Channel 4 have also begun to conduct such work.

These changes are different from previous visual developments in jour-
nalism, though, because of the emergence of collaborative networks and
cross-hiring patterns with the human rights community. For example, Sam
Dubberley of Eyewitness Media Hub is the new special adviser to Amnes-
ty's Citizen Evidence Lab, founded by Christoph Koettl, who now works
for the Visual Investigations Unit at the *New York Times*, which in turn is
headed by a former Storyful staffer. An alumnus of Amnesty's Digital Veri-
fication Corps program also works for this unit, which has collaborated on
different investigations with Forensic Architecture, among other organiza-
tions. BBC Africa collaborated with Amnesty and Bellingcat on its Peabody

Award–winning video report in 2018 on extrajudicial killings in Cameroon. Human rights collectives are thus becoming recognized as visual experts working within and alongside the spaces where this new genre of journalism is starting to flourish. This shifting relationship between journalism and human rights work can be situated within the broader blending of news and activism in the visual field.

Produced outside of traditional news structures, eyewitness videos cut across the top-down and bottom-up currents in the mediatization of conflict,[68] adding more layers of complexity. Considered most valuable in times of crisis, eyewitness videos are important for another reason: they overlap with activist spaces. The conflict in Syria, for example, sheds light on the interplay between activism and reporting, a distinction often blurred in the co-optation of eyewitness videos to bear witness to events without journalistic presence.[69] In the words of a Reuters reporter, "activist videos have really formed a foundation of the reporting that comes out of that story."[70]

The ubiquity of eyewitness video, then, has brought activist publics into a direct conversation with mainstream journalism. Contrary to journalists, though, human rights activists have long claimed a level of mastery over the evidentiary and conceptual qualities of images. As the previous chapter discussed, using images as tools of evidence gathering and activism has a long history. At the turn of the twentieth century, photography was used, for example, to document and condemn colonial brutalities in Congo, yet photojournalism was still not accepted as a form of journalism.[71] Human rights collectives have borrowed from and built on this tradition of visual human rights activism.

Human rights staffers think of eyewitness video as a valuable tool: it is just "like any other form of evidence, really."[72] Similarly, Josh Lyons, a satellite image analyst, told me: "Human Rights Watch has always had an omnivorous approach to research and data gathering, so whenever there was an available video, it would have always been used and absorbed whenever possible. . . . The obvious fact is that citizen journalism has always existed. It has simply been transformed with the new technology. But this is not a qualitative change. It is a quantitative one in the diversity, the capacity, and the frequency of materials."[73] The quantitative shift is significant because video is becoming the strength of visual investigative work.

The common understanding is that one eyewitness video can never tell the story. For Robert Trafford at Forensic Architecture, "in the face of a set

of fragmentary pieces of evidence—when fragmentary information about the scene or sequence of a human rights violation is all we have—what is critical is a space, digital and intellectual, in which to combine and unite those fragments, and to understand the relationships of space and time between them, and the causalities, necessities, and thresholds that emerge from those relationships."[74] In other words, the multiplicity of (even fragmentary) video perspectives, when corroborated with other data, is what helps human rights investigators establish the occurrence of an event.

Situating eyewitness videos as part of the latest iteration of evolving visual practices, Amnesty and HRW were quick to expand the responsibilities of their satellite-image analysts and crisis-response units to accommodate for the relevance of eyewitness video to human rights work. Amnesty started training its new staff in video-assessment skills, believing that "you will not have in a few years from now [the] traditional human rights researcher who only does interviews and then somebody like me who verifies YouTube videos. . . . [Staffers] will have to learn this skill because if they don't have that skill, then they are not employable. It's as simple as that."[75] To respond to the growing need for this kind of work, HRW set up a dedicated open-source investigative unit in 2019.

By fully embracing evolving visual practices, human rights collectives have taken on a prominent role in today's highly visual information environment, claiming expertise deemed relevant to contemporary journalism, too. In particular, WITNESS considers itself among the leading human rights collectives who took the role of eyewitness video seriously early on, a belief deeply engraved in the organization's founding story: George Holliday's amateur recording of the police brutality against Rodney King. This incident epitomizes the different views toward eyewitness visuals held by journalists and human rights activists. Although the Holliday tape was central to the widely covered news story—performing the eyewitness function for journalists who were absent from the scene of the incident—it did not alter journalism's thinking about the status of images. Journalism instead continued mostly to relegate eyewitness images to the realm of entertainment and tabloids.

According to one journalist at the time of the King incident, eyewitness images were sensationalist, valuable in local news only when depicting "fires, car crashes and other minor disasters."[76] Popular shows such as ABC's *America's Funniest Home Videos* and NBC's *Unsolved Mysteries* were

quickly labeled "pseudo-news shows . . . sensationalizing TV news, with more emphasis on moral disorder and a leaning toward the subjective."[77] In 1993, the documentary *Video, Vigilantes, and Voyeurism* on the British public-service station Channel 4 framed eyewitness videos as good for ratings.[78] A staffer at the Poynter Institute for Media Studies worried: "It's hard enough for journalists to monitor the work of other journalists, but when you add to that the work of amateurs, the situation becomes impossible."[79]

WITNESS, in contrast, interpreted the Holliday tape as a game changer for human rights practice. Since then, it has sought to develop and maintain verification and ethical standards for eyewitness videos. It built the human rights channel the Hub as a repository of online human rights videos in 2007, not long after the launch of YouTube in 2005. The goal was to advocate "for a new global standard for human rights video online."[80] According to the Hub's manager at the time,

> It is very clear now that we were doing journalism. . . . We were trying to gather video from around the world, wherever it came from, and then place [a] metadata frame around it. We needed that metadata to reflect the kind of human rights values and challenges that we were trying to wrestle with at the time. We were [among] the first people to do this. Nobody had ever done it before. Most people told us that we were either irresponsible or going to fail terribly. . . . We were juggling a lot of [factors] around that, trying to understand how this kind of video could be used. Most people were pretty dismissive of it.[81]

As traffic gravitated more toward social media platforms, WITNESS was quick to partner with Storyful and curate verified eyewitness media on the Human Rights Channel on YouTube in 2012, which was eventually folded into the Media Lab. Declaring itself one of the pioneers in approaching eyewitness video with methodological rigor and ethical sensibility, WITNESS has positioned itself among the key groups shaping video standards. This specialty is considered of utmost importance for navigating visual information online. Staffers see their ability to provide guidance and to participate in conversations about the role and shape of news images as important because "citizen video is becoming a necessity for [journalists], as it has always been [part] of our focus."[82]

The ascendancy of eyewitness video has thus thrown into sharp relief pressing questions about evolving visual news norms to which journalists have been slow to respond. This tardiness, however, has opened new opportunities for human rights collectives to tap into the culture of journalism

by shaping video activism and eyewitness reporting in ways that seem to fit the parameters of journalism. Human rights collectives not only produce videos that appear in the news but also develop measures and advocate for best practices in eyewitness video usage for investigative purposes and as a mode of news relay.

### Shifting Expectations about Models of Information Relay

As actors who have traditionally been excluded from journalism partake in the production and dissemination of news, questions about the role of journalism in society emerge yet again. "Multimedia is heavily influencing the journalistic ideology."[83] Enduring attempts to separate news from opinion, facts from perspective, reasoning from imagination, and deliberation from emotional engagement are turned on their head as news is increasingly shaped by emotional and subjective modes of storytelling.[84] Images are central in those efforts.

What we are seeing is a tension between journalism's gatekeeping and advocacy paradigms, a tension that has been at the heart of US journalism since the American Revolution.[85] The view that journalists need to take a stance when covering injustice has taken on various names over the years: "the fourth estate,"[86] "journalism of attachment,"[87] "peace journalism,"[88] "committed journalism,"[89] and "human rights journalism."[90] Underpinning this call is a critique of objectivity, "the supreme deity" of journalism,[91] which is understood to be reinforcing the status quo and enabling the moral failures of societies, in particular Western democracies. Unable to reconcile this tension, journalists have struggled to sustain their legitimacy as authoritative storytellers.

The advocacy model has acquired new momentum through the global rise of civic journalism as "the product of a growing consciousness among civic groups about the importance of media in the construction of public problems, and the need to approach the press as a tactical ally."[92] Social movements, activist groups, and NGOs have been fundamental to this development. Advocacy journalism thus rises as a set of viable tactics for news visibility among civil society and blends with the various permutations of eyewitness reporting. Human rights collectives such as HRW, Amnesty, and WITNESS embrace advocacy journalism as a vehicle for human rights agendas and a platform to influence policy reform. Bairin worked for CNN for twenty years as a field producer reporting on conflicts and breaking

news before moving to HRW: "I was always in the field covering wars and stuff, and I got tired of risking my life to do a stupid show. . . . [Making] the end product something really worthwhile is more interesting."[93] Woolwich expressed similar sentiments: "I worked for . . . thirty-six years in broadcast television journalism and worked for ABC News, for the BBC, Channel 4, and lots of other people . . . making documentaries or, rather, hard-hitting investigations. Only two stories I've ever done in that role have ever effected any change whatsoever. Using video in an organization like Amnesty International can effect change every day."[94]

The activist ethos and the growing resources of global human rights collectives allow former journalists to use their skills while devoting more time to stories with clear advocacy goals, which are perceived as more impactful than news. Before becoming the communications director at HRW, Daly worked as a journalist:

> I was in Bosnia, which was a defining experience for a lot of journalists in my generation. And it was the place where, I think, a lot of us really felt . . . that because of us there, they really can't [say] that we didn't know. No political leader can [say] he really didn't know what was happening in ways they did in previous conflicts, which was also a lie. But in this case it was clear that everybody knew what was happening. So we can proudly say that, but to what end[?] . . . There was a long line between the stories and the action that was finally taken, and, I guess, I wanted to shorten that line.[95]

The rise of advocacy journalism among human rights collectives is clearly implicated in their recruitment of former journalists,[96] who take on positions in the communications, multimedia, and news units.[97] Padania remembers being surprised that the job description for the person replacing him at WITNESS incorporated journalism because he had thought of journalism and human rights work as two distinct practices.[98] This trend suggests a significant change from two decades ago, when being a legal professional was the most desirable profile for human rights workers.[99] As human rights collectives grow, they appropriate and develop new skills, strategies, and tactics to remain relevant as a community that fights for human rights.

The unease with advocacy in journalism and the new hiring trends in the human rights community have helped human rights collectives—whose information work is on the rise—claim a home for advocacy journalism. Human rights organizations embrace it as part of their mission "to bear witness in order to change,"[100] and human rights work can be packaged as

news segments through the skills former journalists bring to the table. The tension between the gatekeeping and advocacy models not only resurfaces but comes even more to a head around visuals, which introduce additional layers of anxiety into the core of journalistic identity.

The surge in viral deception at times of record low public trust across institutions of government, business, and media around the world challenges long-standing institutional authorities and assumptions about the parameters under which deliberative democracy works. The inability to reconcile the presumed tensions between different modes of knowing—reason and emotion, judgment and imagination, word and image, fact and story, politics and art—is turned on its head as emotions, opinions, and stories account for what draws people to viral deception. Thus, the unfolding information disorder not only questions whether and how democracies work but also cuts to the core of institutional assumptions about appropriate epistemologies and modes of citizen engagement.[101] Indeed, scholarship on mis/disinformation and deception finds videos to be better than text at correcting fabricated information.[102] The concern, though, is that video can also be overtrusted even when it is false.

Here, too, human rights collectives have proposed solutions. WITNESS, for example, has spearheaded efforts to think through the possible impact of "deepfakes" and other forms of artificial-intelligence-generated synthetic media, hosting workshops and publishing reports with other groups such as First Draft.[103] WITNESS program director Sam Gregory's motto, "prepare, don't panic," was echoed by staff members in my interviews with them in 2019. Forensic Architecture has written extensively on how the rigor and transparency of open-source investigation and its correlated ethos of open verification of multiple videos from diverse sources can be good ways to combat the possible harm of deepfakes.

The current set of circumstances in journalism has moved video away from being an afterthought in news production to the center of practice, complicating a centuries-old resistance to acknowledging the status and role of visuals in news on their own terms. The rise of video thus embodies a contradiction: it emerges simultaneously as a solution and as a problem for journalists. In contrast, human rights collectives have embraced the primacy of video and its correlated practices, thus gaining a firmer foothold in journalism. From shifting concerns that the news media underreport human rights stories due to a lack of accompanying audiovisual materials

to growing anxieties over the ability of news media to properly assess and use online videos with a human rights focus,[104] human rights collectives' video practices are becoming more prominent in journalism. The following section scrutinizes the practices, with their related strategies and tactics, that help human rights collectives model journalistic work through the proxy profession's emerging legitimacy.

## Human Rights Collectives as Journalists

Human rights collectives often compare their methodological commitments to those of journalists. "We share a lot of the DNA of journalists. . . . We're trying to get as close to the truth as we can. We're trying to build up as comprehensive a picture of what happened as possible, but often we have the resources to go further."[105] Moreover, they position their work on par with bona fide journalism:

> We enter the field with open minds and open notebooks [but] without preconceived judgments or conclusions about who is responsible or how bad things are. . . . We may have some leads, but, really, we listen, and we collect information in a neutral way; . . . we also present the information in a fair way. We are accurate in what we say, but then we don't stop there; . . . we just spend more time, and we interview more people, and the investigation is more in depth, . . . [although] we really look only at a very specific basket of issues. . . . It's a lot of the same issues as journalism because really the best journalism is about the abuse of power.[106]

The advocacy stance has typically been seen as contaminating impartial news reporting. Driven by Western iterations of modernity, professionalism in journalism has insisted on objective reporting to safeguard journalism practices, thus qualifying advocacy as something to be avoided. Yet as Lorraine Daston and Peter Galison have famously reminded us, objectivity is an aspiration to "knowledge that bears no trace of the knower" and emerged only in the mid–nineteenth century.[107] The very premise of how journalists claim their authority through eyewitnessing,[108] a process predicated on someone being there and thus knowing what happened, makes it impossible to eliminate the traces of the knower. Obviously, both gatekeeping and advocacy are messy, reflecting the complexity of journalistic practice. Blanket statements against advocacy can conceal the intricate circumstances that make investigative work on the abuses of power possible in the first place.

Human rights collectives strategically situate their work against this background. Being able to lay claim to journalism's methods is a way of rhetorically validating their own information work. It is also an entry point from which to assert the necessity of their skills in offsetting some of the deficiencies of mainstream journalism in keeping the public informed on international affairs. Declaring that human rights collectives are able to disseminate news content on a par with journalism lends their work "an aura of legitimacy," one of journalism's key facets.[109] The advocacy journalism actively embraced by human rights collectives seeks to present itself as a vital force that helps the public make sense of global suffering when journalists are struggling to do so. In other words, human rights collectives are developing strategies and tactics for video activism to better situate their work as news segments.

Although human rights encompass a wide spectrum of issues, the ones that get most publicized are typically those framed around war, conflict, physical violence, and abuses of power. These issues speak to the core of journalists' aspirations when defining their professional identity. John Hartley identifies journalists' preferred professional ideology as one of violence: "The good journalistic watchdog fights for stories that someone doesn't want told; the best stories are those that expose violence and corruption concealed within seemingly respectable institutions, from tin-pot dictatorship to children's home."[110] Similarly, the image that human rights collectives have promoted about themselves is that they are fighters for human freedom and dignity, shedding light on the darkness in which abuse and violence happen. A former investigative journalist at Amnesty drew this parallel: "Standing up for the underdog, the individual against the rich and powerful people, holding people to account, challenging power, doing it for the benefit of ordinary people who don't have a voice."[111] The ability of human rights collectives to assert a public authority on global instantiations of violence can thus be seen as an attempt to raise their profile as critical figures bringing people's voices on human suffering into the public realm.

As the unfolding shape of human rights work speaks to the heart of journalism's identity, it is worth asking how human rights collectives place their work as news stories. Press releases, dispatches, and news briefs have been a large part of the efforts "to operate systematically in the vacuum left by commercial media."[112] Human rights collectives that operate solely on the written word are perceived to be at a loss because they are missing

an opportunity to tap fully into the channels through which public opinion is formed. Andrew Stroehlein, the European media director at HRW, told me that information accompanied by a visual piece is more likely to attract public attention and to be shared by journalists: "You've just got to build up the visuals."[113] A former media archivist at Amnesty echoed that view: "There are way more people who will watch a five-minute video than [people who] will read a fifty-page report."[114] At the same time, video meets journalism's needs for international news content.

To better understand how human rights collectives permeate journalism's visual practices, I address the strategies and tactics for video production, investigation, verification, and training that are giving rise to the proxy profession in journalistic contexts.

### Video Production

The strategies and tactics for video production vary by human rights collective. Both HRW and Amnesty have multimedia newsrooms in charge of video production, which involves stand-alone products and clip reels that can be broadcast by news organizations. HRW's Media Center and Amnesty's Asset Bank are online sites that serve as repositories of images, audio and video files that news organizations can use. Amnesty's audiovisual unit is in charge of all forms of videos the organization produces—from news segments to campaign and fund-raising videos. HRW has split its multimedia unit into news (short video projects) and advocacy (longer pieces with cinematic qualities). Both organizations believe that video increases the coverage they get in mainstream news media.

HRW modified its approach from providing clip reels to news agencies to producing original videos. At first, it selected, on average, twelve to fourteen issues to address through video. The worry was that video production would take away from funds allotted to field research and investigations. As a result, HRW sometimes needed to secure grants for video work. In 2014, for example, it turned to Kickstarter to raise necessary funds for a project. Soon afterward, the group decided to allocate special funds for video production as part of its annual budget, implementing a new internal policy mandating that every report needs to be accompanied by a video. Journalism's need for video content is centrally implicated in this shift: "In the most basic way, TV won't cover your story without video . . . but now you added the fact that everybody wants video, so you're more likely to get print

coverage if you can provide video. . . . It's filling a hole that's being created. People now expect video more and more."[115] The new policy illuminates the elevated status of video within HRW and highlights how this collective regards video as a valuable asset for its goals: "Anything that's visual works better."[116] This assessment reiterates the assumptions that video accounts for the greater prevalence and prominence of HRW in target news outlets that staff members have noted.

HRW places a great emphasis on producing videos that look like stand-alone news segments. The core philosophy is that everything HRW produces for the media "should look as much as possible like journalism."[117] Staff members approach video with the same rigor they apply to doing reports, aiming for the kind of quality that appears to fit the parameters of journalism:

> [The] videos need to have [the] same qualities [as the written reports]. They need to be exclusive in some ways, either because we are offering something . . . nobody has seen before—like the interviews we did with defectors from the Syrian army . . . before anybody had spoken with those people—or because we want [our] videos to be seen and respected by journalists. How do you do that? Stylistically, [they] must be like a news piece. We just show the evidence, [which] has exclusive quality either because the element is exclusive—first time you see it—or because we curated a series of existing public videos that are not exclusive, but . . . we curate this existing material and present it in a new way. . . . You need to do something new in a kind of newsworthy way.[118]

By paying attention to exclusive footage, human rights collectives adopt a journalism strategy to tell a story of injustice, playing to journalistic norms. Exclusivity, then, becomes a guiding principle for video production because it helps human rights collectives reach the news media.

Amnesty also provides footage to news organizations on a regular basis, either through its produced videos or through mobile footage recorded by its research teams during investigations. Amnesty equally emphasizes exclusive footage: "The pictures have to be arresting as well as relevant. We're always looking for footage that hasn't been seen before. We don't want to tell a story rehashing footage from CBS or AP. We want to be able to tell a story by using compelling and unique footage."[119] The determinant for which stories are turned into video projects is not necessarily the severity of the human rights violation but the perceived newsworthiness of the available material. The former audiovisual head instructed his team to look for "fresh stories": "I say to people in the AV [audiovisual] team as they go out to other countries on mission . . . [that] if they find themselves

standing next to a news crew, they're in the wrong place. . . . We are only of value in news terms, apart from when reports come out, in the area where we might come across something that is newsworthy mainly because the more established news gatherers are not there." He elaborated:

> Personally, if I see another refugee living in a tent in Syria, you know, I will turn away. There is a lot of compassion fatigue. We had seen it all before, heard it all before, and we have an attention span of a gnat. You need to attract people to stories and find a different way of telling the familiar in a way that might engage them. So instead of just interviewing endless victims of torture who all basically say the same thing: "How they stuck needles under my fingers or they waterboarded me, you know, they hung me up by my toenails." All horrendous, of course, but after you've heard those sorts of stories, it's very difficult to have the same sort of empathy that you would the first time someone had told you the story. So you have to start thinking in totally lateral ways about the issue and how to engage people in it. So you might say, for example, let's not talk to the tortured; let's go and interview the wives of the torturers.[120]

Human rights collectives perceive the task as being either to visualize an unknown story of injustice or to paint a new light on a familiar story central to their video strategies.

The focus on exclusivity underscores how human rights collectives select stories based on assumptions about audiences, taking on pragmatic positions vis-à-vis traumatic occurrences. The selection is not about the authenticity of the violation or the testimony as much as it is about its perceived news value—Has the story been seen or heard before? In taking this approach, human rights collectives illuminate an aspect of sensationalism, a key contradiction in news epistemology from which journalists have tried to hide.[121] For Kevin Barnhurst, "the sensational lurks everywhere in efforts to make 'news' from what occurs,"[122] but modern news has dismissed it as a tabloid manifestation. A look at the human rights community's quest for "newsworthy" stories that play through the mainstream news media and the ease with which journalists seem to respond to this content signal that sensationalism is at the heart of how news engages its viewers: even hard news is interwoven with moral and emotional judgment.

Attempts to maintain control over how journalists use human rights footage encompass not only the packaging of video as a news segment but also the restrictions on the kind of footage news agencies can use. HRW, for example, provides finished videos and a shot list with clips.

> We don't want [journalists] to go, "Oh we need some shots of Syria, let's go and
> see if Human Rights Watch has some street scenes of Damascus." We aren't going
> to have that. We're only going to have very specific [material] . . . because we are
> not a footage agency. . . . We don't want people to use our footage to tell another
> story. . . . It's all free, they can steal it, but [they should use it] to tell our story
> and not something else. . . . We want them to use only stuff that's important, so
> we give them less. . . . You're in control [of] what they are going to use by giving
> them less choices.[123]

Short lengths are thus preferred because tightly packed videos or clips are
perceived as better in reinforcing HRW's stance on an issue and allowing it
to maintain its authority over the content.

Video activist tactics are often flexible and improvisational. When rely-
ing on tactics, Amnesty produces videos with different aesthetic features
that accommodate the particularities of the situation. The tactics are "often
my own, what's described as a feeling in the water. . . . I will decide on the
basis of what we have: Is it strong, is it newsworthy, could it effect change if
we gave it time and space?"[124] HRW, in contrast, initially insisted that all of
its videos should look "like a news piece,"[125] adopting journalistic strategies
instead. It produced mostly short videos, normally around five minutes. In
the past few years, however, HRW has further diversified its video produc-
tion to appeal more to general audiences online (a topic of chapter 5).

Both HRW's and Amnesty's videos that are aimed at news outlets fall into
two general categories: (1) original content, which usually features testimo-
nies of survivors of human rights abuse, interviews with field researchers,
and other supplementary evidentiary information; and (2) curated content
made up of a compilation of contextualized eyewitness videos and survi-
vors' and researchers' testimonies.

For example, HRW's widely cited report on Syria's torture centers was
released with a video, *Syria's Torture Centers Revealed*, in July 2012. It includes
a series of sketches demonstrating the torture techniques in addition to per-
sonal testimonies of tortured individuals and defectors from the Syrian army
who have never been heard in public prior to the HRW video. A former
detainee testifies in darkness so that his identity can be concealed. Only a
backlight distinguishes him from the black background. He also describes
the horrific pain in distorted voice for full anonymity (figure 3.1). A draw-
ing of a torture scene (figure 3.2) shows up on the screen as he explains:
"*Shabeh* is a technique when you are hung by your arms and suspended in
the air. Of course, it's painful. It degrades our humanity. But they have no

**Figure 3.1**
Screenshot, *Syria's Torture Centers Revealed*, HRW, July 2, 2012, https://www.youtube
.com/watch?v=5lr-dcHOtzo.

respect for human beings. They beat us and said, 'You want freedom? You want democracy? Here is your freedom. Here is your democracy.'"

Another torture victim gives an account of his traumatic experiences. He is framed in a shot that shows only his hands. An HRW staffer provides information that contextualizes the testimonies. The video clearly mimics news, and a simple Google search illuminates its widespread use by numerous media outlets, including CNN, NPR, *Der Spiegel*, and news agencies such as Agence France-Presse.[126]

Curated videos combine original content with eyewitness footage. For example, in April and June 2015 Amnesty released two videos on Boko Haram's atrocities in Nigeria. Both videos showcase survivors' testimonies, which are situated within a broader sociopolitical context through the information provided by Amnesty researchers and a narrator. *Boko Haram's Female Fighters* includes eyewitness videos shot by the perpetrators of violence. It features statements by a researcher filmed against an Amnesty poster along with a testimony read by an actress, a tactic more common in activism than in news that is used to protect the identity of the victim (figure 3.3).

*Stars on Their Shoulders, Blood on Their Hands: Nigerian Military War Crimes* features eyewitness footage of extrajudicial military killings. Reconstructed interviews along with a voice-over narration and statements by Amnesty

**Figure 3.2**
Screenshot, *Syria's Torture Centers Revealed*, HRW, July 2, 2012, https://www.youtube
.com/watch?v=5lr-dcHOtzo.

staff render the graphic footage meaningful. According to a former Nigerian
field researcher who worked on these projects, the "videos were picked up
by international and domestic media organizations. So when [these media
organizations] were covering the launch of these reports, they would often
lead with footage from the press release and from these videos."[127]

The value of eyewitness footage is twofold. On the one hand, when con-
ducting field investigations, human rights collectives encounter images and
videos that have not previously been broadcast or even uploaded online.

**Figure 3.3**
Screenshot, *Boko Haram's Female Fighters*, Amnesty International, April 13, 2015, https://www.youtube.com/watch?v=GwskRNFCAN8&feature=emb_logo.

This helps them provide exclusive materials to news media: "The more compelling stuff that we want to use and look after is the user-generated content because this is the stuff that [our field researchers] receive first-hand. This is the material that I've always been keen to look after, to get into the archives, to make sure we can record everything about it."[128] On the other hand, human rights collectives curate existing eyewitness videos from social media platforms. By navigating the information overflow online, they select and render content meaningful when they embed it as part of a larger investigation.

HRW, for example, curated graphic eyewitness footage shot by hate groups in Russia while engaging in horrific acts of torture against LGBTQ people. One of the eyewitness videos—far less violent than the others—shows police officers detaining LGBTQ activists who have been previously attacked. The footage is intercut with close-up shots of activists interviewed about the systematic hate crimes against this population committed by citizens and police forces. Gleb Latnik testifies about the police's unwillingness to investigate these human rights violations: "I was punched in the forehead, and the bruises descended under my eyes. There was a lot of swelling, one eye didn't open at all. And when I went to the police to submit a claim,

the officers at the station just said, 'That's all right; you're gay, so it's nor-
mal that you were attacked. Why would you need to submit a complaint
against someone? That's how it goes.'" Released right before the start of
the Sochi Winter Olympics in 2014, the video, *Russia: Gay Men Beaten on
Camera*, was widely covered in the news media and reached more than 4.5
million views on YouTube. Its newsworthiness rested on the strategic pre-
sentation of the eyewitness material as investigative work and the tactical
release that seized the public attention on the Olympics as an opportunity
to raise global awareness about this human rights issue. The international
news media broadcast this video widely.

These examples illustrate how curation has ensued as an important com-
ponent of the media work of human rights collectives. "Out of this huge
amount of information that's going through YouTube and other channels,
we are one of the organizations that can sort of filter it and determine what's
legitimate," the HRW European media director told me.[129] By embracing
curation, human rights collectives take on the redaction function of jour-
nalism, which Hartley predicted.[130]

As more people exercise their ability to participate directly in the infor-
mation landscape, states Hartley, "the journalist can develop a new role
as one who cuts through the crap," and "such editorial practices [could]
determine what is understood to be true, and what policies and beliefs
should follow from that."[131] Hartley sees this role as exceeding the repre-
sentative democratic function, moving journalism away from its preferred
focus on "violence" to the realm of the everyday. Human rights collectives
have taken on a redactional responsibility precisely in the context of vio-
lence, sorting through the abundance of online visual information with
a human rights focus, telling the public what is relevant, how it matters,
and what can be done in response. This is part of their repertoire of tactics
as they seek to expand the spaces where human rights stories can be seen
and heard. As their curated videos are increasingly featured on mainstream
news media, embedded in human rights campaigns, or used in targeted
advocacy efforts to institutional stakeholders, human rights collectives are
incorporating and expanding on a role that has typically been perceived
unique to journalists. The redaction role helps them emerge as another rep-
resentative communicative body that speaks in the name of public interest
alongside journalists.

**Video Investigation**

Video has become not only a primary storytelling device but also important evidentiary material that unveils human rights violations around the world. According to Peter Bouckaert, a former Emergencies Division director at HRW, "One of the most interesting developments in conflict zones is the rise of citizen journalism. . . . It presents tremendous opportunity for human rights activists, but it also presents very unique challenges because the only way you can use this material is actually [to] verify its content—when you can strip away the political motivations that sometimes motivate people to take these videos but sometimes also to manipulate them."[132] Human rights collectives were quick to embrace eyewitness video much sooner than did legacy news media. HRW and Amnesty invested early in developing investigative skills to incorporate these videos along with on-the-ground research, testimonies, and satellite images to corroborate evidence and uncover human rights offenses. Highly regarded reports, such as the investigations of the Syrian government's use of chemical weapons and Boko Haram's atrocities in Nigeria,[133] depended on eyewitness footage as an essential evidence tool. The use of eyewitness videos in human rights research is not only a common practice but also an ongoing area of investment, as evident, for example, in HRW's new unit dedicated to open-source investigation.

Human rights collectives also spoke publicly early on about their use of eyewitness videos, elaborating on how they would not take visuals at face value but would apply vigorous assessment techniques. This arguably discursive tactic has helped them claim the status of visual experts. According to a former field researcher at Amnesty, "Any video that we use as a form of evidence is treated like any other form of evidence. So we would never base findings on only one witness testimony or only one photograph. For any form of evidence, we make sure we are able to corroborate what we get from that source with multiple independent sources. So, in that respect, [eyewitness video] is quite similar to the rest of our work."[134] In other words, eyewitness videos are treated on their own terms with the same rigor as other evidentiary materials. Forensic Architecture's methodological explication is instructive here: eyewitness videos need to be authenticated, a process that involves both a vertical dimension, or deep investigation of the video itself (e.g., composition of pixels, analysis of any available metadata), and a horizontal dimension, or determining lateral relationships between different sources of evidence.[135]

WITNESS, although different from HRW and Amnesty in that it does not conduct its own investigations, has taken a key role in the eyewitness video landscape over the past two decades, insisting that it excels at journalism. Bair, a founding manager of the WITNESS Media Lab, the latest iteration of a number of curatorial platforms for eyewitness footage, told me:

> What we do is pretty much journalism. It's reporting. [It's] the same [thing] I would do if I were reporting as a journalist and received information from a source I would want to look into. . . . I can't just take this source—especially if it's an unknown source—at his or her word. What other information can I find to corroborate what that person says is true? Is there other information that I can find on it? How can I judge the reliability of this source? The consistency of this source?[136]

Newsrooms have been slow to tap into the potential of eyewitness images for investigative work. As the human rights community was conducting key visual investigations in Syria, Rina Tsubaki from the European Journalism Centre told me that journalists at the time were often unaware of the possibilities that eyewitness footage could offer when used to gather evidence or corroborate information.[137] They instead opted for familiar practices, "looking for the content that fits into the story" but not realizing how they could use video effectively on its own terms.

More newsrooms have more recently embraced open-source investigations. Yet the underemployed value of eyewitness images by journalists enabled human rights collectives early on to write prominently, alongside a few journalists from highly regarded news outlets and entrepreneurial news agencies dealing with these issues, on how to assess visual evidence. For example, Amnesty and WITNESS staff were featured in the two-part publication *Verification Handbook for Investigative Reporting: A Guide to Online Search and Research Techniques for Using UGC and Open Source Information in Investigations* and its predecessor, *Verification Handbook: An Ultimate Guideline on Digital Age Sourcing for Emergency Coverage.*[138] The inclusion of human rights collectives on such platforms helped solidify their profile as specialists on images of suffering that permeate social media. They became the go-to experts on how to filter through the noise on social media and shaped the standards used to recognize and authenticate what is of news value, editorially speaking. The recognition of their expertise in the journalistic community is further evident in the hiring trends discussed earlier.

The financial struggles in journalism have also been implicated in the rise of human rights collectives as visual experts. Although verification

of eyewitness footage is in many ways traditional journalism with a new technical layer, the process is costly and time-consuming. My interviews with human rights staffers attest to this issue. "You are applying the same techniques of evidence verification, although with some additional technical expertise."[139] The technical skills demand financial investment in terms of resources and time: "It does put a huge burden and requirements onto human rights investigators to do due diligence at a technical level that was never required of a traditional human rights group before. And, I think, that's one of the reasons why we have been expanding our technical capacity to work with video and to work with satellite imagery, as the two prominent examples."[140] In response to rapidly diminishing numbers of newsrooms and newsworkers, journalists at first opted for existing services, such as traditional news agencies, which also struggled with video content, or places such as Storyful. Then they turned to human rights collectives for free content. The public claims to expertise in this area exemplify a key tactic through which human rights collectives have sought legitimacy for their video investigations.

## Video Verification

When Amnesty launched its Citizen Evidence Lab in the summer of 2014, the recommended reading list included articles pointing to the legacy news media's failure to properly authenticate eyewitness videos. This was an important tactic to establish the credibility of human rights work in this area. Christoph Koettl, the lab's founder, told me that "media outlets make mistakes, but they don't correct them. They move on to the next story. That's pretty outrageous, I think, because that should be a practice: if there is a mistake, which happens, then correct it."[141]

At the time, prominent examples of news media's mishandling of images posted on the lab's website included the *New York Times* incorrectly dating a front-page screenshot of an eyewitness video of Syrian rebels executing unarmed government officials in 2013 and the BBC's story on a massacre in 2012 showing a picture taken a decade earlier in Iraq. The news stories surfaced during a congressional debate about potential US military intervention in Syria and an upcoming UN Security Council resolution on the crisis. Therefore, when promoting their verification expertise, human rights collectives maintained that they could offer an important corrective to erroneous news reports. Koettl argued for the necessity of video-verification

measures: "Novel approaches to fact-finding are needed. The urgency of this statement cannot be emphasized enough, as videos or images are regularly distributed with incorrect contexts, including in major news outlets."[142]

The Citizen Evidence Lab was launched to help fill the need for verification mechanisms in human rights investigations. In its original instantiation, the lab's website included a step-by-step guide and detailed checklist for how to assess sources and content (figure 3.4) and how to account for professional

**Figure 3.4**
Screenshot, "Assessing the Source," Citizen Evidence Lab, Amnesty International, n.d., https://citizenevidence.org.

standards to ensure protection of the people filming or being filmed. The You-Tube Data Viewer section (figure 3.5) included a free tool that allowed for extracting hidden data, such as upload time and thumbnails, from online videos. Assessment exercises (figure 3.6) offered an opportunity to practice these skills, including performing a reverse-image search to find possible previous versions of the same imagery, tracking the original uploader, extracting exact upload time, and determining the location where the video was shot using open-source geospatial platforms. The website's toolbox and reading list provided resources and information on video assessment, including suggestions for various tools and technologies that facilitate verification processes.

Although the lab was established to address the needs of human rights investigators faced with the profusion of eyewitness visuals, it was soon appropriated as a resource for journalists as well. The Nieman Journalism Lab featured an article with the title "Amnesty International Launches a New Site to Help Journalists Verify YouTube Videos."[143] The Poynter Institute stated, "Amnesty International is in the verification game and that is

**Figure 3.5**
Screenshot, "YouTube ID Identification," Citizen Evidence Lab, Amnesty International, n.d., https://citizenevidence.org.

## Citizen Video Assessment - Exercise 1
Systematically assessing citizen video from YouTube for use in human rights research and advocacy.

0%

## INTRODUCTION

This excercise is intended to learn about the basic steps of assessing citizen video. Using the exercise video below, and our step-by-step guide, it is intended as an introduction to validation techniques and tools.

At the end of the excercise, students will be able to **download an answer key** that can be compared to the answers provided by the student.

Please note that this exercise is geared towards YouTube videos. However, the basic steps and methodologies used here can be applied to any video. For additional help, please click the (?) for screenshots, or the "How To" link for detailed tutorials provided by the Citizen Evidence Lab.

**Expected completion time: 30-45mins**

Before continuing, please open the exercise video in a new window.

## Figure 3.6

Screenshot, "Citizen Video Assessment," Citizen Evidence Lab, Amnesty International, n.d., https://citizenevidence.org.

good news for journalism."[144] The noticeable lack of standards around the use of eyewitness images in news—the failure to authenticate a particular video, label it as such, acknowledge a source, and give credit—enabled human rights collectives to emerge as important visual experts, spearheading the development of verification mechanisms and best practices for navigating the visual-information landscape online. The efforts to publicly disclose the procedures that human rights collectives use to verify eyewitness videos are an extension of long-standing activist tactics through which this community has sought to uphold credibility and affirm their integrity.

In a sense, human rights collectives became codified as public experts on eyewitness imagery because of journalism's failure to face the challenge. "You'll be surprised talking to public broadcasters, to international news agencies, that they don't have any methods," noted a staff member at the European Journalism Centre.[145] This lack of standardized practices around eyewitness video suggests that journalism continues to struggle with visual modes of information relay. Human rights collectives have been quick to point to the lack of editorial procedures evident in the workflow of news media and ensuing reporting. Bouckaert, formerly at HRW, was cynical regarding how eyewitness images slip into news: "I always chuckle when media talk about unverified videos because it's kind of a lazy shorthand because there are ways in which you can verify the information; there are ways in which you can even contact the very activist who uploaded the video to ask them more questions. It just takes doing your homework like with any other kind of reporting that you do."[146] Implicit in this statement is the notion that human rights collectives examine eyewitness media as thoroughly as they do any other evidence. Journalists, in contrast, fail to do their homework on such media. A verification expert at WITNESS expressed a similar opinion: "You need to be very transparent about what you understand to be true and what you simply don't know and can't say. We see blatant and frequent errors in news media in using citizen videos that were not what they purported to be or were from years previous or were just completely misinterpreted. They didn't take any of the steps to either verify the video, obviously, but also to provide readers with an understanding, with the clarity to understand what we don't know."[147] Pointing to journalism's erroneous reports has thus served as a discursive activist tactic, enabling human rights collectives to publicly validate their work and situate it as a corrective to journalism's inability to maintain visual news standards.

Before moving to the *New York Times* in 2017 to work for the Visual Investigations Unit, Koettl reflected on his work at Amnesty:

> I'm not a journalist, so I don't want to make that claim. It's just so much over-lap. . . . A lot of journalists started using my tools. . . . I suddenly [started to] get more and more invited to journalism conferences, which is interesting to me—to some degree it makes sense because it's the same work. . . . I created Citizen Evidence Lab because there were just no resources. When I started doing training two or three years ago, there was almost nothing there. [At] the first social media training I did, the only resources I had were three blog posts from Storyful. . . . Last year I did a few training [sessions] for traditional journalists. . . . There aren't that many trainers existing in that space, I noticed.[148]

Since this conversation with Koettl in 2015, open-source investigation has grown exponentially, and journalists have improved their work in visual verification. Yet there is still a lack of skilled journalists to work in this space.[149] By contrast, human rights collectives continue to invest in video verification while embracing the values of video activism as a public and collective effort to bring human rights voices to the public realm. In the process, they have claimed marketable sets of skills and taken part in the development of visual news standards.

Modern journalism's long discomfort with human rights activist content is changing gradually in the visual field, and so is the relationship between these communities of practice as journalists sometimes turn to human rights collectives to learn verification skills. Amnesty launched an updated version of the Citizen Evidence Lab in 2019, seeing it again as a public service to both the human rights and the journalistic communities.[150] Moreover, collaborations on visual investigations are starting to emerge, as, for example, between the *New York Times* and Forensic Architecture or between the BBC and Amnesty. A corollary of this development is the emerging role of human rights collectives as image brokers who mediate between eyewitness-content producers and journalists.

The idea behind image brokering is certainly not new. Zeynep Gürsel has looked at the brokering role of news agencies in the process of selecting, describing, commissioning, selling, and arguing for particular kinds of images to appear in the news.[151] Kari Andén-Papadopoulos and Mervi Pantti address the media work of the Syrian diaspora engaged in "cultural brokerage" by connecting protesters in Syria with international mainstream media and helping news media contextualize and translate social media

content about the conflict.[152] What is interesting about the unfolding dynamics between journalists and human rights collectives is the institutional brokerage across these communities of practice long kept separate for the presumed differences in how and why they operate in the public realm.

### Video Training

The broker role is further solidified as some human rights collectives also train activists to navigate the current media landscape. In particular, WITNESS has taken a proactive approach to improving the quality and verifiability of eyewitness content so that it is of better use to news media, legal settings, and political advocacy environments (the subject of the next two chapters). Bair told me, "We need to make sure that what we are seeing, what we are sharing, if we are sharing or using it in a report or in a piece of advocacy, is true."[153] The way to do this, in WITNESS's view, is to equip those using eyewitness videos with the skills necessary to contextualize their material and to train activists and citizens how to take videos that can be of editorial value to news organizations.

WITNESS's Critical and Surge Response program was established for specialized training purposes to teach activists how to document ongoing conflicts or sudden escalations of violence effectively and safely in a way that will appeal to a target audience. In doing so, WITNESS develops and promotes strategies and tactics for video activism that help the content blend with news: teaching people how to "have the skills to report with the integrity of journalism."[154] These programs have been established in Latin America, Europe, the Middle East, and most recently the United States to address the needs of activists involved in criminal justice reforms, immigration movements, and Indigenous rights.

Raja Althaibani, the program manager for the Critical Response program in the Middle East, told me that WITNESS started training in 2012:

> We did it because we were trying to respond to an overwhelming volume of content that was being shared by local activists in Syria, and a lot of the footage was very compelling. But because there is restricted access in the country, no one was really able to verify the content [easily]. . . . You know, the videos are very compelling and provided insight, but they were filmed by average citizens who have never used video with that intent . . . so a lot of the footage was shaky. It lacked context. You couldn't tell whether it is really filmed in Damascus or somewhere else.[155]

The training is intended to raise the overall quality and the evidentiary value of eyewitness videos. Teaching activists how to use videos better positions their footage to compete for news media attention. On-the-ground and online training programs, how-to guides, training videos, and various video tools all emphasize that a video maker should know ahead of time the needs of the intended audience, including how a video should look if its target audience is the news media.

According to Bair, "News media are most likely to pick up on and share [a video] without much information behind it . . . those sorts of videos that in a short period of time shock us."[156] Activists are quick to recognize what gets news media attention. What WITNESS does is help them strategize about how to reach desired audiences. Because credibility is an essential principle guiding human rights work and news production, the emphasis is on how to create videos that are both relevant and verifiable.

> It is actually crucial and important to ensure that your video is verifiable, that whatever you're collecting has . . . enough context and has the information within the video . . . [but] if you're presenting it to a media outlet, you wouldn't necessarily present it with all the information; . . . you technically wouldn't send an entire large video file of an interview. . . . Most of these reports are done in very short and quick digestible ways. And that's what the news is. It's to take serious issues and to . . . communicate them in a way that's very digestible and attracts attention. So you wouldn't include a lot of the extra information that you would typically for [legal] evidence.[157]

By training others, WITNESS disseminates visual knowledge and thus acts as an intermediary between citizens and activists, on one hand, and the news media, on the other. Morgan Hargrave, a former system-change coordinator, situates this role at the core of WITNESS's mission: "We are trying to just facilitate and build capacity" around the various affordances of video in the current media moment.[158]

Other human rights collectives conduct video training, too. In 2018, Syrian Archive trained more than 300 people in the Middle East–North Africa region. Most of the training is conducted in person over a three-day period and involves sessions on best practices in digital security, secure storage of video content, and verification methods and workflows.[159] Videre has been conducting video training since 2008. Such efforts help render human rights video activism appropriate for mainstream journalism.

Part of capacity building has been the development of verification tools so that eyewitness images better fit the requirements of journalism. Over the past few years, for example, a growing number of smartphone-based applications have been developed to address the needs of those who take video on the ground. In 2012, WITNESS collaborated with the Guardian Project on the InformaCam platform, a winner of the Knight News Challenge for mobile media. The platform hosts various apps whose goal is to enhance the reliability of eyewitness video.

Bryan Nuñez, one of InformaCam's creators, claims that "in an age where digital manipulation of images and video is commonplace, news agencies have to contend with the possibility that digitally altered media is being passed off as unadulterated truth."[160] To address this problem, the apps associated with the InformaCam platform enable those shooting video on their mobile devices to capture geographic location, temporal and environmental markers, and motion in a form of securely encrypted metadata, which in turn simplifies verification. Verification apps shape activist involvement ahead of time—an activist must download the appropriate app and learn how to use it before shooting a video. Such apps highlight the strategic process that increases the likelihood of a video's news coverage.

Amnesty set up the Digital Verification Corps (DVC) to train volunteers in the skills needed to verify eyewitness videos and conduct open-source investigations. The program was piloted in partnership with Florida State University at the end of 2013 to set up a network of volunteers who are trained to discern location, time, and source of eyewitness videos. The vision then was to foster a community.[161] Today, the program runs as a network with seven universities: University of California, Berkeley, University of Cambridge, University of Essex, University of Hong Kong, Universidad Iberoamericana, University of Pretoria, and University of Toronto. Sam Dubberley, who manages it, told me that the organizational goals for the DVC are twofold.[162] First, it "helps Amnesty deal with a huge amount of content at scale." The research staff dedicated to a specific country cannot go through hundreds of videos, which is necessary for a rigorous open-source investigation. Amnesty's report and an accompanying interactive website about a US-led campaign in Raqqa, Syria, for example, incorporated DVC's analysis of more than 1,000 videos.[163] Second, Amnesty's partnership with universities is the first such network to train students on video

verification, helping offset the lack of skilled labor in this area. Though the program has been running for only a few years in its current formation, its graduates have gone on to work for news media, other human rights collectives, and the nonprofit sector. DVC is thus seen as a contribution to human rights in general, serving an important public function.

By developing various initiatives to guide eyewitness reporting and nurture a community of activists and practitioners trained in video-assessment skills, human rights collectives are brokering relationships between activists and journalists, shaping human rights video activism in ways that are more likely to get media coverage.

## The Proxy Profession in Journalistic Contexts

This chapter has examined how the ongoing technological, economic, political, and cultural transformations in journalism have facilitated the rise of the visual work done by human rights collectives. Journalism's challenges have opened up opportunities for human rights collectives to use diverse strategies and tactics to tap into the culture of journalism. This development is implicated in the current proliferation of technologies and platforms that elevate the status of video in the information environment. The visual turn in journalism, however, has brought to the forefront journalism's long-standing discomfort with images and its failure to treat them on an equal footing with words. By contrast, visuals are a familiar territory for human rights activists.

Borrowing from and building on this tradition, human rights collectives such as Amnesty, HRW, and WITNESS have embraced advocacy journalism by mastering visual tools for information relay that are essential in today's media landscape. They have been seeking to respond to journalism's deficiencies in international news reporting and its lack of standards around eyewitness imagery. Human rights collectives have thus embraced the values of video activism—as a collective practice with a public function that sheds light on the voices and stories of injustice ignored by mainstream news media—shaping it in ways that play to journalistic norms. The multimedia unit at Amnesty insists that it is important to "professionalize that element of news gathering within our research teams by offering them the training to gather the footage."[164] For HRW, human rights videos "are

supposed to be like a news spot."[165] Similarly, WITNESS believes that activists can report with the integrity of journalists.[166]

Through the efforts to professionalize human rights video activism in ways that fit the modalities of journalism, human rights collectives embrace a proxy profession that helps offset some of journalism's need for global coverage. They partake in the development of verification measures for eyewitness videos, thus consolidating their identity as image specialists. They do so by promoting standards for the proper usage of eyewitness videos, both those standards aimed at journalists (e.g., using eyewitness imagery in news reporting and investigative work) and those aimed at activists (e.g., taking effective, safe, and easily verifiable footage that fits the parameters of journalism).

Michel de Certeau's concepts of strategies and tactics are useful for understanding the unfolding of the proxy profession in journalistic contexts.[167] The proxy profession implements various journalistic strategies (e.g., focusing on exclusive news content) and activist tactics (e.g., taking advantage of different failures of news media) as it engages in video production, analysis, verification, and training. I suggest that the proxy profession is better positioned to expand the range of activist voices in the mainstream news media when it relies on tactics that are improvisational and free from institutional confines and that address a specific set of circumstances. The proxy profession uses tactics for video production, for example, when it documents incidents in countries from which journalists are less likely to report and uses aesthetic features that best fit the story while not necessarily mimicking the standardized formats and looks of news segments. When the proxy profession adopts journalistic strategies, it tends to follow formalized news procedures that prioritize exclusivity (e.g., interviewing the spouses of torturers for the sake of exclusive video content) and thus potentially downplay important human rights voices.

Much has been written about NGO communication—from the skeptical accounts worried that civil society merely imitates corporate media logic to those praising this sector's ability to provide coverage on issues and places that otherwise receive minimal news attention.[168] Powers proposes that we move away from "boon or bane" tropes[169] and instead look at humanitarian and human rights organizations as a double-edged sword. His research shows that these groups expand news coverage, but they tend to appear

more where news media already have an interest in being. The unfolding of the proxy profession in journalistic contexts confirms these findings, cautioning that the aspirations for professional legitimacy may be causing human rights collectives to play too much to the geopolitical dynamics that have long been engrained in how Western media cover international news.

Although journalism struggles with crumbling reputation and trust, economic hardship, slow adoption of visual technology, and unresolved tensions about models of information relay, and even as journalists feel that the business of journalism is broken and other actors engage in news work,[170] "a commitment to the ideology of journalism remains firmly in place."[171] In line with Powers's research,[172] this chapter has shown how former journalists help diffuse news norms in the human rights community, a result of new institutional blending.

The values of video activism, though, also morph with news, not only inserting human rights activist angles into certain news topics but also bringing the visual expertise of human rights collectives into the culture of journalism—another aspect of the new institutional blending. A commitment to open-source investigation as a new genre of journalism, as a human rights practice, and as an open-verification model for combating viral deception has emerged in the process. With the visual field becoming a central meeting point for competing flows of information, an ability to assert jurisdiction over visuals of suffering through the proxy profession lends human rights collectives the integrity to speak about global injustice on public platforms.

The representative and redaction functions of journalism remain important. What is changing is who can claim these roles alongside journalists and to what effects.

# 4 Human Rights Video in Court

The profusion of visual technologies and platforms is changing the courtroom, an environment whose authority, like that of journalism, has long rested on the power of words. Since the arrival of photography in the nineteenth century, legal doctrines have both contested and legitimized visual evidence. The presumed ability of visuals to communicate what words alone cannot is what drives and constrains the image's admissibility as evidence. Conceived as both accurate and misleading, irrefutable and manipulative, complete and partial, the image oscillates between a mere illustration with no legal value in and of itself to a privileged form of truth. The unfolding visual turn in the law—marked by the growing importance of visual media in trials—is compelling courts to adapt practices and doctrines that can take account of new modes of producing visual evidence.[1] This chapter addresses this development through the human rights lens, seeking to understand the opportunities that the advent of video is creating for human rights activism in connection with the law.

The emergence of the legal notion of human rights is intimately connected to the visual documentation of the Holocaust and its subsequent trials. This connection makes human rights courts an important arena for scrutinizing the relationship between the law and visuality. This chapter therefore examines the role of video at the International Criminal Tribunal for the former Yugoslavia, the first court of its kind and the first to integrate fully visual practices, standardizing video's ability to serve as evidence and to facilitate the judicial process. The ICTY is also important for its incorporation of eyewitness video shot on camcorders as key evidence in trials. Since the Yugoslav Wars of the 1990s, eyewitness video—in its digital permutation—has become such a ubiquitous form of visual documentation that the

International Criminal Court formed the Technology Advisory Board in June 2014 to guide the judiciary on new technologies and forms of evidence.

As a case study, the ICTY generates fruitful opportunities to trace how courts render video legally meaningful up to the current moment. It also illuminates how this tribunal has influenced the work of human rights collectives: HRW, for example, used images as legal evidence for the first time in front of the ICTY. WITNESS gave video equipment and trained Kosovar Albanians, who provided the ICTY with eight hours of videotaped interviews with survivors of a village massacre. WITNESS also incorporated the lessons learned at the ICTY trials for its video-evidence program.

This chapter maps the relationship between the ICTY, the ICC, and human rights collectives to examine the shifting epistemological status of video and the agents who qualify its evidentiary potential. It proceeds with a brief historical overview of the salience of images in the law, particularly in human rights trials. It discusses the use of video as evidence at the ICTY and the unfolding challenges that human rights courts face in light of technological, economic, and cultural developments, all of which contribute to video's newly elevated evidentiary status. The chapter concludes by examining how the visual turn in the law has created various possibilities for human rights work. Echoing Michel de Certeau, it emphasizes that strategies and tactics are important for observing the dynamics between the proxy profession and the law, just as they are in journalism.[2] I argue that the advent of digital video is facilitating a new relationship between courts and human rights collectives that now use strategies and tactics to better tap into the legal sphere, thus actively shaping the evidentiary potential of video through the legitimacy of the proxy profession.

## Brief History of Images and the Law

Images belong to the overarching category called "demonstrative evidence," which entered the legal vocabulary with the introduction of photography in the nineteenth century.[3] This means that an image's legal significance draws from its representational mode, serving as a visual supplement to oral or written testimony. The parameters of demonstrative evidence equate an image's communicative impulses to that of drawings, maps, diagrams, and the like. Yet a photograph does not simply demonstrate; it also persuades

by virtue of its indexical and iconic qualities. Restricting the image's role to that of a testimonial appendage has left courtrooms unable to recuperate the tension between doctrine and practice in regard to visuals. Film and video have simply been rendered analogous to photography plus sound. Unaccounted for by the legal framework, then, the perceived veracity, mnemonic, and emotional dimensions of various camera-mediated images shape legal practices despite scholars warning about the different manifestations of naive realism in courts and calling for legal training in visual literacies.[4]

Jennifer Mnookin argues that the introduction of photography "brought into existence a new epistemic category that hovered uncomfortably on the boundary between illustration and proof."[5] She attributes the judicial reluctance to tackle photography in all of its complexity to four possible explanations. First, the conservative nature of the law generally responds to innovation with anxiety, preferring to draw analogies between new practices and established doctrines. Second, photographs threaten the hegemony of words, on which traditional judicial authority rests. Third, the perceived veracity of photographs risks generating a high degree of certainty and thus challenging the status of the courtroom as a place of deliberative judgment. Last, relegating photographs to the category of demonstrative evidence preserves the legal hierarchy, letting judges decide the admissibility of evidentiary materials (as opposed to outsourcing this decision to extrajudicial experts). The legal rendering of photography as a visual aid to testimony has thus "kept words in the picture" and contained the complex communicative reach of images in the background.[6]

The various war crimes trials after World War II brought the conflicted legal nature of images to the forefront of public debate. Questions about visual evidence were implicated in discussions about the function of human rights trials as sites of deliberation, judgment, and memory. Perhaps nowhere is the extrajudicial purpose of the courtroom more readily available than in the case of human rights trials, which are vested with hopes of bringing justice and setting the historical record straight. Images are well positioned to address these needs, especially when written and verbal records are perceived as insufficient for capturing horrors of inconceivable dimensions. It is not surprising, then, that images have been a central feature of evidentiary displays in human rights trials since the International Military Tribunal at Nuremberg. Nevertheless, the use of images in these trials has drawn

precisely from those qualities that the legal category foreclosed—the mne-
monic and persuasive power of visual records.

As a novel charge, a crime against humanity necessitated a paradigm of
proof that could adequately present convincing evidence for crimes com-
monly understood to be beyond representation. In his opening statement
at Nuremberg in November 1945, Justice Robert H. Jackson, the US chief
counsel, alluded to the importance of images to respond to this challeng-
ing task: "We will not ask you to convict these men on the testimonies of
their faults. There's no count in the indictment that cannot be proved by
books and other records. We will show you their own films, you will see their
own conduct and hear their own voices."[7] The films at Nuremberg served
judicial, historical, and pedagogical functions—by proving unprecedented
atrocity through visual means, they also created a mnemonic record of the
Holocaust.[8]

Despite the prominence of visual evidence, the unresolved tension
between legal practice and doctrine in regard to photography—and to film
as its legal analogy—continued to shadow the use of images in human rights
trials, often generating controversial responses in and out of courtrooms.
For example, during the trial of Maurice Papon in France in 1998—accused
of personal involvement in the Vichy government's deportation of Jews—
presiding judge Jean-Louis Castagnède declined the prosecutor's request to
showcase photographs. The desire to preserve the integrity of the courtroom
as a place of deliberative judgment is explicit in Castagnède's response: "My
concern at the moment—and I do not want us to be led astray—is that, to
the extent that the proceedings permit, we present to the jury the evidence
that will crystalize the facts and allow them to deliberate and make their
decision. And I do not, at this time, want at this stage of the argument,
such as it is, to introduce anything other than what witnesses say and the
documents show. . . . My role, and I want to fulfill it to the letter, is already
onerous without adding anything more to it."[9] The judicial reaction to the
use of photographs during the Papon trial mirrors Hannah Arendt's well-
known critique of the Adolf Eichmann trial in 1961: "the purpose of the
trial is to render justice, and nothing else . . . to weigh the charges brought
against the accused, to render judgment, and to mete out due punish-
ment."[10] Anything that could challenge or exceed the court's capacity to
deliver judgment was perceived to contaminate legal logic.

Responses to Arendt's claims insisted that far from being a theatrical performance, Eichmann's trial served a crucial extrajudicial function. It gave semantic authority to the victims of abuse and initiated a responsible memory-making process of great historical importance that challenged the limits of the legal imagination.[11] The focus on the testimonial paradigm eclipsed questions about the mediation of testimony through visual technologies, yet the trial recordings were central for transmitting survivors' testimonies, creating witnessing publics, and triggering processes of collective remembrance. Against this background, Amit Pinchevski argues, "the technological unconscious of trauma and testimony discourse is the videotape as an audiovisual technology of recording, processing, and transmission."[12] The video recordings of the Eichmann trial facilitated the process of bearing witness beyond the courtroom—creating publics who would partake in the cognizance of trauma and history in Israel and around the world—and became one of the most recognizable records of the Holocaust.

Although there are important differences between the inquisitorial and adversarial legal systems, the disputed status of photography, film, and video in these various Holocaust trials is a reflection of the broad judicial culture. In the Anglo-American tradition, for example, the Criminal Justice Act 1925 banned cameras from the courtroom in the United Kingdom. This prevalent ban on cameras was only partially lifted in the 2000s. The UK Supreme Court authorized filming when the court was created in 2009. The Court of Appeal started televising some cases in 2013. The British Ministry of Justice allowed judges' sentencing remarks in high-profile criminal cases in English and Welsh courts to be broadcast in 2020.[13]

In the United States, the American Bar Association recommended prohibiting cameras in its Canons of Professional and Judicial Ethics of 1937, characterizing them as disruptive to the legal decorum.[14] In a key decision in *Estes v. Texas* (381 US 532 [1965]), the Supreme Court ruled that the presence of the camera violates the defendant's right to due trial process. What is interesting about this decision is how the court described the impact of the camera. Justice Tom C. Clark wrote for the majority: "At least 12 cameramen were engaged in the courtroom throughout the hearing taking motion and still pictures and televising the proceedings. Cables and wires were snaked across the courtroom floor, three microphones were on the judge's bench and the others were beamed at the jury box and the counsel

table. It is conceded that the activities of the television crews and news photographers led to considerable disruption of the hearings."[15] The film crews and their cameras were seen to impair the trial proceedings.

The advent of video in the late 1970s and 1980s, however, significantly eased the legal attitudes toward audiovisual technologies in US courts.[16] Cameras were integrated in thirty-five state courts on permanent or experimental grounds by the end of the 1980s.[17] Several technological advancements simplified the recording process and made video cameras seem less obtrusive. Cameras became smaller and lighter. The loud film magazines were replaced by nearly silent videocassettes. The three-person crew often required to handle recording on one film camera (an operator, a focus puller, and a sound technician) was replaced by one person who could operate the camera even remotely—from outside the courtroom—and simultaneously record sound and images.

By virtue of these technological specifications, video also streamlined the handling of visual evidence.[18] Tendering film as evidence required testimony about every phase of the filmmaking process, such as recording (the identity of the operator, the type of camera and film used, and the exposure settings), development (who unloaded the film magazine, who handed over the reels to the film-processing lab, who developed the film and how), and screening (the identity of the projectionist and the state of the screen). Such authenticating mechanisms were often lengthy and involved testimonies from various people who worked with the film. In contrast to film, video does not need to be developed and processed and requires a smaller crew. The authentication process is thus simpler and shorter. Moreover, video can be screened without adjusting the lights in the courtroom, making the presentation of visual evidence less distracting. Louis Georges Schwartz thus argues that in the US context "the court's assimilation of video technology led to a widespread acceptance of video as physical proof of an event and thus to a proliferation of the moving image as nonsubjective vision."[19] Video gradually raised the importance of seeing during trials.

Despite its firm stance against cameras, even the US Supreme Court permitted in *Maryland v. Craig* (497 US 836 [1990]) the use of closed-circuit video as sufficient to meet the requirements of the Sixth Amendment right to direct confrontation in criminal cases. This decision came only two years after the Court had ruled that protecting two sexually assaulted thirteen-year-old victims by letting them testify from behind a physical screen

violated the defendant's right to confront the witnesses in *Coy v. Iowa* (487 US 1012 [1988]). At the heart of this constitutional interpretation is a belief in video's presumed ability to offer a truthful mediation of reality, thus disregarding the camera's presence and its role in providing a fragmented and subjective record. Though the US Supreme Court continues to reject video coverage of its proceedings, federal courts have integrated cameras as part of pilot programs.[20] In the spring of 2020, many judicial systems around the world, including all US courts, moved to virtual proceedings on various videoconferencing platforms due to the COVID-19 pandemic.[21]

The increasing integration of cameras in court can be traced back to the 1990s. Throughout this decade, the popularity of camcorders as a user-friendly consumer technology and the perceived immediacy of video, facilitated by a higher frame rate and easier screening means than film, generated renewed interest in the veracity of images. As courts started to accommodate video, they developed stronger legal beliefs in the probative value of images and began actively to shape the epistemological status of visual media. Seen as an access point to knowledge inaccessible through other evidentiary modes, video became a facilitator (not a hindrance) to justice. These developments coincided with the establishment of the ICTY, which became a test ground for how future human rights courts would incorporate video. The Special Tribunal for Lebanon, for example, consulted the ICTY about the courtroom plan and camera placements.[22]

The ICTY was an international ad hoc court established via a UN Security Council resolution in May 1993 to prosecute serious violations of international humanitarian law in the territory of the former Yugoslavia. The tribunal's jurisdiction was to investigate crimes that had occurred since the beginning of the armed conflicts in 1991 and to indict their perpetrators. Throughout its mandate, which ended in 2017, the ICTY indicted 161 people for four types of crimes: genocide, crimes against humanity, violations of the laws or customs of war, and grave breaches of the Geneva Conventions. It heard 4,650 witnesses over 10,800 trial days. Although Nuremberg could be considered its legal precedent, the ICTY initially had to operate while the war was still unfolding, posing tremendous challenges for the Office of the Prosecutor (OTP). Video became helpful not only to prove crimes in the courtroom but also to assist with human rights investigations.

Reflecting on shifting legal attitudes toward images in the human rights context, Alex Whiting, a former ICTY and ICC prosecutor, told me:

> We have become more accustomed to the power of video, and perhaps during the Holocaust trials there wasn't quite that level of comfort or understanding [of images], and there was so much other kinds of evidence. The crimes of the Holocaust were also incredibly notorious, so video might have felt like it was gratuitous since the crimes were so well known already. And all that's changed. . . . Whether you're talking about domestic criminal prosecution or international criminal prosecution, video and photographic evidence have become standard features of those cases. There's kind of an expectation that they might be part of the evidence.[23]

Whiting's observation raises important questions to which the following section turns: Given the history of legal skepticism toward images, how has video become a taken-for-granted form of evidence in criminal proceedings? How have international criminal courts conceived and operationalized video's "power" as a medium? What does this development show about the salience of human rights images, the relationship between the law and visuality, and the institutional agents who render images meaningful in a human rights context?

### Video's Role at the ICTY

The ICTY embraced video from the beginning, justifying it on the grounds that it helped the tribunal's mission to deliver efficient and transparent international justice. According to Rob Barsony, supervisor for audiovisual courtroom production at the ICTY, "Video facilitates justice and enables justice to be seen to be done."[24] Video as both a technology and a medium had four functions at the ICTY: (1) serving as evidence, (2) recording trial proceedings, (3) facilitating the legal process inside the courtroom (e.g., enabling testimonies via videoconference or giving the chamber an opportunity to consult the trials' recordings when needed), and (4) assisting with outreach initiatives.[25] The tribunal's integration of video elevated the salience of images: video became centrally implicated in the process of bearing witness in court.

The ICTY broadcast every trial hearing, beginning with its first trial on May 7, 1996. The Registry Office was in charge of archiving tapes and then digital files. In addition, thousands of hours of video footage were shown during trials in the form of direct or contextual evidence, so-called victim-impact videos, or recordings of testimonies and investigations. News footage and eyewitness videos—shot by civilians, military, and paramilitary members—were presented. In 2004, for example, the evidence records

submitted by the OTP alone included 5,500 videotapes—at that time, the well-publicized trial against former Serbian president Slobodan Milošević was still ongoing, but Ratko Mladić and Radovan Karadžić, two other high-ranked officials indicted for crimes against humanity and genocide, were fugitives.[26] The ICTY's Rules of Procedure and Evidence granted video its status, and the court's architecture internalized its logic.

After clearing an initial security checkpoint, one would enter the tribunal's lobby area, where three flat-screen televisions broadcast trials in session from the courtrooms. Courtrooms 1 and 3 were equipped with six remote-controlled cameras: one for the judges, who were in the center of the room; one for the prosecution (to the right); another for the witness (at the opposite end of the judges), two for the defense (to the left); and one overhead camera behind the prosecution (figure 4.1). The second camera for the defense was added as the court merged trials with multiple individuals accused of similar indictments into one megatrial. Courtroom 2 was smaller and had four cameras, one for each trial party. The video booth, where audiovisual staff managed the recording process, was behind the defense (figure 4.2).

**Figure 4.1**
ICTY Courtroom 1, n.d., http://www.icty.org/en/about/registry/courtroom-technology.

**Figure 4.2**
ICTY video booth recording a trial in Courtroom 1, n.d., http://www.icty.org/en
/about/registry/courtroom-technology.

The public gallery (figure 4.3) was behind the witness stand, where inter-
ested citizens and members of the press could observe trials. Two overhead
monitors on each side of the gallery livecast the proceedings unless the
court was in closed session. The trial proceedings were broadcast and avail-
able online with a thirty-minute delay to ensure that no sensitive informa-
tion was accidentally disclosed (e.g., details that could jeopardize the safety
of a witness testifying under protection).

The ICTY used to archive the footage of each camera. However, a review
conducted prior to the transition to e-court around 2006–2007 recom-
mended a new policy: only one master recording per trial session, to be
available in four languages (Bosnian/Serbian/Croatian, English, French,
and "the floor," which encompassed the languages used during trials with-
out translation). The transition to e-court also meant further integration of
digital technology. After that, the judges and lawyers had two monitors in
front of them: a passive screen that showed everything that was recorded
and presented in the courtroom and an active screen that enabled the per-
son to interact with the material (e.g., select video segments, play them in
slow motion, highlight passages in a document, and so on).

**Figure 4.3**
ICTY Courtroom 1 public gallery, n.d., https://www.icty.org/en/content/virtual-tour
-courtroom-i.

The omnipresence of cameras, monitors, and television screens illumi-
nates how the ICTY naturalized video technology. Research conducted at
the tribunal in 1999 found that the judges, prosecutors, defense counsel,
and court staff saw the cameras as "discreet," "unobtrusive," and "hidden,"
explaining that "they simply forgot that cameras were present in the court-
room."[27] Although the cameras were visible, this study suggested that the
ICTY legal staff had become accustomed to them. According to Paul Mason,
the trial coverage was appreciated for its legitimizing function: it enabled
the international community to see the workings of the court, thus facili-
tating "endorsement and approval."[28]

Video's integration into the legal architecture and its centrality to the
ICTY's work indicate a significant departure from its required anonymity
in earlier trials (e.g., during the Eichmann trial, the production crew had to
hide the cameras from view in the courtroom to obtain broadcast authori-
zation). The advent of video has thus contributed to the changing legal atti-
tudes toward motion pictures from seeing them as a disruptive presence to
considering them a transparent medium of communication that facilitates
the judicial process.[29] For Barsony, "by providing an objective record of the
trials, video ensures transparency of the legal process."[30] Although Barsony

refers to the trials' broadcast, his use of the term *objective* is significant. The more courts see video as an objective record, as an impartial witness, the less the medium needs to depend on authenticating testimony to anchor its meaning.

At the ICTY, video did not necessarily have to be tendered as evidence through a witness. It could also be presented from the bar table (e.g., on an attorney's motion). The party tendering the video needed to demonstrate its relevance and reliability. Videos from news organizations, however, generally did not require testimony by the journalist.[31] This was a major legal step toward full recognition of visual media's ability to serve as evidence on their own terms. The date and time stamp on the recording, the news organization's logo, or the journalist's introduction on camera were sufficient for the authentication of video at the ICTY. The content's relevance to the case could sometimes present adequate grounds for admission as well.

In the trial of Zdravko Mucić and others, for example, the defense counsel objected to admitting video recordings that showed an interview with the accused that originally aired on a Croatian television and another tape depicting him in a detention center. The tapes had been seized from the home of the accused. The defense contended the authenticity of the videos because their authors and the chain of custody were unknown. Nevertheless, the chamber admitted the videos, and the Decision on the Motion of the Prosecution for the Admissibility of Evidence read: "It is clear from the relevant provisions of the Rules that there is no blanket prohibition on the admission of documents simply on the ground that their purported author has not been called to testify in the proceedings. . . . The nature of the contents of the two exhibits—that is recordings of recognizable persons conducting interviews—is further such that their probative value is not necessarily excluded by a certain remaining uncertainty concerning the source of these exhibits."[32] In a different trial, *Prosecutor v. Krstić*, video impeached evidence provided by the accused.[33] The ICTY's criteria for admissibility thus indicate that video no longer plays only a supportive role for verbal and written records in international criminal cases. Video can speak on its own or corroborate other materials, just like other kinds of evidence can.

Video normally falls under the legal category of documentary evidence unless forensic processes have been applied to the digital file, in which case it falls under the category of forensic evidence, and it may need to be

introduced through an expert witness.[34] At the ICTY, the chamber determined video's probative weight at the end of the trial in light of the submitted evidence as a whole, enabling video to play different evidentiary roles (e.g., as direct evidence, contextual evidence, or corroborating evidence). The ICTY and subsequent international courts and tribunals have generally required minimum standards of relevance and reliability; therefore, the focus has been not as much on whether the evidence is admissible as on what weight it holds.[35]

A significant component of the evolution of video evidence in international criminal trials is the nature of the courts. Lindsay Freeman, an international criminal lawyer and member of the ICC's Technology Advisory Board, explains that "evidentiary standards in international criminal law are generally more permissive than [in] common law jurisdictions since there are no juries." As a result,

> international criminal trials have been exceptional with a diverse body of evidence from the beginning because of the unique nature of the institutions, the perpetrators, and the crimes themselves. In order to understand the evidence and its significance in international criminal cases, the parties and judges need considerable background information and context on the historical, cultural, and political nature of the conflict. Thus, technologically derived evidence and innovative methods of evidence collection, preservation, and presentation have been an integral part of the international criminal justice story from start.[36]

This is not to say that there have not been challenges. Judges at international courts come from both common and civil law systems that are different in their approaches to evidence, complicating the decision making on the admission of evidence and its weighing. As Keith Hiatt of ICC's Technology Advisory Board argues, "The ICC's flexible evidentiary standard allows it to take a holistic approach to weighing evidence. On the other hand, the flexibility has the effect of concealing the standard. The weighing happens in the judges' heads, not in written decisions."[37] Prosecutors may thus lean on the side of making the case for the video materials at their disposal even if the footage may not be given much (or any) weight as evidence at the end. This ultimately has the effect of making visual decision making—and all that it entails—prevalent in court.

Section 3, rule 89, of the ICTY's Rules of Procedure and Evidence states:

(A)  A Chamber shall apply the rules of evidence set forth in this Section, and shall not be bound by national rules of evidence.

(B)  In cases not otherwise provided for in this Section, a Chamber shall apply rules of evidence which will best favour a fair determination of the matter before it and are consonant with the spirit of the Statue and the general principles of law.

(C)  A Chamber may admit any relevant evidence which it deems to have probative value.

(D)  A Chamber may exclude evidence if its probative value is substantially outweighed by the need to ensure a fair trial.

(E)  A Chamber may request verification of the authenticity of evidence obtained out of court.

(F)  A Chamber may receive the evidence of a witness orally or, where interests of justice allow, in written form.[38]

These rules of evidence were adopted in 1994 and last amended in 2015. They generally permitted any evidence that was relevant to the case and had a probative value that outweighed any prejudicial effects. From an evidentiary standpoint, the ICTY set an important legal precedent for other international criminal courts. In two separate rulings on the use of satellite images, the chamber placed the burden on the defense to show that the digital images lacked reliability or authenticity before they could challenge the evidence on those grounds.[39] More flexible rules of evidence resulted in a wide range of visual displays at the ICTY.

The ubiquity of video at international human rights courts like the ICTY suggests that the law cannot be thought of only as a profession of words. Video's entanglement with testimony, deliberation, judgment, and memory means that visual meaning making undergirds the legal process in international criminal cases. In other words, video is attaining a high degree of recognition as a technology and a medium that is crucial to the witnessing process in court. This premise rests on three key legal perceptions about the affordances of video, perceptions that are inextricably linked and build off of each other: video is an important documentary, persuasive, and mnemonic tool.

### Video as a Documentary Tool

Video's perceived ability to provide a stable and vivid record of the past is central to its documentary function in trials. According to the ICTY attorneys, video gives details and nuances that can be permanently stored as

evidence. In Whiting's view, "[Video] is a record that is not going to change. It will stay the same from when it's taken to [the moment it's presented in] trial. . . . It's unlike witness evidence[, which can be eliminated through] intimidat[ion] or bought off or [made to] disappear. . . . It's more permanent; it's more secure than other forms of evidence. . . . You don't have to worry about lapses in memory or misperception. You can just watch the video. . . . It preserves the real evidence whether it's a video of the crimes or the aftermath of the crimes or of conversations."[40] Video's form inscribes a permanent witnessing record. The underlying assumption is that video, if proven authentic and relevant, tethers to the real, reliably conveying the eyewitness experience in the courtroom. Whiting contrasts between the seemingly unbiased mediation through video and the subjective discursive dimension of personal testimony. At times when the law is embracing a forensic sensibility, often preferring evidentiary objects and materials to eyewitness accounts,[41] the permanence of video lends itself to this emerging judicial logic.

The compelling weight of video in the legal context is premised not only on its stability as a record but also on its richness as a mode of information relay. This weight is evident in an excerpt taken from a trial transcript of the case against Stanislav Galić for sniping and shelling attacks in Sarajevo. Michael Blaxill, a prosecuting attorney, requested that the official OTP visit to Sarajevo be videotaped: "The final thing, Your Honours, is that really the manner of recording. Two options have been considered in the past. Whether you have periods of audio-visual recording with a video camera on site so that when you are looking at specific locations, it is actually viewed, the parties are present, and it is recorded both audio and visual, or in conjunction with, written minutes with the locations visited and any communications with Your Honours. Maybe the video thing is more comprehensive and a better option for recording the visit than simply written minutes."[42] Video here is understood as a record of nuance, so it suspends the long-held skepticism toward images. Explicit in the prosecution's demand is that video as a mode of information relay subjugates words—it is able to transport the viewer to the recorded scene and thus provide a more complete picture than written records.

This underlying logic also dominates the justification for using video as evidence in trials. According to Silvia D'Ascoli of the OTP, "Video recordings

can capture important details that would otherwise be missed and can be essential in the process of reconstructing certain events or assessing the nature and magnitude of these [events]."[43] Similarly, in the opening statement in the trial against Galić, attorney Mark Ierace explained the use of video to support the prosecution case:

> Your Honours, the nature of the individual crimes which constitute the crime base for the indictment are such that they are difficult to convey in a courtroom. In the case of sniping, they involve persons being shot in the open. In circumstances where the killer is secluded in the case of shelling, the use of indirect fire means that those who were present at the place where the shell landed generally did not see where the shell emanated from. The Prosecution is aware of the difficulties that these factors present to the Trial Chamber in understanding the evidence which the Prosecution shall call. Traditional means of conveying a crime scene involve the use of photographs and maps, and indeed they would go part of the way to placing Your Honours in the position where the crime scene can be imagined, according to the evidence. In order to better assist the Trial Chamber, the Prosecution has prepared a video of each of the sniping and shelling incidents.[44]

Video is seen as instrumental because it provides a perspective and a sense of presence. It combines verbal and visual cues in depicting the complexity of war crimes; thus, it is perceived as superior to both still images and words. Ierace concluded his statement:

> Finally, Your Honours, I will show a short collage of video clips. It takes approximately 8 minutes and 40 seconds, taken before and during the indictment period, up to approximately spring of 1993. I do so in order to demonstrate more vividly than words could some of the anticipated evidence I have alluded to during my opening. . . . The video illustrates, in particular, the terror that was communicated not just to those who were unable to dodge the sniper's bullet or the shells, but to those who lived and witnessed what happened to their fellow Sarajevans. It conveys a sense as to how they were targets, even though they were not hit, of the intention to inflict terror.[45]

These video clips show civilians trying to avoid sniper fire on the streets of Sarajevo. The camera situates the viewer among the civilians. The sniper fire starts out of nowhere, catching everyone by a surprise. The people run, hiding behind cars or waste containers in attempts to avoid deadly bullets. The long takes with frequent panning and zooming communicate a sense of shock and immediacy, adding further emotional dimension to the portrayal of the war experience.

Although courts have tried to restrict the visual's appeal to emotion and imagination by defining them as prejudicial, the prosecution's justification

for presenting video materials in this case rested precisely on these qualities. It is neither the quantified dead bodies nor the link between the accused and the crimes that matters for screening the video collage of Sarajevo. What matters is the video's power to contextualize speech—"to demonstrate more vividly than words," as Ierace claimed—that is assumed to trigger an engagement with the crime. The video clips offer a glimpse into the emotional state of those who witnessed the unfolding terror, which the prosecution deemed legally relevant for understanding the magnitude of the crimes. The perceived stability of video as a record and its richness as a mode of information relay that has sensory power and emotional resonance have made video an exceptional documentary tool capable of providing crucial evidence in human rights trials.

### Video as a Persuasive Device

In the sentencing hearing of Miodrag Jokić's trial, the prosecution screened a so-called victim-impact video to portray the human losses as a result of the shelling of Dubrovnik.[46] The video combines wide-angle shots of historic sites in Dubrovnik in fire and smoke with medium to close-up shots of civilians witnessing the attacks on their city. The different clips document various scenes on the day of the shelling—a man with a camera running from gunfire, a woman trying to calm her dog while hiding behind a container, an injured man covered in blood lying on a presumably makeshift hospital bed, and a monk whose interview with the camera crew is interrupted by an explosion. The constant camera zooming and the disturbing sound of bombs and gunshots as the incidents unfold aesthetically capture the chaos in the city.

Susan Somers, the lead counsel for the prosecution, justified screening this video on the grounds that it was the best mode of relaying in the courtroom vital information about illegal war conduct:

> These are the human losses, and of course there's nothing that can be said further to bring these people back. We hope that their deaths are not in vain and that they are remembered by all who understand the futility of the action that happened in Dubrovnik that day. If I may turn for a moment to a video which we think will best portray the losses, the damage, the injury, as it were, to the living monuments, the objects, to Dubrovnik as an ancient, protected city. It would be, I think, more effective for Your Honours to see than for me to further narrate.[47]

This case suggests that the assumed sensory authority of video—its portrayal of the emotional layers of the war experiences—also makes it an

exceptionally persuasive device. This belief lingers in the prosecutors' understanding of why video is more effective than narration.

The persuasive power of video was often invoked during the presentation of evidence at the ICTY's trials. In the trial against Radovan Karadžić, the former president of Republika Srpska (in Bosnia and Herzegovina), the prosecution questioned a witness after showing a video about the shelling of the Markale market in Sarajevo.

**MR. GAYNOR:** I'd now like to move to a video which has already been admitted in evidence as P1450, and I'll be playing some extracts from that. Initially, I'd like to play the first minute of this video, please.

[Video clip played.]

**MR. GAYNOR:** We stopped at 48 seconds.

**Q:** Mr. Besic, it's been repeatedly asserted in this court that many of the bodies at the Markale I and Markale II incidents were brought from the frontline, that the bodies were already dead. I want to ask you if you can comment on that assertion.

**A:** It's difficult to comment. We can see, with our own eyes, everything that happened. All sorts of stories circulated, that bodies were brought there and planted there. However, we've seen what's going on. If dead bodies had been brought here, then the wounded people here would not be acting this way. You see the man without his lower leg. If you look at the other photographs and recordings, you will see parts of extremities. There were all sorts of stories and guesses, but the facts are here.[48]

The video clip used here starts with a wide shot of dead and injured bodies on the street. As cars pass by, people move the bodies to the side of the market. Sirens and painful screaming accompany the sights of blood and death. The camera situates the viewer in the midst of the incident. Although the video does not show actual evidence of who killed the people or how the bodies appeared there, the presumed link between the shelling attack and the immediate panic on the street is what provided this video grounds for evidentiary submission in Karadžić's trial. The witness's response to this footage reiterated the importance of seeing. Screening the video and subsequently examining the witness implied the importance of visual persuasion in court. The video was framed as an undeniable testament to the horrors in Sarajevo, capable of dismissing any false allegations.

Facilitated by the relatively flexible rules of evidence—to provide background and setting for crimes in countries far away from the courtroom in The Hague—the prosecution screened many videos as contextual evidence. In the case against Slobodan Milošević, the former president of Serbia, for example, the prosecution showed excerpts from a two-hour video depicting executions committed by the paramilitary unit Scorpions, which were filmed by a Scorpions member with a hand-held camera. The complete video features three key scenes. In the first, a Serbian Orthodox priest sings a prayer and gives blessings to Scorpions (figure 4.4) while being observed by local men, women, and children. The camera slowly pans throughout the ceremony, showing the faces of those in attendance. The time and date stamp are inscribed on the bottom-left corner of the frame.

The second scene starts in the back of a truck, showing several men with tied hands. A uniformed person kicks one of them and orders the men to get out of the truck and lie down facing the ground. Soon afterward, the camera operator asks for a replacement battery. The continuity in the scene

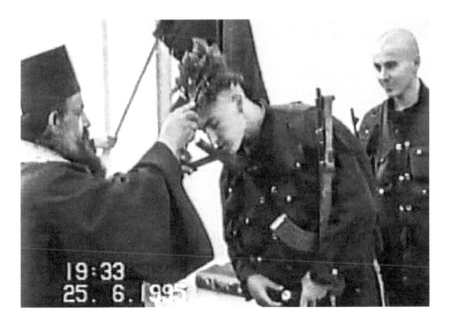

**Figure 4.4**
Screenshot, Scorpions video shown at the ICTY, June 1, 2005, https://www.youtube .com/watch?v=norSzT312L8.

is interrupted as the camera is turned off and then continues recording from a different angle, showing the truck leave. One long take captures the chitchat of the Scorpions while the civilians lie helpless. At one point, one of the men pleads for help. A uniformed person comes close and talks to him (figure 4.5). Soon, the men are told to get up again and walk toward the woods.

In the last scene, which was screened in court, the men are lined up (figure 4.6) and ordered to walk slowly, one after the other. The camera moves behind them. Gunfire starts, and they fall dead on the ground one by one. The footage is particularly shaky as the camera moves rapidly between the civilians as they walk and the places where their dead bodies fall. In an ironic moment, the camera operator warns that he will be out of battery soon.

Although fundamental legal details were lacking about this video— for example, who shot and edited it and what its provenance was—the

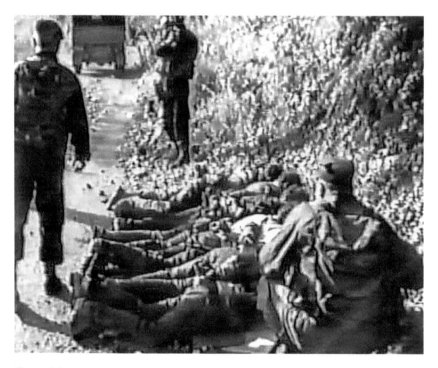

**Figure 4.5**
Screenshot, Scorpions video shown at the ICTY, June 1, 2005, https://www.youtube
.com/watch?v=norSzT312L8.

**Figure 4.6**
Screenshot, Scorpions video shown at the ICTY, June 1, 2005, https://www.youtube
.com/watch?v=norSzT312L8.

prosecution decided to present portions of it in court during the cross-
examination of a defense witness. Hours of trial time were dedicated to
deliberations about the video, which was contested in and out of the court-
room.[49] The video was eventually ruled inadmissible, and the sudden death
of Milošević put the case to rest. The trial transcripts shed light on how any
video exhibit in the courtroom is inevitably a form of visual persuasion.

Despite not immediately having the necessary information that would
help solidify the video as evidence in the case against Milošević, the pros-
ecution's choice to screen it rested on the long-disregarded qualities of
images—perception, emotional appeal, and intuitive resonance. Although
claiming that the video was not relevant to the case, even a defense witness
acknowledged that it depicted horrific crimes.

**JUDGE ROBINSON:** Mr. Nice, can you tell us about that film?

**MR. NICE:** Yes, to a degree I will. But if I can just deal with—

**MR. KAY:** We haven't established any foundation for this. To my mind, this
looks like sensationalism. There are no questions directed to the witness on

the content of that film in a way that he can deal with it. It's merely been a presentation by the Prosecution of some sort of material they have in their possession that has not been disclosed to us and then it has been shown for the public viewing without any question attached to it. It's entire sensationalism. It's not cross-examination.

**JUDGE ROBINSON:** Mr. Nice, there's some merit in that. That's why I asked what are we going to be told about the film. Who made it, in what circumstances, and what questions are you putting to the witness in relation to it?

**MR. NICE:** Certainly, he can answer that question, yes.

**Q:** I'm suggesting this film shows Skorpions [*sic*] executing prisoners from Srebrenica.

**A:** As I am upset, I have to say that this is one of the most monstrous images I have ever seen on a screen. Of course I have never seen anything like this in—live. I am astonished that you have played this video in connection with my testimony because you know full well that this has nothing to do with me or the units I commanded. I attempted to explain this yesterday, and I have also attempted to explain it today. I'm not saying that you do not have the right to do this, but I have to say that I am really upset—

**JUDGE ROBINSON:** Do you agree with the—do you agree with the Prosecutor's suggestion or proposition that this is a film that shows Skorpions executing prisoners from Srebrenica?

**WITNESS:** [Interpretation] Of course I do not intend to cast doubt on what the Prosecutor is saying, but I have not seen a single person I know here, and I have seen no evidence that this is the unit in question.[50]

Immediately following the courtroom screening, the Scorpions video was broadcast in the countries of the former Yugoslavia and around the world. For a moment, it fostered a public debate even in Serbia about the crimes in Srebrenica. Indeed, when Milošević made remarks in regard to the video a few days after the initial screening, his main worry was its persuasive impact on the public.

**THE ACCUSED:** [Interpretation] Mr. Robinson, I would like to draw your attention first of all to what Mr. Nice said a few minutes ago. You can see it in the transcript. I wrote it down properly. He said, verbatim, that the link between what he showed will be established. Please bear that in mind. Is that an appropriate way to act? On all world TV stations and Serb TV

stations, it has been said time and again that this is footage from Srebrenica. And Mr. Nice says now that he is yet to establish the link showing that this has to do with Srebrenica.

**JUDGE ROBINSON:** Mr. Milosevic, whether he establishes the linkage or not is a matter for the Chamber. We have no concern with the public's perception of the matter. Ultimately we will examine all the evidence before us and come to a conclusion as to the worth, the value of the—of the tape.[51]

This case illustrates how visual persuasion can take a front seat in the courtroom. Video can be screened in court and deliberated on without necessarily being admitted as evidence or given weight. Its use is partly extrajudicial. It draws from its perceived immediacy, permanence, and sensory qualities to make moral and historical claims.

### Video as a Mnemonic Tool

The ubiquity of video at the ICTY signals an attempt to reconcile those visual qualities that were overlooked by the initial adoption of photographic images as demonstrative evidence. Video's legal functions inevitably exceed demonstration. According to Whiting, "Now investigations are much harder to conduct. They're conducted far away. They take a lot longer. . . . So the force that video brings to the trial is really important; . . . it brings the events—that usually occurred years before—into the courtroom, which is powerful because oftentimes these trials occur many years later, and some of the force and power of the events can be lost when you're years and thousands of miles away."[52] Implicit in this account is a tribute to video's mnemonic power, which surfaces in his description of video's force. The intensity and perceived instantaneity with which audiovisual records reference the past bring visual memories to the forefront of the legal process. Video, then, provides a tool to seemingly overcome the unavoidable loss of the past. It facilitates the process of bearing witness in court through which people are supposed to come to grips with past atrocities.

Video operates as a vehicle of memory, providing an enduring record through which crimes can be rendered legible long after their occurrence. D'Ascoli echoes this view: "The advantages of video evidence are in the impact of this type of evidence and the powerful nature of it, which allows visualizing even events from the distant past and thus gives a 'visual aid'

to the public and to the judges."[53] Video directs the judges and publics on how to remember a crime. It provides memory with texture that facilitates the trial proceedings and historical understanding outside the courtroom. It acts as an indicator "to preferred meaning by the fastest route."[54]

The law has long been an important institution for the creation of collective memory.[55] The advent of visual media in the courtroom, however, is indicative of a process of institutionalizing visual memories as legal tools. What used to be considered the image's legal surplus is now central to video's unique evidentiary contribution. Even the ICTY's online timeline of achievements presents a chronology of indictments and judgments using screenshots of key video evidence.

The beginning of the first ICTY trial, *The Prosecutor v. Duško Tadić* (1996),[56] for crimes committed against Bosnian Muslim and Croatian men in the Omarska detention center in Bosnia and Herzegovina, is exemplified by one of the most iconic images of the Yugoslav Wars (figure 4.7). It is a screenshot of the Omarska and Trnopolje camps in the famous Independent Television News (ITN) video by Penny Marshall and Ian Williams. The video documents the journalists' tour of the camps and the hesitation of

**ICTY Timeline**

**Figure 4.7**
Screenshot, ICTY timeline, n.d., http://www.icty.org/en/in-focus/timeline.

those in Trnopolje to discuss anything about the conditions in which they lived. The camera shows the journalists' point of view as they speak with the civilians, whose bodies indicate signs of starvation. A wired fence separates the journalists from these men.[57]

The ICTY online timeline draws attention to a large screenshot of the ITN video, while the image of the accused is minimized in the bottom-right corner. What is interesting about this depiction is how it resembles visual patterns prevalent in the news media at the time of the Yugoslav Wars. The *New York Times*, for example, announced the first ICTY's trial with a small image of Tadić and a larger one of the courtroom in Nuremberg during the Holocaust trials.[58] Both cases illustrate how visual memories can be mobilized in the representation of trials. The news media drew attention to the larger human rights legal context, while the ICTY timeline directs the viewer to a visual memory of the crime.

With its institutional logic, the law is interested in demarcating individual guilt. When communicating its legacy to the public, though, the tribunal subordinated the image of the person guilty of a human rights violation to an iconic representation of the crime. What is significant and deserving of critical attention, then, is neither the individual on trial nor the legal process per se but rather the historical moment the image epitomizes. Although the ITN video initially served as evidence in trials related to detention centers, it also became a legal tool for remembrance.

The ICTY's first life sentence, issued to Stanislav Galić, for sniping and shelling attacks in Sarajevo, and the guilty plea by Miodrag Jokić for shelling Dubrovnik are portrayed in the same fashion on the online timeline. The complexity of lengthy trials is thus reduced to a visual marker strategically guiding the public on how to bear witness to, come to terms with, and remember the crimes. A single video frame freezes a moment of the war atrocities, serving as a reminder of the human rights crimes that happened there. The first case (figure 4.8) symbolizes the emotional terror experienced by those who managed to escape the sniper fire. The prosecution emphasized this information as legally relevant during the trial of Galić. Indeed, this emphasis also constituted the ground upon which the attorneys justified the screenings of similar video materials as evidentiary submissions. The second image (figure 4.9) testifies to the damage in Dubrovnik, reminding the public of the fire and smoke that ruined parts of the city, causing emotional and physical harm to its citizens. The prosecutors also evoked

**Figure 4.8**
Screenshot, "First Life Sentence by the Appeals Chamber," ICTY, November 30, 2006,
http://www.icty.org/en/in-focus/timeline.

this reasoning when they screened the video in court during Jokić's trial.
These examples indicate how video has become a carrier of collective mem-
ory in court during trials and then outside of legal spaces when it commu-
nicates the tribunal's accomplishments.

The legal justification for the use of videos at the ICTY has involved a
combination of three interrelated propositions about video's evidentiary
potential that augment each other. Video is understood as a vivid and sta-
ble documentary record of the past, a powerful persuasive tool, and a mne-
monic device. Videos screened at the ICTY, such as the shelling of Sarajevo

**Figure 4.9**
Screenshot, "Guilty Plea for the Shelling of Dubrovnik," ICTY, December 4, 2003,
http://www.icty.org/en/in-focus/timeline.

and Dubrovnik and the brutal executions by the Scorpions, are arguably a
subgenre of the documentary film tradition.

Although not always duly noted, central to the birth of documentary
film was the European avant-garde movement, "the rhetoric of social per-
suasion" emerging in the 1920s, and the "activist goals" inscribed in nonfic-
tion filmmaking.[59] Chapter 2 discussed Dziga Vertov's *Kino Pravda* series and
John Grierson's film group in this light. This history suggests that any docu-
mentary media is a form of persuasion on some level. Therefore, despite
attempts to separate the working of visual media from their social and cul-
tural resonance,[60] the proliferation of documentary video records in court
sheds light on the thin line between visual evidence and persuasion. In
other words, it brings the law into direct conversation with the wider culture
in which images are produced, interpreted, circulated, and remembered.

The ICTY is not alone in using video this way. Its legacy is important for international criminal courts writ large. Along with the International Criminal Tribunal for Rwanda, founded in 1994, the ICTY set up an important legal precedent, including on evidentiary criteria related to video materials. The ICC, founded in 2002, is a permanent international criminal court that operates on similar principles as the ICTY. At the ICC, the chamber examines whether the submitted materials "(1) are relevant to the case; (2) have probative value; and (3) are sufficiently relevant and probative to outweigh any prejudicial effect that could be caused by their admission."[61] Similarly, there is no strict requirement that each piece of documentary evidence be authenticated by a witness. Exclusion of evidence is uncommon, and the focus is also on the weight of the evidence. What is interesting is that the ICC does not have explicit rules on hearsay evidence. In the context of digital evidence, "as a general rule, the ICC has held that such anonymous hearsay could be admitted, but its use was limited to 'corroborate other evidence.'"[62]

The ICC's first trial in the case of Thomas Lubanga Dyilo in 2002 incorporated video (as mentioned in chapter 1 and discussed further later in this chapter), while *Prosecutor v. Ahmed Al Faqi Al Mahdi* in 2016 involved You-Tube videos, Google images, and an interactive digital platform that presented the visual evidence (discussed in chapter 2). This is not insignificant because in its tenure from 2002 to 2016, the ICC issued only six trial judgments, three of which came in 2016. The arrest warrant for Mahmoud al-Werfalli in 2017 was based on open-source video evidence (chapter 1). All this suggests that video's role in international criminal courts is growing.

## The Visual Turn in the Law as an Opportunity for Human Rights Collectives

The increasingly porous boundaries between the law and today's intensely mediated public culture challenge the law to extend its professional logic to the kinds of knowledge it has traditionally dismissed. They also provide opportunities for various visual experts to partake in legal renderings of the truth. Neal Feigenson argues, "The use of and reliance on the visual, the digital, and the Internet entail a democratization of meaning-making, a redistribution of traditional patterns of authority, and indeed a reconceptualization of the very nature of social organization."[63] An avalanche

of digital visual media in court marks the visual turn in the law, which has generated favorable circumstances for human rights collectives. Through the proxy profession, these collectives claim visual expertise that grants them new access to legal constructions of truth.

From their beginning, human rights courts and tribunals have relied on research and testimonies by human rights collectives. Both Amnesty and HRW reports, for example, were used as evidence at the ICTY. In addition, the origin of the HRW's Emergency Response Division goes back to the conflict in Kosovo. The HRW team photographed the aftermath of the Gornje Obrinje massacre in Kosovo in 1998 and testified in front of the ICTY. Indeed, HRW used images as legal evidence for the first time in front of the ICTY, and its more extensive evidentiary employment of video dates to the Darfur crisis in the early 2000s.[64] This suggests that since the Yugoslav Wars of the 1990s international courts and human rights collectives have become more accustomed to conceptualizing video as evidence in a legal sense.

Today, international human rights courts such as the ICC are encountering crimes that are ever more documented, digitally recorded, and circulated on social media platforms. Because some of these materials need to be considered under the category of forensic evidence, visual expertise becomes of legal value. To navigate the unfolding media landscape, for example, courts may need to turn to visual experts for advice on video-verification practices and tools. This turn to video in the legal sphere has been an opportunity for human rights collectives that now consult on authenticating mechanisms and train activists and lawyers about video's evidentiary potential.

The following subsections examine how human rights collectives assert their video skills as valuable to the ICC and other courts by looking at the strategies and tactics these collectives use when shaping video activism to fit legal parameters. The subsections show how the proxy profession provides human rights collectives legitimacy to engage in video production, to work with video evidence, to develop custom technologies, and to conduct training in the context of legal evidence. In the process, I argue, these collectives offer a pragmatic solution to bringing a wider range of human rights voices into legal decision-making settings, although these voices currently come mostly from existing and emerging activist networks with ties to the human rights NGO community.

## Video Production

Amnesty and HRW normally do not produce specialized videos for human rights trials because they want to exercise their right to decide whether and how to cooperate in a legal case. Param-Preet Singh, senior counsel of the International Justice Program, explained to me why HRW is not investing in specialized videos for courts such as the ICC. "We don't really want to collaborate with them because we don't want that to be grounds for us then to be called as witnesses or to be subpoenaed to give evidence in courts. So it's best to just keep them separate."[65] This choice is strategic and a part of the professionalization of human rights video activism because it enables human rights collectives to claim autonomy.

WITNESS occasionally produces such videos by recording testimonies of human rights victims; it also trained and equipped activist groups to submit video evidence to the ICTY (video interviews with survivors of a massacre) and to the tribunal in Rwanda (video recording of the exhumation of genocide victims). Bukeni Waruzi, a former senior WITNESS program manager for Africa and the Middle East, shot a video of child soldiers serving in the Democratic Republic of Congo (DRC). Born and raised in the DRC, he was personally invested in exposing the human rights violations there. He edited two separate versions of the footage—one for the local communities, who were generally approving of the recruitment of children, and another for the ICC. Waruzi told me: "The video I made for the communities in the DRC was totally different from the video I made for the ICC. The difference, of course, is driven by the audience. . . . I wanted [the parents] to take a stand after they saw the video in terms of preventing the recruitment, discouraging their children from joining the militia. . . . When you go to the ICC, you want the ICC to understand the necessity of prosecuting those who are recruiting child soldiers."[66] His statement not only sheds light on the centrality of audience differentiation for unfolding video activism patterns but also illuminates how video can serve both as an evidentiary submission and as a mode of persuasion in human rights trials.

The video version submitted to the ICC, *A Duty to Protect: Child Soldiers in the Democratic Republic of Congo* (2008), documents the experiences of child soldiers such as Mafille, a fifteen-year-old former soldier who has been struggling to adjust to life outside of the army, and January, a sixteen-year-old girl who has served in the military for six years. The video starts with a singing and dancing ceremony at the training camps, with children dressed in

military uniforms. Waruzi narrates the footage, which is driven mainly by the testimonies of these girls. Perhaps the most chilling moment is when Mafille recounts the sexual abuse she experienced at the military base but avoids looking at the camera: "Before that, I didn't know men. [pause] My first experience was being taken by force. [editing cut] Either the commanders or the bodyguards took us by force and raped us. [editing cut] I'm still in shock, I cry whenever I think about it. [close-up shot of her hand covering the face]" (figure 4.10). Supplementary information is provided through interviews with the girls' families, members of the community, and other child soldiers. The video incorporates footage from the camps documenting the poor living conditions, malnutrition, lack of medical help, and excessive use of drugs.

Waruzi submitted his video to the ICC at a time in which the OTP was still conducting investigations and preparing indictments. The ICC has limited resources to investigate complex crimes. The DRC case involved multiple war crimes, such as rape, extrajudicial killings, illegal detentions, and destruction of property. Waruzi met with members of the prosecution

**Figure 4.10**
Screenshot, *A Duty to Protect: Child Soldiers in the Democratic Republic of Congo*, WIT-NESS, June 2, 2008, http://hib.witness.org/DutyToProtect.

to screen his video, turn in the raw footage, and answer any questions. The video not only helped accomplish Waruzi's goals—the ICC pursued the case of child soldiers—but also served as contextual evidence in the pretrial phase, which confirmed the charges against the accused, and as direct evidence in trial, proving that children younger than eighteen were recruited to serve in the national army. Waruzi told me that the video "was built into the argumentation of the prosecutor to show how dangerous, how serious the crime is."[67] However, Waruzi never testified in front of the ICC. The information he provided to the court was deemed sufficient to tender the video into evidence. In response to the video, a presiding judge at the ICC stated, "We were unable to dispute the visual images or deny the sound."[68]

As with the videos submitted at the ICTY, this case also suggests how video can be captivating and persuasive even in the courtroom. It can simultaneously serve activist and evidentiary purposes. Although formalizing mechanisms solidify video's admissibility as evidence, the case of A Duty to Protect illustrates how images are amenable to various uses and conceptually flexible to fit different legal categorizations, just as they are open to interpretations in society at large. This video example also shows a good implementation of activist tactics that capitalize on the moment to advocate for prosecution of those who violated the rights of children in the DRC. The use of tactics when producing videos for the courtroom is also implicated in professionalization dynamics because it can extend the authority of human rights collectives in legal decision-making settings, which, in turn, can bring human rights voices into court and help strengthen human rights litigation.

## Video as Evidence

Contrary to the law and its "tendency towards hostility to novelty—novum omne cave,"[69] human rights collectives are more flexible about adopting new technologies in their work. Indeed, they feel that the desire and ability to innovate are what sets them apart from governmental and judicial human rights investigators. Josh Lyons, image analyst at HRW, sees these qualities as an advantage for human rights collectives: "I think we've done a phenomenal job, where, you know, a unique video comes in, a unique set of testimonies, and it clearly presents an opportunity to make sense of [the human rights situation] and make [a] powerful report out of it in a very short period of time. We can innovate and install [new software], test

a prototype on the fly in the context of that investigation. And we've done that routinely well. Really, you could never predict or anticipate that you would need that type of software and that type of workflow to address that need."[70] The flexible workflow and receptiveness to experimentation have been key for enlisting human rights collectives among the agents of video knowledge, in conjunction with other specialized forensic experts. Human rights collectives, though, have the advantage of being able to improvise in light of new forms of evidence and different sets of circumstances. In other words, their forensic expertise is most valuable when they use tactics to render eyewitness video meaningful as evidence.

In this context, Forensic Architecture has promoted *forensis* as a counter-hegemonic practice that inverts the forensic gaze of the state and its agents to monitor them and expose their wrongdoings.[71] A staffer told me that there is a "rebalancing of the relationships of power between states and militaries and security forces [on one end] and citizens and civil society [on the other]."[72] Open-source investigations have a general approach (e.g., answer a specific question, collect video evidence and other open-source data, analyze each piece of evidence, and establish relationships across the material). Yet the investigations are different from one another in terms of the techniques used and completion time. Their strength rests on the tactical approach: the flexibility to innovate depending on the topic and available material.

The tactics used are creative, improvisational, and "more flexible to adjust to perpetual mutation" in tune with any given situation.[73] The reliance on such tactics has enabled human rights collectives to consider a wide range of visual imagery as evidence whenever the appropriate circumstances present themselves. Lyons also noted: "It's not as if video was never considered to be a source of potential evidentiary material or that it wouldn't be relevant to a human rights investigation. It was just a very exotic and hard-to-come-by source of information. The fact that it's now a ubiquitous form of data, that in most cases we would need to work with, changes the approach from an ad hoc best-effort basis towards an obligation to have a professional methodology and workflow that can be scaled across the organization."[74] HRW and Amnesty are developing measures, restructuring, and training internally to accommodate the emerging forensic needs to work with eyewitness video. Staffers iterate that corroboration between testimony, eyewitness videos, and satellite images is becoming the gold standard for human rights investigations.[75]

The prevalent understanding is that eyewitness "video—embedded in research and advocacy—can help secure justice. It contributes to impartial, independent investigations, which are often the first step in providing accountability through domestic or international trials."[76] To this end, human rights collectives leverage technology with traditional techniques of checking the source and provenance of visual records to verify eyewitness footage and triangulate it with satellite data and on-the-ground investigations whenever possible. Although similar to the open-source investigations for journalism discussed in the previous chapter, visual investigations for courts need to meet higher criteria for legal evidence.

Images that demonstrate the verification process have thus become a regular component of a human rights report, serving as a legitimizing tactic for the forensic skills of human rights collectives. In an Amnesty report about mass graves in Burundi, for example, two Google Earth images are shown—before and after the incident—along with screenshots from an eyewitness video that helped establish the location of five separate graves within a larger area of disturbed earth (figure 4.11).[77]

**Figure 4.11**

Screenshot, *Burundi: Suspected Mass Graves of Victims of 11 December Violence*, Amnesty International, January 29, 2016, https://www.amnestyusa.org/files/burundibriefinga fr1633372016english2.pdf.

The views in the human rights community about what constitutes the evidentiary potential of videos mirror those of the courts covered in the case study of the ICTY. This mirroring is in part expected because many Amnesty and HRW staffers come with legal backgrounds—after all, lawyers founded both groups. Belkis Wille, an HRW researcher, believes that "if you have a video showing the massacre that the victims are talking about, it adds a lot of persuasiveness."[78] The assumption that video, by virtue of its form, is a documentary, persuasive, and mnemonic record par excellence is deeply engrained in the work of human rights collectives.

Video has thus become the standard response to concerns raised decades ago at the Nuremberg trials to find "credible evidence to establish incredible events."[79] According to Wille, "Video helps us confirm certain allegations we hear about. A school was bombed; you get testimony from three different people that the school was bombed, but until you see the video or photo evidence, it's hard to visualize the extent of the damage. Testimony can only go so far in, sort of, capturing that . . . so video evidence is invaluable to us in being able to go further."[80] Other staff members echo this understanding: "In general, video provides so much more detail that's much more powerful in many cases";[81] "video can [sometimes] enable you to tell a bigger story and to tell it more convincingly."[82] It is not surprising, then, that visual meaning making is at the heart of human rights work and central to video investigations ranging from Burundi to Syria to Myanmar.

The mastery of tactics by developing visual methodologies and skills as well as the legal understanding of evidence are turning human rights collectives into reliable practitioners with visual expertise that can benefit the law as well. This reliability comes at a time when legal institutions are struggling to "preserve and validate legal justice as sufficiently distinct from the popular [lay reasoning]" as a result of the unprecedented advent of visual media in court.[83] It is a common understanding that the law relies on its own rituals, institutional rules, and procedures to regulate legal reasoning. It also draws on other professions, as when an expert witness is called to testify. Grounded in a rhetorical tradition dismissive of images, the law has never really addressed the full complexity of visuals. Yet the changing media landscape demands attention to images. As a result, the law is turning to other parties who have developed professional standards for handling visual evidence. The proxy profession gives human rights collectives such authority.

Berkeley's Human Rights Center was founded in 1994 with a vision to make human rights legal practice more effective.[84] One of its programmatic areas has been technology and human rights. Since 2009, it has been organizing workshops—attended by prominent human rights collectives such as Amnesty, HRW, and WITNESS—and publishing reports on digital technologies in human rights practice. Alexa Koenig, the HRC's executive director, told me that the ICC was experiencing problems during the early prosecutions because of overreliance on NGO reports and witness testimonies. "While those survivors' stories are at the heart of these prosecutions, without corroborating information, the judges are just saying there is not enough to go on to actually support prosecution. So that began the work that we've been doing for the last eight years of asking what kinds of new technologies are helping us understand facts on the ground in conflict zones and in sites of human rights atrocity."[85] The HRC has convened gatherings of human rights practitioners to diagnose the areas of concern and think through possible solutions moving forward.

Sam Gregory remembers sitting at one of those workshops with members of the ICC in 2012, discussing the video evidence work done by WITNESS. "I was surprised that almost the first thing that he [the ICC legal staff member] said—and he subsequently said it publicly—was that they knew there was a storm coming of citizen documentation, and they really wanted to be grappling with it in a purposeful way."[86] Two years later the ICC established the Technology Advisory Board to assist the court's work with new technologies and forms of evidence. According to a former ICC prosecutor, "The court has recognized that new technologies have the potential to transform human rights investigations. And we're talking about the full range of technologies—video, satellite, and other forensic technologies—to investigate crimes and draw conclusions. So with the Advisory Board, the court is seeking to keep connected with these technologies, keep aware of them, see how they can be used, resolve legal issues that might arise, and so forth."[87] Because human rights collectives have been at the forefront of developing and implementing mechanisms for working with video evidence, they have secured a place on this board. Members of the HRC, Amnesty, HRW, and WITNESS are part of it. Among them is Lyons, who told me,

> The hard part legally that the ICC is grappling with at the moment is establishing the protocols to absorb and authenticate video and photographic material that has obviously been provided to them in a form that they would have never

accepted . . . before. Namely, photographic material that has no established chain of custody: we don't know who took it; we don't necessarily know who handled it; and we don't know much about the camera because the metadata [have] been stripped. I mean, traditionally, that evidence would just be thrown out. Now, with the explosion of social media and with the proliferation of citizen videos, we have new techniques—in many ways improvised, ad hoc, and highly experimental techniques—for establishing the authenticity and the verification of these videos where we don't know anything about the recorder or about the camera.[88]

The need to improvise to adjust to the current moment is at the heart of the tactics that human rights collectives use when working with video. The law, because of its own lack of professional visual standards, benefits from such tactics that purposefully import the professional legal logic to video-assessment techniques.

At the same time, being part of the roster of independent image experts consulting with and supporting the work of the ICC further validates this special skill set among human rights collectives. The proxy profession turns them into go-to specialists who can guide human rights courts on how to address and regulate visual judgment. This process of boundary renegotiation between the law and the wider culture signals a blending and redefinition of the markers between legal judgment and video meaning making.

## Custom Technology

The need for video skills in the courtroom is due not just to the advent of technology but also to the economic and sociopolitical challenges facing the courts. Video is a cheaper form of evidence at times when witness protection is becoming costly. Moreover, fewer journalists and civil society actors are willing to testify in court, where they might, for example, verify footage. Whiting commented on this trend:

> With the ICTY, journalists and NGOs were generally very cooperative, but I think it was because of two reasons. First of all, it was the first court [of its kind], so everybody was kind of excited about it and wanted to be involved and thought of it as a kind of one-off. The second thing is that a lot of the cases at the ICTY were done many years after the conflict, so people didn't feel any kind of danger from later testifying. But with the ICC that has changed. First of all, the ICC gets involved in investigations and conflicts that are still unfolding, and obviously it's a routine player. It investigates conflict after conflict. Then, the second thing is that this is no longer a one-off thing, and so civil society, NGOs, and journalists

started to think: "Well, hang on, if we keep cooperating with these courts in these investigations, it's going to endanger our mission." So they just became much more cautious about their cooperation.[89]

Personal safety and the possibility of inflicting safety risks on their sources are common reasons reporters and civil society groups decline to testify in court. Moreover, journalists, especially in the United States, believe that giving court testimony violates journalism's professional standards by making them pick a side.[90] Hiatt raises another important point, "When witnesses do testify, corroboration from open sources helps make them safer. A lone witness is a vulnerable witness. But when witness testimony is backed by corroboration from other sources, the witness is bolstered and supported."[91]

Wendy Betts, director of the eyeWitness to Atrocities project at the International Bar Association, echoed the need for open-source information to provide additional layers of corroboration. "We've just seen a change in the accessibility of mobile cameras to ordinary citizens that shifts the availability of the sources of information. [Human rights] trials have always relied very heavily on witness statements, and I don't think those will be replaced. But, I think, we're seeing increasing calls for additional sources of information either to corroborate the witness statements or to use at times when the statements are either too dangerous for the witness or too questionable."[92] Technological developments and the challenges of obtaining witness testimony or corroborating it in times of growing forensic sensibility contribute to shifting legal doctrines and practices that further accommodate eyewitness video. As a result, visual verification has become a skill in demand in various legal domains.

Traditional admissibility criteria remain—video needs to be reliable, relevant, and of good quality (e.g., blurry images and distorted sound can be grounds for rejecting the evidence). There is an emerging trend toward authentication through technology as a first step in video investigation— either video that is self-authenticated through its metadata or multiple eyewitness videos of the same incident from different angles that corroborate each other. As a classical example, Raja Althaibani, Middle East and North Africa program coordinator at WITNESS, mentioned a case against the Israeli military in 2010 when the prosecution used videos from different activist and news cameras in an attempt to prove the murder of a demonstrator in Bil'in.[93]

Human rights collectives have intervened in the technological space not only through their forensic skills but also by creating platforms and tools to

streamline verification processes. In particular, they have invested in technical solutions to use metadata securely as a formal mechanism for video's evidentiary capacity. According to Morgan Hargrave, former systems-change coordinator at WITNESS,

> Metadata has [*sic*] a bad name these days in human rights circles because it's how we are being tracked and spied on, but it's actually very useful. . . . The truth is video, whether through metadata, facial recognition, or any video analysis, is being used against us in so many ways. All the fears you have of how people are going to use it, they are already doing it. So we are trying to use tools to sort of pick and identify people who are uploading videos with human rights content and hit them with guidance. . . . We are not ahead of the Department of Defense, the NSA [National Security Agency], or any number of other actors. We are always playing catch-up.[94]

Hargrave's statement speaks to the heart of any activist endeavors: activism needs to develop new tactics constantly to destabilize the power dynamics that violate human rights. Military and law enforcement strategies have long included the "mastery of places through sight" to exercise control.[95] Current surveillance practices are just the latest iteration of such strategies. Working within the rules of the social system and finding creative solutions for how to bypass and challenge potential abusive effects are at the core of human rights activist tactics. As part of their efforts to professionalize video activism, however, human rights collectives also turn to strategies to control for the variability of circumstances.

To minimize safety or surveillance risks, for example, WITNESS has partnered with legal professionals and technology developers to design and launch tools that can use metadata in beneficial ways, such as CameraV and its reboot as the Proof Mode app, the latest iteration of the InformaCam platform set up with the Guardian Project (see chapter 3). This Android-based mobile app has two recording modes: one without the identifiable information and another with securely stored metadata, which can be sent to a trusted party through encrypted channels for anonymous communication. Proof Mode enables the app to run in the background, so it can store videos and images without registering them in the phone gallery. This ability is particularly useful in case of an uncomfortable encounter with police. WITNESS used the experiences of its partners, on-the-ground activists in the United States and Brazil who systematically document police violence, to address video activist needs when designing the app. These verification tools can be seen as part of an emerging set of strategies that shape video

activism ahead of time through standardized technologies to play to the modalities of the law.

WITNESS's consultant on the initial version of InformaCam was the International Bar Association, which implemented the lessons from this project to launch its own eyeWitness to Atrocities app. Like CameraV and Proof Mode, this app records, embeds, and encrypts information, such as GPS coordinates, time, date, and camera movements, while capturing the video. It also calculates and compares the pixels at the time of recording with the time of receiving, so it can alert users to potential modifications. The videos captured by this app are sent securely to a repository maintained by the eyeWitness project, thus creating a trusted chain of custody. The eyeWitness app serves as a registry of eyewitness videos, which, if and when relevant, can be used as evidence in human rights prosecutions.

Although these apps are free and available to anyone, they predominantly serve a specialized niche, most notably human rights activists already connected to wider activist networks that are savvy about technology. Not any bystander who happens to be a witness to a crime can benefit from these tools. A person needs to know about the existence of the app, download it to their phone, be interested in recording potential visual evidence, and learn how to use the app well in advance. Freeman of the ICC's Technology Advisory Board reflected on these apps: "You can't force adoption on people. . . . People use the products they like to use, and you aren't going to get people to move away from using Facebook or Twitter or whatever they are already using. [The eyeWitness project] sort of pivoted towards actually helping people with the training, making it more of a specific tool used by actual human rights actors on the ground who know why they are using it."[96]

Verification apps such as Proof Mode and eyeWitness are part of the emerging strategic patterns for human rights activism that specialize in how to tailor eyewitness videos to fit legal criteria. Through technology development, training, and partnership, human rights collectives foster a network of human rights activists and lawyers, which is ultimately the reason behind the success stories. For example, TRIAL International (an NGO fighting impunity for international crimes and assisting human rights victims), WITNESS, and the eyeWitness to Atrocities project partnered to support victims' lawyers in collecting video footage that was used in a military tribunal in Bukavu, DRC, the first use of video evidence in the Congolese

judiciary.[97] Developing custom technologies that respond to the growing needs for video verification in human rights investigations and prosecutions and the parallel nurturing of human rights networks enable human rights collectives to further partake in the production of legal truths.

### Video as Evidence Training

Despite the move toward self-authenticating videos, people remain a central component in the use of video as evidence. According to Kelly Matheson, senior attorney and program manager at WITNESS,

> Technology can help a lot to allow you to enhance the reliability of video: to organize, manage, analyze, and search your videos. . . . I think technology is going to play a very important role, especially as we have more and more video that is being used for human rights. But there is still a limitation. A person out there, on the scene, on the front line is still going to have to decide what to put in the frame. They are still going to have to decide the ethics of sharing the video. They are still going to have to decide whether it's safe to share it. And those are all human decisions that technology isn't going to be able to make for us. So people really have to still understand how to document with video.[98]

Technology—whether a phone camera or a verification app—is a tool requiring a certain degree of specialized knowledge for it to be used effectively for legal goals. Shooting video as evidence is a combination of filmmaking skills and a basic understanding of what constitutes legal evidence and how crimes are proved in court.

Human rights collectives invest in nurturing networks of citizens and activists—in the countries in which they operate and online—to which they can turn for assistance in finding information or verifying content. For example, Amnesty has conducted such training in Nigeria. Daniel Eyre, a former Amnesty researcher in this country, told me: "One thing that we've done in a piecemeal way, from time to time, is to try to train and enable human rights defenders to collect video evidence themselves, to take video footage. So, just as we, at Amnesty, are trying to expand our own production of video, video interviews, and video in the places that we go to, we're also encouraging human rights defenders or enabling them to be able to take video footage of either violations or witness statements or the context in which violations happen."[99] Human rights collectives are involved in supporting activists already engaged in video making by training them how to take videos that meet the threshold of evidence and are relevant in

a legal case. WITNESS has developed a specialized "video as evidence" program, training, and curriculum. The program is active in the Middle East, Brazil, Ukraine, India, and the United States.

According to WITNESS, video has the potential to democratize the evidence-gathering process. Priscila Neri thinks

> that the cell phone and the cell phone camera have proven to be very significant democratizing force for citizens to collect evidence themselves. So if we think about a community where there have been systematic police extrajudicial killings, for example, the police wouldn't be too vested in collecting that evidence because it's evidence that would incriminate them. So there's not a lot of political will; there's not a lot of movement on the collection of evidence. Now, you have at least ten YouTube clips when something like this happens, of either the incident itself or the aftermath or the testimonies.[100]

As a senior program manager for Latin America, Neri works on issues around police violence in Brazil. She helps train activists and members of communities most directly affected by these crimes on how to take tactical videos with a specific goal and for a particular audience so that the videos are not merely exposure of illegal behavior but catalysts for justice. The training thus addresses the specific needs of video activists.

For example, Neri has observed a common situation, especially during protests, when people intuitively record the injustice, disregarding vital information that can help qualify the video as evidence. "You're at a protest; a cop starts beating someone, and you have, like, 57 cameras on that one cop beating that one protestor. Then, right over there, no one's filming the key commander giving instructions to all the other cops to do the same. So no one has that image. So how can we coordinate better so that we have better coverage, . . . we aren't duplicating, but . . . we are thinking more strategically about the production and utilization of that content?"[101] What Neri describes is the necessity for diversified tactics that respond to the situation at hand, such as police violence during protests. Activists need to improve their recording tactics, so they can better respond to the strategies of those in power. Implicit in Neri's statement is the understanding that activism is no longer about the authenticity of being on the street to take a stance against injustice. The purposeful witnessing and recording act has the potential to contribute to social change.[102] In other words, specialized tactics are crucial for leveraging the evidentiary potential of video. WITNESS thus brings together human rights attorneys, public defenders,

and activists for video training, further contributing to the blending of the law and activism around video.

WITNESS released the *Video as Evidence Field Guide* in the summer of 2015, and it has updated it since then. The guide incorporates step-by-step guidelines on capturing, storing, and sharing video evidence as well as developing a collection plan on gathering video evidence; an overview of key legal principles; risk and safety considerations; and lessons from the field—such as the usage of video at the ICTY. The guide is a culmination of the training that WITNESS has conducted over the years. It was developed in consultation with international human rights attorneys and courts. The core premise is that video activists need to learn tactics relative to the intended audience. According to Matheson,

> When you are collecting video for the media or going out to make a film about an issue, you will film differently than you film for documentation. A lot of it goes back to the techniques you will use. With traditional filmmaking, you are not going to stand in front of the camera and say every time you do a scene: "This is Kelly Matheson; it's September 8, 2016; I work for Witness.org, and if this video is relevant to your investigations, you can contact me at this number. What I'm about to film is a mass grave that we saw in Cambodia." And then how I would film the mass grave is very different. For documentation, I would film it from all sides; I would film the wide, medium, and close-up shots, just like the filmmaker would do, but I would literally map out the crime scene with the camera. I would map out the mass grave. The filmmakers are just going to get the shots they need for their story and move on to getting the next shot. While you're still trying to tell a story with your video documentation, you're trying to tell it as video evidence, not [as] video storytelling. And you're trying to tell it in a way that a judge or a jury can assess exactly what is going on on the ground instead of telling it in a compelling story-driven sort of way.[103]

Matheson describes video tactics that incorporate the professional logic of the law. She draws clear boundaries between shooting video as either news or legal evidence or documentary film. To increase the likelihood of evidentiary use in court, for example, a video activist should record the crime scene in a systematic and detailed manner, contrary to visual storytelling, where the focus is on how to record with a compelling sense of aesthetics. As a result, an establishing shot of a location may be sufficient for documentary filmmaking, but recording the location from different positions and angles works better for legal evidence.

The tactics associated with video evidence, as emphasized by WITNESS's guides and training, vary depending on the human rights violation. In the

context of an unfolding incident, such as police violence, it may be intuitive to film a body lying on the ground, but stepping back to capture a badge number, a license plate, or key location marker does not come naturally. The latter shots, however, could be essential to proving a crime. Therefore, the tactics for capturing video evidence include understanding basic legal principles.

> With excessive police violence, in most jurisdictions you have to prove that the officer was on duty. You have to prove that the force was excessive. And you have to prove that he or she intended to use excessive force. . . . Okay, so, how do you prove that the officer was on duty? Easy—badge number, cop car, weapons, boots, insignias . . . there are any number of ways to show that an officer is on duty. But how do you show the officer intended to inflict excessive harm? Now you need to get more creative. So in order to prove a crime, we break a crime into the elements, and we create a shot list for each element. . . . That's how you gather relevant information that's going to help an attorney. Showing intent is harder than showing a crime.[104]

Central to training on video as evidence is teaching activists what constitutes video's reliability and relevance in human rights trials and helping lawyers understand filmmaking language. Reliability in video is often easier to teach because it copies the professional standards and strategies of the law (e.g., a technological solution can help raise the authenticity of the material, whereas a mere shot of a badge number can be sufficient to prove the identity of a police officer on duty). Relevance is where tactics are essential because it requires creative thinking and experimentation to establish the legal status of the video in court. The training in video tactics, then, brings activism in direct conversation with the law. In doing so, it shapes activism in ways that comply with and take advantage of the professional legal parameters.

## The Proxy Profession and the Future of Legal Standards for Video

This chapter has demonstrated how video has penetrated the law, triggering investigations, prompting legal judgments, and generating lasting memories of human rights crimes. As human rights courts are integrating visual technologies, video is attaining legal legitimacy and becoming centrally implicated in the witnessing process in and out of the courtroom. Incorporating video as evidence at the ICTY routinized video's legal use for human rights, setting a precedent both for other international human rights courts

such as the ICC and for human rights collectives. The proliferation of digital technologies and platforms, the difficulties in obtaining testimonies and cooperation from journalists and civil society actors, and ongoing risks to witnesses have further elevated the legal status of video, demanding doctrines and practices that can account for new modes of producing and qualifying digital evidence, of which video is a component.

Commonly understood as a powerful medium, video draws its evidentiary contributions from the same qualities it holds in the wider public culture. In court, just like elsewhere, video figures as a stable and vivid documentary record of the past, an important persuasive device, and an authoritative mnemonic tool. As courts institutionalize the instrumentality of images, they signal that judicial authority no longer rests exclusively on words. The courtroom is becoming a place of deliberative and visual judgment, urging the law to draw on different experts to sort through the admissibility of new forms of evidence to regulate its professional boundaries.

This chapter has illustrated how the proxy profession helps human rights collectives tap more prominently into legal spaces. Staff members now serve on legal advisory boards, design technologies, develop standards and protocols, and conduct training to maximize video's potential as evidence. They also occasionally produce videos. Human rights collectives are thus becoming viable agents of video knowledge that human rights courts can use. The proxy profession is also actively shaping the future of visual legal standards. As Koenig of the HRC told me:

> One of my big concerns . . . is that some of these video explainers are so convincing that I think there is a twofold risk with judges. First that they would either find the videos overly convincing and will not know how to probe and ask the right questions of the underlying content because they would find it so convincing. Or, two, that they are going to undervalue that information, and they are going to say, "I don't know how to evaluate this, and so I really can't give it any weight in a court of law." So I do think the next effort is going to have to be preparing judges for the kinds of open-source information that human rights advocates around the world are increasingly collecting.[105]

To that end, HRC, which has a very different mandate than traditional human rights collectives, has spearheaded work on international protocols for open-source evidence, including video.

Taking as examples international protocols on how to investigate torture, extrajudicial killings, and sexual violence, HRC has been working on

the International Protocol on Open Source Investigations, a project supported by the Office of the UN High Commissioner for Human Rights. Freeman leads the team drafting the protocol, which will set minimum international legal standards for open-source evidence. As part of this project, HRC has been developing three separate training programs for lawyers and investigators, civil society actors with less resources, and judges, hoping for a wide adoption of the protocol that will bring clarity on these new forms of evidence.[106]

Alexa Koenig of the HRC, Sam Dubberley of Amnesty, and Daragh Murray of the University of Essex (Amnesty's partner for the Digital Verification Corps) coedited the volume *Digital Witness* on open-source information for human rights investigation, documentation, and accountability, where video features prominently.[107] Publications like this help create a sense of professional community, further validating the proxy profession, whose specialized sets of practices put the knowledge provided by video in service of human rights across institutions such as the law.

Borrowing from de Certeau,[108] this chapter has demonstrated how the effects of the proxy profession in the law can be traced by looking at the strategies and tactics for video activism that enable human rights collectives to partake in the development of visual legal standards and the production of legal knowledge. The proxy profession relies on strategies (e.g., developing standardized verification apps) and tactics (e.g., using flexible approaches to open-source investigation that account for the particularities of each situation) to render video activism appropriate for legal decision-making contexts. By doing so, it is well positioned to extend the spaces where activist video can potentially make a difference.

I suggest that, as in the dynamics observed in journalism (chapter 3), the proxy profession is better able to bring diverse human rights voices to court through its tactical approaches. When it turns to strategies, however, it can limit the range of voices to those who are already part of the wider human rights NGO networks (e.g., local activist groups that work with the more prominent and resourceful global human rights collectives). The mediating function of the proxy profession is thus visible in its interactions with legal environments as well: it brokers arrangements between eyewitnesses, activists, and courts as it develops methodologies and standards through which human rights video attains legal prominence, meaning, and relevance.

# 5 Human Rights Video in Political Advocacy

Video has become an integral component of the political advocacy tool-kit. Communication tactics—whether distributing pamphlets, lobbying governments, or crafting campaigns and appeals—have been the oxygen of the global human rights movement, whose work rests on the premise that violations need to be investigated and exposed to be stopped. Because visuals have long been assumed to generate an intimacy connecting the viewer with suffering, wide-ranging images have been central to endeavors to mobilize publics on human rights issues. In this sense, the use of video in political advocacy draws from a long-standing deployment of visuals in social change projects (as discussed in chapter 2). Tackling the current role and shape of human rights video in political advocacy is at the heart of this chapter.

The rise of digital video in its various manifestations has influenced the strategies and tactics of activists working for or with global human rights collectives. It has also had an impact in the kind of institutional spaces that have long denied images a status on par with words. Video is now increasingly being incorporated as a tool for gathering evidence or a mode of information relay on its own terms, not only by journalists and courts but also by government agencies and intergovernmental bodies working on humanitarian and human rights issues. In the context of the Syrian conflict, for example, video provided the core of the news coverage and the key evidence about chemical weapon attacks in the country obtained by the US Senate Intelligence Committee and discussed at a congressional hearing.[1] Similarly, the UN Commission of Inquiry on Syria relied on video evidence in its reports documenting various human rights violations.[2] From Syria to Burundi to Myanmar, eyewitness video is increasingly harnessed for its

evidentiary, policy, and advocacy potential across institutions, which, in turn, lowers the barriers to entry in institutional spaces such as the United Nations for human rights collectives as the new visual experts.[3]

This chapter briefly discusses the changing role of images in institutional politics to highlight the possibilities that human rights video is creating for political advocacy. It then maps the practical reasons behind the increasing use of video as a standard advocacy tool, showing how human rights collectives have turned the institutionalization of video into an opportunity to summon not only publics but also institutional stakeholders as key audiences for their videos. Such usage draws from video's perceived ability to mobilize emotions toward political involvement, putting forward the idea that *feeling is believing*. Borrowing from the tradition of video activism, human rights collectives now produce strategic videos, which are tailored to targeted audiences and highlight institutional solutions even when they pursue broader public engagement. As a result, the unfolding of the proxy profession in political advocacy domains ends up transforming the tactics long associated with video activism, moving them into the territory of strategies, as defined by Michel de Certeau.[4] In the process, I argue, institutional strategies are becoming central in defining which human rights violations warrant treatment and how.

## Images in Institutional Politics

Although notions and forms of visuality have long been central to political engagement and an active body politic, speech and conversation have been idealized as the standard that nurtures democratic politics. Images, commonly understood to appeal to the emotions and imagination, have traditionally been pushed aside to accommodate the centrality of words as vehicles of reason in prevailing democratic institutional designs, where the ability to feel is subordinated to the faculty of reason. Rational knowledge has manifested "in the entire institutional realm of modern society."[5] This normative basis for democratic politics largely seals the authority of written texts and deliberations.

It should be no surprise, therefore, that the study of political communication has long presumed a dissonance between emotion and reason, relegating images to the realm of spectacle or private consumption while reserving the spaces of political participation and action for words. As

George Marcus notes, "We seem to have settled on the need to secure a politics without emotion if we are to realize a politics of judgment and justice."[6] As we know all too well by now, emotions are everywhere in the sphere of politics, and so are images as one of their key vehicles. Barbie Zelizer thus argues that "a reliance on images has been intertwined with the political domain for as long as images have been in existence."[7] In other words, visuals have shaped political debates in spite of the logic of Western modernity insisting that images are detrimental to a healthy body politic.

The import of images in politics has taken three predominant shapes—as a tool for control and surveillance,[8] as a tool for persuasion or propaganda,[9] and as a tool that stimulates public debate.[10] These functions have generated a binary understanding of images: they have been conceived either as a form of evidence—promoted in particular by institutionally sanctioned ways of knowing that impose the state's mode of seeing—or as vehicles of imagination, emotion, and memory. Yet images navigate these evidentiary and emotional terrains simultaneously, exceeding their presumed representational logics and challenging assumptions about the parameters under which deliberative democracy works. Their relational logic, sensory richness, imaginative appeal, and emotional resonance complicate their sidelined status. It therefore makes sense that to maintain the normative ideal, images have been granted an institutional standing inferior to words.

Institutional decision-making processes and political campaigning typically focus on carefully constructed arguments or messages, in which images are assumed to serve as an illustration of or supplement to the textual counterpart, as in journalism and the law. When images are used extensively in service of politics, institutional logics normally downplay the complexity of visual epistemologies, insisting that, for example, an evidentiary image can be stripped of its emotional dimensions. By contrast, images have long constituted an activist tool of choice in the struggles for human rights precisely because of their emotional appeal and their intricacy as a mode of information relay.

The turn to emotions in the humanities and social sciences in the 2000s has challenged the long-standing label for emotion as "a troublemaker, intruding where it does not belong and undermining the undisturbed use of our deliberative capacity."[11] The turn instead abandons the spurious classification between reason and emotion by highlighting how their interplay underpins our cognitive skills, shaping political engagement.[12]

The unfolding institutionalization of human rights video demands urgent engagement with visual forms of knowledge production as important vehicles of emotions across political advocacy domains.

The wide availability of visual technologies and platforms that decrease the costs and simplify the ways to gather, store, display, and distribute content has propelled digital video to the forefront of today's public culture. Human rights collectives believe that "pictures now have supremacy over text"[13] and that "everyone is turning to the visual."[14] According to Raja Althaibani, Middle East and North Africa program coordinator at WITNESS, "We've seen that the more traditional entities and organizations, like the UN, for example, have become far more receptive to using videos. So they began integrating video and using the videos that are being produced [by others] to help their investigations. . . . They have their researchers, who are constantly collecting testimonies, and now . . . they are also collecting video [and] using it to corroborate [other evidence]."[15]

The turn to video across political advocacy milieus is occurring not just because of its sheer proliferation. When traditional evidentiary materials are insufficient or simply lacking—usually due to the inability to enter a conflict zone—using an available video becomes a necessity. Growing concerns for the safety of UN workers, human rights investigators, and journalists, paired with frequent bans on entering countries where violations happen (as in Myanmar, Iran, and Syria), contribute to shifting practices that further accommodate video. Christoph Koettl, former emergency response manager at Amnesty, described this change well:

> I worked for years with satellite images to document human rights violations, especially in areas that we couldn't access properly. So when the Syrian uprising started . . . and developed into an armed conflict, we started working a little bit with satellite images. [But] it was completely useless because the violations that happened were disappearances, tortures, extrajudicial executions, none of which we [could] see in satellite images. At the same time, you see suddenly hundreds and thousands of videos on YouTube. So . . . that was, in a way, a game changer for my work and for human rights work generally. . . . People really picked this up.[16]

As technological, cultural, and sociopolitical circumstances are urging institutions to incorporate video as part of their workflows, video is becoming institutionalized as a form of knowledge in political advocacy settings (not just in journalism and the law). Video now cuts across the mechanisms

that investigate, document, present, and legitimize human rights claims, and human rights collectives are becoming central to the shaping of video.

## The Turn to Video in Human Rights Advocacy

The advent of social media and mobile phones with camera features in the mid-2000s parallels the full integration of video as an advocacy tool by human rights collectives. Key here were WITNESS, HRW, and Amnesty, although each employed slightly different approaches in its integration of video. WITNESS, founded on the premise that video can be a democratic tool for human rights, is unlike HRW and Amnesty in that it does not engage in human rights investigations. It instead develops guiding mechanisms and tools for human rights video activism, teaching activists globally how to leverage video's potential for social change. According to its program director, WITNESS's approach to video has evolved over the years, following other trends in advocacy.[17] WITNESS initially distributed cameras to human rights activists, who then produced the videos. Later it started working with and training activists in more sophisticated methods for the production of goal-oriented and audience-driven videos, moving on from simplified notions of video as a transparent medium for human rights and social change.[18]

This was around the time that HRW and Amnesty, the oldest and the most recognizable global human rights collectives, turned to multimedia more seriously, implementing video in their campaigning and advocacy work. HRW and Amnesty resemble traditional news media and legal environments in that they have had to adapt to the digital landscape. Carroll Bogert, a former executive at HRW, told me, "We sort of sneaked in [the Multimedia Program] slowly to avoid internal opposition."[19] HRW started to commission photographers regularly in the early 2000s and turned to video more noticeably in the early 2010s. During this time, the media staff grew from two to thirty. Because the organization takes pride in its human rights research and advocacy work, the assumption was that video making would distract it from its core mission. HRW's legal origin accounts for how it thought of visuals for a long time. Today, however, it not only produces video for every report but also occasionally releases just video.

An advocacy video about lead poisoning from gold mining in Nigeria in 2012 is illustrative of what has now become a common practice. HRW

screened this video at a conference of medical professionals in Abuja. The video features footage from the daily life in the gold mines. One scene shows a man crushing and grinding gold. It also portrays the pervasiveness of the toxic dust. The bright sunlight outside stands in sharp contrast to the shadows and dust inside. Another gold miner testifies to how he lost two of his children because of lead poisoning. A twenty-year-old resident of a gold-mining village explains in tears that three of her children died. The close-up shots of these testimonial acts add an emotional layer to the information provided by the voice-over narrator—400 children have already died from lead poisoning in the area, and 1,500 are in desperate need of treatment. The video contributed to successful advocacy efforts to convince the Nigerian government to allocate $4 million to clean up the villages.

HRW has recently turned toward public engagement via video as well, signaling an important change from its deeply engrained institutional advocacy tradition. Liba Beyer, who launched HRW's first campaigning unit, told me, "We have lost the battle of hearts and minds over human rights values." HRW sees the global rise of authoritarian populism and information disorders as an immediate and pressing threat to the public resonance of human rights narratives. The common perception is that "the [mainstream news] media are no longer the gatekeepers to public opinion," so it is becoming important to break into the information bubbles of social media.[20] The best way to do this, from HRW's perspective, is through video, echoing the values long associated with human rights video activism. Yet institutional and professional dynamics demand pragmatic and measurable solutions, urging HRW to turn to marketing strategies and microtargeting on social media even as it produces video to engage broader publics on the importance of human rights norms and values.

Amnesty experienced internal changes similar to those at HRW. After all, it, too, was founded by a lawyer. Although it produced its first film, *More Than a Million Years*—about political prisoners in Indonesia—as early as 1976, it long prioritized text-based practices in its campaigning work, such as written reports, slogans, and letters. The cover of Amnesty's first annual report in 1961–1962, for example, had no visuals (figure 5.1), which would be unheard of today for a human rights report. When used, images typically supplemented the written material, as illustrated by the slogans in an Amnesty-led demonstration in Denmark in 1972 about political violence in Paraguay (figure 5.2). Visual media, however, became a prominent feature

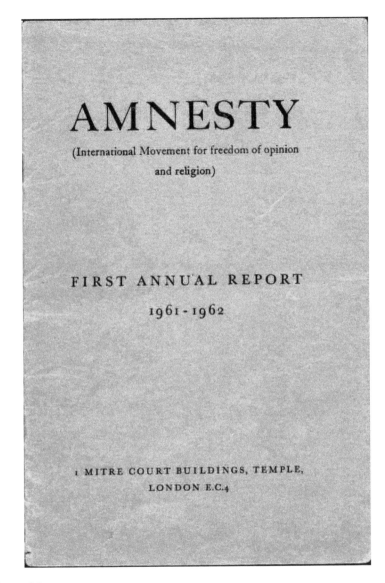

**Figure 5.1**
Amnesty (International Movement for Freedom of Opinion and Religion), *First Annual Report 1961–1962.*

**Figure 5.2**
Amnesty Denmark Paraguay campaign, 1972. The poster in the middle says, "Amnesty International / a movement to fight persecution and protect human rights"; the poster on the left says, "Død efter tortur [dead after torture]: Juan J. Farias—1969, Juan Benitez—1967, G. Gamaria—1968 i Paraguay [in Paraguay]." From Amnesty's Asset Bank (unrestricted use), May 16, 2011, https://adam.amnesty.org/asset-bank /action/viewAsset?id=133434&index=0&total=1&view=viewSearchItem.

of Amnesty's work over time. This collective incorporated photography as a regular component of investigations and campaigns in the late 1970s, and the more serious use of video started in the late 1990s.[21]

Amnesty, though, is still working through the internal disagreements about the role of visual media in human rights work. The long-privileged status of words is evident in an explanation provided to me by Morton Winston, a former chair of Amnesty's board of directors in the United States: "While [the visual] is certainly valuable from the point of view of raising public awareness, it is not really a good substitute for the carefully written and edited reports prepared . . . for elite audiences."[22] During his time at Amnesty as the audiovisual director, Paul Woolwich observed a gradual shift toward video: "[The] audiovisual was always a second thought. The most important thing was getting the report out, getting the press release, and then as an afterthought they'd think, 'What if we got a video that

we could put out somewhere?' . . . That is all now changing, of course. . . .
Campaigners and researchers have realized that if they want the fruits of
their labors to get noticed, they will need to work hand in glove with us
[the Audiovisual Production Unit] because we can assist that and enable
it."[23] Amnesty is now diversifying its video work, producing and dissemi-
nating human rights videos to reach publics and political stakeholders. It
is also turning to marketing strategies to appeal to audiences online, using
video to explain the nature of rights, not just to tell human rights sto-
ries. Overall, the videos range from campaigning to educational content to
those intended to help Amnesty grow its membership.[24]

The internal struggles around visuals in the human rights community
are testament to the residues of the Western manifestation of modernity
that linger in the tension between words and images in the early work of
HRW and Amnesty, although with certain distinctions. To be perceived as
collectives that did rigorous work, they privileged words. Images were seen
as good for visibility, marketing, and fund-raising but not as suitable mate-
rials for political advocacy. Despite venerating video's potential early on,
WITNESS also failed to account for the particularities of video as a unique
mode of knowledge production. It initially accepted the notion that seeing
is believing, by which the mere documentation of the human rights viola-
tion was a sufficient advocacy undertaking.

These three human rights collectives started thinking about video advo-
cacy in systematic and rigorous ways in the mid-2000s. According to Sam
Gregory, program director at WITNESS, "Activists needed training to operate
cameras, and they needed strategic guidance on where the audiences were
for the video they shot, and how to incorporate video into their attempts
to influence those audiences. They needed support through the process of
production and post-production, and in the implementation of distribu-
tion and advocacy plans with the finished video."[25] This was also around
the time that HRW and Amnesty created separate multimedia units and
hired specialized staff to produce advocacy videos and to train the research
teams on how to incorporate video strategically as part of their fieldwork.

These developments indicate that video is no longer simply a visual aid
for words. It is instead becoming a central human rights tool for politi-
cal advocacy across institutional domains and media platforms, where it
is expected to reach diverse audiences for a range of purposes. Account-
ing for the specific role and scope of video in human rights advocacy has

thus become a necessity for the human rights community. I attribute the human rights collectives' easing of attitudes toward video in the context of political advocacy to interlinked technological, cultural, and economic developments.

Technological advancements have propelled digital video to the forefront of the current information environment. CISCO calculates that video traffic constitutes 75 percent of the entire internet traffic globally.[26] More than half of the world's population is now connected to the internet,[27] so the assumption is that "you can't get by without visuals."[28] As the information landscape is becoming more visual, video has become an expected mode of information relay. Institutions and publics are becoming accustomed to it. Turning to video is therefore seen as a necessity to remain a relevant player in the current media environment. According to Elizabeth Meckes, former head of digital engagement at Amnesty, "[Video] is just how people expect to consume their content now. . . . If video [isn't] one of our chosen mediums for expressing things, we're falling further and further behind."[29] Similarly, Pierre Bairin, former multimedia director at HRW, believes that "people might not consume the text at all. So if we don't have it on video, they won't know about the issue."[30]

Every technology and medium comes with its own set of affordances, assumptions, and protocols for how and where it can be used.[31] Michael Newman thinks of online video today as an "interstitial form": it is short, it is concise, and it can fill in "gaps between other activities." In other words, online video "tends to maximize its appealing qualities while minimizing its length."[32] It is therefore suitable for the information overload that characterizes today's media ecology. In this context, Param-Preet Singh, a senior counsel of HRW International Justice Program, told me, "We want to get to diplomats who have a million other countries to cover. You know, they're looking at something on their phone, they're scrolling through, and they're more likely to click on the video if it's going to give them a three- or five-minute summation of a crisis with, you know, the next steps forward. It's much more efficient."[33] Video is now the preferred mode of media advocacy geared toward institutional stakeholders with packed schedules.

A short length, typically three to five minutes, has become the gold standard for video advocacy. Human rights collectives explain video's effectiveness by referencing its length as if it were an inalienable quality. In the words of Belkis Wille, HRW researcher, "[Government officials and

legislators] don't have time to read the thirty-page report. They don't even have time to read the two-page press release. [So] I think that three-minute video gets to the heart of what we're trying to do much more effectively."[34] Its short length sets video apart from written documents at times when speed enjoys social prominence.[35] The widely accepted qualities of video as brief and succinct thus correspond to unfolding cultural expectations about how information is disseminated and consumed in the current moment. They offer a formulaic parallel to highlight the key findings of a human rights investigation, serving as a shortcut to understanding an issue. For microtargeting online, the optimal length is even shorter because internal experiments with message testing suggest that the thirty-second video is the best for grabbing attention on social media platforms such as Facebook and Twitter.[36]

Work in current capitalist systems is premised on a neoliberal logic and thus measured by efficiency standards, which resonate well with the kind of video logic that human rights collectives seem to be embracing in their advocacy efforts. Video is perceived as capable of securing the attention of publics and political stakeholders who are supposedly always on the move, performing many tasks at once. Yet although a short video may provide a pragmatic solution for grabbing people's attention, it goes contrary to the complicated systematic nature of human rights that demands thorough critical engagement. In this context, human rights video activism moves away from its iteration as an activist craft that encourages complex story-telling and closer to marketing practices that highlight brief and strategic messaging.

Video is also a financially viable option for human rights advocacy. In the words of Bairin, "It's much more useful to assign video because then you can distribute it. We own the copyright of the video. We can give it to everybody."[37] This is how video differs from photography, for example. According to Emma Daly, communications director at HRW, "When we work with still photographers, typically we have one or two images for distribution, but obviously [the photographers] retain the copyright. When we hire a videographer, we make a deal where we own the five minutes of video. We own it outright. We can distribute [it]."[38] Similarly, WIT-NESS used to share the copyright of the footage produced by local activist groups to whom it provided equipment and video support. Video provides human rights collectives with control over the material, which they can

then license to others. Philippa Ellerton, former audiovisual archivist at Amnesty, believes that "[video] is a valuable commodity. We often have to buy footage from other parties, and nobody thinks twice about charging Amnesty for it. So I work quite hard to establish in what circumstances we're going to sell footage and in what circumstances we're going to give it away for free."[39]

These examples illustrate how video as a tool for political advocacy is being shaped by the overall marketization streams in humanitarian and human rights practice.[40] Human rights collectives see video as an effective advocacy tool that helps them target specialized audiences: "We can go direct to audiences; we can find our own audiences. We can address governments; we can address legislators. We can address ordinary people with the messages we want to put out there ourselves through our own networks. And the most effective way of doing that, I repeat, is through pictures and audiovisual materials."[41] How human rights collectives navigate institutional and professional dynamics infused in the market logic of neoliberalism as they seek to accomplish advocacy goals with video has direct effects on the proxy profession's ability to serve broader human rights visions. The interplay between strategies and tactics provides a useful lens to consider these dynamics as they undergird video's role in political advocacy and its shaping by human rights collectives.

## Human Rights Video's Role in Political Advocacy

Human rights collectives describe video as a powerful, compelling, and engaging tool for institutional and public advocacy. They see it as an exceptional vehicle for justice: "For us, video is all the more important to really explain why justice is important, why victims of injustice are important, why credible justice matters. . . . [Video can] create that context for policy makers, so that they know that this [work] does make a difference to people."[42] Video communicates important information about human rights crimes in ways that are complimentary to, but different from, other forms of expression.

Human rights collectives now believe that video relates to reports, providing an additional layer of information that enriches advocacy efforts. Contrary to normative assumptions about how institutional politics and advocacy work, the use of video by human rights collectives draws precisely

from its appeal to the emotions. Woolwich told me, "Maya Angelou, the poet from the US, said: 'No one remembers what you tell them or how you tell them, but they'll always remember how you made them feel.' And that is what video can do in a way that [any] other medium can't [do]."[43] In their advocacy pursuits, human rights collectives are tapping into video's ability to hold emotions differently than words.

Carving emotional spaces that promote democratic engagement and human rights has long constituted a core value of video activism (as discussed in chapter 2). The iteration of human rights video activism as an occupational craft has embraced Raymond Williams's notion of the structure of feeling—the experiential and emotional threshold that gives rise to collectively held meanings and values—which does not position emotion against reason "but [describes] thought as felt and feeling as thought: practical consciousness of a present kind, in a living and interrelating continuity."[44] Human rights video activism has sought to facilitate such platforms by negotiating the interplay of different dynamics: action and acting, horizontal and vertical forces, transformative and transactional outcomes.

Human rights collectives are borrowing from this tradition as they celebrate video for its emotional resonance. Yet their embrace of the proxy profession confines them to the institutional and professional dynamics that nurture its authority. The NGO structure helps human rights collectives legitimize their visual expertise, but it also makes them vulnerable to diverse neoliberal forces: competition for funding and resources, pressure to maximize efficiency, and increasing accountability to donors. As a result, the proxy profession prefers vertical action, transactional outcomes, and efficient messaging as it aspires to produce videos that generate emotions that can shape political judgment across public platforms and policy contexts.

Amnesty, whose reputation was built on public campaigning, produced a video in 2015 to counter a popular backlash against its policy to protect the human rights of sex workers. Through *Human Rights for Sex Workers*, it hoped to make clear that it advocated only for health care, safety, and the right to be free from violence. Ellerton told me that "the [video] was produced specifically for people who take issue with Amnesty's work in this area. . . . There's a huge, sort of, antipornography movement, [an] anti–sex workers, antiprostitution movement who just don't think that [sex workers] should be on the cards at all, let alone Amnesty working on the issue

to protect people involved in the industry. So the [video] that we produced was directly targeted at the critics of Amnesty's policy."[45]

The video intercuts news segments critical of Amnesty's work—which are read out loud—with an interview with the deputy European director of the organization, who counters these arguments in the press. In one segment, a voice-over reads the title of an article in *The Guardian*, "Amnesty International Says Prostitution Is a Human Right—but It's Wrong," which is followed by the staffer's statement, "Prostitution is not a human right, but sex workers have human rights." Several images augment the claims by Amnesty—sex workers are shown kneeling on the ground with their faces covered in a tilted shot in addition to images of demonstrations in defense of sex worker rights. The editing choices are not driven solely by rhetorical arguments that counter the press claims but also by the desire to generate emotional response through the careful combination of sounds and visuals. The production of this video was tactical: it responded creatively to particular circumstances, doubling down on Amnesty's position even in light of mainstream news media backlash. Yet its objective to provide a quick and efficient message came at the expense of a more meaningful engagement with the issue at hand.

Human rights collectives leverage video's emotional power in advocacy to various effects. HRW, whose reputation long rested on targeted advocacy, made and screened a short video about political prison camps in North Korea for a side event in New York City for government officials and diplomats after the release of the UN *Report of the Commission of Inquiry on Human Rights in the Democratic People's Republic of Korea* in 2014. The decision was tactical to "give meaning to a 400-page [report] that hardly anybody is going to read."[46] The video, *North Korea: Accounts from Camp Survivors*, includes testimonies from three former prisoners, a prison guard, and an anonymous police officer as well as statements by human rights researchers. It also features drawings by one of the camp survivors who testifies in the film.

The video starts with a testimony that is initially heard as a voice-over narration to a series of drawings. The first drawing directs the viewer's attention to the center of the composition, where a uniformed person appears to be drowning a woman. Immediately to the right is a presumably dead body (figure 5.3). In the second drawing, a man holds the body of a woman covered in blood. The agricultural tools next to these figures suggest that they

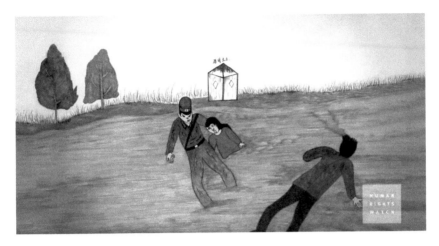

**Figure 5.3**
Screenshot, *North Korea: Accounts from Camp Survivors*, HRW, February 17, 2014, https://www.youtube.com/watch?v=cZby_vxrJ0Q.

may be farmers. In the background, a person bears witness to the scene. The third drawing depicts three women gathered around a man whose face is covered in blood. The vivid coloring of these drawings stands in sharp contrast to the death they portray. The experience of looking at these images is further amplified by the camp survivor's narration: "The prisoners didn't care. People died every day. We'd wrap up the bodies and bury them. In the winter, the dogs would gnaw at the corpses." He finishes with the statement, "Death just wasn't important," which appears as a title card on a black background, eventually fading out.

The video continues with other testimonies. The close-up framing of the survivors' faces draws the viewer's attention to the story, demanding careful listening. Kim Hye-Sook (figure 5.4) is among those who speak, and her drawings constitute the visual core of the human rights story this video tells. She was imprisoned at the age of thirteen after her grandfather escaped to South Korea. Having spent twenty-eight years in the camps, she tells of the horrors she has experienced with other prisoners. At one point she explains, "They didn't tell us anything. When we entered the camp, there were ten rules, and the first was to not ask about your crime. Because of this rule, the people inside never knew what their crime was. There were no trials or anything like that." Another one of her drawings shows up

**Figure 5.4**
Screenshot, *North Korea: Accounts from Camp Survivors*, HRW, February 17, 2014, https://www.youtube.com/watch?v=cZby_vxrJ0Q.

on the screen, depicting an execution scene. Three uniformed individuals shoot a person tied to a piece of wood as others watch, and a seemingly high-ranked official gives an order from a podium. The interplay between the testimonies and the drawing humanizes the story about horrific human rights abuses in North Korea and helps communicate it with an emotional richness. The video gives names, faces, and voices to human rights survivors, telling a compelling story.

Singh was involved with this case and explained to me that HRW decided to produce and screen the video "to create . . . a sense of urgency that something had to be done in this situation because it had been ignored for so long, in part because people didn't understand it. Everybody knew North Korea was bad, but they didn't know what, in concrete terms, that meant. So I think . . . the UN Commission of Inquiry report helped illustrate that in an intellectual way. But then the video that we presented helped show the human consequences of these horrific caucuses." Claiming that the video was effective, she further noted: "When the video played . . . it was dark, and then they turned on the lights, and there was just like a palpable silence in the room [that] . . . was very affecting."[47] This case suggests how human rights video, through its emotional resonance, can be used tactically to shape an understanding of the magnitude and effects of human rights abuses. Its power draws from its ability to humanize a story of injustice whose emotional pull can sometimes facilitate political judgment and action even in institutional decision-making domains.

Another example is relevant for this discussion. In 2012, WITNESS produced *Our Plea: Women and Girls from the Central African Republic Turn to the ICC for Justice* in partnership with two local activist groups. The video documents the testimonies of two young women from the Central African Republic (CAR) who suffered from sexual and physical violence under Joseph Kony and the Lord's Resistance Army (LRA). The video begins with a narration by a local human rights activist who stands in front of a map, pointing to the places where the LRA operates and commits crimes. Then the video focuses on the stories of Nanzouna-Dadine and Joelle, who testify to the beating, torture, and sexual violence they endured while being held hostage by the LRA.

When the video first shows Joelle, she holds a baby in her arms, and she later reveals that she conceived the child as a result of a rape. Nanzouna-Dadine smiles in the first shot when she says her name and age. As she starts talking about her traumatic experiences, her voice sounds angry. Through their testimonies, the video captures the facts about the abuses and the emotional consequences of the suffering. The viewer hears facts about the human rights crime (e.g., what happened, when, and how) in addition to the personal difficulties of living with trauma (e.g., adjusting to life in the community, living with nightmares, fearing for the safety of loved ones, having the sole responsibility of raising a child while dealing with the trauma of how the child was conceived). The video was part of tactical advocacy efforts to urge the prosecutors at the ICC to extend the investigation of the LRA's crimes to the CAR in general, which it eventually did in 2014. The successful use of *Our Plea* in WITNESS's advocacy work indicates that video is capable of rendering a human rights violation more concrete and readily accessible even in spaces long driven by aspirations of undisturbed rationality. It is not just the facts that matter in video; it is also the emotional appeal that can trigger a meaningful engagement.

These examples illustrate what human rights collectives consider success stories in the context of specific advocacy projects, indicating how emotions can underpin institutional decision making. Even in spaces presumably driven by systematic reasoning, facts alone are seen as insufficient to explain the realities of human rights abuses. Singh told me:

> We're already in New York, removed from a lot of suffering. And yet we're trying to influence the policy of people who are also similarly removed from the suffering of the crisis they are trying to address. . . . I think video is a really good medium to bridge that gap and to remind people what the consequences are of an

action or of a particular course of action and to really humanize what could oth-
erwise seem like an abstract concept without consequences. I mean . . . [that by]
keeping things real for people who are removed from the situation, who are mak-
ing decisions about the situation, [video] can serve a very important purpose.[48]

Implicit in her observation is that video, by bearing witness to human
rights abuses and portraying the personal stories of those who suffered, can
generate a feeling of compassion among audiences. Beyond the comparison
between the Global North and Global South that Singh draws, the assump-
tion is that video makes the experiences of trauma and injustice—no matter
where they occur—more readily understandable even for decision makers
and other stakeholders.

The wide-ranging criticism of compassion in relation to the suffering
of others has raised objections about its alignment with biopolitical para-
digms, colonial discourses, unevenness, partiality, and commercialization.[49]
Martha Nussbaum, however, insists that the particularities of positionality
and emotions should not be grounds to turn our backs on compassion as an
ethical compass. She argues that we should instead build compassion into
the rules and institutions that structure political life.[50] Human rights collec-
tives are well positioned to prompt compassion and coax political response
through their video work.

Beyer told me that compassion is a key value that HRW has found people
share across the political spectrum.[51] Staffers thus seek to deploy video in
ways that place compassion at the heart of policy making and promote a
visual epistemology that brings the workings of emotion in political delibera-
tion into sharp focus. Tirana Hassan, the former director for crisis research at
Amnesty and now chief program officer at HRW, iterated this commitment:

I do recall showing videos of . . . South Sudan into a room full of diplomats once.
And, you could see, when we described what people were telling us, [and] they
[saw] the images . . . that all came to life. It's about transporting somebody out
of their headspace into getting an element of compassion but also [about] real-
izing in a much less clinical way what the repercussions of human rights abuses
are. And that doesn't necessarily have to be graphic. People are so far removed
from the realities of war, for example, so it's hard to conceive [these human rights
crimes]. And visual imagery helps us with that.

Hassan further believes that video "can change the way someone pro-
cesses information" because it provides an "immersive experience."[52] The
longtime logic of sidelining images because of their entanglement with

emotions and imagination is turned on its head as these same visual qualities are now institutionally recognized precisely because they work differently than words do.

If the advent of photography popularized the notion that *seeing is believing*, video brings forth a new premise that *feeling is believing*. Although the act of seeing is centrally implicated in emotional processes, the significance of feeling underscores how human rights collectives operationalize video's power in advocacy even with institutional stakeholders. The act of seeing remains important because it facilitates feeling, but the emphasis is on how video makes the viewer feel. Human rights collectives claim that video is best able to trigger the emotions while conveying vital information that explains the scope and scale of the injustice at hand.

Emotions have long guided human rights communication, but dominant social, political, and legal structures have failed to evaluate the status of emotions on an equal footing with that of reason and deliberation. Yet this failure is enabling human rights collectives to aspire to build their authority around video as a unique mode of knowledge that facilitates emotions so that the proxy profession can better serve political advocacy domains. At the same time, the shaping of human rights video under the auspices of the proxy profession also results in strategic choices that sometimes instrumentalize emotions and underplay the more radical potential and imaginative scope of video activism.

The marketization of the human rights field is thus reflected in how the proxy profession works in political advocacy. By virtue of its orientation to pragmatism and efficiency, it incorporates the emotions better when it seizes the moment to have an impact where there is already a potential for change (as in the case of HRW's video on North Korea or of WITNESS's video on the LRA). Such approaches draw on the power of tactics. Yet human rights staffers are the first to admit that they struggle to change the attitudes of those who oppose human rights values even though public engagement is becoming an organizational priority for these collectives.[53] As a solution, they are embracing marketing strategies for producing online videos and engaging in microtargeting practices on social media. In this context, the proxy profession narrows the possibilities for thinking through a more rigorous innovation in the visual field that does not import the market logic into the realm of compassion and civic engagement.

Thirty-second videos of hope may be appealing online, but they may be making viewers feel better about their brief engagement with human rights at the expense of both a more meaningful and thorough program for social change and a deeper engagement with that program.[54] Building compassion into the institutions that structure political life and protect human rights requires more than marketing efficiency.

## How Human Rights Collectives Produce Videos for Political Advocacy

Amnesty, HRW, and WITNESS produce advocacy videos about ongoing systematic problems. They embrace video activism's core values while emphasizing goal-driven and audience-oriented approaches. Recording a human rights story in a compelling fashion is perceived as no longer sufficient by itself. Kelly Matheson, senior attorney and program manager at WITNESS, told me, "People have this feeling that if they film something, others will see it, believe it, and be moved to action, . . . but you have to know how to use video."[55] Bryan Nuñez, formerly at WITNESS, echoed this view: "Video is just another technology, and as a technologist I think people put too much emphasis on technology. They want it to take place like a proper practice, so people don't have to learn things, and they can just rely on the technology to do things that can never be automated."[56]

Using video in political advocacy is thought to require a specialized set of knowledge and skills. To harness its power, human rights collectives think through mechanisms that take into account the whole video-making process. They maintain that, beyond technical and storytelling competence, the deployment of video in political advocacy means learning how to tailor the content, style, and distribution plan according to the audience who can take a particular course of action.

The audiences for human rights videos are news media, primarily as a vehicle to reach political elites as well as a platform for branding and fundraising (discussed in chapter 3); courts (discussed in chapter 4); semijudicial settings (e.g., institutions with soft power, such as the UN or human rights commissions); direct-to-decision-maker contexts (e.g., government officials or legislators); and publics (local, national, and global). Human rights collectives not only produce videos tailored for these audiences but also develop and promote video standards for political advocacy according to assumptions about these audiences.

Amnesty, HRW, and WITNESS delineate the centrality of the audience as a defining feature of their video work. Gregory describes how "at WITNESS, videos are created for audiences as much as about a topic. They are constructed with an appropriate style, format, and visual and storytelling language for specific audiences."[57] Similarly, Veronica Matushaj, director of documentary video and photography at HRW, reflected: "We first ask: What are we trying to change? Who can help us change this? And then we work from there."[58] The conceptualization of audiences drives how, if at all, the human rights story is turned into video advocacy.

Amnesty also thinks through differentiated audiences as a crucial aspect of video making: "One of the key things, of course, is to know your audience. . . . It's thinking not what but who. Who is this supposed to be directed at? Who are we trying to interest in this?"[59] Daniel Eyre, a former researcher at Amnesty, reiterated these views:

> Your objectives and the audiences you want to reach are the primary considerations in how you decide to tell a story; . . . then that can be shaped in different ways according to what kind of video material you have and also [according to the] different priorities within Amnesty. We always have a debate about what our key messages are, and that will often reflect people's priorities for the audience. So some people will be more oriented towards reaching government officials; some people [will be] more oriented to reaching the domestic or international media and the international public; and some people will be more oriented towards reaching Amnesty's membership. So there can be different priorities in terms who you want to reach with the story. But the audience is one of the main driving factors behind how the story is structured.[60]

The assumptions about audiences play a central role in the development of the guiding principles and standards for the production and implementation of video in political advocacy across these human rights collectives. Communications, multimedia, and research staff take part in the endeavors to leverage video's emotional resonance in political advocacy.

As human rights collectives turn to video, they transform the practices and values typically associated with video activism—such as the assumed public function of video, its facilitation of open and collective participation in media making, its ability to provide alternative vision and voice, and its reliance on emotional engagement as the foundation for public critique (chapter 2)—in ways suited for political advocacy. As a result, their work does not necessarily rest on the premise that video makes a social difference in the world simply by bearing witness to human rights abuses, as has

long been the case in activism. It instead depends on the role of audiences in shaping video. Human rights collectives define what kinds of audience can serve the public needs in the context of a specific violation; then they shape the content, style, and distribution plan of a video accordingly, promoting video standards in the process. The specific focus on specialized institutionalized audiences or segmented publics online who can help the video achieve measurable advocacy goals delineates the emerging patterns in video making for social change from previous modes of video activism.

## Content

Amnesty, HRW, and WITNESS have produced videos on a range of human rights issues, including war crimes, migration, gender-based violence, police brutality, forced evictions, health, and media freedom, among others. The majority of videos incorporate personal testimonies of human rights survivors that are situated within broader sociopolitical circumstances either through statements by human rights researchers and experts or via title cards. Every video ends with a specific call for action. The efficacy for action usually comes from how a video balances the evidentiary and emotional qualities of testimonies and how it addresses audiences directly by proposing ways in which they can help solve the problem. The call for action is typically framed within a particular set of political or legal parameters and emphasizes specific results over the pursuit of broader critical involvement with the issue.

WITNESS's video *Hear Us: Zimbabwean Women Affected by Political Violence* (2011), for example, includes title cards that contextualize the human rights violation. They are followed by the testimony of a woman who describes her traumatic experience of torture and rape. She speaks not only to the facts about her abuse—how she was beaten and raped and how she was infected with HIV—but also how she has been struggling to cope with the subsequent mental, physical, and financial difficulties. *Hear Us* features minimal B-roll footage—for instance, how the woman prepares food for her child, which is edited together with a song: "It's your right to be happy. It's your right to have peace. It's your right to survive." The lyrics correspond to the overall human rights message of the video.

The personal story of this trauma survivor is a mechanism to illustrate the consequences that human rights crimes can have on a person's life, which is at the heart of video advocacy. "At night, I cry myself to sleep," the survivor says, explaining how she has struggled personally and feared

for the life of her child. *Hear Us* ends with title cards, recommending that the Zimbabwean government needs to implement the Global Political Agreement and the Southern African Development Community Protocol on Gender and Development. In doing so, the government can ensure that (1) women are protected under the legal system, (2) all cases of political violence are investigated and prosecuted, and (3) victims can receive assistance. WITNESS screened this video to government representatives in Zimbabwe, who eventually implemented assistance funds for the survivors.[61]

HRW used to identify itself as an organization engaged in "high-level advocacy with lawmakers."[62] And so even today as it seeks to connect with publics through campaigning, its videos tell human rights stories within legal or policy frameworks. *Media Freedom under Attack in the Western Balkans* (2015) documents the physical attacks, threats, and imprisonment of investigative journalists in Bosnia and Herzegovina, Kosovo, Macedonia, Montenegro, and Serbia. It is based on the personal testimonies of four journalists out of a total of eight interviewed during the research phase. The video is driven by the implicit assumption that governments can take on the responsibility for protecting journalists—a point still vastly contested in the region—although the stories are about governmental violations or failures to take measures.

The video starts with the statement of a journalist from Kosovo: "I had been a journalist during the war. We were supposed to think, 'Where is the fire line, where is the danger coming from, where are the shots coming from?' I didn't imagine that the postwar is going to be some sort of a minefield as well. You have to watch your back like you did during the war." An HRW researcher provides background information, and other journalists share their experiences. Artan Haraquia, involved with mapping the locations of radical Islamic groups in Kosovo, speaks about the state's failure to respond to death threats against him. Tomislav Kežarovski, who investigated the death of another journalist in Macedonia, describes how fifteen masked and fully armed members of the Ministry of Interior raided his home and arrested him. Eyewitness footage from demonstrations in Skopje demanding Kežarovski's release from prison accompanies the testimony. A journalist from Montenegro holds cartoons from a state-owned daily newspaper that portray independent journalists in a prison cell under the title "The Department of Media Mafia" or in a waste container as "the media trash." She speaks about the intimidation tactics the government

uses to silence critical reporting and about the financial consequences these tactics have on journalists like her. Because a particular policy framework underpins how this video depicts the issue, at the end of it the human rights researcher recommends that the European Union make media freedom a priority in its negotiations with the western Balkan states for EU membership. Although this may be a sensible recommendation, the state of the media in Hungary serves as an acute reminder about the limitations of EU frameworks even for its members.[63]

Amnesty produces videos aimed at institutional stakeholders, just as HRW and WITNESS do, but it also uses video as part of its public campaigning. When it does so, it only highlights the key message and typically urges people to sign a petition. *Got a Sinking Feeling They Don't Care* is a video on the refugee crisis in Europe produced in April 2015. It intercuts footage of German chancellor Angela Merkel and other politicians on a boat trip with footage of sinking boats carrying refugees in the Mediterranean. The melody of a children's nursery rhyme, "Row, Row, Row Your Boat," accompanies the video montage, contributing to the irony that European politicians have been indifferent to the refugee situation unfolding in front of them. The purpose of the video was to collect signatures for a petition to EU leaders. Amnesty staff mentioned it as an example of a particularly effective video, seen by half a million people within twenty-four hours, leading to 300,000 signatures.[64] Though successful within the parameters of what it tried to achieve, this example is precisely the kind of short advocacy video that instrumentalizes emotions, reducing a complex problem to a catchy content.

These human rights collectives' political advocacy work suggests how the focus on audiences defines the content of the video in terms of both how it tells the story and how it frames the solution. Priscila Neri, senior program manager for Latin America at WITNESS, described the importance of tailoring the content:

> When we see the bulk of cases where there's a success, usually there is, in advance, a clear idea of the audiences . . . what we want each audience to do and why and also what speaks to that audience. You know, my dad is a mathematician. When I speak to him, I put a few numbers in what I'm saying because I know he'll pay more attention. Same thing with a lawmaker—you have to know what discourse will drive action. . . . We, as activists, end up saying what we want to say, what we think is important and true—which we should do—but not always in the way that our audience understands it or [is] moved to take action.[65]

Human rights collectives embrace a strategic positioning vis-à-vis the human rights violation, pursuing pragmatic solutions within policy-based frameworks. Their videos bear witness to suffering within the parameters of the perceived audience's mandate and the specific action it can take.[66] WITNESS's video on gender-based violence, for example, assumes that the government implementation of legal protocols is an adequate solution to the problem, so it frames the story accordingly. It falls short of explaining what will guarantee the implementation of the protocols in practice or the victims' awareness of assistance programs. It assumes that Zimbabwe will adopt the measures because it is the right thing to do, and change will follow as a result.

HRW presumes that pressure by the European Union constitutes an appropriate response to the serious violations of media freedom in the western Balkans. Yet it fails to tackle how EU recommendations on these issues have been ignored in the region for years already. It also takes the EU negotiations at face value, ignoring the conflicting governments' views on European integration. Organized around this a priori assumption about the audience, the video leaves aside broader questions about the social implications of severely restricted media environments and the need to protect journalists. Last, in trying to quickly grab public attention and submit a petition to EU leaders, Amnesty reduces its message to "politicians do not care about refugees," setting aside a more critical engagement with the complexity of the problem.

Human rights video activism has long been centered on tactics that tap into opportunities as they present themselves. Although it strives for change, its primary focus has been the public articulation of critique, not necessarily the need to yield easily measurable impacts. This focus has been facilitated largely by activism's existence outside of institutional settings. Human rights collectives adopt the practices and values of video activism for uses in political advocacy and situate them in NGOs with a legal status and responsibilities to donors. By claiming an organizational home for human rights video making, these collectives move video away from its old tactical use in activism to a new strategic framing in political advocacy by the proxy profession.

At the heart of this shaping of video in advocacy is the understanding that "it's not necessarily the circumstances [that make video effective] but the strategies that are used to really leverage that tool."[67] De Certeau

argues that strategies "give oneself a certain independence with respect to the variability of circumstances."[68] A strategy that accounts for the role of audiences is perceived as essential for effective video in political advocacy because it gives human rights collectives a certain amount of control over the content. Rather than pursuing multidimensional goals that challenge the root causes of injustice, the collectives develop strategies that are "tailored for each profile and each set of problems."[69] By molding the content in this way, they pragmatically advocate for existing political and legal frameworks that are more likely to initiate concrete steps toward the protection of human rights.

This is not a small endeavor. A legal action, a policy recommendation, or a petition is hugely important in pushing human rights agendas forward. The strategic shaping of the content of a human rights video according to specialized audiences, however, is biased toward vertical structures and targeted appeals. It thus can leave out critical articulations of injustice in its broader scope. Although such strategies are legible to dispersed institutional stakeholders and may reach online publics more easily, they tend to define a priori which human rights violations are worthy of video engagement and how they should be addressed.

### Style

The audience also plays a role in how human rights collectives approach the style of video making. WITNESS and HRW produce videos for institutional advocacy in a style that resembles the expository mode of documentary filmmaking.[70] They combine personal testimonies with narration and images. Bill Nichols describes this style as "evidentiary" in that images "illustrate, illuminate, evoke, or act in counterpoint to what is said."[71] This style of video making blends well with institutional expectations about how human rights information should be communicated. The emotional appeal of video works under the guise of an evidentiary style. WITNESS and HRW underscore the importance of high production quality so that institutional stakeholders can take the video seriously. Yet "if you're trying to document a crisis developing in a particular country, of course, you aren't going to have something polished. If it's polished, it makes it seem like it's manufactured."[72] The style of the video is not necessarily driven by the authenticity of the experience itself or by decisions on how best to portray

the human rights violation but rather by assumptions of what seems legitimate in the eyes of the audience.

Amnesty produces videos whose styles range from expository documentaries to animations and reenactments. It distinguishes between campaign videos, which are about a general issue such as the death penalty, and advocacy videos, which are about a specific case or issue.[73] Both campaign and advocacy videos tend to focus on institutional solutions, a strategic choice reflected in the rhetorical and aesthetic style of the videos. *Myanmar: The Land of Make Believe* (2015), for example, is an animation structured as a children's bedtime story. In about two minutes, it tells the history of Myanmar as bullet points—from the military dictatorship and imprisonment of Aung San Suu Kyi to her release, the new sets of human rights violations, and the hopes for the first democratic election. The story is told through a voice-over narration as animated images of public protests, military attacks, prison scenes, international news coverage, and diplomatic meetings are shown. The calm narration throughout and the visual aesthetic that resembles a fairy tale visibly differ from the story the video tells. The video calls on its viewers to sign a petition urging the international community to pressure Myanmar's president to release all political prisoners prior to the election of 2015. The video falls in line with Amnesty's tradition to campaign for so-called prisoners of conscience around the world. The idea behind it is to quickly engage the viewer to sign a petition that Amnesty can use to substantiate its campaigning efforts.

*Gaza Platform Findings* (2015), in contrast, is an advocacy video produced by Amnesty in partnership with the Forensic Architecture team at Goldsmiths University of London. It urges international governments to support the work of the ICC in investigating the war crimes committed by Israel during the Gaza conflict between July and August 2014. The video starts with Israeli prime minister Benjamin Netanyahu's statement to the United Nations that his government has done "everything possible to minimize Palestinian civilian casualties." It then features interviews with forensic experts and Amnesty's researchers as well as graphic eyewitness footage of the attacks and the immediate aftermath, such as explosions and injured children in hospitals. Because the video is framed around the need for a legal investigation, its visual style embraces a forensic sensibility. The eyewitness footage and the maps seem pixelated. A segment demonstrates

the authentication process of the evidence used for the investigation. The title cards are featured against a satellite map of the region with numbers indicating civilian deaths and the different locations of the attacks (figure 5.5), reinforcing a sense that forensic rigor has shaped both the findings and the subsequent call for action.

When producing videos for political advocacy, Amnesty, HRW, and WITNESS construct their videos by seemingly playing to the professional logics of the institutional audiences they seek to reach. They weave together testimonial acts with images—whether B-roll footage, eyewitness materials, or other components of human rights investigations—in ways that emphasize the video's evidentiary qualities. They borrow from the practices of video activism to generate an emotional response by incorporating personal accounts of trauma that exceed mere presentations of facts—as in the case of the WITNESS's video on gender-based violence in Zimbabwe—or by selecting images that can create visceral reactions—such as the eyewitness footage of injured children in *Gaza Platform Findings*. Campaigning videos, in contrast, often work through irony and contrast achieved by the interplay of rhetorical and visual style, as in the case of *The Land of Make Believe*.

**Figure 5.5**
Screenshot, *Gaza Platform Findings*, Amnesty International, July 10, 2015, https://www.youtube.com/watch?v=sIEH91fu0Gw&t=1s.

When producing advocacy videos in the style of expository documentaries, Amnesty, HRW, and WITNESS typically emphasize close-up to medium framing of the person who testifies in the video, eye-level camera positioning, and natural lighting—all components of a sanitized visual aesthetic appropriate for institutional decision-making contexts. There are visible deviations from these standards when the identity of the person testifying needs to be protected. In such cases, these human rights collectives rely on standardized visual-obscuration techniques with the help of lighting and framing or via specialized tools. For example, they record the testimonial act in darkness to hide the witness's face; they show the back or the hands instead of the face; or they distort the image in postproduction. For full anonymity, they sometimes distort the witness's voice as well. WITNESS has worked on a set of tools, such as the ObscuraCam app (in collaboration with the Guardian Project), that can pixelate faces at the time of recording.

To better leverage the power of video in its campaigning work, Amnesty first established a digital engagement unit to help reach audiences via digital platforms more effectively. The unit was later folded into the marketing office.[74] The former head of this unit underscored the need for mechanisms that adequately gauge tone, voice, and length relative to a desired audience. In other words, digital analytics have become important in deciding on the format and style of a particular video: "We talk very specifically about the tone of voice and how we speak . . . and we're doing it for video as a whole. So we break down the different types of video and [decide] what element should go in those, what should their length be, what should the tone of voice be."[75] Implicit in her statement is that visual style is no longer about tactics; it is about strategies that, as de Certeau puts it, are "able to predict, to run ahead of time by reading a space."[76]

The perceived need to select a style in ways that account for audiences and to craft an appropriate level of emotional involvement signals attempts to transform uncertainties, which is at the heart of strategies. Through the strategies of predictive analytics, Amnesty turns audiences' taste into a matter that can be measured and exploited to advance human rights. HRW's new campaigning unit operates under the same principles, testing its messages with different audiences before finalizing the video. Although different in certain aspects, the work of all three collectives suggests that strategies are becoming of utmost importance in the use of video in political advocacy.

## Distribution

Distribution strategies are thought to augment the advocacy potential of video. Staffers told me, "a common mistake that we see a lot in activist video . . . is not having a distribution strategy."[77] To live up to its potential to accelerate justice, a successful video needs to be distributed to the desired or right audience. It also needs to be part of a larger advocacy effort—such as lobbying that audience, campaigning, and drafting legislation—rather than a stand-alone product.

Amnesty, HRW, and WITNESS promote smart narrowcasting strategies or microtargeting online, which means that targeted screenings are preferred over general distribution. "Whose eyes, not how many" is WITNESS's motto because "more important than five million people seeing your video on YouTube is the five people that really have the responsibility to do something about it. . . . Instead of a broadcasting kind of mindset, it's more the smart narrowcasting. Who needs to see this so that you achieve your advocacy goal?"[78] WITNESS organizes specialized screenings. For example, during demonstrations in Brazil preceding the World Cup in 2014, it showed a compilation video on police violence at a meeting of the Inter-American Commission on Human Rights in Washington, DC.

HRW's video *Yemen: End Female Genital Mutilation* (2015) was screened in front of parliamentarians and government representatives in Yemen, who "[didn't] understand at all what FGM [female genital mutilation] really [was] because none of their kids [had] been through it."[79] The video includes a medium shot of an elderly woman who demonstrates the FGM procedure on camera using a razor blade, a box, and some leaves. A midwife explains the cultural beliefs underlying the practice: "Our whole community is circumcised. The whole community. They say an uncircumcised girl is indecent. There is shaming. People would point fingers at the uncircumcised girls. She would be an outcast." The video features interviews with other midwives and practitioners as well as with gynecologists, imams, and legislators who speak against the practice. At the end of the video, the human rights researcher urges the Yemeni government to take proper proactive measures to criminalize the practice and to inform its citizens of the health risks.

The digital engagement work at Amnesty and HRW rests on marketing strategies to engage global online publics on human rights issues. Digital analytics is used to understand target audiences, which are being transformed

into a segmented market in which these organizations can place their content. According to Meckes, "The audience is incredibly important. . . . What we're looking at now . . . [is] who is following us, who's coming to our content in our entire ecosystem, be it [through] our website or [our] Facebook channel or [our] Twitter channel or [on] Google or YouTube. We know this in minute detail, which is really exciting. So we can very easily tailor content for those audiences." Digital analytics are employed as strategies for both production and distribution. Meckes further explained to me: "When we don't push something out on a specific channel or [when] we don't build a specific piece of content, it's not that we're saying 'no' or 'it's not good.' What we're saying is [that] 'it's not right for this channel' or 'we don't have that audience that you're trying to reach, [so] we're not going to be able to help you achieve your goals.' So having those conversations with people so they're starting to think about their content in a much different way is a slow process but [an important part of our capacity building]."[80] The goals of public advocacy have typically been about raising awareness on a particular issue. The proxy profession, however, implements marketing strategies to account for audience differentiation and so risks simplifying both the issues and the proposals to action, sometimes even strategically replacing ethical involvement with brand recognition.[81]

De Certeau argues that "strategies do not 'apply' principles or rules; they choose among them to make the repertory of their operations."[82] Human rights collectives select from established advocacy and marketing strategies to put video into use for political advocacy. The operational logic behind video distribution reflects the organizational structure of these human rights collectives, which has delineated a new home for human rights video activism through the proxy profession that seeks an insider status in decision making and counts on quantifiable results to demonstrate impact to donors. In other words, the proxy profession, by virtue of its orientation toward professional standing and institutional legitimacy, limits the horizon of civic engagement that human rights video can promote.

## Video Standards

Human rights collectives not only develop and implement strategies for how to produce and distribute human rights videos for political advocacy but also promote these strategies via training and publications. In doing so, they set up standards for human rights video activism that are appropriate

for political advocacy. This is evident in the work of WITNESS, which has focused much more extensively on advocacy around best video practices over the past few years. According to Morgan Hargrave, former system-change coordinator, "It's so key that we figure out how to turn that video into advocacy—or into evidence—because people are literally putting their lives on the line to create that video."[83] The underlying assumption is that documenting injustice and raising one's voice against it is not enough. Video activism can better live up to its social change potential when it is turned into advocacy. To tap into the knowledge provided by video for long-term justice and accountability, WITNESS highlights the importance of strategies during its training and via its materials.

A video activist from Western Sahara commented on the benefits of training in a promotional video for WITNESS: "We had been using video as a tool for change, but now we know why the videos we were making weren't effective; . . . we didn't have training like this. . . . Before, we did the work spontaneously. Now I know how to use the video so that it is evidence or so that it is a tool for change."[84] The centrality of strategies to the new shaping of human rights video activism by the proxy profession surfaces in this statement. Spontaneity is associated with tactics as the improvisational and creative modes of action used by those caught up in the power nest of institutional structures. Shifting toward strategies, by contrast, implies a sense of control, an ability to order knowledge to better leverage its potential. In its training, WITNESS promotes video activism as a set of strategies that hone the content, style, and distribution of the video according to differentiated audiences.

WITNESS has elaborated on these strategies in multiple templates, guides, how-to videos, blogs, and practical on-site and virtual training that teach activists how to take convincing videos for advocacy safely. *Video for Change Toolkit*, for example, is an online interactive training program that enables users to develop a customized advocacy plan that attends to all aspects of video making. The program *Video for Change Curriculum* similarly includes thirty-seven sessions that teach best practices in video advocacy and production techniques for various recording devices. All materials are available for free download and sharing in English, Spanish, Russian, Arabic, and Portuguese. Different manuals teach activists how to record protests, crime scenes, and sensitive testimonies, among other scenarios. By publishing these materials and conducting training according to their

principles, WITNESS further claims its authority over the knowledge provided by video in a human rights context.

The development and promotion of video standards that emphasize strategic modes of video making create a distinct shape of activism, which some human rights activists recognize and seek to address. Neri reflected on this issue during our conversation:

> I don't know if it's US centric, but it's a very specific type of methodology. And the reality in Latin America and other places where we go to do our training—and we say, "What's your goal?"—is, more often than not, not formulated in those methodological terms. People aren't going to say, "Well, my target audience is legislator X because he's working on this bill Y, and the timing for it is Z." . . . You know, that's a very specific methodology, which has demonstrated success over the years in many different cases and is valid. But it's not always the way that [a particular activist] group works.[85]

The emerging video standards aspire to broader relevance, but activism insists on diversity and sociocultural specificity. Tactics must be flexible and speak the language of the culture and history that shape them. Strategies, in contrast, aspire to generalization and broad applicability. Implicit in Neri's reflection is the tension embedded in the proxy profession between video activism as a series of tactics and its permutation into video advocacy as a set of systematic strategies for institutional contexts.

The more strategies define the incorporation of video in political advocacy, the more institutional parameters will overtake other considerations in what deserves coverage as a human rights violation and what solutions constitute an appropriate form of restitution.

## The Proxy Profession in Political Advocacy Settings

Although images have long been denied their due status in institutional politics, technological, sociocultural, and economic changes facilitate the institutionalization of video as a unique mode of knowledge across political advocacy contexts. Various institutions whose purview includes humanitarian and human rights work are now incorporating the policy potential of video, thus creating opportunities for human rights collectives to tap more prominently in such decision-making spaces.

Human rights collectives operationalize video's power in political advocacy by means of its underlying emotional pull, which can trigger understanding

of and engagement with a human rights crime. Video's function in political advocacy draws precisely from those qualities that have traditionally been framed as contaminating the normative ideals of deliberative democracy. In mobilizing emotions for political involvement, human rights collectives borrow from the tradition of video activism, shaping it in ways that can appeal to publics and institutional stakeholders within a specific framework for change. This new shaping, however, risks importing market logics into the realm of emotions, civic engagement, and social change.

Amnesty, HRW, and WITNESS put video in the service of political advocacy by implementing goal-driven and audience-oriented approaches to video activism. In the process, they aspire to professionalism so that their videos can be taken seriously by decision makers who can do something in response to the portrayed violations. Human rights collectives believe that "if [the] videos have the professionalism to be taken clearly [and] contain all of the visual information that a viewer in New York City or in Geneva would need to understand what's going on in that video, then, [they provide] the world with a better tool to monitor the human rights situation."[86] The focus on differentiated audiences illuminates how professionalism is sought as a mechanism for external legitimacy, an important reason why the proxy profession cannot attain the autonomy of a full profession.

The video advocacy work of Amnesty, HRW, and WITNESS sheds light on how video activism, in its new shaping by the proxy profession, is no longer just a series of tactics to advocate for social change. Tactics indicate creative, intuitive, and experimental actions—often isolated and gradual—through which people negotiate the power dynamics imposed on them. The proxy profession instead develops, employs, and promotes strategies to better leverage video's advocacy power. Strategies exhibit a level of schematic and patterned behavior that seemingly controls for the instability of circumstances (e.g., seeking to predict audiences for online videos through digital analytics or developing a universal approach to video making for advocacy purposes that mimics institutional politics). The turn to strategies helps the proxy profession claim institutional legitimacy across political advocacy settings. It facilitates the collective sense of a community united by a common logic for video making that can yield measurable results (typically when there is already some potential for change).

Because the proxy profession seeks solutions within existing policy-based frameworks, its unfolding in political advocacy gradually moves human

rights video activism away from its core engagement with broader constituencies for the public good. The focus is no longer how to tell a story convincingly to engage the general public on pressing issues—although any human rights work inevitably involves at least some public components—but how to persuade or put pressure on institutional stakeholders to take action within available political and legal mechanisms. The video thus needs to look and speak in a language and aesthetic understood by the assumed viewer. In other words, human rights collectives are developing strategies to tailor the content, style, and distribution plan appropriate for the targeted audience. This specialization around institutional platforms can bring measurable success, such as the establishment of official human rights inquiries and legal and policy changes, which are very important indeed. The flip side of this development, however, is the potential narrowing of the power and scope of human rights video activism. The trade-off can be a diminished role for human rights activism as a cultural practice that sustains critical dialogue even when political and legal paths seem closed.

In recent years, Amnesty and HRW have sought to amplify their public engagement efforts through video, recognizing that human rights narratives may be losing their public resonance. Who the publics are and how best to reach them are changing nevertheless. According to a former multimedia staffer, "Rather than just [saying], 'Oh, here's a campaign,' and hop[ing] everyone is watching it—which they won't—you can be far more objective and far more targeted, far more precise [so you] can have a further reach and effect."[87] Digital analytics has become a key strategy for assessing online audiences as a way of tailoring videos. Thus, even when video is used for public engagement, marketing strategies and the neoliberal dynamics that influence the proxy profession are taking over what could be a more meaningful collective endeavor with potentially better long-term impact.

Human rights, although ratified through declarations and supported by institutions, have long rested upon the emotional investment and imaginative capacity of people around the world who fight for human dignity. To sustain human rights as a moral grammar for human dignity and justice in the world may require tactics that think anew what human rights advocacy can do to address the complex structural problems underpinning different human rights violations in the world.

# 6   The Proxy Profession and the Power of Human Rights Voices

This book has shown how video has become centrally implicated in the promotion and protection of human rights. Deeply infused with transformative language, human rights video is part of long-standing and wide-ranging visual practices used for activist purposes. Video activism's core values—its public function, facilitation of open and collective participation in media making, embrace of alternative vision and voice, and preference for democratic designs where emotions matter—echo in video's use as a human rights tool today.

Bridging between reason and emotion, evidence and persuasion, memory and imagination, video exceeds its presumed representational forms. Its meaning is always fluid, taking different shapes as its material circulates across different platforms, performing various policy functions: setting agendas; providing medium and content for policy debate; serving as legal evidence; facilitating legal arguments; serving as a forensic tool and record; supporting the legal process; providing a means of legal education; and influencing how people understand the nature of rights. As a result, human rights video can—and necessarily does—mimic the logics of the institutional environments that use it.

Valued as a unique mode of knowledge that encompasses image, sound, perspective, movement, metadata, and immediacy, video has attained legitimacy across the institutions central for human rights: journalism, the law, and political advocacy. These institutions are characterized by different internal logics and dynamics, which have long rested on the affordances of words as presumed vehicles of reason, evidence, testimony, and deliberation. In the current moment, though, all of these institutions are turning to video as a way of offsetting ongoing cultural, social, financial, and technological challenges. The resulting institutional blending in spaces overlapping with

human rights activism demands practices, standards, and doctrines that can account for the particularities of video as a unique mode of knowledge. The rise of the proxy profession thus helps human rights collectives claim visual expertise through which they transform activist video into a suitable material for human rights policy making across institutions.

As a key instrument for publicity, journalism helps recognize and legitimize human rights violations as they unfold. In this sense, it gives human rights collectives a vehicle for immediacy, recognition, and agenda setting while also serving as a platform for branding and fund-raising. The law, as an institution that enforces human rights, can redeem activists' claims, lending a platform not only for restitution but also for legacy. Political advocacy ensures that human rights agendas remain relevant, providing human rights collectives an entry point into institutional decision-making domains. All three institutions therefore offer possibilities for human rights collectives to extend the spaces for human rights voices through video.

This chapter looks more closely at the power of video as a platform for voice, mapping how the proxy profession shapes the role and scope of human rights voices across institutions. The previous chapters underscore that the proxy profession proposes a pragmatic solution to broaden the reach of the voices of both activists and those who have directly experienced human rights violations. It is better positioned to do so when it uses tactics, in Michel de Certeau's language, to address a specific set of circumstances. Yet by virtue of its orientation toward institutional and legal leverage and its infusion in market dynamics, the proxy profession might also end up representing, mediating, filtering, or silencing those voices as it seeks to play strategically to the modalities of journalism, the law, and political advocacy. Highlighting these dynamics, I argue that the efforts to professionalize any kind of information work are inevitably fraught with contradictions. At times when human rights remain a deeply politicized discourse and information control is key to state power, scrutinizing the contradictions at the heart of the proxy profession is crucial for understanding the status of video evidence, human rights, and activism today.

## Human Rights Video as a Platform for Voice

Key to video's centrality as a tool for human rights is its ability to facilitate voice. Having voice, Lilie Chouliaraki writes, is a "disposition of symbolic

recognition that creates community by valorizing the opinion and testimony of ordinary people."[1] At the most fundamental level, voice signals the ability to tell a story about oneself.[2] It enables participation in sociopolitical processes.[3] Voice has both a sociological and normative dimension. It is entwined in struggles for social recognition,[4] and it encapsulates democratic values.[5] For Alice Baroni, "voice is a quintessential marker of being."[6] It is one way through which people claim their fundamental human right to communicate. Claiming voice is therefore crucial for enacting democratic processes and advocating for human dignity. Voice, however, depends on articulation, positionality, and perspective. It can be silenced when its articulation is prevented or its perspective is dismissed. Markers of identity shape voice in important ways, and they, too, can be used as grounds for silencing. For voice to matter, there needs to be an audience that engages with voice's articulation, perspective, and positionality.

Voice has long been a key activist currency. Video activism, in its aspirational forms, seeks to uncover the processes that obstruct voice,[7] connecting the personal experience of injustice with a larger human rights framework. In this context, voice has several dimensions: literal, figurative, recorded, and transmitted. A human rights survivor can claim voice or be given voice (in the literal sense) through video, which in turn facilitates the recorded and transmitted voice across institutions and media platforms. An eyewitness can capture a video of an unfolding traumatic event, claiming a figurative voice in the process.

I argue that video facilitates the articulation of voice—in its various dimensions—acoustically and visually by combining its perceived authenticity and emotions. This facilitation has been central to how human rights video activism seeks to engage audiences. Yet whose voices matter and whose voices are heard—and why—are deeply political questions, further amplified by the workings of the proxy profession. Human rights collectives use video to give voice to human rights survivors and activists. Through the processes of video production, verification, and training, human rights collectives give voice a form that corresponds to the institutional perspectives and professional dynamics of journalism (chapter 3), the law (chapter 4), and political advocacy (chapter 5). They thus push forward human rights agendas. In the process, however, they also end up arranging the articulation, perspective, and positionality of human rights voices in ways that can

limit the more radical potential and imaginative power of video activism to propose bold programs for justice.

## Acoustic and Visual Voice

The public insertion of an activist voice is connected to social recognition and political engagement. Chouliaraki argues that voice has political agency when it is accepted as something worth listening and responding to.[8] Voice, however, is not a given quality. It needs to be both obtained and sustained. In the context of human rights work, the silencing of voice—whether on the part of the victim who cannot speak out or on the part of the addressee who does not listen—signals a moral dispute of the first order, which Jean-François Lyotard calls "the differend." In his view, "the 'perfect crime' does not consist in killing the victim or the witness (that adds new crimes to the first one and aggravates the difficulty of effacing everything), but rather in obtaining the silence of the witness, the deafness of the judges, and the inconsistency (insanity) of the testimony. You neutralize the addressor, the addressee, and the sense of the testimony; then everything is as if there were no referent (no damages)."[9]

The "perfect crime" indicates the failure of communication as the fundamental facilitator of claiming voice. The addressor (the plaintiff, the victim) is silent; the addressee is deaf; there is no possibility to put into phrases the wrong that has been suffered; the referent is destroyed. These silences can be attributed to various cultural, social, economic, and political factors that hinder the articulation or challenge the perspective and positionality of voice. Part of the work of human rights activists has thus been to break down the silences: to enable trauma survivors to testify, to secure an audience that can bear witness to their experiences, and to find corroborating evidence. Human rights video activism is closely tied to the struggle to assert voice in ways that make a difference.

Video is a platform for voice that manifests itself acoustically and visually. On a basic level, video is a vehicle through which survivors testify, claiming an acoustic voice in its literal dimension. According to Pierre Bairin, the former multimedia director at HRW, "The people we interview understand the power of video and the importance for them to testify because often the people we talk to [are the ones] nobody listens to. So we go and [ask them] to tell us what happened, what went wrong, and they understand that they can make a difference."[10] As an unclaimed experience,[11] trauma needs voice

to articulate the suffering and start the healing process. Voice, in the form of testimony, means breaking the silence about the experienced trauma. The ability to testify in front of an audience also gives the human rights voice the power to assert personal experience as publicly relevant. Testifying is therefore a political act that indicates agency. Because video records the testimonial act, it can help transmit voice to decision-making settings. The interplay between literal, recorded, and transmitted voice in human rights video is significant because it amplifies the acoustic manifestation of voice in critical spaces.

Voice as testimony facilitates "the acquisition of semantic authority by victims,"[12] which is crucial to the public awareness of injustice. As Dori Laub famously argues, "The emergence of the narrative which is being listened to—and heard—is, therefore, the process and the place wherein the cognizance, the 'knowing' of the event[,] is given birth to."[13] In this sense, Shoshana Felman insists that the testimonies of more than 100 Holocaust survivors during the Eichmann trial in 1961 were important beyond their legal purpose.[14] Testimony provides an acoustic form through which voice materializes. By mediating the testimonial act about one's personal trauma, human rights video acts as an important platform for voice, whose emotional resonance and narrative power can serve ethical, historical, and political functions.

Voice also has visual qualities. Trauma's "effects can be discerned and felt in the visual field."[15] Both mimetic and antimimetic theories conceptualize trauma as a visual, a scene.[16] Survivors reexperience trauma through nightmares and flashbacks, and trauma cuts at the heart of questions about the crisis of representation. It is a lacuna that can be transmitted and received through the interpersonal bounding of testimony.[17] Speaking, hearing, and seeing are thus deeply entwined in the process of claiming voice through testimony. Video is a unique mode of knowledge production that records, processes, and transmits cognitive, sensory, and affective information indiscriminately (see chapter 2). As a result, it is particularly suitable for recording and transmitting the power of voice through testimony in its fuller acoustic and visual scope.

Using voice as a heuristic to understand how people relate to images, Barbie Zelizer argues that voice signals "an image's orientation to the imagined, emotional, and contingent cues in its environment, which facilitate its relationship with a broad range of contexts, events, people, practices,

and other images."[18] In other words, voice renders images meaningful beyond their denotative and connotative appeals. Voice in its visual manifestation is figurative. When human rights collectives invoke descriptions of video as a tool that provides a "deeper insight into what the realities are [on the ground],"[19] they underscore an understanding of voice as visual. The vagueness surrounding the explanations about the "deeper insight" of video—such as "[eyewitness video] gives you a feeling of a context" or "a combination of picture and sound is greater than the sum of its parts"[20]—points precisely to the meanings that people infer from video beyond what it seemingly portrays. Video thus relies on a particular relationship between the aural and the visual, necessitating an engagement where hearing is seen and seeing is heard.

Slavoj Žižek's provocation "I hear you with my eyes" speaks to this mode of involvement. Following Jacques Lacan, he argues that "silence is not . . . the ground against which the figure of voice emerges; quite the contrary, the reverberating sound itself provides the ground that renders visible the figure of silence."[21] In this sense, through video, silence can make human rights survivors heard even before they speak. This is what Christian Delage refers to when stating about the Nuremberg trials that the "audiovisual mediation reflected the true essence of Nuremberg in a way that words could not."[22] He sees the eleven seconds of silence in the testimony of one Holocaust survivor as the most powerful and telling part of the witness's statement, one that best verbalized his suffering. This moment is available only on the audiovisual recording of the trial, not in the transcripts, where the silences were edited out. The centrality of video as a platform for acoustic and visual voice rests precisely on its ability to communicate what otherwise seems to resist and exceed representation.

In 2013, WITNESS screened a video about sexual and gender-based violence in the eastern provinces of the Democratic Republic of Congo to government officials in the country. The video includes personal testimonies of women who were sexually assaulted by government soldiers and militia members. Even the title of the video, *Our Voices Matter*, signals the centrality of voice. The video was part of an advocacy action to press for compliance with relevant national and international laws. It was also used to seek assistance and reparations for women and girls whose lives had been affected by these crimes. By screening this video tactically to officials already prone

to wanting change (or primed to listen to those seeking reform), WITNESS helped make these women's voices heard.

Bukeni Waruzi, who directed the project, told me that the video contributed to the allocation of more compensation funds and that the DRC Ministry of Justice used the video to train legal professionals on the seriousness of these types of crimes. In Waruzi's words, "The Minister of Justice would tell us, 'You know, the magistrates that we have, I'm not sure they understand the gravity of the rape crime. If they see this video, maybe they will, and they will interpret the law as they should.' [The problem is that] in most of the cases they see the rape as a gang crime; . . . the perpetrator [is] fined $100, which is nothing, and [sentenced to] four weeks in prison, and that's it. . . . So it didn't seem like this crime was being perceived as a serious crime."[23] Implicit here is the assumption that video is capable of capturing the magnitude of a human rights violation in ways that are more readily accessible, even in institutional spaces. Although testimony is part of the methodological toolkit for human rights fact-finding, its relevance surpasses the evidentiary dimension. This excess lies in the visuality of voice.

*Our Voices Matter* begins with a close-up shot of a young woman. There are a few seconds of silence before she says, "My name is Riziki Shobuto. We are twelve children in our house. I'm a student, but I missed the school opening this year." The silence continues. After it, the viewer finds out that Riziki was raped. Seeing and hearing the silence are significant because it makes her voice heard even before she speaks. The silence creates a mood that directs the viewer on how to engage with the video testimony. The interplay of the visual and acoustic voice triggers an emotional engagement with the human rights story, reinforcing the complicated notion that through video, feeling can contribute to believing (see chapter 5).

HRW's video work also illuminates the acoustic and visual manifestation of voice. In 2016, it produced the video *LGBT Students Bullied in Japan*. The Japanese government was already slated to review its bullying-prevention policy. HRW turned to video as a tactic to seize this moment, urging Japan to name and protect LGBT people as a particularly vulnerable population. The video starts with two images sketched in the style of Japanese manga. The voice of a bullying victim narrates the images through his testimony: "Ever since I was little, I was seriously physically abused because my mannerisms and way of talking was not like the other boys. I was not supposed

to be myself. I needed to act like somebody else. I always believed that." The images the testimony could evoke in the viewer's mind do not directly relate to the first drawing this video shows, which only portrays a close-up of a face in profile with Japanese text in a bubble next to it (figure 6.1). This seeming dissonance between the testimony and the drawing is crucial to how voice works. "Voice makes an image's completion dependent on features beyond its parameters."[24] The cartoon draws the viewer's attention to the eye of the depicted face, which appeals to the viewer's imagination for its meaning.

The centrality of the visual and acoustic voice is implicit in how human rights collectives describe and operationalize video's power in their work. In 2009, WITNESS coproduced a video with the Centre for Minority Rights Development in Kenya, *Rightful Place: Endorois' Struggle for Justice*. The video documents four decades of forced evictions of the Endorois community from their lands. It emphasizes personal testimonies as authentic claims to justice. WITNESS submitted and screened this video in front of the African Commission on Human and Peoples' Rights, which eventually ruled against the expulsions. Priscila Neri, senior program manager, described the significance of the video: "The courtroom was in another country. These were Indigenous pastoralist communities who would never be able to go to the courtroom. So, I think, in that context, you being able to literally bring the voice of that person who is directly affected face to face . . . with the

**Figure 6.1**
Screenshot, *LGBT Students Bullied in Japan*, HRW, June 10, 2016, https://www.youtube.com/watch?v=kVUyw8Pob68.

judges is something that photography can't do, for example, and is something that other mediums can't do as effectively because [with video] we're hearing the person's voice. We're seeing the person's face."[25] The interplay of hearing their voices—when human rights survivors speak and when they are silent—and seeing their faces is thought to help the viewer understand the magnitude of the human rights violation.

Even so, not all human rights videos show the face of the person who testifies. For safety reasons, sometimes the videos feature pixelated or shadowed faces. As part of a campaign for law enforcement units in Macedonia to reduce violence committed by police officers against sex workers, WITNESS coproduced *You Must Know About Me: Rights, Not Violence for Sex Workers in Macedonia* (2009). The video features testimonies of women who have been victims of violence. The viewers cannot see these women's faces. Instead, black silhouettes are portrayed against a colorful background (figure 6.2). Yet the women's testimonies remain powerful: "I didn't have any air to breathe." "They took us to the Bit Pazar police station . . . they taunted us in the station. 'Now dance, now stand like sheep.' . . . They abused us. . . . They didn't even give us water or bread."

**Figure 6.2**
Screenshot, *You Must Know About Me: Rights, Not Violence for Sex Workers in Macedonia*, WITNESS and the Healthy Options Project Skopje, December 8, 2009, https://vimeo.com/207838742.

Amnesty's video *Nolwandle's Story* (2013), on political violence against women in Zimbabwe, by contrast uses animation along with a personal testimony (figure 6.3). This video captures how voice can be powerful even without directly seeing the speaker's face. As a series of animated images show on the screen, the viewer hears Nolwandle's testimony: "One time I was beaten about nine times, told to count how many strokes. There was this old woman next to me. She was also beaten. I stood up, and I just screamed for them to stop. I didn't care whether they would do anything more to me because I had had enough." The relationship between the visual aspect of voice and the pixelated and shadowed faces, or the replacement of the face with other images, is a corollary to the relationship between acoustic voice and silence. The absence of one helps the viewer understand the amplification of the other. This is why voice is central to how human rights videos function.

Voice also helps explain how human rights video works in journalism and the law. For example, when news organizations broadcast the footage provided by HRW on Syria's torture centers—featuring drawings and testimonies—or a curatorial video on hate crimes in Russia—weaving eyewitness footage with LGBTQ activists' testimonies (see chapter 3)—they played to the acoustic and visual dimensions of voice. For safety reasons, the faces of the torture victims are not shown in *Syria's Torture Centers Revealed* (2012), yet this visual absence is strengthened by the power of

**Figure 6.3**
Screenshot, *Nolwandle's Story*, Amnesty International, July 25, 2013, https://www.youtube.com/watch?v=W7n1Ks3exko.

testimony. The horrific eyewitness videos that make up *Russia: Gay Men Beaten on Camera* (2014) remain with its viewers, shaping how they hear and see the testimonies of the activists and trauma survivors.

The documentary, persuasive, and mnemonic functions of video in human rights courts (see chapter 4) also draw from the power of video as a platform for voice. Repeated justifications for the submission of video as evidence at the ICTY get to the heart of how voice works. At multiple trials, attorneys evoked how video portrayed the emotional and physical harm more vividly than words could, how it effected a better understanding of the crime, and how it created lasting memories of prior human rights abuses. Implicit in the use of video by human rights courts such as the ICTY is how the interplay of sound and vision as well as the generated sense of immediacy, mood, expression, and immersion are central to video's evidentiary contributions. These qualities, however, exceed the presumed representational logic that has long underscored the use of visual imagery in court. They rest instead on a notion of voice that elucidates how images move viewers through their appeal to emotions, memory, and imagination, all of which makes visual meaning making dependent on features outside of the image itself.

The acoustic and visual qualities of voice—in the various dimensions facilitated by video—draw from a double-sided recognition of its perceived authenticity and emotions. The authenticity of the personal experience with violence or injustice grants authority to the articulation of voice via testimony.[26] Human rights collectives insist that "the video has to be a story of a person. Instead of the horizontal wide, broad evidence, you need the vertical deep evidence. . . . It's a weird thing because all day long our [researchers] are meeting people and hearing their stories, but [because of] the way they combine or the way they gather that evidence, they aren't, in the end, writing up the whole story."[27] A report highlights the evidentiary scope of a human rights investigation, whereas a video reaches beyond truth telling by capturing the emotional dimensions and perceived authenticity that undergird the testimonial act that is central for human rights work. Reports can talk about human rights in abstract legal terms, but "video puts a human face in the human rights atrocity story."[28]

As "the intervening variable between experience and action,"[29] witnessing has long constituted the main operational mechanism in human rights work.[30] Video gains power through the assumptions associated with this

tradition. It can document human rights violations as they unfold, it can bear witness to personal testimonies and experiences, and it can reference past trauma in the present. Video can mediate witnessing as an individual experience to other platforms. In doing so, it can strategically transform witnessing into material that is socially relevant and suitable for journalism, the law, and political advocacy. In other words, it can render witnessing appropriate for policy making.

Witnessing also draws from video's power to facilitate voice in that it designates a particular mode of seeing and feeling whereby seeing can be felt and heard and feeling can be heard and seen. Referencing the power of eyewitness video, Raja Althaibani, a program coordinator at WITNESS, told me that video "provides people who aren't there the opportunity [to see and hear] what the individuals who were collecting and producing the content were witnessing and seeing firsthand."[31] Video can potentially expand the spaces where human rights voices—in their acoustic and visual forms—matter.

### How the Proxy Profession Shapes Voice

When human rights collectives put video into institutional and legal service, they shape the articulation, perspective, and positionality of voice through the streams of professionalism. To facilitate voice in journalism, the law, and political advocacy, video's claims to authenticity need to be verified. Authenticity is never assumed. Having seen or experienced trauma is a necessary, but not sufficient, condition to assert authenticity in institutional and legal environments. Institutions and their agents are central to how authenticity is framed.[32] Through its emerging institutional authority, the proxy profession now helps define the authenticity of human rights voices, rendering them meaningful across decision-making contexts. For example, it verifies eyewitness videos or records and transmits human rights testimonies. In the process, the proxy profession can help human rights voices—in their acoustic and visual manifestations—find resonance in the institutional matrix that recognizes and redeems human rights claims.

The unfolding of the proxy profession suggests that human rights collectives can help bring the voices of human rights survivors, activists, and eyewitnesses to journalism, the law, and political advocacy. These collectives are better positioned to do so in ways that make a difference when they rely on de Certeau's notion of tactics. In other words, the proxy profession has

the potential to magnify voice when it profits from circumstances, turning institutional challenges into opportunities for human rights activism. This potential is immensely important indeed.

Forensic Architecture, for example, insists on the tactical use of *forensis* as a counterhegemonic practice to expose injustice. Because each investigation is different,[33] the organization has flexible models of work across settings not limited to the traditional human rights domain. In a notable recent project, Forensic Architecture partnered with Laura Poitras for the video investigation *Triple Chaser* at the Whitney Biennial 2019. The investigation exposed the weapons-selling business of Warren B. Kanders, then the vice chair of the board of trustees of the Whitney Museum of American Art in New York, who ultimately had to resign from this position. The sale and export of tear gas in the United States is not a matter of public record; thus, the video investigation was important in uncovering how tear gas canisters used by state agencies in conflicts and protests from the Middle East to the US–Mexican border were manufactured by Kanders's company. The investigation profited from the circumstances to expose wrongdoings through video-verification principles, extending the spaces where human rights voices—in their figurative dimensions—can make a difference.

In its pursuit of institutional leverage, however, the proxy profession can underplay the centrality of literal voices. Ryan Kautz, senior video producer and editor at WITNESS, explained to me:

> You are trying to make a difference so that video needs to speak in a language that would appeal to the people [who] can make that difference. A lot of times activists are so impassioned—they are either from the communities that are affected or [are] advocating for those communities—so you have this sort of black-and-white view of the issue: there's right, and there's wrong. But, sometimes, if you are talking to decision makers, you have to be a little bit more diplomatic and speak in a language that's not confrontational necessarily while still advocating strongly for your point.[34]

Although video is perceived as a tool that facilitates voice, Kautz suggests that the strategic employment of voice is what matters: how to position the articulation of voice vis-à-vis the audience's perspective. Human rights activists are expected to take a pragmatic view and insert their claims by learning how to speak the language of targeted audiences.

The materiality of voice, though, has long constituted grounds for silencing, especially when its emotional reverberation has been associated

with identity markers, such as race,[35] gender,[36] or class,[37] just to name a few. Kautz's call for pragmatism unintentionally implies dislodging markers of identity. To influence decision-making processes in the context of human rights, activists need to shape their voice and display of emotions in relation to the audience. What is silenced in the process is the positionality of voice, a key dimension that, when preserved, can help diversify the voices that matter in the institutions central to human rights.

When the proxy profession turns to strategies in de Certeau's sense, it can not only displace voice's identity indicators but also speak on behalf of voices or leave them out. HRW, for example, produced the video *Yemen: End Child Marriage*, which was shown in a closed screening to Yemen's minister of human rights, government officials, and lawmakers in 2013.[38] The goal was to provide a platform for political elites to discuss how they could put forward a constitutional provision to establish a minimum marriage age. Tailoring the content to make it appropriate for government representatives and for the pursuit of institutional solutions, however, narrowed the video in two notable ways.

By virtue of its institutional standing, HRW (just like other human rights collectives) is better positioned to give voice rather than to help create the conditions that would allow people to claim voice on their own. It is not surprising, then, that despite the presumed power of video as a vehicle through which people voice their experiences and define their needs, *Yemen: End Child Marriage* features mostly traditional authorities, such as an imam, a parliamentarian, a gynecologist, a Noble Peace Prize winner, and a father who regrets marrying off his daughter as a child. The people most directly affected by the practice of child marriage are largely *spoken for* in this video. In addition, by focusing on a specific legal reform, the video fails to tackle adequately the socioeconomic problems underpinning the practice. This element is only implicit in the video through the testimony of the father who regrets his decision and the supplemental information provided by the HRW researcher explaining how child marriage is most prevalent in rural areas. This example sheds light on how the proxy profession can often represent key human rights voices even as it claims that video's power rests with the emotional resonance and authenticy of the human rights testimony.

The proxy profession can also silence voices. For the purposes of political advocacy, it turns to institutional strategies that tailor the content,

style, and distribution of a video to a targeted audience. And sometimes the impossibility of defining an audience and an appropriate advocacy goal means a decision not to engage with a topic. For Morgan Hargrave, former systems-change coordinator at WITNESS,

> the question isn't where the most egregious human rights issue in the world is. The question is where video can make an impact. . . . We looked at migrant rights in certain parts of Africa, and it turned out it was going to be really hard to use video in these spaces for lots of reasons. Some are security, some just basic equipment and literacy issues on how to use it. . . . On this particular issue, it [also] seemed like it was going to be really hard to tell these specific stories and make a larger impact. It wasn't entirely clear who we're appealing to and what the end goal is. It just wasn't there.[39]

This example further illustrates how the focus on audiences, concrete pragmatic solutions, and measurable impacts compels human rights collectives to work within organizational constraints and frameworks. Legitimized within NGO structures, the proxy profession is vulnerable to market dynamics and their neoliberal logics. These dynamics are not keen on the ethical and political importance of preserving diverse human rights voices through complex storytelling whose effects cannot be easily quantified. As a result, when the proxy profession turns to strategies, voice—as an unbounded critical articulation of injustice that exceeds institutional frameworks, professional logics, and market streams—loses its central human rights currency.

## The Difficulties in Professionalizing Information Work

Eliot Freidson argues that "to understand how formal knowledge can influence the social world around it . . . one must understand both the professions that serve as its carriers and the institutions that make those professions possible."[40] This book has shown how the knowledge provided by video is becoming institutionalized across journalism, the law, and political advocacy, demanding new skills and practices within an institutional calculus aspiring to the logic of professionalism. This development suggests that institutional standing is necessary to restore the value of the knowledge provided by video that human rights activists have long nurtured and promoted.

Professionalization is widely recognized as a process through which specialization is sought and the status of professionalism is established.

Those who work for global human rights collectives are able to position themselves better as agents of video knowledge through their aspirations to professionalism. By putting video to use in human rights policy making, human rights collectives develop practices and standards that build on a tradition long evident in visual politics. These efforts help them assert and sustain occupational control over a particular visual epistemology that is pertinent today.

This book has demonstrated two key developments that facilitate the emerging professionalization of human rights video activism: (1) the new institutional circumstances created through the incorporation of human rights video across journalistic, judicial, and political advocacy milieus, and (2) the broader "NGO-ization" process that has elevated the institutional expertise of human rights collectives as key representatives of civic voices in the human rights domain.

Sabine Lang defines NGO-ization as "the process by which social movements professionalize, institutionalize, and bureaucratize in vertically structured, policy-outcome-oriented organizations that focus on generating issue-specific and, to some degree, marketable expert knowledge or services."[41] In her view, professionalization meets the needs of public and commercial sectors because it speaks a language understood and sought out by governments and businesses. As a result, civil groups have an incentive to turn into NGOs, whose legal status grants them better access to funding structures and decision-making processes. In other words, the NGO structure can be appealing as a survival strategy in societies where knowledge is shaped by institutions and the logic of professionalism.

Following Max Weber,[42] Lang sees professionalization as a mechanism for developing institutional expertise. This new institutional authority turns NGOs from outsiders in political decision making to entities welcomed at negotiation tables with governments and intergovernmental organizations such as the United Nations. Lang, however, also shows how institutional leverage can come at the expense of the activists' critical voices. In her view, a direct consequence of the professionalization and institutionalization of social activism is NGOs' preference for institutional advocacy venues (e.g., lobbying governmental officials or advocating for a policy proposal), which offer more immediate and measurable returns over broader agendas to generate and maintain public dialogue, even on issues that do not lend themselves to easy political or legal solutions.[43] Implicit in Lang's argument is

how market forces can encourage professionalization and institutionaliza-
tion. Civil society groups—which struggle for existence in institutional and
corporate environments—have partially taken on this reasoning through
the process of NGO-ization.

The rise of NGOs as influential and visible actors in international politics
created an institutional home for human rights activism. Aryeh Neier, a for-
mer executive director at the American Civil Liberties Union and HRW (as
well as a president emeritus of the Open Society Foundation), sees the NGO
structure as key for sustaining and expanding the relevance of the global
human rights movement.[44] The segmentation of human rights activist col-
lectives into NGOs around the world, which have better access to fund-
ing and can form structural ties—weak or strong—with political and legal
institutions, has placed them at a relatively advantageous position to assert
rights claims in formal venues over other activist groups lacking such orga-
nizational links. To maintain their institutional authority in the human
rights realm, leading human rights collectives that enjoy the legal status
of an NGO are further compelled to work within existing institutional and
legal structures. As this book has shown, this process plays out in the visual
field as well. Here, the efforts to professionalize video activism give rise to
a proxy profession that has to navigate the logic of neoliberalism as part of
its institutional legitimation.

Though these efforts do not take on the same form across institutions,
they follow three interrelated trajectories of practice: video production,
development of standards, and training. Professionalization is pursued as a
guiding mechanism for the production of human rights videos that meet
the criteria of different institutional milieus. According to Kelly Matheson,
senior attorney and program manager at WITNESS, it is important to make
a video "that the BBC can verify and broadcast, the UN Security Council
could rely on, commissions of inquiry might use and that courts could
be able to use . . . for long term justice and accountability."[45] This kind of
prospective reasoning is seen as the best way to ensure that video lives up
to its human rights potential. As a result, to professionalize video activism,
human rights collectives are incorporating strategies and tactics that mimic
the professional paradigms of the targeted audiences.

The professionalization of video activism offers a way for human rights
video to perform specialized tasks within institutional and legal frameworks.
Through professionalism, human rights collectives seek recognition and

acceptability as visual experts. Yet their practices depend on other institutions because differentiated audiences and market logics have become central to shaping human rights video. There are important practical gains in the process, as the various success stories discussed throughout the book illustrate well. At the same time, the proposed actions and solutions that the new iteration of video activism brings forward tend to operate within the sociocultural paradigm of Western modernity, which is crumbling beneath us.[46] The resulting proxy profession thus comes at the expense of fresh thinking about what human rights could be as a moral and political force in the world and how to harness the power of video to innovate in this space.

Related to video production is the emergence of standards, which serves as another evidence of professionalism because it embodies the ideals and principles that guide the development of specialized knowledge. Human rights collectives are developing and promoting standards for video verification and for ethical, safe, and efficient video making to achieve human rights. They elaborate on these standards and best practices in various publications, including those by academic presses, as a means to claim broader theoretical relevance for the knowledge provided by video in human rights policy making.[47]

Standards for the proper production, distribution, and verification of human rights videos are promoted through training as well. Formal training constitutes an important aspect of professionalization.[48] Although there is no formal education for human rights video activism and its related practices, human rights collectives aspire to professionalism by conducting online and in-person training internally for their staff and externally for others. Training helps shape human rights video activism ahead of time, suggesting that activism is no longer a practice that can be learned on the spot but one that should be understood in advance to ensure effective use of video in policy-relevant contexts. Through training, human rights collectives diffuse relevant knowledge that other video activists and human rights practitioners can apply. The centrality of differentiated audiences to various training programs, however, makes human rights video activism dependent on the professional parameters of journalism, the law, and political advocacy. This dependency is further amplified by the fact that many staff members at global human rights organizations have backgrounds in these professions.

Through video production, standards, and training developed to accommodate external and internal needs for legitimacy and impact, human

rights collectives seek to professionalize video activism. Yet their efforts are contingent upon other institutional environments with their respective professional logics. The professionalization of video activism is therefore a primarily outward-looking process, unable to result in professional independence. It also does not involve the kind of licensing procedures, competence tests, and educational accreditations that are emblematic of traditional professions such as medicine and the law. In other words, the aspiration to professionalize human rights video activism is an incomplete endeavor, suggesting instead a professional orientation about what to do and what to avoid when using video for institutional and legal decision making. This book's core argument has been that the efforts to professionalize result in a proxy profession that puts its knowledge to use when brokering between various publics and the institutions that serve public needs. In the process, the proxy profession can pragmatically amplify the presence of human rights voices across institutions while also strategically downplaying the centrality and diversity of these voices in other circumstances.

The professionalization project around human rights video activism is fraught with contradictions, many of which resemble those in journalism. In his powerful account of media history in the United States, John Nerone addresses professionalism in journalism in ways that indicate parallels to the unfolding professionalization of human rights video activism.[49] There are fundamental challenges in professionalizing information work writ large because the kind of information practices that best challenge the abuses of power often find professional strategies too constraining. Against this background, the interplay between tactics and strategies, as defined by de Certeau and examined in this book, provide a metaphorical way of thinking about the dynamics of professionalism in information work more broadly.

Training and certification provide autonomy and independence for ordering specialized knowledge, which is necessary for reaching the status of a profession. In other words, a profession has to develop strategies for its specialty. Autonomy and independence, though, often come from science, as in the case of medical science that sets medical professionals apart through their systematic application of medical knowledge. Yet there is no journalism science per se. There are standards and practices for verification and legitimacy. Even calls for journalism education in the United States articulated early on by Joseph Pulitzer (Columbia University) and Walter

Williams (University of Missouri) documented a set of information tactics necessary for journalism's civic mission.[50]

Journalists have often been dependent on others for their infrastructure—whether corporate monopolies or state and party bureaucracies. This is why Nerone argues that "by telling themselves that they are professionals like doctors and lawyers, journalists leave themselves less capable of resisting the forces that render them dependent. They are, for instance, less capable of challenging manipulation of empowered sources. And they are often incapacitated by a felt need to be balanced."[51] Thinking about journalism as a profession is already a complicated and unsettled matter because journalism displays few of the characteristics that sociologists identify with professions.[52] But even when journalism is seen as such, journalists often do their best investigative work when they bypass some of the strategies shaping journalism as an institution associated with distinct professional dynamics. To put it differently, the best of journalism, just like the best of human rights practice, continues to profit from tactics that challenge state and corporate power.

Similar to journalism, the unfolding efforts to professionalize human rights video activism also depend on others for the infrastructure and framework in order to sustain human rights practice. Human rights collectives rely heavily on institutions such as the law, a reliance that can limit their ability to advocate for justice in other ways. Jacques Derrida provides an invaluable lesson here with his notion of justice as an experience of the impossible. This kind of justice is different from the law, which is defined by a history of rights, documents, and legal systems. According to Derrida, "Justice is what gives us the impulse, the drive or the movement to improve the law."[53] For him, justice exists outside of the visible, the readily knowable, the calculable; justice is irreducible to legal structures and strategies.

Derrida highlights the importance of envisioning justice as an exercise in imagination that facilitates legal and political innovation. By operating within existing institutional and legal frameworks, human rights video activism in its manifestation as a proxy profession may be missing out on an important opportunity to engage differently with the fragility of human experiences, which, for all of their legal fallibility, provide the key sources of inspiration to fight for human rights and human dignity in the world.

There is another parallel between professionalization in journalism and professionalization in human rights video activism as two examples of information work. The project of professionalism in US journalism has had

a capacity problem, struggling with class and privileging elite audiences. As Nerone puts it, "The working class did not abandon news. News abandoned them. Journalists abandoned them in the hunt of prestige. News executives abandoned them in the pursuit of advertising revenue."[54] In addition, prestigious newsrooms typically hire journalists with degrees from elite institutions, just like prominent human rights NGOs do. The streams of professionalism in human rights video activism are similarly biased toward elite audiences and Western contexts, where civic and political rights have long taken the priority over the broader spectrum of human rights. Yet this assumed hierarchy among human rights is proving inadequate in resisting the fuller range of corporate and state powers that violate human dignity globally.

As a response to growing authoritarian populism in the world, Amnesty and HRW have recently expanded their programs in the areas of economic, social, and cultural rights,[55] working to educate publics on the nature of human rights as well.[56] Video is central to these efforts. However, the institutional strategies that shape video are not enough, for, as Samuel Moyn documents, the era of human rights as we know it has been marked by an exponential growth of inequality in the world across national settings. He argues, "The real trouble about human rights, when historically correlated with market fundamentalism, is not that they promote it but that they are unambitious in theory and ineffectual in practice in the face of market fundamentalism's success. Neoliberalism has changed the world, while the human rights movement has posed no real threat to it."[57] The values, practices, and aspirational visions that have long shaped video activism as an occupational craft could provide signposts for how to go about repositioning human rights today as an ambitious platform for global human dignity and equality. To do so, political will is of utmost importance. To rally behind this platform, the streams of professionalism—and their existence in market fundamentalism—may be too confining.

## The Future of the Proxy Profession

This book has examined how and to what ends video's potential to advocate for social change and achieve human rights depends on the agents and institutions that shape and use it. Human rights videos are not a neutral instrument for social change. Video's depiction of what some see as injustice is not

sufficient by itself to legitimize a human rights claim. The closer look at how different human rights collectives work with video illuminates that what counts as a human rights violation is not automatic but is often shaped by journalistic, legal, and political advocacy structures and assumptions. Even in a digital landscape characterized by democratized image production and culture of circulation, institutions with their internal professional logics continue to use and privilege one set of videos over others when recognizing human rights claims. What gets picked up is not divorced from cultural framings, market dynamics, and sociopolitical ideologies.

Human rights collectives give rise to video activism as a proxy profession to tap more efficiently into video's evidentiary, policy, and advocacy potential. The emergence of this proxy profession is a complex phenomenon that provides important lessons for the scope of activism, the power of human rights, and the status of video evidence moving forward. The proxy profession embodies a key tension evident in its legitimacy through and within existing NGO structures. It retains some flexibility through tactics, but the growing emphasis on strategies makes it give up on the more radical possibilities of activism to propose innovative and ambitious programs for change.

The proxy profession can facilitate exchange of experiences and best practices, creating a community of global human rights video activists and practitioners. It can help activists learn how to mimic and use institutional tools and standards to increase the likelihood of human rights videos being pushed to the forefront of institutional and legal debate. The proxy profession can ensure that news organizations, courts, and global institutions such as the United Nations, for example, do not dismiss valuable video materials on the grounds of poor quality or unreliability. Yet the institutional and legal orientation of the proxy profession tends to confine human rights activism. By pointing the finger at traditional authorities who violate or fail to protect human rights while seeking to work within their formal mechanisms, the proxy profession rescues institutional power at the same time that it denounces it. Not to mention that institutional parameters might not always be the best venue for pursuing human rights agendas.

Livia Hinegardner's analysis of grassroots videos documenting police violence in Atenco, Mexico, is a powerful reminder that when the appropriate laws and policy regulations are in place, but the system fails to comply with them, the act of filmmaking alone can be an important activist

engagement. In her view, "the production and distribution of films created a social field of action in which political actors could transform themselves from bystanders (or victims) to active participants. Thus, the political field that activist film opens in Mexico represents an attempt at more profound social and political transformation than formal legal changes."[58] The focus on institutional action that the proxy profession promotes can leave out the importance of continuous acting as key in nurturing and sustaining public dialogue on injustice.[59] As the work of proxy professionals unfolds, how human rights practitioners and activists on the ground (who work with or are trained by global human rights collectives) negotiate the dynamics of professionalization will be important to understand.

The proxy profession navigates an already politicized human rights terrain;[60] how it does that is significant for the future of human rights as a moral grammar for global justice and for the institutional and legal status of video evidence. Monroe Price provocatively suggests that in the current media landscape, "for a state to be a state, even a democratic state, it must have a greater sway over the legitimate use of information."[61] States are increasingly co-opting human rights narratives for their own interests, military expansions, and interventions.[62] For these purposes, states have already used a wide range of visual imagery throughout history, beginning with maps and diagrams.[63]

In more recent memory, the satellite image held by US Secretary of State Colin Powell at the United Nations in 2003 as he justified the military invasion of Iraq on the grounds of the existence of weapons of mass destruction is a great reminder of states' strategic use of visual information crafted around a human rights narrative. Such strategies are becoming even more common today as states ranging from North Korea to Israel turn to video to dismiss the legitimacy of human rights activist claims and to promote their own narratives instead.[64]

Even the ideologies of global human rights collectives have changed as they have grown in size and relevance. Amnesty, for example, moved away from its core principle to advocate against violence. The same group that did not support Nelson Mandela as a prisoner of conscience gave full support of NATO troops in Afghanistan. Amnesty and HRW are no longer the underdogs they once were. Human rights collectives are political actors whose ideologies and actions demand careful scrutiny, just as those of the institutions of governance do. This similarity is further complicated

by the marketization of the human rights field. Funding schemas, growing accountability to donors, the push for efficiency, and a preference for measurable impacts—all matter for what kinds of human rights violations are addressed, if at all, and how. WITNESS, for example, received funding for specialized programming on criminal justice, immigration, and Indigenous rights in the United States after the 2016 presidential election,[65] despite these issues mattering long before then.

The struggles to assert the relevance of human rights video are ongoing. Video can be an important tool for documenting, investigating, and litigating human rights claims, especially when new modes of evidence are necessary to address the challenges facing human rights practice today. The use of this tool, however, demands further scrutiny. As video increasingly provides the main mode of accessing ongoing conflicts, and as institutions and publics trust the knowledge provided by video, the visual field will grow as a site of struggle and manipulation, with the rise of deepfakes posing just one set of problems. These developments iterate that today's social, legal, political, and media institutions need to address rigorously the power and limitation of video as a unique mode of knowledge.

Seeing human rights through video's lens from within the institutions central to civic life can create important political engagement with injustice. Yet video's ultimate potential for social change is implicated in how human rights activism—in its multiple permutations—negotiates institutional and professional dynamics with their respective logics and ideologies to make its voice matter. And voice is the oxygen for human rights.

# Notes

## Chapter 1

1. John Tagg, *The Burden of Representation: Essays on Photographies and Histories* (Minneapolis: University of Minnesota Press, 1988), 63.

2. Tina Askanius, "Video Activism as Technology, Text, Testimony—or Practices," in *Citizen Media and Practice: Currents, Connections, Challenges*, ed. Hilde C. Stephansen and Emiliano Treré (Oxon: Routledge, 2020), 136–151.

3. Quoted in Maria Bustos Hawkes, "The Square's Jehane Noujaim on Filming a Revolution," *WITNESS*, blog, January 31, 2014, http://blog.witness.org/2014/01/jehane-noujaim-on-filming-egypts-revolution/.

4. See Omur Harmansah, "ISIS, Heritage, and the Spectacles of Destruction in the Global Media," *Near Eastern Archaeology* 78 (3) (2015): 170–177.

5. See, for example, Johanna Drucker, *Graphesis: Visual Forms of Knowledge Production* (Cambridge, MA: Harvard University Press, 2014); Neal Feigenson and Christina Spiesel, *Law on Display: The Digital Transformation of Legal Persuasion and Judgment* (New York: New York University Press, 2009); George E. Marcus, *The Sentimental Citizen: Emotion in Democratic Politics* (University Park: Pennsylvania State University Press, 2002); Jennifer L. Mnookin, "The Image of Truth: Photographic Evidence and the Power of Analogy," *Yale Journal of Law & the Humanities* 10 (1) (1998): 1–74; Michael Schudson, *Discovering the News* (New York: Basic Books, 1978); James Thompson "'Pictorial Lies'?—Posters and Politics in Britain c.1880–1914," *Past and Present* 197 (1) (2007): 177–210; Barbie Zelizer, *About to Die: How News Images Move the Public* (New York: Oxford University Press, 2010).

6. See, for example, Lynn Hunt, *Inventing Human Rights: A History* (New York: Norton, 2007); Sharon Sliwinski, *Human Rights in Camera* (Chicago: University of Chicago Press, 2011).

7. Sandra Ristovska, "Imaginative Thinking and Human Rights," in *Visual Imagery and Human Rights Practice*, ed. Sandra Ristovska and Monroe Price (New York: Palgrave, 2018), 311–320.

8. Sandra Ristovska, "The Case for Visual Information Policy," *Surveillance & Society* 18 (3) (2020): 418–421.

9. See, for example, Kari Andén-Papadopoulos and Mervi Pantti, "Re-imaging Crisis Reporting: Professional Ideology of Journalists and Citizen Eyewitness Images," *Journalism* 14 (7) (2013): 960–977; Barbie Zelizer, *Remembering to Forget: Holocaust Memory through the Camera's Eye* (Chicago: University of Chicago Press, 1998); Zelizer, *About to Die*.

10. Zelizer, *About to Die*, 3.

11. James S. Ettema and Theodore L. Glasser, *Custodians of Conscience: Investigative Journalism and Public Virtue* (New York: Columbia University Press, 1998).

12. See, for example, Claire Wardle, "How Newsrooms Use Eyewitness Media," in *Visual Imagery and Human Rights Practice*, ed. Ristovska and Price, 299–308.

13. Feigenson and Spiesel, *Law on Display*, 4.

14. See, for example, Elizabeth G. Porter, "Taking Images Seriously," *Columbia Law Review* 114, no. 7 (2014): 1687–1782.

15. Sabine Lang, *NGOs, Civil Society, and the Public Sphere* (New York: Cambridge University Press, 2013), 91.

16. John Durham Peters, "Distrust of Representation: Habermas on the Public Sphere," *Media, Culture, & Society* 15 (1993): 563.

17. See, for example, Lang, *NGOs, Civil Society, and the Public Sphere*.

18. Christina Twomey, "Framing Atrocity: Photography and Humanitarianism," *History of Photography* 36 (3) (2012): 255–264.

19. Sliwinski, *Human Rights in Camera*.

20. Leshu Torchin, *Creating the Witness: Documenting Genocide on Film, Video, and the Internet* (Minneapolis: University of Minnesota Press, 2012).

21. Aryeh Neier, *International Human Rights Movement: A History* (Princeton, NJ: Princeton University Press, 2012).

22. Neier, *International Human Rights Movement*, 234.

23. Amnesty International, "About Amnesty," n.d., para. 2, https://www.amnesty.org.uk/issues/about-amnesty.

24. Amnesty International, "Who We Are," 2016, para. 3, https://www.amnesty.org/en/who-we-are/.

25. Human Rights Watch, "Mission Statement," 2016, para. 3, https://www.hrw.org/about.

26. WITNESS, "About," 2016, para. 1, https://witness.org/about/.

27. See, for example, Nicola Perugini and Neve Gordon, *The Human Right to Dominate* (New York: Oxford University Press, 2015).

28. The UN Refugee Agency, "Worldwide Displacement Tops 70 Million, UN Refugee Chief Urges Greater Solidarity in Response," June 19, 2019, https://www.unhcr.org/en-us/news/press/2019/6/5d03b22b4/worldwide-displacement-tops-70-million-un-refugee-chief-urges-greater-solidarity.html.

29. Ristovska, "Imaginative Thinking and Human Rights."

30. See, for example, Carleen F. Maitland, ed., *Digital Lifeline? ICTs for Refugees and Displaced Persons* (Cambridge, MA: MIT Press, 2018).

31. For example, see Sam Dubberley, Alexa Koenig, and Daragh Murray, *Digital Witness: Using Open Source Information for Human Rights Investigation, Documentation, and Accountability* (Oxford: Oxford University Press, 2020).

32. See Jeff Deutch and Hadi Habal, "The Syrian Archive: A Methodological Case Study of Open-Source Investigation of State Crime Using Video Evidence from Social Media Platforms," *State Crime* 7 (1) (2018): 46–76; Sandra Ristovska, "Human Rights Collectives as Visual Experts: The Case of Syrian Archive," *Visual Communication* 18 (3) (2019): 333–351.

33. See, for example, Marwan M. Kraidy, *The Naked Blogger of Cairo: Creative Insurgency in the Arab World* (Cambridge, MA: Harvard University Press, 2016); Graham Meikle, *The Routledge Companion to Media and Activism* (New York: Routledge, 2018); Emiliano Treré, *Hybrid Media Activism: Ecologies, Imaginaries, Algorithms* (New York: Routledge, 2019); Zeynep Tufekci, *Twitter and Tear Gas: The Power and Fragility of Networked Protest* (New Haven, CT: Yale University Press, 2017).

34. Walter W. Powell and Paul J. DiMaggio, eds., *The New Institutionalism in Organizational Analysis* (Chicago: University of Chicago Press, 1991).

35. Andrew Delano Abbott, *The Systems of Professions: An Essay on the Division of Expert Labor* (Chicago: University of Chicago Press, 1988).

36. Ronald L. Jepperson, "Institutions, Institutional Effects, and Institutionalism," in *The New Institutionalism in Organizational Analysis*, ed. Powell and DiMaggio, 143–163; Powell and DiMaggio, *The New Institutionalism*.

37. Malachy Browne, phone interview, July 9, 2019.

38. Bukeni Waruzi, interview, New York City, August 6, 2015.

39. See, for example, Independent International Commission of Inquiry on the Syrian Arab Republic, *10th Report of Commission of Inquiry on Syria,* Report no. A/HRC/30/48 (New York: Office of the United Nations High Commissioner for Human Rights, 2015).

40. Belkis Wille, interview, New York City, June 25, 2015.

41. Eliot Freidson, *Professional Powers: A Study of the Institutionalization of Formal Knowledge* (Chicago: University of Chicago Press, 1986), xi.

42. Michel de Certeau, *The Practice of Everyday Life*, trans. Steven Rendall (Berkeley: University of California Press, 1984).

43. Meg McLagan, "Circuits of Suffering," *Political and Legal Anthropology Review* 28 (2) (2005): 223.

44. Philip Elliott, *The Sociology of the Professions* (London: Macmillan, 1972).

45. See Abdul Rahman Al Jaloud, Hadi Al Khatib, Jeff Deutch, Dia Kayyali, and Jillian C. York, "Caught in the Net: The Impact of 'Extremist' Speech Regulations on Human Rights Content," May 2019, https://www.eff.org/files/2019/05/30/caught_in_the_net_whitepaper_2019.pdf.

46. For an overview of how activists negotiate their relationship with mainstream technologies, see Elisabetta Ferrari, "The Technological Imaginaries of Social Movements: The Discursive Dimension of Communication Technology and the Fight for Social Justice" (PhD diss., University of Pennsylvania, 2019); Natalie Fenton and Veronica Barassi, "Alternative Media and Social Networking Sites: The Politics of Individuation and Political Participation," *Communication Review* 14 (3) (2011): 179–196; Tina Askanius and Nils Gustafsson, "Mainstreaming the Alternative: The Changing Media Practices of Protest Movements," *Interface* 2 (2) (2010): 23–41.

## Chapter 2

1. Louis-Georges Schwartz, *Mechanical Witness: A History of Motion Picture Evidence in U.S. Courts* (New York: Oxford University Press, 2009).

2. See, for example, John Downing, *Radical Media: Rebellious Communication and Social Movements* (London: Sage, 2001); Alan Fountain, "Alternative Film, Video, and Television 1965–2005," in *The Alternative Media Handbook*, ed. Cate Coyer, Tony Dowmunt, and Alan Fountain (New York: Routledge, 2007), 29–46; Thomas Harding, *The Video Activist Handbook* (London: Pluto Press, 2001).

3. See, for example, Deirdre Boyle, "Subject to Change: Guerrilla Television Revisited," *Art Journal* 45 (3) (1985): 228–232; Deirdre Boyle, "From Portapak to Camcorder: A Brief History of Guerrilla Television," *Journal of Film and Video* 44 (1–2) (1992): 67–79.

4. See, for example, DeeDee Halleck, *Handheld Visions: The Impossible Possibilities of Community Media* (New York: Fordham University Press, 2002).

5. Katherine Dieckmann, "Electra Myths: Video, Modernism, Postmodernism," *Art Journal* 45 (3) (1985): 195–203; Lucinda Furlong, "Tracking Video Art: 'Image

Processing' as a Genre," *Art Journal* 45 (3) (1985): 233–237; Rosalind Krauss, "Video: The Aesthetics of Narcissism," *October* 1 (1976): 50–64.

6. See, for example, Tina Askanius, "Video for Change," in *The Handbook of Development and Social Change*, ed. Karin Gwinn Wilkins, Thomas Tufte, and Rafael Obregon (Malden, MA: Wiley, 2014), 453–470.

7. See Jane Sassen, *The Video Revolution: A Report to the Center for International Media Assistance* (Washington, DC: CIMA–National Endowment for Democracy, 2012), https://www.cima.ned.org/wp-content/uploads/2015/01/Video-revolution-FINAL .pdf; Michael Z. Newman, *Video Revolutions: On the History of a Medium* (New York: Columbia University Press, 2014); Laurie Ouellette, "Camcorder Dos and Don'ts: Popular Discourses on Amateur Video and Participatory Television," *Velvet Light Trap* 36 (1995): 33–43.

8. Newman, *Video Revolutions*, 36.

9. See, for example, Sliwinski, *Human Rights in Camera*; Sharon Sliwinski, "Human Rights," in *Visual Global Politics*, ed. Roland Bleiker (New York: Routledge, 2018): 169–175.

10. See, for example, Vicky Goldberg, *The Power of Photography: How Photographs Changed Our Lives* (New York: Abbeville, 1991).

11. See, for example, Martin F. Norden, "A Good Travesty upon the Suffragette Movement: Women's Suffrage Films as Genre," *Journal of Popular Film and Television* 13 (4) (1986): 171–177.

12. See, for example, David Craven, *Art and Revolution in Latin America, 1910–1990* (New Haven, CT: Yale University Press, 2002).

13. See, for example, Bill Nichols, *Introduction to Documentary*, 2nd ed. (Bloomington: Indiana University Press, 2010).

14. See, for example, Bleiker, *Visual Global Politics*.

15. Thompson, "'Pictorial Lies'?," 209.

16. See John Brewer, *The Common People and Politics, 1750–1790s* (Cambridge: Chadwyck-Healey, 1986); Thomas E. Crow, *Emulation: Making Artists for Revolutionary France* (New Haven, CT: Yale University Press, 1994); Lynn Hunt, *Politics, Culture, and Class in the French Revolution* (Berkeley: University of California Press, 1984); Eirwen E. C. Nicholson, "Consumers and Spectators: The Public of the Political Print in Eighteenth-Century England," *History* 81 (262) (1996): 5–21.

17. Downing, *Radical Media*, 162.

18. Sliwinski, *Human Rights in Camera*; Thompson, "'Pictorial Lies'?"

19. Sliwinski, "Human Rights," 170.

20. Goldberg, *Power of Photography*.

21. Aryeh Neier, foreword to *Digital Witness: Using Open Source Information for Human Rights Investigation, Documentation, and Accountability*, ed. Sam Dubberley, Alexa Koenig, and Daragh Murray (Oxford: Oxford University Press, 2020), vii–x.

22. Immanuel Kant, "The Contest of Faculties: A Renewed Attempt to Answer the Question: 'Is the Human Race Constantly Progressing?,'" in *Kant's Political Writings*, 2nd ed., ed. Hans Reis (Cambridge: Cambridge University Press, 1991), 176–190.

23. Sliwinski, *Human Rights in Camera*.

24. Karen Halttunen, "Humanitarianism and the Pornography of Pain in Anglo-American Culture," *American Historical Review* 100 (2) (1995): 303–334.

25. The spectatorship of suffering—as the underside of the efforts to link visuality with morality that Halttunen discusses thoroughly—was also promoted during the Middle Ages (e.g., Zelizer, *About to Die*) and shaped colonial discourses (e.g., Nicholas Mirzoeff, *The Right to Look: A Counterhistory of Visuality* [Durham, NC: Duke University Press, 2011]; S. Sliwinski, "The Childhood of Human Rights: The Kodak on the Congo," *Journal of Visual Culture* 5 [3] [2006]: 333–363), and still challenges the production and consumption of traumatic images (e.g., Luc Boltanski, *Distant Suffering: Morality, Media, and Politics*, trans. Graham Burchell [Cambridge: Cambridge University Press, 1999]; Lilie Chouliaraki, *The Spectatorship of Suffering* [London: Sage, 2006]; Lilie Chouliaraki, *The Ironic Spectator: Solidarity in the Age of Post-humanitarianism* [Cambridge: Polity Press, 2013]).

26. See, for example, Zelizer, *Remembering to Forget*.

27. Sliwinski, *Human Rights in Camera*, 59.

28. Craven, *Art and Revolution*, 67.

29. Michael T. Ricker, "El Taller de Gráfica Popular," *Graphic Witness*, blog, 2002, http://graphicwitness.org/group/tgpricker2.htm.

30. TGP, "Declaration of Principles of the Taller de Gráfica Popular" (1945), in *Estampas de la Revolución Mexicana: 85 grabados de los artistas del Taller de Gráfica Popular* (Mexico City: La Estampa Mexicana, 1947), para. 2, my translation, http://econtent.unm.edu/cdm/ref/collection/artmuseum/id/65.

31. See, for example, David Gillespie, *Early Soviet Cinema: Innovation, Ideology, and Propaganda* (London: Wallflower Press, 2000).

32. Kristin Thompson and David Bordwell, *Film History: An Introduction*, 2nd ed. (New York: McGraw-Hill Higher Education, 2003), 312.

33. For a theoretical discussion on the radical potential of art, film, and technology, see also Walter Benjamin, *Selected Writings*, vol. 4: *1938–1940*, ed. Howard Eiland and Michael W. Jennings (Cambridge, MA: Harvard University Press, 2006).

34. Patricia Rodden Zimmerman, *States of Emergency: Documentaries, Wars, Democracies* (Minneapolis: University of Minnesota Press, 2000), 19.

35. De Certeau, *The Practice of Everyday Life*.

36. Andrew Calabrese and Claudia Padovani, eds., *Communication Rights and Social Justice: Historical Accounts of Transnational Mobilizations* (New York: Palgrave, 2014); Halleck, *Handheld Visions*; Stefania Milan, *Social Movements and Their Technologies: Wiring Social Change* (New York: Palgrave Macmillan, 2013); Clemencia Rodríguez, *Fissures in the Mediascape: An International Study of Citizens Media* (Cresskill, NJ: Hampton Press, 2001); International Commission for the Study of Communication Problems, *Many Voices One World: Towards a New, More Just, and More Efficient World Information and Communication Order* (London: Kogan Page, 1980).

37. For an overview of these terms and the naming discussion, see Rodríguez, *Fissures in the Mediascape*; Clemencia Rodríguez, Dorothy Kidd, and Laura Stein, eds., *Making Our Media: Global Initiatives Toward a Democratic Public Sphere*, vol. 1: *Creating New Communication Spaces* (Cresskill, NJ: Hampton Press, 2009).

38. Halleck, *Handheld Visions*.

39. Furlong, "Tracking Video Art," 234.

40. Boyle, "Subject to Change" and "From Portapak to Camcorder."

41. Newman, *Video Revolutions*, 21.

42. See, for example, Boyle, "From Portapak to Camcorder"; Furlong, "Tracking Video Art."

43. Harding, *Video Activist Handbook*; Fountain, "Alternative Film."

44. Downing, *Radical Media*, 193.

45. Cees J. Hamelink, *Trends in World Communication on Disempowerment and Self-Empowerment* (Penang, Malaysia: Southbound and Third World Network, 1994), 141.

46. See, for example, Jennifer Deger, *Shimmering Screens: Making Media in an Aboriginal Community* (Minneapolis: University of Minnesota Press, 2006); Faye D. Ginsburg, Lila Abu-Lughod, and Brian Larkin, introduction to *Media Worlds: Anthropology on New Terrain*, ed. Faye D. Ginsburg, Lila Abu-Lughod, and Brian Larkin (Berkeley: University of California Press, 2002), 1–36; Jeff D. Himpele, *Circuits of Culture: Media, Politics, and Indigenous Identity in the Andes* (Minneapolis: University of Minnesota Press, 2007).

47. Pat Aufderheide, "'You See the World of the Other and You Look at Your Own': The Evolution of the Video in the Villages Project," *Journal of Film and Video* 60 (2) (2008): 26–34.

48. Boyle, "From Portapak to Camcorder."

49. See, for example, Coyer, Dowmunt, and Fountain, *The Alternative Media Handbook*.

50. Richard Edwards, "Torrents of Resistance," *Film International* 10 (2004): 39.

51. Dorothy Kidd, "Indymedia.org: The Development of the Communication Commons," *Democratic Communiqué* 18 (2002): 65–86.

52. Dorothy Kidd, "Occupy and Social Movement Communication," in *The Routledge Companion to Alternative and Community Media*, ed. Chris Atton (New York: Routledge, 2015), 457–468; see also Paolo Gerbaudo, *The Mask and the Flag: Populism, Citizenism, and Global Protest* (New York: Oxford University Press, 2017).

53. Tufekci, *Twitter and Tear Gas*.

54. Justine Calma, "Facebook Says It 'Mistakenly' Suspended Hundreds of Activists' Accounts," *The Verge*, September 24, 2020, https://www.theverge.com/2020/9/24/21454554/facebook-acitivists-suspended-accounts-coastal-gaslink-pipeline.

55. Avi Asher-Schapiro and Ban Barkawi, "'Lost Memories': War Crimes Evidence Threatened by AI Moderation," *Reuters*, June 19, 2020, https://www.reuters.com/article/us-global-socialmedia-rights-trfn/lost-memories-war-crimes-evidence-threatened-by-ai-moderation-idUSKBN23Q2TO. See also Megha Rajagopalan, "The Histories of Today's Wars Are Being Written on Facebook and YouTube. But What Happens When They Get Taken Down?," *BuzzFeed News*, December 22, 2018, https://www.buzzfeednews.com/article/meghara/facebook-youtube-icc-war-crimes.

56. For an overview, see Human Rights Watch, "'Video Unavailable': Social Media Platforms Remove Evidence of War Crimes," September 10, 2020, https://www.hrw.org/report/2020/09/10/video-unavailable/social-media-platforms-remove-evidence-war-crimes#_ftn36.

57. Martha Gever, "Pressure Points: Video in the Public Sphere," *Art Journal* 45 (3) (1985): 241.

58. Sam Dubberley, WhatsApp interview, July 24, 2019.

59. Liba Beyer, Skype interview, July 31, 2019.

60. See, for example, Deger, *Shimmering Screens*; Faye D. Ginsburg, "Screen Memories: Resignifying the Traditional in Indigenous Media," in *Media Worlds*, ed. Ginsburg, Abu-Lughod, and Larkin, 39–57; Halleck, *Handheld Visions*; Harald E. L. Prins, "Visual Media and the Primitivist Perplex: Colonial Fantasies, Indigenous Imagination, and Advocacy in North America," in *Media Worlds*, ed. Ginsburg, Abu-Lughod, and Larkin, 58–74.

61. Rodríguez, *Fissures in the Mediascape*, 127.

62. David Whiteman, "Out of the Theaters and into the Streets: A Coalition Model of the Political Impact of Documentary Film and Video," *Political Communication* 21 (2004): 51–69.

63. Bukeni Waruzi, interview, New York City, August 6, 2015.

64. Oren Yakobovich, "Hidden Cameras That Film Injustice in the World's Most Dangerous Places," *TED Talk*, October 2014, https://www.ted.com/talks/oren_yakob ovich_hidden_cameras_that_film_injustice_in_the_world_s_most_dangerous_places ?language=en.

65. Eyal Weizman, *Forensic Architecture: Violence at the Threshold of Detectability* (New York: Zone Books, 2017).

66. Eyal Weizman, "Open Verification," *E-flux Architecture*, 2019, para. 18, https:// www.e-flux.com/architecture/becoming-digital/.

67. Sandra Braman, "The Medium as Power: Information and Its Flows as Acts of War," in *Communicating with Power*, ed. Cherian George (New York: Peter Lang Publishing, 2017), 3–22.

68. Weizman, "Open Verification," para. 19.

69. Scott Edwards, phone interview, March 22, 2018.

70. Jonathan Gray, "Data Witnessing: Attending to Injustice with Data in Amnesty International's Decoders Project," *Information, Communication, & Society* 22 (7) (2019): 986.

71. Madeline Bair, interview, New York City, July 2, 2015.

72. Robert Trafford, Jitsi interview, July 10, 2019.

73. Weizman, "Open Verification."

74. Ristovska, "Human Rights Collectives as Visual Experts."

75. See, for example, Alexandra Juhasz, *AIDS TV: Identity, Community, and Alternative Video* (Durham, NC: Duke University Press, 1996); Alexandra Juhasz, "Video Remains: Nostalgia, Technology, and Queer Archive Activism," *GLQ* 12 (2) (2006): 319–328.

76. Chantal Mouffe, *The Democratic Paradox* (London: Verso, 2000), 16.

77. De Certeau, *Practice of Everyday Life*, 37.

78. Luc Boltanski and Eve Chiapello, *The New Spirit of Capitalism*, trans. Gregory Elliott (London: Verso, 2005), 36.

79. Michelle Bogre, *Photography as Activism: Images for Social Change* (Oxford: Focal Press, 2012).

80. Friedrich A. Kittler, *Gramophone, Film, Typewriter*, trans. Geoffrey Winthrop-Young and Michael Wutz (Stanford, CA: Stanford University Press, 1999).

81. Amit Pinchevski, *Transmitted Wounds: Media and the Mediation of Trauma* (New York: Oxford University Press, 2019), 43.

82. Pinchevski, *Transmitted Wounds*, 45.

83. See Benjamin, *Selected Writings*, vol. 4, in particular the essay "The Work of Art in an Age of Mechanical Reproduction."

84. Priscila Neri, interview, New York City, August 6, 2015.

85. See also Christian Delage, "Simon Srebnik: Narratives of a Holocaust Survivor," in *Visual Imagery and Human Rights Practice*, ed. Ristovska and Price, 109–129.

86. Rebecca Wexler, "Technology's Continuum: Body Cameras, Data Collection, and Constitutional Searches," in *Visual Imagery and Human Rights Practice*, ed. Ristovska and Price, 89–105.

87. Trafford, interview.

88. Syrian Archive, *Eyes on Aleppo—Visual Evidence Analysis of Human Rights Violations Committed in Aleppo*, March 29, 2017, https://syrianarchive.org/en/investigations/Eyes -on-Aleppo/.

89. Human Rights Watch, "Syria: Coordinated Chemical Attacks on Aleppo," February 13, 2017, https://www.hrw.org/news/2017/02/13/syria-coordinated-chemical -attacks-aleppo.

90. Beyer, interview.

91. Lindsay Freeman, "Digital Evidence and War Crimes Prosecutions: The Impact of Digital Technologies on International Criminal Investigations and Trials," *Fordham International Law Journal* 41, no. 2 (2018): 283–336.

92. Situ Research, "ICC Digital Platform: Timbuktu, Mali," n.d., para.1, https://situ .nyc/research/projects/icc-digital-platform-timbuktu-mali.

93. Freeman, "Digital Evidence and War Crimes Prosecution," 318.

94. Freeman, "Digital Evidence and War Crimes Prosecution, 319.

95. Jackie Zammuto, Skype interview, July 2, 2019.

96. Freidson, *Professional Powers*.

97. Silvio Waisbord, *Reinventing Professionalism: Journalism and News in Global Perspective* (Cambridge: Polity, 2013), 15.

98. Elliott, *Sociology of the Professions*, 10.

99. Freidson, *Professional Powers*.

100. Freidson, *Professional Powers*; Elliott, *Sociology of the Professions*; Magali Sarfatti Larson, *The Rise of Professionalism: A Sociological Analysis* (Berkeley: University of California Press, 1977).

101. Freidson, *Professional Powers*.

102. Elliott, *Sociology of the Professions*.

103. Eliot Freidson, *Professionalism: The Third Logic* (Chicago: University of Chicago Press, 2001).

104. Elliott, *Sociology of the Professions*.

105. Boltanski and Chiapello, *New Spirit of Capitalism*.

106. Boltanski and Chiapello, *New Spirit of Capitalism*, 87.

107. De Certeau, *Practice of Everyday Life*, xix.

108. Elliott, *Sociology of the Professions*.

109. Neri, interview.

110. Larson, *Rise of Professionalism*, xiii.

111. Freidson, *Professional Powers*.

**Chapter 3**

1. De Certeau, *Practice of Everyday Life*.

2. See, for example, Robert McChesney and John Nichols, *The Death and Life of American Journalism: The Media Revolution That Will Begin the World Again* (New York: Nation Books, 2010); Robert McChesney and Victor Pickard, eds., *Will the Last Reporter Please Turn Out the Lights: The Collapse of Journalism and What Can Be Done to Fix It* (New York: New Press, 2011).

3. See, for example, W. Lance Bennett, Regina G. Lawrence, and Steven Livingston, *When the Press Fails: Political Power and the News Media from Iraq to Katrina* (Chicago: University of Chicago Press, 2007); Thomas Patterson, *Informing the News: The Need for Knowledge Based Journalism* (New York: Vintage Books, 2013); Jeremy Tunstall, *The Media Were American: US Mass Media in Decline* (Oxford: Oxford University Press, 2007).

4. See, for example, Stuart Allan, *Online News: Journalism and the Internet* (New York: Open University Press, 2006).

5. See, for example, Pablo J. Boczkowski, "Materiality and Mimicry in the Journalism Field," in *The Changing Faces of Journalism: Tabloidization, Technology, and Truthiness*, ed. Barbie Zelizer (Oxon: Routledge, 2009), 56–67.

6. Manuel Castells, "The New Public Sphere: Global Civil Society, Communication Networks, and Global Governance," *Annals of the American Academy of Political and Social Science* 616 (1) (2008): 78–93; Lang, *NGOs, Civil Society, and the Public Sphere*.

7. Emma Daly, interview, New York City, August 18, 2015.

8. Berland Edelman, *2014 Edelman Trust Barometer Executive Summary* (2014), https://www.scribd.com/document/200429962/2014-Edelman-Trust-Barometer.

9. Pew Research Center, *Public Trust in Government: 1958–2019* (Washington, DC: Pew Research Center, April 11, 2019), https://www.pewresearch.org/politics/2019/04/11/public-trust-in-government-1958-2019/; Mark Jurkowitz, Amy Mitchell, Elisa Shearer, and Mason Walker, "U.S. Media Polarization and the 2020 Election: A Nation Divided," Pew Research Center, January 24, 2020, https://www.journalism.org/2020/01/24/u-s-media-polarization-and-the-2020-election-a-nation-divided/.

10. See, for example, Monroe E. Price, *Free Expression, Globalism, and the New Strategic Communication* (New York: Cambridge University Press, 2015).

11. Carroll Bogert, interview, New York City, May 6, 2014.

12. Daly, interview.

13. Daly, interview.

14. Weizman, "Open Verification," para. 32.

15. Rasmus Kleis Nielsen and Lucas Graves, "'News You Don't Believe': Audience Perspectives on Fake News," Reuters Institute for the Study of Journalism Report, October 2017, https://reutersinstitute.politics.ox.ac.uk/sites/default/files/2017-10/Nielsen%26Graves_factsheet_1710v3_FINAL_download.pdf.

16. Claire Wardle, Angela Pimenta, Guilherme Conter, Nic Dias, and Pedro Burgos, "An Evaluation of the Impact of a Collaborative Journalism Project on Brazilian Journalists and Audiences," *First Draft*, June 27, 2019, https://firstdraftnews.org/wp-content/uploads/2019/06/Comprova-Full-Report-Final.pdf?x19006.

17. Pew Research Center, *The State of the News Media 2015* (Washington, DC: Pew Research Center, April 29, 2015), http://www.journalism.org/files/2015/04/FINAL-STATE-OF-THE-NEWSMEDIA1.pdf.

18. Michael Barthel, "5 Key Takeaways about the State of the News Media in 2018," Pew Research Center, July 23, 2019, https://www.pewresearch.org/fact-tank/2019/07/23/key-takeaways-state-of-the-news-media-2018/.

19. Quoted in Nick Visser, "CBS Chief Les Moonves Says Trump's 'Damn Good' for Business," *HuffPost*, March 1, 2016, https://www.huffpost.com/entry/les-moonves-donald-trump_n_56d52ce8e4b03260bf780275.

20. John Maxwell Hamilton, *Journalism's Roving Eye: A History of American Foreign Reporting* (Baton Rouge: Louisiana State University Press, 2009); Priya Kumar, "Foreign Correspondents: Who Covers What," *American Journalism Review*, December 2010–January 2011, http://ajrarchive.org/article.asp?id=4997.

21. Ulf Hannerz, *Foreign News: Exploring the World of Foreign Correspondents* (Chicago: University of Chicago Press, 2004); Bill Keller, "It's the Golden Age of News," *New York Times*, Opinion, November 3, 2013, http://www.nytimes.com/2013/11/04/opinion/keller-its-the-golden-age-of-news.html?_r=0; Collen Murrell, *Foreign Correspondents and International Newsgathering: The Role of Fixers* (New York: Routledge, 2015); Lindsay Palmer, *The Fixers: Local News Workers and the Underground Labor of International Reporting* (New York: Oxford University Press, 2019).

22. Zeynep Devrim Gürsel, "The Politics of Wire Service Photography: Infrastructures of Representation in a Digital Newsroom," *American Ethnologist* 39 (1) (2012): 81.

23. Carroll Bogert, "Similar Paths, Different Missions: International Journalists and Human Rights Observers," *Nieman Reports* 64 (3) (2009): 59–61, https://niemanreports.org/articles/similar-paths-different-missions-international-journalists-and-human-rights-observers/; Carroll Bogert, "Whose News? The Changing Media Landscape and NGOs," in *Human Rights Watch 2011 World Report* (New York: Human Rights Watch, 2011), https://www.hrw.org/world-report/2011/country-chapters/africa-americas-asia-europe/central-asia-middle-east/north-africa.

24. Pierre Bairin, interview, New York City, June 16, 2015.

25. Matthew Powers, *NGOs as Newsmakers: The Changing Landscape of International News* (New York: Columbia University Press, 2018).

26. Matthew Powers, "The Structural Organization of NGO Publicity Work: Explaining Divergent Publicity Strategies at Humanitarian and Human Rights Organizations," *International Journal of Communication* 8 (2014): 90–107.

27. Bogert, interview.

28. Matthew Powers, "Opening the News Gates? Humanitarian and Human Rights NGOs in the US Media, 1990–2010," *Media, Culture, & Society* 38 (3) (2015): 315–331, first published online April 4, 2015, doi: 10.1177/0163443715594868.

29. Ella McPherson, "Advocacy Organizations' Evaluation of Social Media Information for NGO Journalism: The Evidence and Engagement Model," *American Behavioral Scientist* 59 (1) (2014): 124–148; Shani Orgad and Irene Bruna Seu, "The Mediation of Humanitarianism: Toward a Research Framework," *Communication, Culture, & Critique* 7 (1) (2014): 6–36; Matthew Powers, "The New Boots on the Ground: NGOs in the Changing Landscape of International News," *Journalism* 17 (4) (2016): 401–416, first published online January 29, 2015, doi: 10.1177/1464884914568077.

30. Powers, "Opening the News Gates?"

31. Bogert, interview.

32. Daly, interview.

33. Daly, interview.

34. Daniel Eyre, Skype interview, August 14, 2015.

35. Bogert, interview.

36. Paul Woolwich, Skype interview, September 15, 2015.

37. See also Kate Nash, "Global Citizenship as Showbusiness: The Cultural Politics of 'Make Poverty History,'" *Media, Culture, & Society* 30 (2) (2010): 167–181; Powers, *NGOs as Newsmakers*.

38. Bogert, interview.

39. Daly, interview.

40. Philippa Ellerton, Skype interview, August 12, 2015.

41. Madeline Bair, interview, New York City, July 2, 2015.

42. Bairin, interview.

43. Philip Rottwilm, *The Future of Journalistic Work: Its Changing Nature and Implications* (Oxford: Reuters Institute for the Study of Journalism, 2014), 16.

44. Barbie Zelizer, *What Journalism Could Be* (Cambridge: Polity Press, 2017).

45. Malachy Browne, Skype interview, July 21, 2015.

46. Zelizer, *About to Die*, 6. See also Julianne H. Newton, *The Burden of Visual Truth: The Rise of Photojournalism in Mediating Reality* (Mahwah, NJ: Lawrence Erlbaum Associates, 2001).

47. Kari Andén-Papadopoulos and Mervi Pantti, Introduction to *Amateur Images and Global News*, ed. Kari Andén-Papadopoulos and Mervi Pantti (Bristol, UK: Intellect, 2011), 10.

48. Gavin Sheridan, Skype interview, June 30, 2015.

49. Wardle, "How Newsrooms Use Eyewitness Media"; Mette Mortensen, *Journalism and Eyewitness Images: Digital Media, Participation, and Conflict* (New York: Routledge, 2015).

50. Omar Al-Ghazzi, "'Citizen Journalism' in the Syrian Uprising: Problematizing Western Narratives in a Local Context," *Communication Theory* 24 (4) (2014): 435–454; Mortensen, *Journalism and Eyewitness Images*.

51. Zelizer, *What Journalism Could Be*.

52. Sameer Padania, Skype interview, July 28, 2015.

53. Barbie Zelizer, "'On Having Been There': 'Eyewitnessing' as a Journalistic Key Word," *Critical Studies in Media Communication* 24 (5) (2007): 425.

54. Zelizer, *Remembering to Forget*; Zelizer, *About to Die*.

55. Zelizer, *Remembering to Forget*, 24.

56. Zelizer, *Remembering to Forget*.

57. Raja Althaibani, phone interview, August 7, 2015.

58. Claire Wardle, Sam Dubberley, and Peter D. Brown, *Amateur Footage: A Global Study of User-Generated Content in TV and Online News Output* (New York: Tow Center for Digital Journalism, Columbia University, 2014), 4, https://doi.org/10.7916/D88S 526V.

59. Wardle, Dubberley, and Brown, *Amateur Footage*.

60. Eyewitness Media Hub, "Eyewitness Media Hub Launch Guiding Principles for Journalists," *Medium*, September 9, 2015, para. 1, https://medium.com/@emhub /eyewitness-media-hub-launch-guiding-principles-for-journalists-54aafc786eeb# .1vf0g92j8.

61. Mervi Pantti, "Visual Gatekeeping in the Era of Networked Images: A Cross-Cultural Comparison of the Syrian Conflict," in *Gatekeeping in Transition*, ed. Tim P. Vos and Françoise Heinderyckx (New York: Routledge, 2015), 203–223; Wardle, Dubberley, and Brown, *Amateur Footage*.

62. Sheridan, interview.

63. Barbie Zelizer, "Journalism's 'Last' Stand: Wirephoto and the Discourse of Resistance," *Journal of Communication* 45 (2) (1995): 78–92.

64. Thomas Patrick Doherty, *Hollywood and Hitler, 1933–1939* (New York: Columbia University Press, 2013).

65. Zelizer, "Journalism's 'Last' Stand"; Zelizer, *Remembering to Forget*; Barbie Zelizer, "Words against Images: Positioning Newswork in the Age of Photography," in *Newsworkers: Towards a History of the Rank and File*, ed. Hanno Hardt and Bonnie Brennen (Minneapolis: University of Minnesota Press, 1995), 135–159.

66. Barbie Zelizer, *Covering the Body: The Kennedy Assassination, the Media, and the Shaping of Collective Memory* (Chicago: University of Chicago Press, 1992).

67. Andén-Papadopoulos and Pantti, "Re-imaging Crisis Reporting."

68. Mortensen, *Journalism and Eyewitness Images*.

69. Kari Andén-Papadopoulos and Mervi Pantti, "The Media Work of Syrian Diaspora Activists: Brokering between the Protest and Mainstream Media," *International Journal of Communication* 7 (2013): 2185–2206; Sahar Khamis, Paul. B. Gold, and Katherine Vaughn, "Beyond Egypt's 'Facebook Revolution' and Syria's 'YouTube Uprising': Comparing Political Contexts, Actors, and Communication Strategies," *Arab Media & Society*, no. 15 (Spring 2012), http://www.arabmediasociety.com/ ?article=791; Marc Lynch, Deen Freelon, and Sean Aday, *Blogs and Bullets III: Syria's*

*Socially Mediated Civil War* (Washington, DC: United States Institute of Peace, 2012); Reporters without Borders, "Syria," March 12, 2012, updated January 20, 2016, https://rsf.org/en/news/syria-2.

70. Quoted in Wardle, Dubberley, and Brown, *Amateur Footage*, sec. 6.3, para. 1.

71. Sliwinski, *Human Rights in Camera*. In the United States, academic training in photojournalism started in 1942 at the University of Missouri Journalism School, and the National Press Photographers' Association was established in 1946.

72. Eyre, interview.

73. Josh Lyons, Skype, August 13, 2015.

74. Robert Trafford, Jitsi interview, July 10, 2019.

75. Christoph Koettl, interview, Washington DC, July 20, 2015.

76. Chris Cobb, "Amateur Videotapes Changing Perspective of News," *Gazette*, February 26, 1995.

77. K. Walker, "The Use of Amateur Video in Television News," Walker's blog, June 1991, para. 3, http://walkerred.com/here-come-the-video-commandos (site discontinued).

78. Fenton Bailey and Randy Barbato, dir., *Video, Vigilantes, and Voyeurism*, Channel 4 broadcast, 1993, https://www.youtube.com/watch?v=Txklb43mkiA.

79. Quoted in Cobb, "Amateur Videotapes Changing Perspective of News."

80. Yvette Alberdingk Thijm, "Update on The Hub and WITNESS' New Online Strategy," *WITNESS*, blog, August 2010, para. 5, https://blog.witness.org/2010/08/update -on-the-hub-and-witness-new-online-strategy/.

81. Padania, interview.

82. Morgan Hargrave, interview, New York City, June 2, 2015.

83. Rottwilm, *Future of Journalistic Work*, 14.

84. Bolette B. Blaagaard, "Situated, Embodied, and Political: Expressions of Citizen Journalism," *Journalism Studies* 14 (2) (2013): 187–200; Chouliaraki, *The Ironic Spectator*; Simon Cottle, "Journalists Witnessing Disaster: From the Calculus of Death to the Injunction to Care," *Journalism Studies* 14 (2) (2013): 232–248.

85. Morris Janowitz, "Professional Models in Journalism: The Gatekeeper and the Advocate," *Journalism Quarterly*, Winter 1975, 618–626, 662.

86. Mark Hampton, "The Fourth Estate Ideal in Journalism History," in *The Routledge Companion to News and Journalism*, ed. Stuart Allan (New York: Routledge, 2010), 3–12.

87. Martin Bell, "TV News: How Far Should We Go?," *British Journalism Review* 8 (1) (1997): 6–16.

88. Johan Galtung, Carl G. Jacobsen, and Kal Frithjof Brand-Jacobsen, *Searching for Peace—the Road to TRANSCEND* (London: Pluto Press, 2002).

89. Jean-Paul Marthoz, "A Call for Committed Journalism," *Global Beat Syndicate*, May 5, 1999, http://www.bu.edu/globalbeat/syndicate/Marthoz050599.html.

90. Ibrahim Seaga Shaw, *Human Rights Journalism: Advances in Reporting Distant Humanitarian Interventions* (New York: Palgrave Macmillan, 2012).

91. David T. Z. Mindich, *Just the Facts: How "Objectivity" Came to Define American Journalism* (New York: New York University Press, 2000), 1.

92. Silvio Waisbord, "Advocacy Journalism in a Global Context," in *The Handbook of Journalism Studies*, ed. Karin Wahl-Jorgensen and Thomas Hanitzsch (New York: Routledge, 2009), 375.

93. Bairin, interview.

94. Woolwich, interview.

95. Daly, interview.

96. See, for example, Glenda Cooper, *From Their Own Correspondents? News Media and the Changes in Disaster Coverage* (Oxford: Reuters Institute for the Study of Journalism, 2011); Louise Grayson, "The Role of Non-governmental Organizations (NGOs) in Practicing Editorial Photography in a Globalized Media Environment," *Journalism Practice* 8 (5) (2014): 632–645.

97. See also Powers, *NGOs as Newsmakers*.

98. Padania, interview.

99. See, for example, Tirana Hassan, Skype interview, June 27, 2016.

100. Daly, interview.

101. For an analysis of such questioning of democracies, see Natalie Fenton, "Fake Democracy: The Limits of Public Sphere Theory," *Javnost—the Public* 25 (1–2) (2018): 28–34.

102. See, for example, Dannagal G. Young, Kathleen Hall Jamieson, Shannon Poulsen, and Abigail Goldring, "Fact-Checking Effectiveness as a Function of Format and Tone: Evaluating FactCheck.org and FlackCheck.org," *Journalism & Mass Communication Quarterly* 95 (1) (2017): 49–75; Stephan Lewandowsky, Ullrich K. H. Ecker, Colleen M. Seifert, Norbert Schwartz, and John Cook, "Misinformation and Its Correction: Continued Influence and Successful Debiasing," *Psychological Science in the Public Interest* 13 (3) (2012): 106–131.

103. Quoted in WITNESS, "Deepfakes—Prepare Yourself Now," report launched October 2019, https://www.witness.org/witness-deepfakes-prepare-yourself-now-report-launched/.

104. International Council on Human Rights Policy, *Journalism, Media, and the Challenge of Human Rights Reporting* (Vernier, Switzerland: ATAR Roto Press, 2002), www.ichrp.org/files/reports/14/106_report_en.pdf; Sassen, *The Video Revolution*.

105. Daly, interview.

106. Bogert, interview.

107. Lorraine Daston and Peter Galison, *Objectivity* (New York: Zone Books, 2010), 17.

108. Zelizer, *What Journalism Could Be*.

109. Michael Schudson, *The Sociology of News*, 2nd ed. (New York: Norton, 2011), 19.

110. John Hartley, "Communicative Democracy in a Redactional Society: The Future of Journalism Studies," *Journalism* 1 (1) (2000): 40.

111. Woolwich, interview.

112. Bogert, "Whose News?," 30; see also Powers, "Structural Organization of NGO Publicity Work."

113. Andrew Stroehlein, interview, Brussels, November 27, 2013.

114. Ellerton, interview.

115. Daly, interview.

116. Bairin, interview.

117. Bogert, interview.

118. Bairin, interview.

119. Ellerton, interview.

120. Woolwich, interview.

121. Kevin G. Barnhurst, "Contradictions in News Epistemology: How Modernism Failed Mainstream US Journalism," *Media, Culture, & Society* 37 (8) (2015): 1244–1253.

122. Barnhurst, "Contradictions in News Epistemology," 1250.

123. Bairin, interview.

124. Woolwich, interview.

125. Bairin, interview.

126. Ivan Watson, "Torture Allegedly Widespread in Syria," CNN, July 3, 2012, video, 2:56, https://www.cnn.com/videos/world/2012/07/03/watson-syria-human -rights-watch.cnn; Mark Memmott, "'Torture Centers' Stretch across Syria, Human Rights Watch Reports," NPR, July 3, 2012, http://www.npr.org/sections/thetwoway /2012/07/03/156179079/torture-centers-stretch-across-syria-human-rights-watch -reports; Raniah Salloum, "Krieg in Syrien: Hier foltern Assads Agenten," *Spiegel Online*, July 3, 2012, http://www.spiegel.de/politik/ausland/folter-in-syrien-human -rights-watch-veroeffentlicht-neuen-bericht-a-842125.html; AFP News Agency, "Former Detainees Reveal Syrian Torture Centers," July 3, 2012, video, 1:17, https:// www.youtube.com/watch?v=CWFTCrloCV4.

127. Eyre, interview.

128. Ellerton, interview.

129. Stroehlein, interview.

130. Hartley, "Communicative Democracy."

131. Hartley, "Communicative Democracy," 43–44.

132. A. Holley, prod., *HRWFF Podcast with Peter Bouckaert*, Human Rights Watch Film Festival Podcast, 2015, MP3 audio, 23:37, https://ff.hrw.org/content/hrwff -podcast-peter-bouckaert.

133. Human Rights Watch, "Syria: Strong Evidence Government Used Chemicals as a Weapon," May 13, 2014, https://www.hrw.org/news/2014/05/13/syria-strong -evidence-government-used-chemicals-weapon; Amnesty International, *Nigeria: Stars on Their Shoulders. Blood on Their Hands: War Crimes Committed by the Nigerian Military. Executive Summary* (London: Amnesty International, June 3, 2015), https://www .amnesty.org/en/documents/afr44/1661/2015/en/.

134. Eyre, interview.

135. Weizman, "Open Verification."

136. Bair, interview.

137. Rina Tsubaki, Skype interview, August 3, 2015.

138. Craig Silverman, ed., *Verification Handbook for Investigative Reporting: A Guide to Online Search and Research Techniques for Using UGC and Open Source Information in Investigations* (Maastricht, Netherlands: European Journalism Centre, 2015), http:// verificationhandbook.com/book2/; Craig Silverman, ed., *Verification Handbook: An Ultimate Guideline on Digital Age Sourcing for Emergency Coverage* (Maastricht, Netherlands: European Journalism Centre, 2014), http://verificationhandbook.com/book/.

139. Eyre, interview.

140. Lyons, interview.

141. Koettl, interview.

142. Chistoph Koettl, "'The YouTube War': Citizen Videos Revolutionize Human Rights Monitoring in Syria," *Mediashift*, February 18, 2014, para. 6, http://mediashift .org/2014/02/the-youtube-war-citizen-videos-revolutionize-human-rights-monitoring -in-syria/.

143. Joseph Lichterman, "Amnesty International Launches a New Site to Help Journalists Verify YouTube Videos," *NiemanLab*, July 8, 2014, http://www.niemanlab .org/2014/07/amnesty-international-launches-a-new-site-to-help-journalists-verify -youtube-videos/.

144. Craig Silverman, "Amnesty International Launches Video Verification Tool, Website," Poynter Institute, July 8, 2014, para. 1, http://www.poynter.org/2014 /amnesty-international-launches-video-verification-tool-website/257956/.

145. Tsubaki, interview.

146. Holley, *HRWFF Podcast*.

147. Bair, interview.

148. Koettl, interview.

149. Browne, interview.

150. Sam Dubberley, WhatsApp interview, July 24, 2019.

151. Gürsel, "Politics of Wire Service Photography."

152. Andén-Papadopoulos and Pantti, "Media Work of Syrian Diaspora Activists."

153. Bair, interview.

154. Bair, interview.

155. Althaibani, interview.

156. Bair, interview.

157. Althaibani, interview.

158. Hargrave, interview.

159. Jeff Deutch, Skype interview, October 19, 2018.

160. Bryan Nuñez, "Is This for Real? How InformaCam Improves Verification of Mobile Media Files," *WITNESS*, blog, January 2013, para. 6, https://blog.witness.org /2013/01/how-informacam-improves-verification-of-mobile-media-files/.

161. Koettl, interview.

162. Dubberley, interview.

163. Amnesty International, "Syria: Unprecedented Investigation Reveals US-Led Coalition Killed More Than 1,600 Civilians in Raqqa 'Death Trap,'" April 25, 2019, https://www.amnesty.org/en/latest/news/2019/04/syria-unprecedented-investigation -reveals-us-led-coalition-killed-more-than-1600-civilians-in-raqqa-death-trap/.

164. Ellerton, interview.

165. Bogert, interview.

166. Bair, interview.

167. De Certeau, *Practice of Everyday Life*.

168. For a good overview on this debate, see Kate Wright, "NGOs as News Organizations," in *Oxford Research Encyclopedias* (Oxford: Oxford University Press, 2010), doi: 10.1093/acrefore/9780190228613.013.852. See also Natalie Fenton, "NGOs, New Media, and the Mainstream News," in *New Media, Old News: Journalism and Democracy in the Digital Age*, ed. Natalie Fenton (London: Sage, 2010), 153–168; Adrienne Russell, "Innovations in Hybrid Spaces: 2011 UN Climate Summit and the Expanding Journalism Landscape," *Journalism: Theory, Practice & Criticism* 17, no. 4 (2013): 904–920; Ethan Zuckerman, "Using the Internet to Examine Patterns of Foreign Coverage," *Nieman Reports* 58 (3) (2004): 51–54.

169. Powers, *NGOs as Newsmakers*.

170. Waisbord, *Reinventing Professionalism*.

171. Mark Deuze, "What Journalism Is (Not)," *Social Media + Society* 5 (3) (2019): 2.

172. Powers, *NGOs as Newsmakers*.

## Chapter 4

1. Feigenson and Spiesel, *Law on Display*; Richard K. Sherwin, "Visual Jurisprudence," *New York Law School Review* 56 (2012): 138–165.

2. De Certeau, *Practice of Everyday Life*.

3. Mnookin, "The Image of Truth."

4. See, for example, Feigenson and Spiesel, *Law on Display*; Elizabeth G. Porter, "Imagining Law: Visual Thinking across the Law School Curriculum," *Journal of Legal Education* 68 (1) (2018): 8–14.

5. Mnookin, "Image of Truth," 65.

6. Mnookin, "Image of Truth," 65.

7. Stuart Schulberg, dir., *Nuremberg: Its Lesson for Today*, motion picture, Schulberg/ Waletzky Restoration, prod. Sandra Schulberg, restored by Sandra Schulberg and John Waletsky (Schulberg Productions, 2010).

8. Christian Delage, *Caught on Camera: Film in the Courtroom from the Nuremberg Trials to the Trials of Khmer Rouge* (Philadelphia: University of Pennsylvania Press, 2014); Lawrence Douglas, *The Memory of Judgment: Making Law and History in the Trials of the Holocaust* (New Haven, CT: Yale University Press, 2001).

9. Quoted in Henry Rousso, "Competitive Narratives: An Incident at the Papon Trial," in *The Scene of the Mass Crime: History, Film, and International Tribunals*, ed. Christian Delage and Peter Goodrich (Oxon: Routledge, 2013), 48.

10. Hannah Arendt, *Eichmann in Jerusalem: A Report on the Banality of Evil* (1963; reprint, New York: Penguin Books, 2006), 253.

11. Shoshana Felman, "Theaters of Justice: Arendt in Jerusalem, the Eichmann Trial, and the Redefinition of Legal Meaning in the Wake of the Holocaust," *Theoretical Inquiries in Law* 1 (2000): 1–43; Douglas, *Memory of Judgment*.

12. Amit Pinchevski, "The Audiovisual Unconscious: Media and Trauma in the Video Archive for Holocaust Testimonies," *Critical Inquiry* 39 (1) (2012): 144.

13. Elian Peltier, "TV Cameras Coming to English Criminal Courts," *New York Times*, January 16, 2020, https://www.nytimes.com/2020/01/16/world/europe/cameras-british-courts.html.

14. See, for example, Kyu Ho Youm, "Cameras in the Courtroom in the Twenty-First Century: The U.S. Supreme Court Learning from Abroad?," *BYU Law Review* 6 (2012): 1989–2031.

15. Quoted in Youm, "Cameras in the Courtroom," 1996.

16. Marjorie Cohn and David Dow, *Cameras in the Courtroom: Television and the Pursuit of Justice* (Jefferson, NC: McFarland, 2002); Schwartz, *Mechanical Witness*.

17. Cohn and Dow, *Cameras in the Courtroom*.

18. Schwartz, *Mechanical Witness*.

19. Schwartz, *Mechanical Witness*, 106.

20. Between July 2011 and July 2015, a total of fourteen district courts voluntarily participated in a pilot study by the Judicial Conference to evaluate the effect of cameras and video recordings of proceedings. On average, the participating attorneys and judges viewed video favorably. See Molly Treadway Johnson, Carol Krafka, and Donna Stienstra, *Video Recording Courtroom Proceedings in United States District Courts: Report on a Pilot Project Submitted by the Federal Judicial Center to the Court Administration and Case Management Committee of the Judicial Conference of the United States* (Washington, DC: Federal Judicial Center, 2016), https://www.fjc.gov/sites/default/files/2017/Cameras%20in%20Courts%20Project%20Report%20(2016).pdf.

21. For an overview of this development and what it means for the administration of justice, see, for example, Neal Feigenson and Christina Spiesel, "How Is the Medium the Message? Zoom as Visual and Legal Practice," *First Monday* (forthcoming).

22. Rob Barsony, interview, The Hague, April 17, 2015.

23. Alex Whiting, phone interview, October 1, 2015.

24. Barsony, interview.

25. The ICTY's Outreach Office produced documentaries to communicate the court's mission and accomplishments to the wider public. A discussion of this project is beyond the scope of this chapter, but for an overview see Nenad Golčevski, "Communicating Justice in Film: The Limitations of an Unlimited Field," in *Visual Imagery and Human Rights Practice*, ed. Ristovska and Price, 153–163; Sandra Ristovska, "Video and Witnessing at the International Criminal Tribunal for the Former Yugoslavia," in *The Routledge Companion to Media and Human Rights*, ed. Howard Tumber and Silvio Waisbord (New York: Routledge, 2017), 357–365.

26. Susan Schuppli, "Entering Evidence: Cross Examining the Court Records of the ICTY," in *Forensis: The Architecture of Public Truth*, ed. Forensic Architecture (Berlin: Sternberg Press, 2014), 279–314.

27. Paul Mason, "Reflections of International Law in Popular Culture: Justice Seen to Be Done? Electronic Broadcast Coverage of the International Criminal Tribunal for the Former Yugoslavia," *Proceedings of the Annual Meeting of the American Society of International Law* 95 (2001): 212.

28. Mason, "Reflections of International Law," 213.

29. See, for example, Schwartz, *Mechanical Witness*.

30. Barsony, interview. These attitudes are echoed in the decisions to record and broadcast trials by the Supreme Courts of Canada in the mid-1990s, Brazil in 2002, and the United Kingdom in 2009. See Youm, "Cameras in the Courtroom."

31. Silvia D'Ascoli, interview, The Hague, October 13, 2015.

32. *The Prosecutor v. Mucić et al.*, ICTY, case no. IT-96-21, January 19, 1998. All passages from official court documents or trial transcripts are presented as released, transcribed, and/or translated by the ICTY. Linguistic errors are not corrected. Throughout the chapter, the excerpts are presented verbatim.

33. See Aida Ashouri, Caleb Bowers, and Cherrie Warden, "Working Paper: An Overview of the Use of Digital Evidence in International Criminal Courts," Salzburg Workshop on Cyber Investigations, 2013, https://www.law.berkeley.edu/files/HRC /Scholarly_articles_Salzburg_2013.pdf.

34. Freeman, "Digital Evidence and War Crimes Prosecutions."

35. Ashouri, Bowers, and Warden, "Working Paper."

36. Freeman, "Digital Evidence," 292, 298.

37. Keith Hiatt, "Open Source Evidence on Trial," *Yale Law Journal Forum* 125 (2016): 329.

38. United Nations, International Criminal Tribunal for the former Yugoslavia, *Rules of Procedure and Evidence*, July 8, 2015, https://www.icty.org/x/file/Legal%20 Library/Rules_procedure_evidence/IT032Rev50_en.pdf.

39. Freeman, "Digital Evidence," 301–302.

40. Whiting, interview.

41. Thomas Keenan and Eyal Weizman, *Mengele's Skull: The Advent of a Forensic Aesthetics* (Berlin: Sternberg Press, 2012); Forensic Architecture, *Forensis*.

42. *The Prosecutor v. Galić*, ICTY, case no. IT-98-29, October 18, 2000, 189.

43. D'Ascoli, interview.

44. *Prosecutor v. Galić*, December 3, 2001, 577–579.

45. *Prosecutor v. Galić*, December 3, 2001, 604.

46. For questions about the admissibility of victim-impact videos in the US context, see Regina Austin, "Documentation, Documentary, and the Law: What Should Be Made of Victim Impact Videos?," *Cardozo Law Review* 31 (4) (2010): 979–1017.

47. *The Prosecutor v. Jokić*, ICTY, case no. IT-01-42/1, December 4, 2003, 41.

48. *The Prosecutor v. Karadzić*, ICTY, case no. IT-95-5/18, December 8, 2010, 9427.

49. Vladimir Petrović, "A Crack in the Wall of Denial: The Scorpions Video in and out of the Courtroom," in *Narratives of Justice in and out of the Courtroom*, ed. Dubravka Zarkov and Marlies Glasius (New York: Springer, 2014), 89–109; Ivan Zverzhanovski, "Watching War Crimes: The Srebrenica Video and the Serbian Attitudes to the 1995 Massacre," *Southeast European and Black Sea Studies* 7 (3) (2007): 417–430.

50. *The Prosecutor v. Milošević*, ICTY, case no. IT-02-54, June 1, 2005, 40278–40279.

51. *Prosecutor v. Milošević*, June 8, 2005, 40733–40734.

52. Whiting, interview.

53. D'Ascoli, interview.

54. Zelizer, *Remembering to Forget*, 7.

55. Jeffrey C. Alexander, "On the Social Construction of Moral Universals: The 'Holocaust' from War Crime to Trauma Drama," *European Journal of Social Theory* 5 (1) (2002): 5–85; Douglas, *Memory of Judgment*; Émile Durkheim, *The Division of Labor in Society*, trans. W. D. Halls (New York: Free Press, 1984); Joachim J. Savelsberg and Ryan D. King, "Law and Collective Memory," *Annual Review of Law and Society* 3 (2007): 189–211.

56. *The Prosecutor v. Duško Tadić*, ICTY, case no. IT-94-1, May 7, 1996.

57. For the contested nature of the fence and the video, see David Campbell, "Atrocity, Memory, Photography: Imaging the Concentration Camps of Bosnia—the Case of ITN versus *Living Marxism*, Part 1," *Journal of Human Rights* 1 (1) (2002): 1–33, and "Atrocity, Memory, Photography: Imaging the Concentration Camps of Bosnia—the Case of ITN versus *Living Marxism*, Part 2," *Journal of Human Rights* 1 (2) (2002): 143–172.

58. Zelizer, *Remembering to Forget*.

59. Bill Nichols, "Documentary Film and the Modernist Avant-Garde," *Critical Inquiry* 27 (4) (2001): 582.

60. See, for example, Schwartz, *Mechanical Witness*.

61. Freeman, "Digital Evidence," 294.

62. Ashouri, Bowers, and Warden, "Working Paper," 8.

63. Neal Feigenson, "The Visual in Law: Some Problems for Legal Theory," *Law, Culture, and the Humanities* 10 (1) (2014): 22.

64. Carroll Bogert, interview, New York City, May 6, 2014.

65. Param-Preet Singh, interview, New York City, October 16, 2015.

66. Bukeni Waruzi, interview, New York City, August 6, 2015.

67. Waruzi, interview.

68. Quoted in Matthew Shaer, "'The Media Doesn't Care What Happens Here': Can Amateur Journalism Bring Justice to Rio's Favelas?," *New York Times*, February 18, 2015, http://www.nytimes.com/2015/02/22/magazine/the-media-doesnt-care-what -happens-here.html.

69. Christian Delage and Peter Goodrich, introduction to *The Scene of the Mass Crime*, ed. Delage and Goodrich, 1.

70. Josh Lyons, Skype interview, August 13, 2015.

71. Eyal Weizman, introduction to *Forensis*, ed. Forensic Architecture, 9–32.

72. Robert Trafford, Jitsi interview, July 10, 2019.

73. De Certeau, *Practice of Everyday Life*, 41.

74. Lyons, interview.

75. Christoph Koettl, interview, Washington DC, July 20, 2015; Lyons, interview.

76. Christoph Koettl, "Can Video Document Possible War Crimes in Syria?," *WITNESS*, blog, January 2013, para. 9, https://blog.witness.org/2013/01/video-war -crimes-in-syria/.

77. Amnesty International, "Burundi: Suspected Mass Graves of Victims of 11 December Violence," January 29, 2016, burundibriefingafr1633372016english2.pdf. For further discussion, see Christoph Koettl, "A Convergence of Visuals: Geospatial and Open Source Analysis in Human Rights Documentation," in *Visual Imagery and Human Rights Practice*, ed. Ristovska and Price, 57–66.

78. Belkis Wille, interview, New York City, June 25, 2015.

79. Delage, *Caught on Camera*, 67.

80. Wille, interview.

81. Koettl, interview.

82. Daniel Eyre, Skype interview, August 14, 2015.

83. Feigenson, "The Visual in Law," 20.

84. Alexa Koenig, phone interview, July 8, 2019.

85. Koenig, interview.

86. Sam Gregory, Skype interview, December 11, 2015.

87. Whiting, interview.

88. Lyons, interview.

89. Whiting, interview.

90. Nine Bernstein, "Should War Reporters Testify, Too? A Recent Court Decision Helps Clarify the Issue but Does Not End the Debate," *New York Times*, Metro sec., December 14, 2002, http://www.nytimes.com/2002/12/14/arts/should-war-reporters -testify-too-recent-court-decision-helps-clarify-issue-but.html?pagewanted=all.

91. Hiatt, "Open Source Evidence," 325.

92. Wendy Betts, Skype interview, August 11, 2015.

93. Raja Althaibani, phone interview, August 7, 2015; Forensic Architecture, "Bil'in: Reconstructing the Death of a Palestinian Demonstrator via Video Analysis," 2010, http://www.forensic-architecture.org/case/bilin/.

94. Morgan Hargrave, interview, New York City, June 2, 2015.

95. De Certeau, *Practice of Everyday Life*, 36.

96. Lindsay Freeman, Skype interview, June 25, 2019.

97. WITNESS, "Use of Video Evidence Leads to Justice in Democratic Republic of Congo," September 2018, https://www.witness.org/video-evidence-helps-lead-to-his toric-conviction-in-democratic-republic-of-congo/.

98. Kelly Matheson, interview, New York City, July 22, 2015.

99. Eyre, interview.

100. Priscila Neri, interview, New York City, August 6, 2015.

101. Neri, interview.

102. Sandra Ristovska, "Strategic Witnessing in an Age of Video Activism," *Media, Culture, & Society* 38 (7) (2016): 1034–1047.

103. Matheson, interview.

104. Matheson, interview.

105. Koenig, interview.

106. Freeman, interview.

107. Dubberley, Koenig, and Murray, *Digital Witness*.

108. De Certeau, *Practice of Everyday Life*.

## Chapter 5

1. Jakes Tapper and Mariano Castillo, "First on CNN: Videos Show Glimpse into Evidence for Syria Intervention," CNN, September 8, 2013, http://www.cnn.com /2013/09/07/politics/us-syria-chemical-attack-videos/.

2. See, for example, Independent International Commission of Inquiry on the Syrian Arab Republic, *10th Report of Commission of Inquiry on Syria*.

3. For example, Jeff Deutch, Skype interview, October 19, 2018.

4. De Certeau, *The Practice of Everyday Life*.

5. Freidson, *Professional Powers*, 3.

6. Marcus, *The Sentimental Citizen*, 6.

7. Barbie Zelizer, "Reflections Essay: What's Untransportable about the Transport of Photographic Images?," *Popular Communication* 4 (1) (2006): 12.

8. See, for example, Kelly Gates, "Professionalizing Police Media Work: Surveillance Video and the Forensic Sensibility," in *Images, Ethics, Technology*, ed. Sharrona Pearl (New York: Routledge, 2016), 41–57; Mirzoeff, *The Right to Look*; William John Thomas Mitchell, *Image Science: Iconology, Visual Culture, and Media Aesthetics* (Chicago: University of Chicago Press, 2015); James C. Scott, *Seeing Like a State: How Certain Schemes to Improve the Human Condition Have Failed* (New Haven, CT: Yale University Press, 1998); Tagg, *The Burden of Representation*.

9. See, for instance, Garth Jowett and Victoria O'Donnell, *Propaganda & Persuasion*, 6th ed. (Thousand Oaks, CA: Sage, 2015); Siegfried Krakauer, *From Caligari to Hitler: A Psychological History of the German Film* (Princeton, NJ: Princeton University Press,

1947); Paul Messaris, *Visual Literacy: Image, Mind, & Reality* (Boulder, CO: Westview Press, 1994).

10. See, for example, Halleck, *Handheld Visions*; Torchin, *Creating the Witness*; Zelizer, *Remembering to Forget*; Zimmerman, *States of Emergency*.

11. Marcus, *Sentimental Citizen*, 5.

12. See, for example, Sara Ahmed, *The Cultural Politics of Emotion* (New York: Routledge, 2004); Barbara Koziak, *Retrieving Political Emotions: Thumos, Aristotle, and Gender* (University Park: Pennsylvania State University Press, 2000); Marcus, *Sentimental Citizen*; George E. Marcus, Russell Newman, and Michael MacKuen, *Affective Intelligence and Political Judgment* (Chicago: University of Chicago Press, 2000); Martha Craven Nussbaum, *Upheavals of Thought: The Intelligence of Emotions* (Chicago: University of Chicago Press, 2001); Martha Craven Nussbaum, *Political Emotions: Why Love Matters for Justice* (Cambridge, MA: Harvard University Press, 2013); Zizi Papacharissi, *Affective Publics: Sentiment, Technology, and Politics* (New York: Oxford University Press, 2015); Zelizer, *About to Die*.

13. Paul Woolwich, Skype interview, September 15, 2015.

14. Bukeni Waruzi, interview, New York City, August 6, 2015.

15. Raja Althaibani, phone interview, August 7, 2015.

16. Christoph Koettl, interview, Washington DC, July 20, 2015.

17. Sam Gregory, interview, New York City, October 11, 2012.

18. See also Ristovska, "Strategic Witnessing in an Age of Video Activism."

19. Carroll Bogert, interview, New York City, May 6, 2014.

20. Liba Beyer, Skype interview, July 31, 2019.

21. Philippa Ellerton, Skype interview, August 12, 2015.

22. Morton Winston, personal communication, July 13, 2015.

23. Woolwich, interview.

24. Jim Ward, interview, London, April 12, 2018.

25. Sam Gregory, "Transnational Storytelling: Human Rights, WITNESS, and Video Advocacy," *American Anthropologist* 108 (1) (2006): 196.

26. CISCO, *CISCO Annual Internet Report (2018–2023)*, white paper, March 9, 2020, https://www.cisco.com/c/en/us/solutions/collateral/executive-perspectives/annual-internet-report/white-paper-c11-741490.html.

27. Jessica Clement, "Internet Usage Worldwide—Statistics & Facts," Statista, October 26, 2020, https://www.statista.com/topics/1145/internet-usage-worldwide/.

28. Emma Daly, interview, New York City, August 18, 2015.

29. Elizabeth Meckes, Skype interview, November 6, 2015.

30. Pierre Bairin, interview, New York City, June 16, 2015.

31. Newman, *Video Revolutions*; see also Lisa Gitelman, *Always Already New: Media, History, and the Data of Culture* (Cambridge, MA: MIT Press, 2006).

32. Michael Z. Newman, "Ze Frank and the Poetics of Web Video," *First Monday* 13 (5) (2008): para. 11, 10, http://firstmonday.org/article/view/2102/1962.

33. Param-Preet Singh, interview, New York City, October 16, 2015.

34. Belkis Wille, interview, New York City, June 25, 2015.

35. For example, see Hartmut Rosa and William E. Scheuerman, introduction to *High Speed Society: Social Acceleration, Power, and Modernity*, ed. Hartmut Rosa and William E. Scheuerman (University Park: Pennsylvania State University Press, 2009), 2.

36. Beyer, interview.

37. Bairin, interview.

38. Daly, interview.

39. Ellerton, interview.

40. For example, see Chouliaraki, *The Ironic Spectator*.

41. Woolwich, interview.

42. Singh, interview.

43. Woolwich, interview.

44. Raymond Williams, *Marxism and Literature* (Oxford: Oxford University Press, 1977), 132.

45. Ellerton, interview.

46. Singh, interview.

47. Singh, interview.

48. Singh, interview.

49. See, for example, Giorgio Agamben, *Homo Sacer: Sovereign Power and Bare Life*, trans. Daniel Heller-Roazen (Stanford, CA: Stanford University Press, 1998); Chouliaraki, *The Spectatorship of Suffering*; Chouliaraki, *The Ironic Spectator*; Halttunen, "Humanitarianism and the Pornography of Pain"; Susan Moeller, *Compassion Fatigue: How the Media Sell Disease, Famine, War, and Death* (New York: Routledge, 1999).

50. Nussbaum, *Upheavals of Thought*.

51. Beyer, interview.

52. Tirana Hassan, Skype interview, June 27, 2016.

53. Beyer, interview.

54. See Chouliaraki, *The Ironic Spectator*, for its discussion of the move from an ethics of pity to an ethics of irony.

55. Matheson, interview.

56. Bryan Nuñez, interview, New York City, June 16, 2015.

57. Gregory, "Transnational Storytelling," 198.

58. Veronica Matushaj, interview, New York City, September 21, 2015.

59. Woolwich, interview.

60. Daniel Eyre, Skype interview, August 14, 2015.

61. Waruzi, interview.

62. Wille, interview.

63. For example, see Amy Brouillette, "Hungarian Media Laws in Europe: An Assessment of the Consistency of Hungary's Media Laws with European Practices and Norms," Center for Media and Communication Studies, Central European University, 2012, https://www.eui.eu/Documents/General/DebatingtheHungarianConstitu tion/HungarianMediaLawsinEurope.pdf.

64. Woolwich, interview.

65. Priscila Neri, interview, New York City, August 6, 2015.

66. See Ristovska, "Strategic Witnessing in an Age of Video Activism," for a discussion of how these videos illustrate a shift away from witnessing as constitutive of the traumatic world to witnessing as a strategic mechanism for change.

67. Madeline Bair, interview, New York City, July 2, 2015.

68. De Certeau, *Practice of Everyday Life*, 36.

69. Neri, interview.

70. See, for example, Nichols, *Introduction to Documentary*, 2nd ed.

71. Nichols, *Introduction to Documentary*, 2nd ed., 168.

72. Singh, interview.

73. Ellerton, interview.

74. Daniel Santos, email interview, July 26, 2019.

75. Meckes, interview.

76. De Certeau, *Practice of Everyday Life*, 36.

77. Neri, interview.

78. Neri, interview.

79. Wille, interview.

80. Meckes, interview.

81. For the consequences of this development in human rights and humanitarian communication writ large, see Chouliaraki, *The Ironic Spectator*.

82. De Certeau, *Practice of Everyday Life*, 54.

83. Hargrave, interview.

84. WITNESS, prod., *Help Make Human Rights Abuse Visible, #WitnessTruth*, June 22, 2016, video, 2:34, https://www.youtube.com/watch?v=x1PhAEwkJD4.

85. Neri, interview.

86. Bair, interview.

87. Woolwich, interview.

## Chapter 6

1. Lilie Chouliaraki, "Re-mediation, Inter-mediation, Trans-mediation: The Cosmopolitan Trajectories of Convergent Journalism," *Journalism Studies* 14 (2) (2013): 267.

2. Judith Butler, *Giving an Account of Oneself* (New York: Fordham University Press, 2005).

3. Mirca Madianou, Liezel Longboan, and Jonathan Corpus Ong, "Finding a Voice through Humanitarian Technologies? Communication Technologies and Participation in Disaster Recovery," *International Journal of Communication* 9 (2015): 3020–3038.

4. Axel Honneth, *The Struggle for Recognition: The Moral Grammar of Social Conflicts* (Cambridge, MA: MIT Press, 1996).

5. Nick Couldry, *Why Voice Matters: Culture and Politics after Neoliberalism* (London: Sage, 2010).

6. Alice Baroni, "Contested Visualities: Courage and Fear in the Portrayal of Rio de Janeiro's Favelas," in *Visual Imagery and Human Rights Practice*, ed. Ristovska and Price, 233.

7. For more on how voice materializes, see Butler, *Giving an Account of Oneself*.

8. Chouliaraki, "Re-mediation."

9. Jean-François Lyotard, *The Differend: Phrases in Dispute* (Minneapolis: University of Minnesota Press, 1988), 8.

10. Pierre Bairin, interview, New York City, June 16, 2015.

11. Cathy Caruth, *Unclaimed Experiences: Trauma, Narrative, and History* (Baltimore: Johns Hopkins University Press, 1996).

12. Felman, "Theaters of Justice," 2.

13. Dori Laub, "Bearing Witness or the Vicissitudes of Listening," in *Testimony: Crises of Witnessing in History, Literature, and Psychoanalysis*, ed. Shoshana Felman and Dori Laub (New York: Routledge, 1992), 57.

14. Felman, "Theaters of Justice."

15. Sliwinski, *Human Rights in Camera*, 94.

16. Ruth Leys, *Trauma: A Genealogy* (Chicago: University of Chicago Press, 2000).

17. Caruth, *Unclaimed Experiences*; Amit Pinchevski, *By Way of Interruption: Levinas and the Ethics of Communication* (Pittsburgh, PA: Duquesne University Press, 2005).

18. Zelizer, *About to Die*, 13.

19. Raja Althaibani, phone interview, August 7, 2015.

20. Christoph Koettl, interview, Washington DC, July 20, 2015; Bryan Nuñez, interview, New York City, June 16, 2015.

21. Slavoj Žižek, "'I Hear You with My Eyes'; or, The Invisible Master," in *Gaze and Voice as Love Objects*, ed. Renata Salecl and Slavoj Žižek (Durham, NC: Duke University Press, 1996), 91, 93.

22. Christian Delage, "The Place of the Filmed Witness: From Nuremberg to Khmer Rouge Trials," *Cardozo Law Review* 31 (4) (2010): 1096.

23. Bukeni Waruzi, interview, New York City, August 6, 2015.

24. Zelizer, *About to Die*, 13.

25. Priscila Neri, interview, New York City, August 6, 2015.

26. On the tenuous relationship between testimony and authenticity, see Michael Bernard-Donals, "Beyond the Question of Authenticity: Witness and Testimony in the Fragments Controversy," *PMLA* 116 (5) (2001): 1302–1315.

27. Carroll Bogert, interview, New York City, May 6, 2014.

28. Veronica Matushaj, interview, New York City, September 21, 2015.

29. Ristovska, "Strategic Witnessing in an Age of Video Activism," 1036.

30. See, for example, Sandra Ristovska, "The Purchase of Witnessing in Human Rights Activism," in *Routledge Companion to Media Activism*, ed. Graham Meikle (New York: Routledge, 2018), 216–222.

31. Althaibani, interview.

32. For example, see Tagg, *Burden of Representation*.

33. Robert Trafford, personal communication, July 10, 2019.

34. Ryan Kautz, interview, New York City, July 2, 2015.

35. See, for example, Sara Ahmed, *On Being Included: Racism and Diversity in Institutional Life* (Durham, NC: Duke University Press, 2012).

36. See, for example, Catherine A. Lutz and Lila Abu-Lughod, *Language and the Politics of Emotion* (New York: Cambridge University Press, 1990).

37. For example, Kay L. Schlozman, Sidney Verba, and Henry E. Brady, *The Unheavenly Chorus: Unequal Political Voice and the Broken Promise of American Democracy* (Princeton, NJ: Princeton University Press, 2012).

38. Bogert, interview; Belkis Wille, interview, New York City, June 25, 2015.

39. Morgan Hargrave, interview, New York City, June 2, 2015.

40. Freidson, *Professional Powers*, 17.

41. Lang, *NGOs, Civil Society, and the Public Sphere*, 64.

42. Max Weber, "Bureaucracy," in *From Max Weber: Essays in Sociology*, ed. Hans Gerth and C. Wright Mills (New York: Oxford University Press, 1947), 196–244.

43. Lang, *NGOs, Civil Society, and the Public Sphere*.

44. Aryeh Neier, *International Human Rights Movement: A History* (Princeton, NJ: Princeton University Press, 2012).

45. Kelly Matheson, interview, New York City, July 22, 2015.

46. For example, see Boaventura de Sousa Santos, *If God Were a Human Rights Activist* (Stanford, CA: Stanford University Press, 2015).

47. See, for example, Sam Gregory, "Cameras Everywhere: Ubiquitous Video Documentation of Human Rights, New Forms of Video Advocacy, and Consideration of Safety, Security, Dignity, and Consent," *Journal of Human Rights Practice* 2 (2) (2010): 191–207; Gregory, "Transnational Storytelling"; Sam Gregory, "Human Rights Made Visible: New Dimensions to Anonymity, Consent, and Intentionality," in *Sensible Politics: The Visual Culture of Nongovernmental Activism*, ed. Meg McLagan and Yates McKee (New York: Zone Books, 2012), 551–562; Sam Gregory, "Ubiquitous Witnesses: Who Creates the Evidence and the Live(d) Experience of Human Rights Violations?,"

*Information, Communication, & Society* 18 (11) (2015): 1378–1392; Dubberley, Koenig, and Murray, *Digital Witness*.

48. Freidson, *Professional Powers*; Larson, *Rise of Professionalism*.

49. John Nerone, *The Media and Public Life: A History* (Cambridge: Polity Press, 2015).

50. See Nerone, *The Media and Public Life*, 156–163.

51. Nerone, *The Media and Public Life*, 224.

52. Zelizer, *What Journalism Could Be*, 25–26.

53. Jacques Derrida, "The Villanova Roundtable: A Conversation with Jacques Derrida," in *Deconstruction in a Nutshell: A Conversation with Jacques Derrida*, ed. John D. Caputo (New York: Fordham University Press, 1997), 16.

54. Nerone, *The Media and Public Life*, 224.

55. Emma Daly, interview, New York City, July 10, 2019.

56. Daly, interview; Jim Ward, interview, London, April 12, 2018.

57. Samuel Moyn, *Not Enough: Human Rights in an Unequal World* (Cambridge, MA: Harvard University Press, 2018), 216.

58. Livia Hinegardner, "Action, Organization, and Documentary Film: Beyond a Communications Model of Human Rights Videos," *Visual Anthropology Review* 25 (2) (2009): 173.

59. See also Nestor García Canclini, *Hybrid Cultures: Strategies for Entering and Leaving Modernity*, trans. Christopher L. Chiappari and Sylvia L. Lopez (Minneapolis: University of Minnesota Press, 1995); Joshka Wessels, *Documenting Syria: Film-making, Video Activism, and Revolution* (New York: I. B. Tauris, 2019).

60. For example, see Perugini and Gordon, *The Human Right to Dominate*; Randall Williams, *The Divided World: Human Rights and Its Violence* (Minneapolis: University of Minnesota Press, 2010).

61. Price, *Free Expression*, 4.

62. For example, see Perugini and Gordon, *Human Right to Dominate*.

63. See Scott, *Seeing Like a State*.

64. For example, see Sandra Fahy, *Dying for Rights: Putting North Korea's Rights Abuses on the Record* (New York: Columbia University Press, 2019); Anat Leshnick, "In One Hand a Camera and in the Other, a Gun: State's Adoption of Visual Activist Strategies for Narrative Legitimacy," *International Journal of Communication* (forthcoming).

65. Jackie Zammuto, Skype interview, July 2, 2019.

# Bibliography

Abbott, Andrew Delano. *The System of Professions: An Essay on the Division of Expert Labor.* Chicago: University of Chicago Press, 1988.

AFP News Agency. "Former Detainees Reveal Syrian Torture Centers." July 3, 2012. Video, 1:17. https://www.youtube.com/watch?v=CWFTCrloCV4.

Agamben, Giorgio. *Homo Sacer: Sovereign Power and Bare Life.* Translated by Daniel Heller-Roazen. Stanford, CA: Stanford University Press, 1998.

Ahmed, Sara. *The Cultural Politics of Emotion.* New York: Routledge, 2004.

Ahmed, Sara. *On Being Included: Racism and Diversity in Institutional Life.* Durham, NC: Duke University Press, 2012.

Alberdingk Thijm, Yvette. "Update on The Hub and WITNESS' New Online Strategy." *WITNESS* (blog), August 2010. https://blog.witness.org/2010/08/update-on-the-hub-and-witness-new-online-strategy/.

Alexander, Jeffrey C. "On the Social Construction of Moral Universals: The 'Holocaust' from War Crime to Trauma Drama." *European Journal of Social Theory* 5 (1) (2002): 5–85.

Allan, Stuart. *Online News: Journalism and the Internet.* New York: Open University Press, 2006.

Amnesty International. "Burundi: Suspected Mass Graves of Victims of 11 December Violence." January 29, 2016. burundibriefingafr1633372016english2.pdf.

Amnesty International. *Nigeria: Stars on Their Shoulders, Blood on Their Hands: War Crimes Committed by the Nigerian Military. Executive Summary.* London: Amnesty International, 2015. https://www.amnesty.org/en/documents/afr44/1661/2015/en/.

Amnesty International. "Syria: Unprecedented Investigation Reveals US-Led Coalition Killed More Than 1,600 Civilians in Raqqa 'Death Trap.'" April 25, 2019. https://www.amnesty.org/en/latest/news/2019/04/syria-unprecedented-investigation-reveals-us-led-coalition-killed-more-than-1600-civilians-in-raqqa-death-trap/.

Amnesty International. "Who We Are." 2016. https://www.amnesty.org/en/who-we -are/.

Andén-Papadopoulos, Kari, and Mervi Pantti. Introduction to *Amateur Images and Global News*, edited by Kari Andén-Papadopoulos and Mervi Pantti, 9–20. Bristol: Intellect Books, 2012.

Andén-Papadopoulos, Kari, and Mervi Pantti. "The Media Work of Syrian Diaspora Activists: Brokering between the Protest and Mainstream Media." *International Journal of Communication* 7 (2013): 2185–2206.

Andén-Papadopoulos, Kari, and Mervi Pantti. "Re-imagining Crisis Reporting: Professional Ideology of Journalists and Citizen Eyewitness Images." *Journalism* 14 (7) (2013): 960–977.

Arendt, Hannah. *Eichmann in Jerusalem: A Report on the Banality of Evil*. 1963. Reprint. New York: Penguin Books, 2006.

Asher-Schapiro, Avi, and Ban Barkawi, "'Lost Memories': War Crimes Evidence Threatened by AI Moderation." *Reuters*, June 19, 2020. https://www.reuters.com /article/us-global-socialmedia-rights-trfn/lost-memories-war-crimes-evidence -threatened-by-ai-moderation-idUSKBN23Q2TO.

Ashouri, Aida, Caleb Bowers, and Cherrie Warden. "Working Paper: An Overview of the Use of Digital Evidence in International Criminal Courts," Salzburg Workshop on Cyber Investigations, 2013. https://www.law.berkeley.edu/files/HRC/Scholarly_ articles_Salzburg_2013.pdf.

Askanius, Tina. "Video Activism as Technology, Text, Testimony—or Practices." In *Citizen Media and Practice: Currents, Connections, Challenges*, edited by Hilde C. Stephansen and Emiliano Treré, 136–151. Oxon: Routledge, 2020.

Askanius, Tina. "Video for Change." In *The Handbook of Development and Social Change*, edited by Karin Gwinn Wilkins, Thomas Tufte, and Rafael Obregon, 453– 470. Malden, MA: Wiley, 2014.

Askanius, Tina, and Nils Gustafsson. "Mainstreaming the Alternative: The Changing Media Practices of Protest Movements." *Interface* 2 (2) (2010): 23–41.

Aufderheide, Pat. "'You See the World of the Other and You Look at Your Own': The Evolution of the Video in the Villages Project." *Journal of Film and Video* 60 (2) (2008): 26–34.

Austin, Regina. "Documentation, Documentary, and the Law: What Should Be Made of Victim Impact Videos?" *Cardozo Law Review* 31 (4) (2010): 979–1017.

Bailey, Fenton, and Randy Barbato, dir. *Video, Vigilantes, and Voyeurism*. Channel 4 documentary. Vancouver: T.H.A. Media Distributors, 1993.

Barnhurst, Kevin G. 2015. "Contradictions in News Epistemology: How Modernism Failed Mainstream US Journalism." *Media, Culture, & Society* 37 (8) (2015): 1244–1253.

Baroni, Alice. "Contested Visualities: Courage and Fear in the Portrayal of Rio de Janeiro's Favelas." In *Visual Imagery and Human Rights Practice*, edited by Sandra Ristovska and Monroe Price, 229–252. New York: Palgrave, 2018.

Barthel, Michael. "5 Key Takeaways about the State of the News Media in 2018." Pew Research Center, July 23, 2019. https://www.pewresearch.org/fact-tank/2019/07/23/key-takeaways-state-of-the-news-media-2018/.

Bell, Martin. "TV News: How Far Should We Go?" *British Journalism Review* 8 (1) (1997): 6–16.

Benjamin, Walter. *Selected Writing*s. Vol. 4: *1938–1940*. Edited by Howard Eiland and Michael W. Jennings. Cambridge, MA: Harvard University Press, 2006.

Bennett, W. Lance, Regina G. Lawrence, and Steven Livingston. *When the Press Fails: Political Power and the News Media from Iraq to Katrina*. Chicago: University of Chicago Press, 2007.

Bernard-Donals, Michael. "Beyond the Question of Authenticity: Witness and Testimony in the Fragments Controversy." *PMLA* 116 (5) (2001): 1302–1315.

Bernstein, Nine. "Should War Reporters Testify, Too? A Recent Court Decision Helps Clarify the Issue but Does Not End the Debate." *New York Times*, Metro sec., December 14, 2002. http://www.nytimes.com/2002/12/14/arts/should-war-reporters-testify-too-recent-court-decision-helps-clarify-issue-but.html?pagewanted=all.

Blaagaard, Bolette B. "Situated, Embodied, and Political: Expressions of Citizen Journalism." *Journalism Studies* 14 (2) (2013): 187–200.

Bleiker, Roland, ed. *Visual Global Politics*. New York: Routledge, 2018.

Boczkowski, Pablo J. "Materiality and Mimicry in the Journalism Field." In *The Changing Faces of Journalism: Tabloidization, Technology, and Truthiness*, edited by Barbie Zelizer, 56–67. Oxon: Routledge, 2009.

Bogert, Carroll. "Similar Paths, Different Missions: International Journalists and Human Rights Observers." *Nieman Reports* 64 (3) (2010): 59–61. https://niemanreports.org/articles/similar-paths-different-missions-international-journalists-and-human-rights-observers/.

Bogert, Carroll. "Whose News? The Changing Media Landscape and NGOs." In *Human Rights Watch 2011 World Report*. New York: Human Rights Watch, 2011. https://www.hrw.org/world-report/2011/country-chapters/africa-americas-asia-europe/central-asia-global-middle-east/north-africa.

Bogre, Michelle. *Photography as Activism: Images for Social Change.* Oxford: Focal Press, 2012.

Boltanski, Luc. *Distant Suffering: Morality, Media, and Politics.* Translated by Graham Burchell. Cambridge: Cambridge University Press, 1999.

Boltanski, Luc, and Eve Chiapello. *The New Spirit of Capitalism.* Translated by Gregory Elliott. London: Verso, 2005.

Boyle, Deirdre. "From Portapak to Camcorder: A Brief History of Guerrilla Television." *Journal of Film and Video* 44 (1–2) (1992): 67–79.

Boyle, Deirdre. "Subject to Change: Guerrilla Television Revisited." *Art Journal* 45 (3) (1985): 228–232.

Braman, Sandra. "The Medium as Power: Information and Its Flows as Acts of War." In *Communicating with Power*, edited by Cherian George, 3–22. New York: Peter Lang Publishing, 2017.

Brewer, John. *The Common People and Politics, 1750–1790s.* Cambridge: Chadwyck-Healey, 1986.

Brouillette, Amy. "Hungarian Media Laws in Europe: An Assessment of the Consistency of Hungary's Media Laws with European Practices and Norms." Center for Media and Communication Studies, Central European University, 2012. https://www.eui.eu/Documents/General/DebatingtheHungarianConstitution/HungarianMediaLawsinEurope.pdf.

Butler, Judith. *Giving an Account of Oneself.* New York: Fordham University Press, 2005.

Calabrese, Andrew, and Claudia Padovani, eds. *Communication Rights and Social Justice: Historical Accounts of Transnational Mobilizations.* New York: Palgrave, 2014.

Calma, Justine. "Facebook Says It 'Mistakenly' Suspended Hundreds of Activists' Accounts." *The Verge*, September 24, 2020. https://www.theverge.com/2020/9/24/21454554/facebook-acitivists-suspended-accounts-coastal-gaslink-pipeline.

Campbell, David. "Atrocity, Memory, Photography: Imaging the Concentration Camps of Bosnia—the Case of ITN versus *Living Marxism*, Part 1." *Journal of Human Rights* 1 (1) (2002): 1–33.

Campbell, David. "Atrocity, Memory, Photography: Imaging the Concentration Camps of Bosnia—the Case of ITN versus *Living Marxism*, Part 2." *Journal of Human Rights* 1 (2) (2002): 143–172.

Canclini, Nestor García. *Hybrid Cultures: Strategies for Entering and Leaving Modernity.* Translated by Christopher L. Chiappari and Silvia L. Lopez. Minneapolis: University of Minnesota Press, 1995.

Caruth, Cathy. *Unclaimed Experiences: Trauma, Narrative, and History.* Baltimore: Johns Hopkins University Press, 1996.

Castells, Manuel. "The New Public Sphere: Global Civil Society, Communication Networks, and Global Governance." *Annals of the American Academy of Political and Social Science* 616 (1) (2008): 78–93.

Chouliaraki, Lilie. *The Ironic Spectator: Solidarity in the Age of Post-humanitarianism.* Cambridge: Polity Press, 2013.

Chouliaraki, Lilie. "Re-mediation, Inter-mediation, Trans-mediation: The Cosmopolitan Trajectories of Convergent Journalism." *Journalism Studies* 14 (2) (2013): 267–283.

Chouliaraki, Lilie. *The Spectatorship of Suffering.* London: Sage, 2006.

CISCO. *CISCO Annual Internet Report (2018–2023).* White paper, March 9, 2020. https://www.cisco.com/c/en/us/solutions/collateral/executive-perspectives/annual -internet-report/white-paper-c11-741490.html.

Clement, Jessica. "Internet Usage Worldwide—Statistics & Facts." Statista. October 26, 2020. https://www.statista.com/topics/1145/internet-usage-worldwide/.

Cobb, Chris. "Amateur Videotapes Changing Perspective of News." *Gazette*, February 26, 1995.

Cohn, Marjorie, and David Dow. *Cameras in the Courtroom: Television and the Pursuit of Justice.* Jefferson, NC: McFarland, 2002.

Cooper, Glenda. *From Their Own Correspondents? News Media and the Changes in Disaster Coverage.* Oxford: Reuters Institute for the Study of Journalism, 2011.

Cottle, Simon. "Journalists Witnessing Disaster: From the Calculus of Death to the Injunction to Care." *Journalism Studies* 14 (2) (2013): 232–248.

Couldry, Nick. *Why Voice Matters: Culture and Politics after Neoliberalism.* London: Sage, 2010.

Coyer, Kate, Tony Dowmunt, and Alan Fountain, eds. *The Alternative Media Handbook.* New York: Routledge, 2007.

Craven, David. *Art and Revolution in Latin America, 1910–1990.* New Haven, CT: Yale University Press, 2002.

Crow, Thomas E. *Emulation: Making Artists for Revolutionary France.* New Haven, CT: Yale University Press, 1994.

Daston, Lorraine, and Peter Galison. *Objectivity.* New York: Zone Books, 2010.

De Certeau, Michel. *The Practice of Everyday Life.* Translated by Steven Rendall. Berkeley: University of California Press, 1984.

Deger, Jennifer. *Shimmering Screens: Making Media in an Aboriginal Community*. Minneapolis: University of Minnesota Press, 2006.

Delage, Christian. *Caught on Camera: Film in the Courtroom from the Nuremberg Trials to the Trials of Khmer Rouge*. Philadelphia: University of Pennsylvania Press, 2014.

Delage, Christian. "The Place of the Filmed Witness: From Nuremberg to Khmer Rouge Trials." *Cardozo Law Review* 31 (4) (2010): 1087–1112.

Delage, Christian. "Simon Srebnik: Narratives of a Holocaust Survivor." In *Visual Imagery and Human Rights Practice*, edited by Sandra Ristovska and Monroe Price, 109–129. New York: Palgrave, 2018.

Delage, Christian, and Peter Goodrich. Introduction to *The Scene of the Mass Crime: History, Film, and International Tribunals*, 1–6. Oxon, UK: Routledge, 2013.

Delage, Christian, and Peter Goodrich, eds. *The Scene of the Mass Crime: History, Film, and International Tribunals*. Oxon, UK: Routledge, 2013.

Derrida, Jacques. "The Villanova Roundtable: A Conversation with Jacques Derrida." In *Deconstruction in a Nutshell: A Conversation with Jacques Derrida*, edited by John D. Caputo, 1–28. New York: Fordham University Press, 1997.

Deutch, Jeff, and Hadi Habal. "The Syrian Archive: A Methodological Case Study of Open-Source Investigation of State Crime Using Video Evidence from Social Media Platforms." *State Crime* 7 (1) (2018): 46–76.

Deuze, Mark. "What Journalism Is (Not)." *Social Media + Society* 5 (3) (2019): 1–4.

Dieckmann, Katherine. "Electra Myths: Video, Modernism, Postmodernism." *Art Journal* 45 (3) (1985): 195–203.

Doherty, Thomas Patrick. *Hollywood and Hitler, 1933–1939*. New York: Columbia University Press, 2013.

Douglas, Lawrence. *The Memory of Judgment: Making Law and History in the Trials of the Holocaust*. New Haven, CT: Yale University Press, 2001.

Downing, John. *Radical Media: Rebellious Communication and Social Movements*. London: Sage, 2001.

Drucker, Johanna. *Graphesis: Visual Forms of Knowledge Production*. Cambridge, MA: Harvard University Press, 2014.

Dubberley, Sam, Alexa Koenig, and Daragh Murray. *Digital Witness: Using Open Source Information for Human Rights Investigation, Documentation, and Accountability*. Oxford: Oxford University Press, 2020.

Durkheim, Émile. *The Division of Labor in Society*. Translated by W. D. Halls. New York: Free Press, 1984.

Edelman, Berland. *2014 Edelman Trust Barometer Executive Summary*. 2014. https://www.scribd.com/document/200429962/2014-Edelman-Trust-Barometer.

Edwards, Richard. "Torrents of Resistance." *Film International* 10 (2004): 38–47.

Elliott, Philip. *The Sociology of the Professions*. London: Macmillan, 1972.

Ettema, James S., and Theodore L. Glasser, *Custodians of Conscience: Investigative Journalism and Public Virtue*. New York: Columbia University Press, 1998.

Eyewitness Media Hub. "Eyewitness Media Hub Launch Guiding Principles for Journalists." *Medium*, September 9, 2015. https://medium.com/@emhub/eyewitness-media-hub-launch-guiding-principles-for-journalists-54aafc786eeb#.1vf0g92j8.

Fahy, Sandra. *Dying for Rights: Putting North Korea's Rights Abuses on the Record*. New York: Columbia University Press, 2019.

Feigenson, Neal. "The Visual in Law: Some Problems for Legal Theory." *Law, Culture, and the Humanities* 10 (1) (2014): 13–23.

Feigenson, Neal, and Christina Spiesel. *Law on Display: The Digital Transformation of Legal Persuasion and Judgment*. New York: New York University Press, 2009.

Feigenson, Neal, and Christina Spiesel. "How Is the Medium the Message? Zoom as Visual and Legal Practice." *First Monday* (forthcoming).

Felman, Shoshana. "Theaters of Justice: Arendt in Jerusalem, the Eichmann Trial, and the Redefinition of Legal Meaning in the Wake of the Holocaust." *Theoretical Inquiries in Law* 1 (2000): 1–43.

Fenton, Natalie. "Fake Democracy: The Limits of Public Sphere Theory." *Javnost—the Public* 25 (1–2) (2018): 28–34.

Fenton, Natalie. "NGOs, New Media, and the Mainstream News." In *New Media, Old News: Journalism and Democracy in the Digital Age*, edited by Fenton Natalie, 153–168. London: Sage, 2010.

Fenton, Natalie, and Veronica Barassi. "Alternative Media and Social Networking Sites: The Politics of Individuation and Political Participation." *Communication Review* 14 (3) (2011): 179–196.

Ferrari, Elisabetta. "The Technological Imaginaries of Social Movements: The Discursive Dimension of Communication Technology and the Fight for Social Justice." PhD diss., University of Pennsylvania, 2019.

Forensic Architecture. "Bil'in: Reconstructing the Death of a Palestinian Demonstrator via Video Analysis." 2010. http://www.forensic-architecture.org/case/bilin/.

Forensic Architecture, ed. *Forensis: The Architecture of Public Truth*. Berlin: Sternberg Press, 2014.

Fountain, Alan. "Alternative Film, Video, and Television 1965–2005." In *The Alternative Media Handbook*, edited by Cate Coyer, Tony Dowmunt, and Alan Fountain, 29–46. New York: Routledge, 2007.

Freeman, Lindsay. "Digital Evidence and War Crimes Prosecutions: The Impact of Digital Technologies on International Criminal Investigations and Trials." *Fordham International Law Journal* 41 (2) (2018): 283–336.

Freidson, Eliot. *Professionalism: The Third Logic*. Chicago: University of Chicago Press, 2001.

Freidson, Eliot. *Professional Powers: A Study of the Institutionalization of Formal Knowledge*. Chicago: University of Chicago Press, 1986.

Furlong, Lucinda. "Tracking Video Art: "Image Processing" as a Genre." *Art Journal* 45 (3) (1985): 233–237.

Galtung, Johan, Carl G. Jacobsen, and Kal Frithjof Brand-Jacobsen. *Searching for Peace—the Road to TRANSCEND*. London: Pluto Press, 2002.

Gates, Kelly. "Professionalizing Police Media Work: Surveillance Video and the Forensic Sensibility." In *Images, Ethics, Technology*, edited by Sharrona Pearl, 41–57. New York: Routledge, 2016.

Gerbaudo, Paolo. *The Mask and the Flag: Populism, Citizenism, and Global Protest*. New York: Oxford University Press, 2017.

Gever, Martha. "Pressure Points: Video in the Public Sphere." *Art Journal* 45 (3) (1985): 238–243.

Ghazzi, Omar Al-. "'Citizen Journalism' in the Syrian Uprising: Problematizing Western Narratives in a Local Context." *Communication Theory* 24 (4) (2014): 435–454.

Gillespie, David. *Early Soviet Cinema: Innovation, Ideology, and Propaganda*. London: Wallflower Press, 2000.

Ginsburg, Faye D. "Screen Memories: Resignifying the Traditional in Indigenous Media." In *Media Worlds: Anthropology on New Terrain*, edited by Faye D. Ginsburg, Lila Abu-Lughod, and Brian Larkin, 39–57. Berkeley: University of California Press, 2002.

Ginsburg, Faye D., Lila Abu-Lughod, and Brian Larkin. Introduction to *Media Worlds: Anthropology on New Terrain*, edited by Faye D. Ginsburg, Lila Abu-Lughod, and Brian Larkin, 1–36. Berkeley: University of California Press, 2002.

Ginsburg, Faye D., Lila Abu-Lughod, and Brian Larkin, eds. *Media Worlds: Anthropology on New Terrain*. Berkeley: University of California Press, 2002.

Gitelman, Lisa. *Always Already New: Media, History, and the Data of Culture*. Cambridge, MA: MIT Press, 2006.

Golčevski, Nenad. "Communicating Justice in Film: The Limitations of an Unlimited Field." In *Visual Imagery and Human Rights Practice*, edited by Sandra Ristovska and Monroe Price, 153–163. New York: Palgrave, 2018.

Goldberg, Vicky. *The Power of Photography: How Photographs Changed Our Lives*. New York: Abbeville, 1991.

Gray, Jonathan. "Data Witnessing: Attending to Injustice with Data in Amnesty International's Decoders Project." *Information, Communication, & Society* 22 (7) (2019): 971–991.

Grayson, Louise. "The Role of Non-governmental Organizations (NGOs) in Practicing Editorial Photography in a Globalized Media Environment." *Journalism Practice* 8 (5) (2014): 632–645.

Gregory, Sam. "Cameras Everywhere: Ubiquitous Video Documentation of Human Rights, New Forms of Video Advocacy, and Consideration of Safety, Security, Dignity, and Consent." *Journal of Human Rights Practice* 2 (2) (2010): 191–207.

Gregory, Sam. "Human Rights Made Visible: New Dimensions to Anonymity, Consent, and Intentionality." In *Sensible Politics: The Visual Culture of Nongovernmental Activism*, edited by Meg McLagan and Yates McKee, 551–562. New York: Zone Books, 2012.

Gregory, Sam. "Transnational Storytelling: Human Rights, WITNESS, and Video Advocacy." *American Anthropologist* 108 (1) (2006): 195–204.

Gregory, Sam. "Ubiquitous Witnesses: Who Creates the Evidence and the Live(d) Experience of Human Rights Violations?" *Information, Communication, & Society* 18 (11) (2015): 1378–1392.

Gürsel, Zeynep Devrim. "The Politics of Wire Service Photography: Infrastructures of Representation in a Digital Newsroom." *American Ethnologist* 39 (1) (2012): 71–89.

Halleck, DeeDee. *Handheld Visions: The Impossible Possibilities of Community Media*. New York: Fordham University Press, 2002.

Halttunen, Karen. "Humanitarianism and the Pornography of Pain in Anglo-American Culture." *American Historical Review* 100 (2) (1995): 303–334.

Hamelink, Cees J. *Trends in World Communication on Disempowerment and Self-Empowerment*. Penang, Malaysia: Southbound and Third World Network, 1994.

Hamilton, John Maxwell. *Journalism's Roving Eye: A History of American Foreign Reporting*. Baton Rouge: Louisiana State University Press, 2009.

Hampton, Mark. "The Fourth Estate Ideal in Journalism History." In *The Routledge Companion to News and Journalism*, edited by Stuart Allan, 3–12. New York: Routledge, 2010.

Hannerz, Ulf. *Foreign News: Exploring the World of Foreign Correspondents*. Chicago: University of Chicago Press, 2004.

Harding, Thomas. *The Video Activist Handbook*. London: Pluto Press, 2001.

Harmansah, Omur. "ISIS, Heritage, and the Spectacles of Destruction in the Global Media." *Near Eastern Archaeology* 78 (3) (2015): 170–177.

Hartley, John. "Communicative Democracy in a Redactional Society: The Future of Journalism Studies." *Journalism* 1 (1) (2000): 39–48.

Hawkes, Matisse Bustos. "The Square's Jehane Noujaim on Filming a Revolution." *WITNESS* (blog), January 31, 2014. https://blog.witness.org/2014/01/jehane-noujaim-on-filming-egypts-revolution/.

Hiatt, Keith. "Open Source Evidence on Trial." *Yale Law Journal Forum* 125 (2016): 323–330.

Himpele, Jeff D. *Circuits of Culture: Media, Politics, and Indigenous Identity in the Andes*. Minneapolis: University of Minnesota Press, 2007.

Hinegardner, Livia. "Action, Organization, and Documentary Film: Beyond a Communications Model of Human Rights Videos." *Visual Anthropology Review* 25 (2) (2009): 172–185.

Holley, Andrea, prod. *HRWFF Podcast with Peter Bouckaert*. Human Rights Watch Film Festival Podcast, 2015. MP3 audio, 23:37. https://ff.hrw.org/content/hrwff-podcast-peter-bouckaert.

Honneth, Axel. *The Struggle for Recognition: The Moral Grammar of Social Conflicts*. Cambridge, MA: MIT Press, 1996.

Human Rights Watch. "Mission Statement." 2016. https://www.hrw.org/about.

Human Rights Watch. "Syria: Coordinated Chemical Attacks on Aleppo." February 13, 2017. https://www.hrw.org/news/2017/02/13/syria-coordinated-chemical-attacks-aleppo.

Human Rights Watch. "Syria: Strong Evidence Government Used Chemicals as a Weapon." May 13, 2014. https://www.hrw.org/news/2014/05/13/syria-strong-evidence-government-used-chemicals-weapon.

Human Rights Watch. "'Video Unavailable:' Social Media Platforms Remove Evidence of War Crimes." September 10, 2020, https://www.hrw.org/report/2020/09/10/video-unavailable-social-media-platforms-remove-evidence-war-crimes#_ftn36.

Hunt, Lynn. *Inventing Human Rights: A History*. New York: Norton, 2007.

Hunt, Lynn. *Politics, Culture, and Class in the French Revolution*. Berkeley: University of California Press, 1984.

Independent International Commission of Inquiry on the Syrian Arab Republic. *10th Report of Commission of Inquiry on Syria*. Report no. A/HRC/30/48. New York: Office of the United Nations High Commissioner for Human Rights, 2015.

International Commission for the Study of Communication Problems. *Many Voices One World: Towards a New, More Just, and More Efficient World Information and Communication Order*. London: Kogan Page, 1980.

International Council on Human Rights Policy. *Journalism, Media, and the Challenge of Human Rights Reporting*. Vernier, Switzerland: ATAR Roto Press, 2002. www.ichrp.org/files/reports/14/106_report_en.pdf.

Jaloud, Abdul Rahman Al, Hadi Al Khatib, Jeff Deutch, Dia Kayyali, and Jillian C. York. "Caught in the Net: The Impact of 'Extremist' Speech Regulations on Human Rights Content." Electronic Frontier Foundation, May 2019. https://www.eff.org/files/2019/05/30/caught_in_the_net_whitepaper_2019.pdf.

Janowitz, Morris. "Professional Models in Journalism: The Gatekeeper and the Advocate." *Journalism Quarterly*, Winter 1975, 618–626, 662.

Jepperson, Ronald L. "Institutions, Institutional Effects, and Institutionalism." In *The New Institutionalism in Organizational Analysis*, edited by Walter W. Powell and Paul DiMaggio, 143–163. Chicago: University of Chicago Press, 1991.

Johnson, Molly Treadway, Carol Krafka, and Donna Stienstra. *Video Recording Courtroom Proceedings in United States District Courts: Report on a Pilot Project Submitted by the Federal Judicial Center to the Court Administration and Case Management Committee of the Judicial Conference of the United States*. Washington, DC: Federal Judicial Center, 2016. https://www.fjc.gov/sites/default/files/2017/Cameras%20in%20Courts%20Project%20Report%20(2016).pdf.

Jowett, Garth, and Victoria O'Donnell. *Propaganda & Persuasion*. 6th ed. Thousand Oaks, CA: Sage, 2015.

Juhasz, Alexandra. *AIDS TV: Identity, Community, and Alternative Video*. Durham, NC: Duke University Press, 1996.

Juhasz, Alexandra. "Video Remains: Nostalgia, Technology, and Queer Archive Activism." *GLQ: A Journal of Lesbian and Gay Studies* 12 (2) (2006): 319–328.

Jurkowitz, Mark, Amy Mitchell, Elisa Shearer, and Mason Walker. "U.S. Media Polarization and the 2020 Election: A Nation Divided." Pew Research Center, January 24, 2020. https://www.journalism.org/2020/01/24/u-s-media-polarization-and-the-2020-election-a-nation-divided/.

Kant, Immanuel. "The Contest of Faculties: A Renewed Attempt to Answer the Question: 'Is the Human Race Constantly Progressing?'" In *Kant's Political Writings*, 2nd ed., edited by Hans Reis, 176–190. Cambridge: Cambridge University Press, 1991.

Keenan, Thomas, and Eyal Weizman. *Mengele's Skull: The Advent of a Forensic Aesthetics*. Berlin: Sternberg Press, 2012.

Keller, Bill. "It's the Golden Age of News." *New York Times*, Opinion, November 3, 2013. http://www.nytimes.com/2013/11/04/opinion/keller-its-the-golden-age-of-news.html?_r=0.

Khamis, Sahar, Paul B. Gold, and Katherine Vaughn. "Beyond Egypt's 'Facebook Revolution' and Syria's 'YouTube Uprising': Comparing Political Contexts, Actors, and Communication Strategies." *Arab Media & Society*, no. 15 (Spring 2012). http://www.arabmediasociety.com/?article=791.

Kidd, Dorothy. "Indymedia.org: The Development of the Communication Commons." *Democratic Communiqué* 18 (2002): 65–86.

Kidd, Dorothy. "Occupy and Social Movement Communication." In *The Routledge Companion to Alternative and Community Media*, edited by Chris Atton, 457–468. New York: Routledge, 2015.

Kittler, Friedrich A. *Gramophone, Film, Typewriter*. Translated by Geoffrey Winthrop-Young and Michael Wutz. Stanford, CA: Stanford University Press, 1999.

Koettl, Christoph. "Can Video Document Possible War Crimes in Syria?" *WITNESS* (blog), January 2013. https://blog.witness.org/2013/01/video-war-crimes-in-syria/.

Koettl, Christoph. "A Convergence of Visuals: Geospatial and Open Source Analysis in Human Rights Documentation." In *Visual Imagery and Human Rights Practice*, edited by Sandra Ristovska and Monroe Price, 57–66. New York: Palgrave, 2018.

Koettl, Christoph. "'The YouTube War': Citizen Videos Revolutionize Human Rights Monitoring in Syria." *Mediashift*, February 18, 2014. http://mediashift.org/2014/02/the-youtube-war-citizen-videos-revolutionize-human-rights-monitoring-in-syria/.

Koziak, Barbara. *Retrieving Political Emotions: Thumos, Aristotle, and Gender*. University Park: Pennsylvania State University Press, 2000.

Kraidy, Marwan M. *The Naked Blogger of Cairo: Creative Insurgency in the Arab World*. Cambridge, MA: Harvard University Press, 2016.

Kraidy, Marwan M. *Reality Television and the Arab Politics: Contention in Public Life*. New York: Cambridge University Press, 2010.

Krakauer, Siegfried. *From Caligari to Hitler: A Psychological History of the German Film*. Princeton, NJ: Princeton University Press, 1947.

Krauss, Rosalind. "Video: The Aesthetics of Narcissism." *October* 1 (1976): 50–64.

Kumar, Priya. "Foreign Correspondents: Who Covers What." *American Journalism Review*, December 2010–January 2011. https://ajrarchive.org/article.asp?id=4997.

Lang, Sabine. *NGOs, Civil Society, and the Public Sphere*. New York: Cambridge University Press, 2013.

Larson, Magali Sarfatti. *The Rise of Professionalism: A Sociological Analysis*. Berkeley: University of California Press, 1977.

Laub, Dori. "Bearing Witness or the Vicissitudes of Listening." In *Testimony: Crises of Witnessing in History, Literature, and Psychoanalysis*, edited by Shoshana Felman and Dori Laub, 57–74. New York: Routledge, 1992.

Leshnick, Anat. "In One Hand a Camera and in the Other, a Gun: State's Adoption of Visual Activist Strategies for Narrative Legitimacy." *International Journal of Communication* (forthcoming).

Lewandowsky, Stephan, Ullrich K. H. Ecker, Colleen M. Seifert, Norbert Schwarz, and John Cook. "Misinformation and Its Correction: Continued Influence and Successful Debiasing." *Psychological Science in the Public Interest* 13 (3) (2012): 106–131.

Leys, Ruth. *Trauma: A Genealogy*. Chicago: University of Chicago Press, 2000.

Lichterman, Joseph. "Amnesty International Launches a New Site to Help Journalists Verify YouTube Videos." *NiemanLab*, July 8, 2014. http://www.niemanlab.org/2014 /07/amnesty-international-launches-a-new-site-to-help-journalists-verify-youtube -videos/.

Lutz, Catherine A., and Lila Abu-Lughod. *Language and the Politics of Emotion*. New York: Cambridge University Press, 1990.

Lynch, Marc, Deen Freelon, and Sean Aday. *Blogs and Bullets III: Syria's Socially Mediated Civil War*. Washington, DC: United States Institute of Peace, 2012.

Lyotard, Jean-François. *The Differend: Phrases in Dispute*. Minneapolis: University of Minnesota Press, 1988.

Madianou, Mirca, Liezel Longboan, and Jonathan Corpus Ong. "Finding a Voice through Humanitarian Technologies? Communication Technologies and Participation in Disaster Recovery." *International Journal of Communication* 9 (2015): 3020–3038.

Maitland, Carleen F., ed. *Digital Lifeline? ICTs for Refugees and Displaced Persons*. Cambridge, MA: MIT Press, 2018.

Marcus, George E. *The Sentimental Citizen: Emotion in Democratic Politics*. University Park: Pennsylvania State University Press, 2002.

Marcus, George E., Russell Neuman, and Michael MacKuen. *Affective Intelligence and Political Judgment*. Chicago: University of Chicago Press, 2000.

Marthoz, Jean-Paul. "A Call for Committed Journalism." *Global Beat Syndicate*, May 5, 1999. http://www.bu.edu/globalbeat/syndicate/Marthoz050599.html.

Mason, Paul. "Reflections of International Law in Popular Culture: Justice Seen to Be Done? Electronic Broadcast Coverage of the International Criminal Tribunal for the Former Yugoslavia." *Proceedings of the Annual Meeting of the American Society of International Law* 95 (2001): 210–215.

McChesney, Robert, and John Nichols. *The Death and Life of American Journalism: The Media Revolution That Will Begin the World Again.* New York: Nation Books, 2010.

McChesney, Robert, and Victor Pickard, eds. *Will the Last Reporter Please Turn Out the Lights: The Collapse of Journalism and What Can Be Done to Fix It.* New York: New Press, 2011.

McLagan, Meg. "Circuits of Suffering." *Political and Legal Anthropology Review* 28 (2) (2005): 223–239.

McLagan, Meg, and Yates McKee, eds. *Sensible Politics: The Visual Culture of Nongovernmental Activism.* New York: Zone Books, 2012.

McPherson, Ella. "Advocacy Organizations' Evaluation of Social Media Information for NGO Journalism: The Evidence and Engagement Model." *American Behavioral Scientist* 59 (1) (2014): 124–148.

Meikle, Graham. *The Routledge Companion to Media and Activism.* New York: Routledge, 2018.

Memmott, Mark. "'Torture Centers' Stretch across Syria, Human Rights Watch Reports." NPR, July 3, 2012. https://www.npr.org/sections/thetwo-way/2012/07/03/156179079/torture-centers-stretch-across-syria-human-rights-watch-reports.

Messaris, Paul. *Visual Literacy: Image, Mind, & Reality.* Boulder, CO: Westview Press, 1994.

Milan, Stefania. *Social Movements and Their Technologies: Wiring Social Change.* New York: Palgrave Macmillan, 2013.

Mindich, David T. Z. *Just the Facts: How "Objectivity" Came to Define American Journalism.* New York: New York University Press, 2000.

Mirzoeff, Nicholas. *The Right to Look: A Counterhistory of Visuality.* Durham, NC: Duke University Press, 2011.

Mitchell, William John Thomas. *Image Science: Iconology, Visual Culture, and Media Aesthetics.* Chicago: University of Chicago Press, 2015.

Mnookin, Jennifer L. "The Image of Truth: Photographic Evidence and the Power of Analogy." *Yale Journal of Law & the Humanities* 10 (1) (1998): 1–74.

Moeller, Susan. *Compassion Fatigue: How the Media Sell Disease, Famine, War, and Death.* New York: Routledge, 1999.

Mortensen, Mette. *Journalism and Eyewitness Images: Digital Media, Participation, and Conflict.* New York: Routledge, 2015.

Mouffe, Chantal. *The Democratic Paradox*. London: Verso, 2000.

Moyn, Samuel. *Not Enough: Human Rights in an Unequal World*. Cambridge, MA: Harvard University Press, 2018.

Murrell, Collen. *Foreign Correspondents and International Newsgathering: The Role of Fixers*. New York: Routledge, 2015.

Nash, Kate. "Global Citizenship as Showbusiness: The Cultural Politics of 'Make Poverty History.'" *Media, Culture, & Society* 30 (2) (2010): 167–181.

Neier, Aryeh. Foreword to *Digital Witness: Using Open Source Information for Human Rights Investigation, Documentation, and Accountability*, edited by Sam Dubberley, Alexa Koenig, and Daragh Murray, vii–x. Oxford: Oxford University Press, 2020.

Neier, Aryeh. *International Human Rights Movement: A History*. Princeton, NJ: Princeton University Press, 2012.

Nerone, John. *The Media and Public Life: A History*. Cambridge: Polity Press, 2015.

Newman, Michael Z. *Video Revolutions: On the History of a Medium*. New York: Columbia University Press, 2014.

Newman, Michael Z. "Ze Frank and the Poetics of Web Video." *First Monday* 13 (5) (2008). http://firstmonday.org/article/view/2102/1962.

Newton, Julianne H. *The Burden of Visual Truth: The Rise of Photojournalism in Mediating Reality*. Mahwah, NJ: Lawrence Erlbaum Associates, 2001.

Nichols, Bill. "Documentary Film and the Modernist Avant-Garde." *Critical Inquiry* 27 (4) (2001): 580–608.

Nichols, Bill. *Introduction to Documentary*. 2nd ed. Bloomington: Indiana University Press, 2010.

Nicholson, Eirwen E. C. "Consumers and Spectators: The Public of the Political Print in Eighteenth-Century England." *History* 81 (262) (1996): 5–21.

Nielsen, Rasmus Kleis, and Lucas Graves. "'News You Don't Believe': Audience Perspectives on Fake News." Reuters Institute for the Study of Journalism, October 2017. https://reutersinstitute.politics.ox.ac.uk/sites/default/files/2017-10/Nielsen%26Graves _factsheet_1710v3_FINAL_download.pdf.

Norden, Martin F. "A Good Travesty upon the Suffragette Movement: Women's Suffrage Films as Genre." *Journal of Popular Film and Television* 13 (4) (1986): 171–177.

Nuñez, Bryan. "Is This for Real? How InformaCam Improves Verification of Mobile Media Files." *WITNESS* blog, January 2013. https://blog.witness.org/2013/01/how -informacam-improves-verification-of-mobile-media-files/.

Nussbaum, Martha Craven. *Political Emotions: Why Love Matters for Justice*. Cambridge, MA: Harvard University Press, 2013.

Nussbaum, Martha Craven. *Upheavals of Thought: The Intelligence of Emotions*. Chicago: University of Chicago Press, 2001.

Orgad, Shani, and Irene Bruna Seu. "The Mediation of Humanitarianism: Toward a Research Framework." *Communication, Culture, & Critique* 7 (1) (2014): 6–36.

Ouellette, Laurie. "Camcorder Dos and Don'ts: Popular Discourses on Amateur Video and Participatory Television." *The Velvet Light Trap* 36 (1995): 33–43.

Palmer, Lindsay. *The Fixers: Local News Workers and the Underground Labor of International Reporting*. New York: Oxford University Press, 2019.

Pantti, Mervi. "Visual Gatekeeping in the Era of Networked Images: A Cross-Cultural Comparison of the Syrian Conflict." In *Gatekeeping in Transition*, edited by Tim P. Vos and Françoise Heinderyckx, 203–223. New York: Routledge, 2015.

Papacharissi, Zizi. *Affective Publics: Sentiment, Technology, and Politics*. New York: Oxford University Press, 2015.

Patterson, Thomas. *Informing the News: The Need for Knowledge Based Journalism*. New York: Vintage Books, 2013.

Peltier, Elian. "TV Cameras Coming to English Criminal Courts." *New York Times*, January 16, 2020. https://www.nytimes.com/2020/01/16/world/europe/cameras -british-courts.html.

Perugini, Nicola, and Neve Gordon. *The Human Right to Dominate*. New York: Oxford University Press, 2015.

Peters, John Durham. "Distrust of Representation: Habermas on the Public Sphere." *Media, Culture, & Society* 15 (1993): 541–571.

Petrović, Vladimir. "A Crack in the Wall of Denial: The Scorpions Video in and out of the Courtroom." In *Narratives of Justice in and out of the Courtroom*, edited by Dubravka Zarkov and Marlies Glasius, 89–109. New York: Springer, 2014.

Pew Research Center. *Public Trust in Government: 1958–2019*. Washington, DC: Pew Research Center, April 11, 2019. https://www.pewresearch.org/politics/2019/04/11 /public-trust-in-government-1958-2019/.

Pew Research Center. *The State of the News Media 2015*. Washington, DC: Pew Research Center, 2015. https://www.pewresearch.org/wp-content/uploads/sites/8 /2017/05/state-of-the-news-media-report-2015-final.pdf.

Pinchevski, Amit. "The Audiovisual Unconscious: Media and Trauma in the Video Archive for Holocaust Testimonies." *Critical Inquiry* 39 (1) (2012): 142–166.

Pinchevski, Amit. *By Way of Interruption: Levinas and the Ethics of Communication*. Pittsburg, PA: Duquesne University Press, 2005.

Pinchevski, Amit. *Transmitted Wounds: Media and the Mediation of Trauma*. New York: Oxford University Press, 2019.

Porter, Elizabeth G. "Imagining Law: Visual Thinking across the Law School Curriculum." *Journal of Legal Education* 68 (1) (2018): 8–14.

Porter, Elizabeth G. "Taking Images Seriously." *Columbia Law Review* 114 (7) (2014): 1687–1782.

Powell, Walter W., and Paul J. DiMaggio, eds. *The New Institutionalism in Organizational Analysis*. Chicago: University of Chicago Press, 1991.

Powers, Matthew. "The New Boots on the Ground: NGOs in the Changing Landscape of International News." *Journalism* 17 (4) (2016): 401–416. First published online January 29, 2015. doi: 10.1177/1464884914568077.

Powers, Matthew. *NGOs as Newsmakers: The Changing Landscape of International News*. New York: Columbia University Press, 2018.

Powers, Matthew. "Opening the News Gates? Humanitarian and Human Rights NGOs in the US Media, 1990–2010." *Media, Culture, & Society* 38 (3) (2016): 315–331. First published online April 4, 2015. doi: 10.1177/0163443715594868.

Powers, Matthew. "The Structural Organization of NGO Publicity Work: Explaining Divergent Publicity Strategies at Humanitarian and Human Rights Organizations." *International Journal of Communication* 8 (2014): 90–107.

Price, Monroe E. *Free Expression, Globalism, and the New Strategic Communication*. New York: Cambridge University Press, 2015.

Prins, Harald E. L. "Visual Media and the Primitivist Perplex: Colonial Fantasies, Indigenous Imagination, and Advocacy in North America." In *Media Worlds: Anthropology on New Terrain*, edited by Faye D. Ginsburg, Lila Abu-Lughod, and Brian Larkin, 58–74. Berkeley: University of California Press, 2002.

Rajagopalan, Megha. "The Histories of Today's Wars Are Being Written on Facebook and YouTube. But What Happens When They Get Taken Down?" *BuzzFeed News*, December 22, 2018. https://www.buzzfeednews.com/article/meghara/facebook-youtube-icc-war-crimes.

Reporters without Borders. "Syria." March 12, 2012, updated January 20, 2016. https://rsf.org/en/news/syria-2.

Ricker, Michael T. "El Taller de Gráfica Popular." *Graphic Witness* (blog), 2002. https://graphicwitness.org/group/tgpricker.htm.

Ristovska, Sandra. "The Case for Visual Information Policy." *Surveillance & Society*, 18 (3) (2020): 418–421.

Ristovska, Sandra. "Human Rights Collectives as Visual Experts: The Case of Syrian Archive." *Visual Communication* 18 (3) (2019): 333–351.

Ristovska, Sandra. "Imaginative Thinking and Human Rights." In *Visual Imagery and Human Rights Practice*, edited by Sandra Ristovska and Monroe Price, 311–320. New York: Palgrave, 2018.

Ristovska, Sandra. "The Purchase of Witnessing in Human Rights Activism." In *Routledge Companion to Media Activism*, edited by Graham Meikle, 216–222. New York: Routledge, 2018.

Ristovska, Sandra. "Strategic Witnessing in an Age of Video Activism." *Media, Culture, & Society* 38 (7) (2016): 1034–1047.

Ristovska, Sandra. "Video and Witnessing at the International Criminal Tribunal for the Former Yugoslavia." In *The Routledge Companion to Media and Human Rights*, edited by Howard Tumber and Silvio Waisbord, 357–365. New York: Routledge, 2017.

Ristovska, Sandra, and Monroe Price, eds. *Visual Imagery and Human Rights Practice.* New York: Palgrave, 2018.

Rodríguez, Clemencia. *Fissures in the Mediascape: An International Study of Citizens Media.* Cresskill, NJ: Hampton Press, 2001.

Rodríguez, Clemencia, Dorothy Kidd, and Laura Stein, eds. *Making Our Media: Global Initiatives toward a Democratic Public Sphere.* Vol. 1: *Creating New Communication Spaces.* Cresskill, NJ: Hampton Press, 2009.

Rosa, Hartmut, and William Scheuerman. Introduction to *High Speed Society: Social Acceleration, Power, and Modernity*, edited by Hartmut Rosa and William Scheuerman, 1–29. University Park: Pennsylvania State University Press, 2009.

Rottwilm, Philip. *The Future of Journalistic Work: Its Changing Nature and Implications.* Oxford: Reuters Institute for the Study of Journalism, 2014.

Rousso, Henry. "Competitive Narratives: An Incident at the Papon Trial." In *The Scene of the Mass Crime: History, Film, and International Tribunals*, edited by Christian Delage and Peter Goodrich, 41–56. Oxon, UK: Routledge, 2013.

Russell, Adrienne. "Innovations in Hybrid Spaces: 2011 UN Climate Summit and the Expanding Journalism Landscape." *Journalism: Theory, Practice, & Criticism* 17 (4) (2013): 904–920.

Salloum, Raniah. "Krieg in Syrien: Hier foltern Assads Agenten." *Spiegel Online*, July 3, 2012. http://www.spiegel.de/politik/ausland/folter-in-syrien-human-rights-watch -veroeffentlicht-neuen-bericht-a-842125.html.

Santos, Boaventura de Sousa. *If God Were a Human Rights Activist.* Stanford, CA: Stanford University Press, 2015.

Sassen, Jane. *The Video Revolution: A Report to the Center for International Media Assistance*. Washington, DC: CIMA-National Endowment for Democracy, 2012. https://www.cima.ned.org/wp-content/uploads/2015/01/Video-revolution-FINAL.pdf.

Savelsberg, Joachim J., and Ryan D. King. "Law and Collective Memory." *Annual Review of Law and Society* 3 (2007): 189–211.

Schlozman, Kay Lehman, Sidney Verba, and Henry E. Brady. *The Unheavenly Chorus: Unequal Political Voice and the Broken Promise of American Democracy*. Princeton, NJ: Princeton University Press, 2012.

Schudson, Michael. *Discovering the News*. New York: Basic Books, 1978.

Schudson, Michael. *The Sociology of News*. 2nd ed. New York: Norton, 2011.

Schulberg, Stuart, dir. *Nuremberg: Its Lesson for Today*. Motion picture, Schulberg/Waletzky Restoration. Produced by Sandra Schulberg, restored by Sandra Schulberg and John Waletsky. Schulberg Productions, 2010.

Schuppli, Susan. "Entering Evidence: Cross Examining the Court Records of the ICTY." In *Forensis: The Architecture of Public Truth*, edited by Forensic Architecture, 279–314. Berlin: Sternberg Press, 2014.

Schwartz, Louis Georges. *Mechanical Witness: A History of Motion Picture Evidence in U.S. Courts*. New York: Oxford University Press, 2009.

Scott, James C. *Seeing Like a State: How Certain Schemes to Improve the Human Condition Have Failed*. New Haven, CT: Yale University Press, 1998.

Shaer, Matthew. "'The Media Doesn't Care What Happens Here': Can Amateur Journalism Bring Justice to Rio's Favelas?" *New York Times Magazine*, February 18, 2015. http://www.nytimes.com/2015/02/22/magazine/the-media-doesnt-care-what-happens-here.html?_r=0.

Shaw, Ibrahim Seaga. *Human Rights Journalism: Advances in Reporting Distant Humanitarian Interventions*. New York: Palgrave Macmillan, 2012.

Sherwin, Richard K. "Visual Jurisprudence." *New York Law School Review* 56 (2012): 138–165.

Silverman, Craig. "Amnesty International Launches Video Verification Tool, Website." *Poynter Institute*, July 8, 2014. http://www.poynter.org/2014/amnesty-international-launches-video-verification-tool-website/257956/.

Silverman, Craig, ed. *Verification Handbook: An Ultimate Guideline on Digital Age Sourcing for Emergency Coverage*. Maastricht, Netherlands: European Journalism Centre, 2014. http://verificationhand book.com /book/.

Silverman, Craig, ed. *Verification Handbook for Investigative Reporting: A Guide to Online Search and Research Techniques for Using UGC and Open Source Information in*

*Investigations*. Maastricht, Netherlands: European Journalism Centre, 2015. http:// verificationhandbook.com /book2/.

Situ Research. "ICC Digital Platform: Timbuktu, Mali." n.d. https://situ.nyc/research /projects/icc-digital-platform-timbuktu-mali.

Sliwinski, Sharon. "The Childhood of Human Rights: The Kodak on the Congo." *Journal of Visual Culture* 5 (3) (2006): 333–363.

Sliwinski, Sharon. "Human Rights." In *Visual Global Politics*, edited by Roland Bleiker, 169–175. New York: Routledge, 2018.

Sliwinski, Sharon. *Human Rights in Camera*. Chicago: University of Chicago Press, 2011.

Syrian Archive. *Eyes on Aleppo—Visual Evidence Analysis of Human Rights Violations Committed in Aleppo*. March 29, 2017. https://syrianarchive.org/en/investigations /Eyes-on-Aleppo/.

Tagg, John. *The Burden of Representation: Essays on Photographies and Histories*. Minneapolis: University of Minnesota Press, 1988.

Taller de Gráfica Popular (TGP). "Declaration of Principles of the Taller de Gráfica Popular" (1945). In *Estampas de la Revolución Mexicana: 85 grabados de los artistas del Taller de Gráfica Popular*. Mexico City: La Estampa Mexicana, 1947. http://econtent .unm.edu/cdm/ref/collection/artmuseum/id/65.

Tapper, Jake, and Mariano Castillo. "First on CNN: Videos Show Glimpse into Evidence for Syria Intervention." CNN, September 8, 2013. https://www.cnn.com/2013 /09/07/politics/us-syria-chemical-attack-videos/index.html.

Thompson, James. "'Pictorial Lies'?—Posters and Politics in Britain c. 1880–1914." *Past and Present* 197 (1) (2007): 177–210.

Thompson, Kristin, and David Bordwell. *Film History: An Introduction*. 2nd ed. New York: McGraw-Hill Higher Education, 2003.

Torchin, Leshu. *Creating the Witness: Documenting Genocide on Film, Video, and the Internet*. Minneapolis: University of Minnesota Press, 2012.

Treré, Emiliano. *Hybrid Media Activism: Ecologies, Imaginaries, Algorithms*. New York: Routledge, 2019.

Tufekci, Zeynep. *Twitter and Tear Gas: The Power and Fragility of Networked Protest*. New Haven, CT: Yale University Press, 2017.

Tunstall, Jeremy. *The Media Were American: US Mass Media in Decline*. Oxford: Oxford University Press, 2007.

Twomey, Christina. "Framing Atrocity: Photography and Humanitarianism." *History of Photography* 36 (3) (2012): 255–264.

United Nations, International Criminal Tribunal for the former Yugoslavia. *Rules of Procedure and Evidence*. July 8, 2015. https://www.icty.org/x/file/Legal%20Library/Rules_procedure_evidence/IT032Rev50_en.pdf.

UN Refugee Agency. "Worldwide Displacement Tops 70 Million, UN Refugee Chief Urges Greater Solidarity in Response." June 19, 2019. https://www.unhcr.org/en-us/news/press/2019/6/5d03b22b4/worldwide-displacement-tops-70-million-un-refugee-chief-urges-greater-solidarity.html.

Visser, Nick. "CBS Chief Les Moonves Says Trump's 'Damn Good' for Business." *HuffPost*, March 1, 2016. https://www.huffpost.com/entry/les-moonves-donald-trump_n_56d52ce8e4b03260bf780275.

Waisbord, Silvio. "Advocacy Journalism in a Global Context." In *The Handbook of Journalism Studies*, edited by Karin Walh-Jorgensen and Thomas Hanitzsch, 371–385. New York: Routledge, 2009.

Waisbord, Silvio. *Reinventing Professionalism: Journalism and News in Global Perspective*. Cambridge: Polity, 2013.

Walker, K. "The Use of Amateur Video in Television News." Walker's blog, June 1991. http://walkerred.com/here-come-the-video-commandos (site discontinued).

Wardle, Claire. "How Newsrooms Use Eyewitness Media." In *Visual Imagery and Human Rights Practice*, edited by Sandra Ristovska and Monroe Price, 299–308. New York: Palgrave, 2018.

Wardle, Claire, Sam Dubberley, and Peter D. Brown. *Amateur Footage: A Global Study of User-Generated Content in TV and Online News Output*. New York: Tow Center for Digital Journalism, Columbia University, 2014. https://doi.org/10.7916/D88S526V.

Wardle, Claire, Angela Pimenta, Guilherme Conter, Nic Dias, and Pedro Burgos. "An Evaluation of the Impact of a Collaborative Journalism Project on Brazilian Journalists and Audiences." *First Draft*, June 27, 2019. https://firstdraftnews.org/wp-content/uploads/2019/06/Comprova-Full-Report-Final.pdf?x19006.

Watson, Ivan. "Torture Allegedly Widespread in Syria." CNN, July 3, 2012. Video, 2:56. http://www.cnn.com/videos/world/2012/07/03/watson-syria-human-rights-watch.cnn.

Weber, Max. "Bureaucracy." In *From Max Weber: Essays in Sociology*, edited by Hans Gerth and C. Wright Mills, 196–244. New York: Oxford University Press, 1947.

Weizman, Eyal. *Forensic Architecture: Violence at the Threshold of Detectability*. New York: Zone Books, 2017.

Weizman, Eyal. Introduction to *Forensis: The Architecture of Public Truth*, edited by Forensic Architecture, 9–32. Berlin: Sternberg Press, 2014.

Weizman, Eyal. "Open Verification." *E-flux Architecture*, 2019. https://www.e-flux .com/architecture/becoming-digital/.

Wessels, Joshka. *Documenting Syria: Film-making, Video Activism, and Revolution.* New York: I. B. Tauris, 2019.

Wexler, Rebecca. "Technology's Continuum: Body Cameras, Data Collection, and Constitutional Searches." In *Visual Imagery and Human Rights Practice*, edited by Sandra Ristovska and Monroe Price, 89–105. New York: Palgrave, 2018.

Whiteman, David. 2004. "Out of the Theaters and into the Streets: A Coalition Model of the Political Impact of Documentary Film and Video." *Political Communication* 21 (2004): 51–69.

Williams, Randall. *The Divided World: Human Rights and Its Violence.* Minneapolis: University of Minnesota Press, 2010.

Williams, Raymond. *Marxism and Literature.* Oxford: Oxford University Press, 1977.

WITNESS. "About." 2016. https://witness.org/about/.

WITNESS. "Deepfakes—Prepare Yourself Now." Report launched October 2019. https://www.witness.org/witness-deepfakes-prepare-yourself-now-report-launched/.

WITNESS, prod. *Help Make Human Rights Abuse Visible, #WitnessTruth.* June 22, 2016. Video, 2:34. https://www.youtube.com/watch?v=x1PhAEwkJD4.

WITNESS. "Use of Video Evidence Leads to Justice in Democratic Republic of Congo." September 2018. https://www.witness.org/video-evidence-helps-lead-to-his toric-conviction-in-democratic-republic-of-congo/.

Wright, Kate. "NGOs as News Organizations." In *Oxford Research Encyclopedias.* Oxford: Oxford University Press, 2010. doi: 10.1093/acrefore/9780190228613.013.852.

Yakobovich, Oren. "Hidden Cameras That Film Injustice in the World's Most Dangerous Places." *TED Talk*, October 2014. https://www.ted.com/talks/oren_yakobo vich_hidden_cameras_that_film_injustice_in_the_world_s_most_dangerous_places ?language=en.

Youm, Kyu Ho. "Cameras in the Courtroom in the Twenty-First Century: The U.S. Supreme Court Learning from Abroad?" *BYU Law Review* 6 (2012): 1989–2031.

Young, Dannagal G., Kathleen Hall Jamieson, Shannon Poulsen, and Abigail Goldring. "Fact-Checking Effectiveness as a Function of Format and Tone: Evaluating FactCheck.org and FlackCheck.org." *Journalism & Mass Communication Quarterly* 95 (1) (2017): 49–75.

Zelizer, Barbie. *About to Die: How News Images Move the Public.* New York: Oxford University Press, 2010.

Zelizer, Barbie. *Covering the Body: The Kennedy Assassination, the Media, and the Shaping of Collective Memory*. Chicago: University of Chicago Press, 1992.

Zelizer, Barbie. "Journalism's 'Last' Stand: Wirephoto and the Discourse of Resistance." *Journal of Communication* 45 (2) (1995): 78–92.

Zelizer, Barbie. "On 'Having Been There': 'Eyewitnessing' as a Journalistic Key Word." *Critical Studies in Media Communication* 24 (5) (2007): 408–428.

Zelizer, Barbie. "Reflections Essay: What's Untransportable about the Transport of Photographic Images?" *Popular Communication* 4 (1) (2006): 3–20.

Zelizer, Barbie. *Remembering to Forget: Holocaust Memory through the Camera's Eye*. Chicago: University of Chicago Press, 1998.

Zelizer, Barbie. *What Journalism Could Be*. Cambridge: Polity Press, 2017.

Zelizer, Barbie. "Words against Images: Positioning Newswork in the Age of Photography." In *Newsworkers: Towards a History of the Rank and File*, edited by Hanno Hardt and Bonnie Brennen, 135–159. Minneapolis: University of Minnesota Press, 1995.

Zimmerman, Patricia Rodden. *States of Emergency: Documentaries, Wars, Democracies*. Minneapolis: University of Minnesota Press, 2000.

Žižek, Slavoj. "'I Hear You with My Eyes'; or, The Invisible Master." In *Gaze and Voice as Love Objects*, edited by Renata Salecl and Slavoj Žižek, 90–126. Durham, NC: Duke University Press, 1996.

Zuckerman, Ethan. "Using the Internet to Examine Patterns of Foreign Coverage." *Nieman Reports* 58 (3) (2004): 51–54.

Zverzhanovski, Ivan. "Watching War Crimes: The Srebrenica Video and the Serbian Attitudes to the 1995 Massacre." *Southeast European and Black Sea Studies* 7 (3) (2007): 417–430.

# Index

## Information Policy Series

Edited by Sandra Braman